The Emphatically *Queer* Career of *artist* PERKINS HARNLY and his *Bohemian Friends*

by Sarah Burns

Lynn + Bryan —
Thanks for
reading!!

♡
Sarah

PROCESS

The Emphatically Queer Career of Artist Perkins Harnly and His Bohemian Friends

ISBN: 9781934170885

Designed by Ron Kretsch

PROCESS MEDIA
1240 W Sims Way #124
Port Townsend WA 98368

Printed in the United States of America
10 9 8 7 6 5 4 3 2 1

TABLE OF CONTENTS

Author's Note..9

Acknowledgements..11

Introduction..15

1. *When Bitchhood Was in Flower*......................................21

2. *Dead Movie Stars*......................................47

3. *What a Drag!*......................................65

4. *Land of the Dead*......................................85

5. *Fat Queens and Victorian Monstrosities*......................103

6. *The Gay Thirties*......................................125

7. *Flaming Families*......................................153

8. *Gremlins in Hollywood*......................................171

9. *Decorating with the Stars*......................................191

10. *Trashy Cafeteria Queens*......................................213

11. *Sort of Famous*......................................235

12. *Such a Sly Old Man*......................................255

Epilogue/Epitaph......................................265

Archival Sources......................................271

List of Illustrations......................................303

Index......................................307

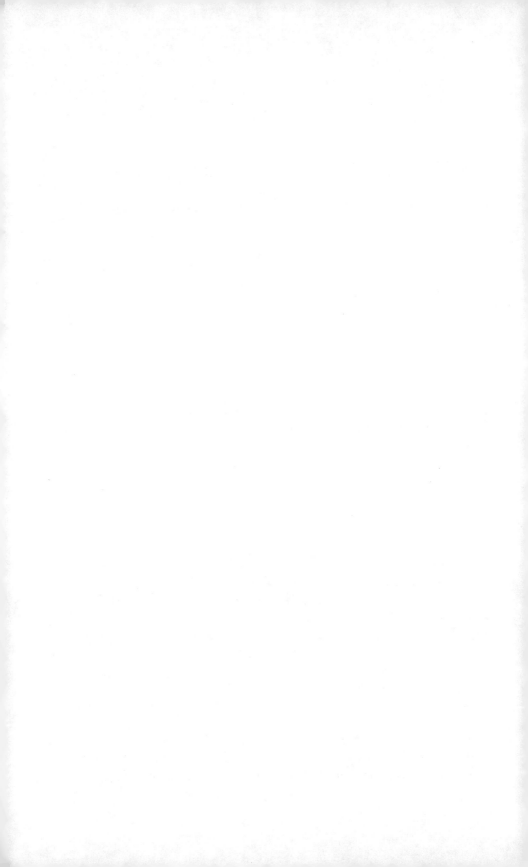

Author's Note

THE MAJOR SOURCES OF PERKINS' STORY ARE THE public and private archives where his papers and memorabilia, and those of his friends and associates, have been preserved. These sources are listed in full at the head of the end notes. The Perkins archive that Tom Huckabee kept for so many years before handing it over to me will join Perkins' other papers at the Archives of American Art once this book is published. However, I feel that it is of highest importance to honor Tom's crucial role as keeper of this priceless Perkins trove. Accordingly, I attribute all citations from this archive—letters, videos, and audiotapes—to the "Huckabee Collection," with the exception of the works that he still owns, which I note as being in his personal collection.

Orthography was not Perkins' strong point as a writer, to say the least, and his letters are rife with unapologetic and sometimes exuberant misspellings. My favorite is "cloisterphobia," which I didn't quote in the text since the right occasion never came up. I have kept most of Perkins' own spellings, like his habitual "git" and "inclosed," which recur over and over. In the service of readability, I have corrected words that appear to be mere typos while including most of the original misspellings followed by [sic].

One of the challenges in writing this book was how to shape Perkins' story: what to select, what to highlight, how to draw and propel the narrative arc. This is something all biographers face, of course. Perkins had other friends and other adventures that I've not touched on for various reasons. Sometimes I couldn't find enough or even any information about people he mentioned in his correspondence. Sometimes there didn't seem to be enough to hang a side story on; for example, during his early travels in England, Perkins met and was befriended by the noted Czech-British actress Hana Pravda, an Auschwitz survivor who had a distinguished career on stage and in film and who helped broker Perkins' 1973 exhibition at the Crane Arts Gallery in London. Yet there was little in surviving bits of her correspondence with Perkins to spin a tale, nor did Perkins himself say much of anything about the connection beyond superficial reports on their various jaunts around the Mother Country together. On the other hand, the utterly obscure Yvonne Kenward, who became a Perkins fan after watching him on the Johnny Carson show, had an offbeat story that fit right in with Perkins' own and therefore made the cut.

Had I included Hana Pravda and others lingering in the background, Perkins' story might have taken a superficially somewhat different shape, but it may well have buckled under the weight of what we now refer to as "too much information,"

often with exclamation point. For the same reason, I made the decision to tread judiciously when it came to Perkins' salacious tales of sexual escapades—his own and others'—that he recounted, with great relish, to a very few. Given Perkins' documented propensity to exaggerate in order to make his stories more colorful, it seems clear to me that in these risqué tales, he deliberately emulated hard-core porn for effect. I've included enough detail for readers to get the gist but have stopped short of the full Monty.

Finally, about Perkins' work and that of other artists who make frequent appearances in this story. While selected examples of Perkins' work are illustrated here, readers who want more can peruse the National Gallery of Art's website, where all of his Index of American Design watercolors, including those later given by Albert Lewin, can be seen, and, even better, allow viewers to zoom in almost ad infinitum. Other than that, there is nearly nothing in other public institutions. Many of Perkins' later paintings are in private collections, and I am pretty sure that more are scattered out there somewhere. Individual works occasionally turn up on the art market, but others may never come to light. There may well be more Perkins letters out there, too, but after many years of searching, I believe I've found more than enough on which to base this tale. Readers curious about Don Forbes' paintings will find representative online examples in the collection of the Museum of Nebraska Art. The Bakker Gallery in Provincetown, Massachusetts represents the art of Bill Littlefield. Much of Rose O'Neill's work—Kewpies, magazine illustrations, and "Sweet Monsters"—is in the collection of the Bonniebrook Museum in Branson, Missouri.

Acknowledgements

FIRST OF ALL, I WANT TO ACKNOWLEDGE THE pioneering research of Lynda Roscoe Hartigan, who curated Perkins Harnly's 1981 exhibition at the National Museum of American Art, wrote an informative catalogue essay, and played a major role in collecting his papers for the Archives of American Art as well as interviewing Perkins for an oral history while he was in Washington, D.C. for the opening of his show. My own research on Perkins is grounded in those materials, and I wouldn't have gotten very far without them. However, as I was to realize, there was a lot more waiting to be discovered.

I never could have written this book without the cheerful and invariably unstinting help and generosity of many people. In book acknowledgments, this sort of pronouncement is *de rigueur*, whether said helpers were cheerful and unstinting—or not. In this case, however, they really were. Towering over all is Tom Huckabee, who not only salvaged a critical mass of Perkins' papers and photographs from a storage locker but also—along with his dear friend, the late Bill Paxton—interviewed Perkins extensively on both audio and videotape. When in September 2014 I managed after reaching several dead ends to track Tom down and explain what my project was all about, he took a leap of faith and trust in me, a total stranger and utterly unknown quantity, bundled up all that material, and handed it over to me without asking for anything in return—except a promise to make good on publishing Perkins' story. I'm not exaggerating when I say I can never thank him enough. That would be impossible. But there was more: Tom put me in touch with Bill Paxton, who during our one phone conversation enthusiastically shared his colorful memories of Perkins and vowed to unearth his own collection of letters. Bill didn't find the letters before his sudden and tragic death in 2017, but through Tom and after a decent interval, I was able to get in touch with Louise Paxton, who agreed to keep an eye out for them, and when they surfaced kindly lent them to me for as long as I needed, for which I am most grateful. Tom also brokered a connection with Rocky Schenck, who shared some of his Perkins correspondence and graciously allowed me to publish his memorable portrait of Perkins, grinning amongst dangling plastic Christmas tree branches. Early on, Tom suggested I get in touch with Ginny Cerella, another friend of Perkins who chatted about him with me and shared some of the letters he had written to her. Throughout the protracted process of putting this story together, Tom has offered unflagging support every step of the way.

One of the choice items that Tom Huckabee sent me was a videotape of Alan Warshaw's ten-minute 1969 movie of Perkins working at the Ontra Cafeteria and talking about his paintings in his room at the Culver Hotel. Not realizing that the film was meant to be brief, I thought that there must be something wrong with the tape—surely there had to be more! But Alan proved difficult to find, and I put that search aside. Then, during one of my periodic online searches for other examples of Perkins' art, I happened upon one of his characteristic "fat queens" on the website of The Illustrated Gallery and on a whim sent a query about it via the gallery's "contact us" link. Proprietor Jared Green answered, recommending that I get in touch with the owner, Alan Warshaw, for more information about the painting. Bingo! I owe Jared a huge thank-you for all, unwittingly putting me in contact with the very person I'd been in search of. Alan Warshaw too has been exceptionally generous, admitting me into his home to see his outstanding collection of Perkins originals and relating stories about his brother Henry, one of Perkins' staunch old-age supporters and boosters. He and his wife Jo are delightful company as well.

I owe a great debt of thanks to Jim Bakker for giving me information about William Horace Littlefield, who worked mightily to preserve Don Forbes' memory, and for providing photographs of Littlefield in St. Tropez, and the portrait of Whitney Norcross Morgan illustrated here. Importantly, Jim connected me with artist Arthur Hughes, whose own research on Littlefield proved invaluable. But the biggest breakthrough came when Arthur sent me the draft of a letter he had *almost* sent to the Museum of Nebraska Art in Kearney, Nebraska, when he was seeking information on the location of papers that had gone missing from Littlefield's archive. I decided to follow through, sent a letter of inquiry, and soon learned that the museum had purchased the missing Littlefield papers, which include not only Don's correspondence but also a trove of never-before-seen letters Perkins wrote to Littlefield when asked to furnish details about Don's early life, including the spicy sojourn with Kewpie creator Rose O'Neill. The Forbes archive enabled me to fill in many blanks as well as embroider on other stories and people who were central to Don and to Perkins as well. However, my schedule was so crammed at that time that I couldn't fit in a visit to Kearney, even though I was ravenously eager to comb through the archive. Jean Jacobsen, MONA's curator, connected me with my wonderful Kearney research assistant April White, who spent many, many hours scanning hundreds of pages, all the while heeding my instructions to perfection. April was indispensable to this project, and I am enormously grateful to her, and to Jean for brokering our arrangement.

I also owe a hearty thank-you to the late Jean Cantwell, mover and shaker who played a major role in forming the International Rose O'Neill Club and who supplied me with tantalizing bits and pieces from her correspondence with Perkins about his memories of Rose. The late Charles Francis, who knew Perkins

in the late 1940s and wrote a whole chapter about him in his memoirs, also shared some additional Perkins tidbits with me, for which I remain grateful. Richard Halliburton scholar Gerry Max has also been extraordinarily generous in sharing his deep knowledge of Halliburton's circle, including Don Forbes and Bill Alexander, and supplying me with a choice selection of photographs. In Los Angeles, several people were wonderfully helpful. Author Sherri Snyder connected me with Allison Francis, who graciously provided the photograph of Barbara La Marr illustrated in this book; Tony Duquette's heir, Hutton Wilkinson, was also most generous, furnishing me with images of Tony, Elsie de Wolfe, and the Baroness d'Erlanger. I also owe a big thank-you to Philip Mershon for "Cafégelah." Ramon Caballero told me choice anecdotes about the experience of filming Perkins in one of his favorite graveyard haunts. Sarah Barab, daughter of Margie King Barab, has been most supportive, relating some of her mother's Alexander King stories to me and supplying priceless photographs of Alex King young and old. I am grateful as well to dance historian Lynn Garafola, who talked with me at length about Hubert Stowitts and the present whereabouts of his paintings, and to Robert Sommers of the Blue Heron Gallery for permitting me to illustrate the 1936 poster featuring Stowitts' heroic representation of the athlete Woodrow Stroud.

I began doing the research that led to this book when I was the fortunate Terra Foundation Fellow in American Art History in residence at the Newberry Library in 2008–09. I thank the Terra Foundation sincerely for this opportunity, which was tremendously fruitful; my colleagues at the Newberry, in particular Diane Dillon and Danny Greene, were enthusiastic supporters and discerning critics; Miranda Hofelt, my research assistant there, was brilliantly resourceful and energetic in compiling bibliographies and copious information on an array of subjects, focusing in particular on the all-out critical and material assault on Victorian style in the modernist 1930s. My research on Ivan Albright brought me into the orbit of the Art Institute of Chicago, where congenial colleagues Judy Barter and Sarah Kelly Oehler afforded me opportunities to write and lecture about Albright and other artists on the darker side of culture; I also spent many productive hours at the AIC's Ryerson and Burnham Libraries combing through Albright's papers. Brandon Ruud and Robert Cozzolino, valued and like-minded colleagues in the Midwest, have been great supporters and friends as well.

I highly value the access I've enjoyed to the collections and resources of the Archives of American Art, the New York Public Library, and the Library of Congress, and I deeply appreciate it as well as the professionalism and unstinting helpfulness of their librarians and archivists. To cite one example among many: during the closure forced by the COVID-19 pandemic, Library of Congress manuscripts librarian Lara Szypszak at my request ordered two cumbersome boxes from the Alexander King Papers, stored offsite, to find and scan a photograph I needed—even though I had only the vaguest notion of where among the many

folders I had seen it, and even though the time she could spend in the actual building was strictly limited. Art Librarian Traci Timmons of the Seattle Art Museum also came to my rescue when I needed a scan of an image in an old art magazine that I had not the least hope of getting to myself, since every library door at the time was closed to the public. Nora M. Plant at the American Heritage Center, University of Wyoming, Simon Elliott at the UCLA Library Special Collections, and Leigh Grissom at the Center for Creative Photography were particularly attentive to my needs. Thanks to all!

A special, loud shout-out to my fabulous former graduate student at Indiana University and research assistant extraordinaire, Erin Pauwels, who first brought Perkins to my attention when she came across a review of his very first exhibition in 1933 and later dug through the Albert Lewin Papers at the University of Southern California to find mention of Perkins in the director's *Dorian Gray* correspondence. Another brilliant former student of mine, Michael Schuessler, now living and teaching in Mexico, did his best to find information about Fernando Felix. That search came up short, but had I not stumbled across Michael's groundbreaking research on Frances Toor and Alma Reed, my chapter on Perkins in Mexico would have been much the poorer.

Finally, I extend heartfelt thanks to the friends and comrades-in-arms who have listened to my Perkins tales over the years and buoyed me up with their enthusiasm for the project, not to mention their cogent questioning: Debra Mancoff, Joan Hansen, Patricia Junker, Erika Doss, Sidney Lawrence, Hanna Rochlitz, Alexis Boylan, Kate Lemay, Larry and Julie Snyder, Sally Webster, Kathie Manthorne, Suzaan Boettger, Julia Rosenbaum, and Klaudia Nelson. I hope I haven't forgotten anyone, but if so, my apologies. And above all, my never-ending gratitude to Dennis, who patiently indulged my obsession with Perkins and made me rack my brains around his one key question: "Why should I be interested in reading about this guy?" With this book, I hope I've answered it at last.

Introduction: Why Write about Perkins Harnly?

PERKINS HARNLY (1901–1986) FIRST SAW THE LIGHT ON a one-cow dairy farm in Ogallala, Nebraska, which he fled at the earliest possible opportunity. He died eighty-five years later in Los Angeles after a life that—however humble on the surface—was anything but humdrum. A self-taught artist and ardent drag queen, Perkins worshipped both the legendary French actress Sarah Bernhardt and the bawdy vaudeville/movie star Mae West, saved up his meager earnings to visit the graves of famous people all over the world, and painted watercolors of morbidly witty graveyard scenes or eroticized Victorian interiors that on one occasion earned him the sobriquet of "The Grandma Moses of Near-Porn."

With the exception of a tiny handful of art historians and a small group of Hollywood hopefuls who knew and cared about him when he was very old—and they were very young—almost no one today has heard of Perkins, though the occasional painting surfaces from time to time at auction, and not a few of his paintings are in the collections of major American museums—but for the most part they are hidden, hanging on storage racks or lying undisturbed in drawers. Given that the artist worked in watercolor, which fades with prolonged exposure to light, it makes sense to keep them in the dark. Historically speaking, Perkins himself has been in the dark for forty years, too. My goal in this book is to bring him out of the shadows—and to show why this is worthwhile.

Why write about Perkins? Art historically, he is a fringe figure, as obscure as any of the hundreds or thousands of other American artists that cluster at the shadowy edges of history. He wasn't a great artist, either, though "greatness" is a relative, culturally specific, and invariably disputed term much dependent on taste, markets, and whatever artists cultural institutions choose to enshrine. No matter what criteria we apply, Perkins falls well outside the "greatness" parameters (more on that below), not that he professed to care, describing himself more often as a manual laborer than a professional painter. Of course, at some level he did care, and he was proud of the fact that his work had appeared many times in public. Indeed, his very first show in New York—in 1933—was in tandem with the then-unsung homegrown surrealist Joseph Cornell at the gallery of Julian Levy, one of the very first American dealers to promote European surrealism. Perkins even exhibited—once, in 1942—at the Metropolitan Museum of Art, albeit on

the mezzanine rather than within the grander galleries. And in 1981, he did enjoy a retrospective—his first, and only—at the then-National Museum of American Art in Washington (now the Smithsonian American Art Museum). By that time, Cornell, dead in 1972, was already on his fourth major museum retrospective, with two more to follow, and counting.

None of this is to plead the cause for Cornell-scale veneration of Perkins Harnly. Cornell's art is the manifestation of an artist's questing spirit, the paths he explored, the dream world of his imagination. His collages and boxes retain their power to intrigue, mystify and haunt. Perkins' art, intriguing to be sure and meticulously crafted, doesn't venture into the same territory. His Victorian interiors and cemeteries may be haunted but, with few exceptions, they are not haunting. His drawings and paintings are often almost, or even outright, cartoonish. They're crammed with campy in-jokes and bawdy innuendo, rendered in enough obsessive detail to rival the fanciest dollhouse. They're fun and funny. But once he had broken his own particular patch of ground, Perkins generally stuck to the same round of subjects and seldom (except during an extended sojourn in Mexico, early in his career) ventured off familiar pathways.

So, why write about Perkins? Unlike his art, his actual life followed twisting, branching paths into and out of odd and often downright weird places. His life course followed no arc but rather traced a wayward line. He kept abundant photographic records of his trips to far-flung graveyards and always had himself photographed by some friendly stranger, wherever he landed, like a human version of what would be, much later, the traveling gnome. His mind zigzagged, too, from almost inconceivably gross flights of fancy (or fact) to nuanced reflections on art and literature. And, like an artistic Zelig, Perkins—flying under the radar all his life—somehow managed to intersect with famous, infamous, and not-so-famous personalities who in turn crossed paths with others, so that we can trace—to take one example among many—a convoluted line leading, ultimately, to Andy Warhol.

Even so, all this might not add up to much beyond six degrees of separation were it not for Perkins' own vividly idiosyncratic voice, preserved in his voluminous correspondence (much of it fortunately saved from destruction, though an unknown quantity appears to be lost), taped interviews, and a handful of video recordings. Even his offhand play with signatures conveys the sense of a quirky but intensely self-aware persona: "Mary, Queen of Sluts," "Sarah Assburn," "Old Man Grandpa Moses," "Tighty Ass," "Clarabelle." There are still many gaps in the record and whole decades of silence, but what's left uncovers the contours of a life so rich and strange and so closely interwoven with the art that together, life and art spark an alchemical transformation that yields narrative gold.

This project began to take shape several years ago when I was collecting material on attitudes toward the American Victorian past, particularly its domestic architecture, in the interwar decades (1920s–1930s). I was trying to figure out why so

many Americans then and now tend to equate "Victorian house" with "haunted." I was curious about Halloween houses, how they almost always seemed to be gloomy Victorian piles standing in the moonlight or luridly etched in a flash of lighting, with a few tombstones scattered about and perhaps a barren tree or two with tortuously twisted branches. I guessed that the Alfred Hitchcock *Psycho* house might have played a role in establishing the type, along with the creepy-funny Victorian mansion inhabited since the late 1930s by the ever-popular Addams family.

But I wanted to dig down deeper: when had this pattern begun to take shape? Who was writing about Victoriana in the earlier twentieth century, and how? It didn't take long to collect an overabundance of evidence from period magazines, newspapers, and architectural literature. Almost without exception, they trashed all things Victorian, labeling architecture and interior decoration alike as monstrous, abominable, abortive, impure, horrible, and hideous. Where else would ghosts lurk and bats make their home?

Then something quite different caught my eye: a review of Perkins' 1933 exhibition at the Julien Levy Gallery. Here for the first time Perkins displayed some of his watercolors of ornate Victorian interiors, crammed with bulging furniture, hothouse flowers, urns, tassels, swags, and draperies, along with well-upholstered ladies in gigantic plumed hats, frilly drawers, and tight corsets. This was obviously no run-of-the-mill hater of the "Monstrosity Decade" (the label coined by Perkins to describe the last gasp of Victorian exuberance in the early twentieth century). Perkins, the review stated, had grown to love and laugh at his garish mid-Victorian surroundings in Nebraska and now, with tongue in cheek, he wove a spell around the "so-called old atrocities" and made them interesting—and funny.

Who was this cheeky artist-satirist? I found more reviews and began to piece together snippets of Perkins' life. Over time, I discovered treasure troves of papers deposited in various archives, libraries, and private collections. I plowed through everything, reading the voluminous and often hilarious letters, picking through photographs, finding more pieces to fill out the jigsaw-puzzle picture of the artist's life. I wanted to write about an artist whose life was at least as interesting as his art—or more so, even. This was not life writ large but etched small. Perkins did not stride upon the world stage, launch a revolution, invent a life-saving cure, or sacrifice himself for any greater good. But in manifold ways, he is memorable and worth remembering.

Having spent quite a few years now with Perkins, I feel that I know him quite well. I've been fortunate to find people who knew him in life, most of all Tom Huckabee, who cleaned out what was left of Perkins' papers from a storage locker when the old man fell ill and had to leave his one-room studio apartment in the fleabag hotel where he had lived for nearly forty years. It was Tom, too, along with a couple of friends, who interviewed Perkins on both audio and videotape

and who later published a fond memoir, which I lit upon through sheer Internet happenstance. I had to find this person!

With another big helping of luck, I located Tom, who, on hearing what I was up to, sent me all the Perkins flotsam and jetsam he had salvaged. Custodian of Perkins' urn, Tom even endowed me with a little piece of the artist: a tiny baggie of his ashes, plus a scaled-to-fit reproduction of his portrait of jowly Queen Victoria. Though Perkins left no will, he did leave instructions for his funeral, should he have one. Only two pall bearers, he insisted. Asked why so few, he cracked, "A garbage can only has two handles!" An old man in a bow tie who would happily spout filthy limericks on request, he charmed people more than half a century younger. As one twenty-something at an exhibition opening squealed: "He's the cutest person!"

In the stories that follow, the curtain rises on "the cutest person," with rotating and periodic appearances by Perkins' friends, peers, and contemporaries, from early to late. Regarding nomenclature, I have chosen for the most part to use given names in preference to surnames, because I want my subjects to seem familiar, close, and real, rather than distant figures out of an encyclopedia or textbook. And while I have tried to uncover every scrap of information, I don't know everything about Perkins. There are gaps in the record, and indeed, lingering and probably unsolvable mysteries: near the end of his life, Perkins stated that there was "a big untold story that will have to go with me into the crematory furnace."

In any case, as mentioned above, this book doesn't aim to dwell on every documentable moment or nail down every detail. Rather, my approach is to focus more selectively on high points, low points, and turning points, to get inside Perkins' head (and those of a few close contemporaries), to feel for the color and texture of his life. The narrative, accordingly, traces a somewhat wayward path that allows for digression, opening up space for sidebars that create ambience or delve into other stories, sub-stories, about those intimates, associates, or fellow travelers who intersected (or collided) with Perkins along the way.

Perkins had a collection of life stories that he told with slight or significant variations on many different occasions. Depending on who was listening, he would tone a tale down or touch it up. In the telling and retelling, most of the stories are structurally consistent, though the trimmings vary. Perkins was thus a reliable narrator, up to a point. And what can't be verified is usually so entertaining (or weird, or outrageous, or shocking) that it doesn't matter whether it's one hundred percent true, or not, unless one has a stake in absolute accuracy. The latter did concern an old acquaintance trying to track down biographical data on Perkins' ill-fated cousin Don Forbes (whom we'll meet in due time). "Perkins exaggerates," complained the would-be biographer, "hence vitiates his credibility." For Perkins, though, exaggeration was an indispensable narrative device: "I would not worry about exact facts too much, but take suggestions and work them

up into dramatic reading matter," he declared. "I would exaggerate, take license, transpose rather ordinary, dull facts into more exciting and interesting narrative for the sake of entertainment or reader stimulation. Dry, authentic statistics are not particularly valuable or enjoyable. Technical precision does not apotheosize an outrageous personality as agreeably as wit and a lilting approach to his vices vs his virtues." In that spirit, I seek here to evoke Perkins' voice, his salty flavor, his exuberant and intentional embellishment of every bare-boned fact—without, of course, departing from whatever verifiable facts there are upon which to anchor his erratic chronicles.

This is a story of how a deeply and proudly queer outsider—a cross-dressing, death-fetishizing, self-taught artist from the windswept plains of remotest Nebraska—managed to survive for the better part of a century in a world that offered few safe places for him to be who he was, whoever that may have been. In a sense, Perkins made himself up as he went along: he became his stories, and his stories became him. He sedulously concealed the abuses and traumatic experiences of his early life, and the hardships of marginal manhood, behind a mask of ironic detachment (or jokey nonchalance) that he seldom dropped. Throughout his life, indeed, he turned hurt into humor. That was how he fought his battles.

When Bitchhood Was in Flower

AS AN OLD MAN, PERKINS HARNLY POSED FOR A portrait by his young Hollywood friend, Rocky Schenck. The photograph was pressed into service to advertise an exhibition that billed Perkins, somewhat misleadingly, as an "American Surrealist." Perkins sits with arms folded on top of a checkerboard-patterned tabletop. In a bunchy tweed jacket and a bow tie, he grins and stares out at us through pebble-glass lenses set into chunky plastic frames. His gray hair is neatly combed from his balding brow. Lit from both sides, he has an aura. Angling down from above are pale tapers with curlicued branches, like icicles in the wind, or frozen lightning (in actuality, segments of a deconstructed plastic Christmas tree). You probably wouldn't give the old man a second look if you passed him on the street. But in this setting, he is strikingly weird.

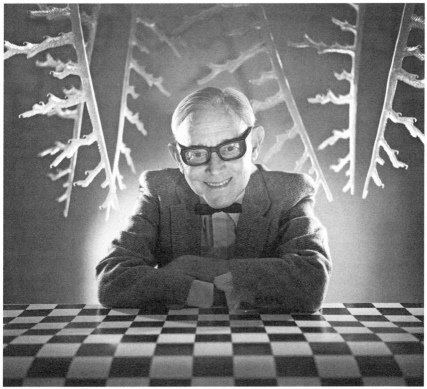

Rocky Schenck's photograph of Perkins Harnly with
deconstructed plastic Christmas tree branches, 1981

Once upon a time, he was very pretty. Scroll back some sixty years to another photograph, taken when he was just turning twenty. He has a cameo-smooth, well-proportioned oval face, smoldering dark eyes, a pensive expression, and abundant dark tousled hair. Open at the neck, his soft shirt sets off a columnar throat. He also seems to be wearing lipstick; it shapes his mouth into a perfect Cupid's bow. Only pluck his eyebrows and he could be taken, or mistaken, for a silent-screen Hollywood starlet. During his Los Angeles cafeteria days, much later, Perkins sent a copy of this photograph to an old friend. His job, he wrote, was hard, but he really didn't care.

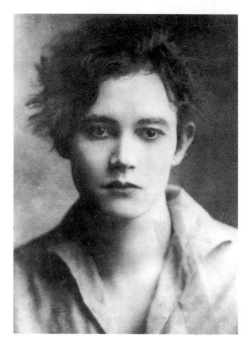

Perkins at the height of his "Bitchhood," c. 1920

"I am needed there and it's nice to be needed. It's better than street walking especially at my age when trade is hard to pick up when there are plenty of young, gorgeous MODERN beauties around! Inclosed photo taken forty one years ago attests to the incidence of the previous statement not having always been the case. Ha! Ha! The title of the picture is: 'When Bitchhood was In Flower.' Or 'Her Bitchship.'"

Her Bitchship began life on a hardscrabble farm near the tiny town of Ogallala, Nebraska, almost three hundred miles from the state capital of Lincoln. By the time Perkins was born, Ogallala was considerably tamer than it had been during its heyday as the terminus of the massive Texas cattle drives; today that frontier ambience has been recreated, complete with a Boot Hill for unlucky gunslingers. Perkins once had a photograph of all his relatives arrayed in front of the house where he was born. The photo, and the house, are long lost, but Perkins' description remains. From the sound of it, the picture was a typical example of the multi-generational family portraits made in the late nineteenth and early twentieth century by traveling operatives and usually representing many scowling people, from toddlers to great-grandparents, in front of a farmhouse somewhere in the Midwest. Often such houses are bedecked with jigsaw Gothic lace that bears material witness to the family's success, or at least their aspirations. The Harnly house, however, seems to have been a great deal less

pretentious: "Birthplace of Perkins Harnly, six miles east of Ogallala, Nebraska, 1900," says the typescript (Perkins was actually born in 1901, but a year plus or minus didn't overly concern him). "Burnt down in early part of the Century. 'Share Cropper' style architecture with Neo Classic influence, (the pediment of main portion of the building), lean-to perhaps a later addition."

The group on the terrace, the typescript continues, is "distinguished looking" and includes "Grandfather who had fought in the Civil War along with eight brothers, all still living at the time picture was taken. Grandmother who got up out of bed especially to be photographed—she had no reason to get up other times. Uncle Tom (cross-eyed), who never did very well for himself and stole the wood from sign-boards to roof the lean-to." The environment was hardly salubrious, either: "Area of lawn without grass was made so by soapy dishwater thrown on it daily. Outhouses one, two, and three are out of range of camera . . . It was an abandoned cattle ranch rented from a midwife who delivered Perkins. Upkeep of the estate was paid for from Grandpa's dollar a day war pension."

Some of Perkins' own reminiscences incorporate the sort of stock elements we associate with tales of rugged frontier boyhood. He didn't walk five miles to school in a blizzard, or at least he never mentioned it, but the school *was* four miles away. He rode there with his siblings in a wagon drawn by an old mule, he said, then back home again in the late afternoon, when they'd have to start the windmill (a ticklish job) and go to the smokehouse for bacon. They went to the county fairs, shucked corn, and raised peaches, which they ripened on sheets of newspaper under the bed where Perkins and four siblings all slept together beneath a horse blanket fastened down with "giant brass safety pins." As a nominal dairy farm, the place didn't exactly live up to its billing: there was one cow, Daisy, who had one calf, sex unknown. There was also an ornery billy goat and a pony or two, along with the mule and some chickens.

His mother, Julia Josephine, had a collection of homely folk remedies that she used to ward off illness and bad luck. "Not only did my mother tie little bags of ASS*A*FED*ITY around our necks, but she tied a bag-full on the gate post in front of our Nebraska farm house which protected us from whatever she had in mind. She also buried the dish rag under the rain spout of our house and when it disintegrated our troubles vanished along with the dish rag." (Perkins used the folk spelling of asafoetida—an herb so pungent that it went by the nickname "Devil's Dung," or, less politely, *merde du Diable*.) In the winter, the children would make ice cream out of snow and sugar. One Christmas there was so little money to spare that Perkins' parents cut down a dead pear-tree sapling and spent the night covering every twig and branch with cotton, presumably to resemble snow. Otherwise, the "messed up bit of scraggly fire wood" was devoid of ornaments. Perkins at school had received a "little red mosquito netting stocking full of hard candy . . . I hung my stocking on the tree and all

of the Heavenly Hosts descended from on high and sang . . ." Filled with such homely touches, Perkins' boyhood recollections paint the picture of an austere but wholesome place. Only, according to other Perkins stories, it was anything but. We can guess this, in fact, by heeding what the angels sang to little Perkins that Christmas day: "'Git out of Nebraska, you jerk!'"

Perkins loathed his birthplace with a passion. "I hated the farm where I was born," he wrote later. "I hated the all pervading stench of animal dung and I hated milking a cow. I milked one while other farm hands milked eight. I loathed the cow's tits, oh how I struggled with those things. They constituted a traumatic experience which took many years to overcome." (Perkins shared his hatred of cows with Henry Ford, who had so detested boyhood farm work that he later declared "the cow must go," and tirelessly promoted soy milk instead.) There was little in the way of entertainment except church services where the long-winded hell-fire homilies delivered by some "traveling Evangelican [sic] loud mouth. . . scared the shit out of you and spoiled your Sunday dinner." Little improved by religion, the Harnly family (in Perkins' view) was a pack of degenerates, "trashy Tobacco Road types." His cross-eyed uncle and his grand-dad—also cross-eyed—for unknown reasons lurked around the windmill all the time. His sisters and little brother were all "a little bit dopey."

That was hardly the worst of it. If we are to believe the future artist, the farm was the site of such depravity that even the hens weren't safe. Everyone "carried on" with animals, including his dad. No one thought it was "perverted." Perkins alleged that he had sex with his sisters, with Dixie the pony, with the hapless chickens, and with Mrs. Oltrogge, the farm wife next door, who had fourteen children and wanted more, and who—for an old woman—was "superb" in bed and as "hardboiled as hell." Perkins also claimed that he had sex in a cornfield with Mrs. Oltrogge's daughter, got caught, and was packed off to reform school, from which he eventually escaped by hiding under a load of sugar beets in an outgoing wagon. Perhaps we should take these stories with a grain of salt. Perkins never alluded to such lurid episodes in any of the surviving correspondence, and when he did divulge them at last, he was an octogenarian whose young friends got a huge kick out of urging him on to more and more outrageous revelations. On the other hand, such behavior on farms was hardly beyond the pale, though not something most people might want to talk about openly, let alone confess to.

And given subsequent family history, it may be that Perkins wasn't simply making it all up to shock his young listeners. In Perkins' version, the family broke apart in 1910, when the children (six of them by then) were separated and put in foster homes. His siblings all "kicked off" during an epidemic, and Perkins was taken in by his grandparents in Lincoln. His father died, he said, and his mother blackmailed a "guy named Fuller," who had a windmill factory in Kearney, Nebraska, to marry her. Little of this is accurate. But the real story

is so sordid, and ultimately tragic, that it lends some credence to Perkins' lurid tales of orgies with animals.

It is unclear what Frank Harnly did for a living beyond farming. The 1910 census lists him as a mason; Perkins described him variously as a horse dentist, streetcar conductor, draftsman, and leather-worker. There is no record that his mother, Julia Josephine, married a windmill factory owner, either. What *is* true is that in January, 1916, Julia filed for divorce, charging Frank with extreme cruelty and nonsupport. On many occasions beginning three years earlier, she claimed, Frank had carried out brutal assaults, pinching, slapping, beating, and choking her while calling her "the vilest of names." At different times, he dragged her upstairs and locked her in a room for hours, until in March of 1914 she escaped from a second-story window and fled with one child to seek refuge in the Gage County seat of Beatrice. Frank farmed out the children and moved to Lincoln to run a rooming house, which later reports identify as the Sanitary Hotel. Two of the children (one of them undoubtedly Perkins) had been in the hands of the juvenile court authorities after keeping company with people of questionable character. Later, Frank placed those two with his parents and refused to let his wife see them. According to the newspaper reports, Frank was a man of the "most violent temper." He had "beat a couple of ponies belonging to the children until blood ran from their nostrils." He also had "abused his own cow until it died." (One can't help but wonder how he had abused the cow, just for starters.) Julia wanted custody and alimony. At the end of the proceedings, she prayed that her husband be restrained from "poisoning the minds of the children" against her. But worse was yet to come.

A scarlet fever epidemic broke out in Lincoln. Seven-year-old Benjamin and three-year-old Lucile, both quartered with the poisonous Frank at the Sanitary Hotel, contracted the disease. Benjamin died on February 22, 1916, three days after he had fallen ill, and Lucile succumbed on March 9. The city health department had immediately quarantined the hotel and sent a trained nurse to care for the children, to no avail. A third child, who had been deposited with her paternal grandparents, came down with the fever around the middle of March. That house too was put under quarantine, but Frank went there anyway to nurse his daughter. She survived, but Frank caught the disease and died on May 1. In light of events earlier that year, it is more than just a tad ironic that the *Lincoln Daily Star's* headline "Harnly Gave Up Life for Child" transformed the cow-killing, pony-beating, mind-poisoning wife-abuser into a hero and martyr.

Julia probably shed no tears for Frank, but the loss of her children, following so soon after the dissolution of the family, must have been devastating. After the separation, she fell on hard times and at one point had to find work as a servant. She kept her three surviving daughters, but Perkins remained with his paternal grandparents in Lincoln and broke off contact with mother and sisters.

He later declared that he hated them and would not have cared if they died of starvation. There is a tiny photograph of Julia with baby Perkins, seven months old. Under his frilly cap, Perkins looks quizzical. Julia wears a stylish dress and a large platter-shaped hat loaded with ostrich plumes. Looking terribly young, she holds her firstborn up, level with her own happy face. Life is still good.

Perkins was about twelve years old when his father went on the rampage. Did Frank keep a lid on his terrible temper all along, until something that happened in 1913 caused him all at once to snap? It's impossible to know, but his out-of-control brutality must have been terrifying. Did the children watch Frank beat their ponies and

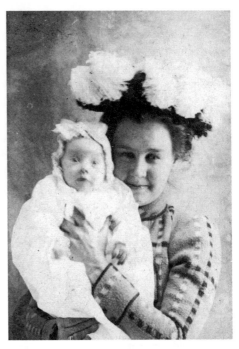

Perkins at seven months with his mother Julia, in Kearney, Nebraska

kill the cow? Did they see him drag their screaming mother upstairs? Could a young boy like Perkins come away from these horrendous scenes unscathed? That's hardly likely. Surely the accumulated trauma was severe. Perhaps it is no wonder that in later retellings Perkins embroidered over the harsh truth of his early years with ridicule and ribald flourishes. As he told it much later, "My mother married my father for money and said she'd stay in bed until he made some. So she was in bed for thirty years." Except when touching on distant memories of the farm, Perkins almost never mentioned his mother in any surviving correspondence or recorded interviews. He alluded to his father only slightly more often. He had buried his anger, fear, and grief in a hermetically sealed vault that he shoved to the darkest and most remote corner of his mind.

As it turned out much later, Julia Josephine enjoyed a windfall of old-age prosperity thanks to her daughter Anna May, who had become improbably rich through savvy investments in California real estate after World War II. One day in the early 1960s, the two of them showed up unexpectedly at the Culver City Hotel, where Perkins had a tiny studio apartment. He told his friend Alexander King (of whom much more in due time) all about it. "Someone came behind me and yanked my sleeve. I turned around to see a beautiful woman in expensive attire. She had lovely hair and huge diamond tear drop ear ornaments. She

introduced herself as my sister, Anna May. She took me out to the curb and introduced me to a stunning and haughty woman. It was my mother. They were in a big black Cadillac with white wall tires . . . Mama was dressed in an identical manner as my sister. She sported the great pear drops of diamonds at her ears. Her hair was done in the latest dyed fashion—moon-beam silver. I did not invite them in." Perkins had not seen them since 1943, when Julia Josephine and her daughters somehow made their way to California to sponge off Perkins during his brief tenure as a sketch artist at MGM (much more on that below, too). They descended on son and brother "like a plague of grasshoppers. They fussed over me and hung around like hungry bed bugs. I stunk them out and later they wrote for money . . . I refused to help them." Two decades later, though, wealthy Julia at age eighty-four was "still screwing rich old men and mooching them out of valuable properties and bonds." Now that the tables were turned, Julia and Anna May offered to extend a helping hand to Perkins. "I turned a cold shoulder," he said. "They even invited me to a steak dinner which I refused." On this one recorded occasion, Perkins allowed his anger to bubble to the surface.

There is only one other photograph of Julia among the surviving heaps of Perkins flotsam and jetsam. It is a formal hand-tinted studio portrait representing her (by my estimate) in her sixties. She has carefully coiffed gray (but possibly not moon-beam silver) hair, large button earrings, and a square-necked black dress with ornamental blue and gold accents. She wears a tiny smile and a benign expression. It's difficult to believe that such a dignified elderly lady would be screwing rich men for favors when she was well into her eighties. Perkins may simply have made up this canard. The portrait was done by the Mattson Studio in Kearney, Nebraska. On the back in swirly cursive is the inscription "Your Sweetheart Mother." Why Perkins kept this photograph is a mystery. There is no record that mother and son ever saw each other again after that Culver City face-off. Julia died in San Diego in 1977, almost one hundred years old. If he even heard the news, Perkins made no recorded comment.

But back to Lincoln. Perkins' years there with his grandparents established the foundations for his art, though that didn't really evolve until much later, and also opened the doors to the local *demimonde*, in which Perkins became something of a player. Before the scarlet fever catastrophe, Perkins lived with his father Frank at the Sanitary Hotel in Lincoln, which he later asserted was also a whorehouse, or, more euphemistically, a "rooming house." This dubious establishment stood next door to a theater that staged vaudeville shows, "crappy junk" redeemed by spectacular scenery and lavishly decorated drop curtains. "When the show would bomb," Perkins noted, "they'd let down the drop curtain. The curtains in those days were painted with Italianate scenes, poor copies of Piranesi. They were usually of a garden with all sorts of urns and balustrades." A restored drop curtain at the Sheridan Opera House in Telluride, Colorado

exemplifies the style. Here are voluminous red draperies with billowing, be-tasseled swags. They frame an idyllic scene in which two figures row a stately barge toward a walled garden where we see urn-topped pillars flanking a broad staircase that leads up to a lush tangle of cascading vines and dramatic cypresses. In the distance are snowy peaks beneath dramatic clouds. The whole affair is a painted dream.

Of far greater impact on Perkins were his paternal grandparents, Benjamin and Mary. Benjamin built fanciful Queen Anne houses in and around Lincoln, and Mary officiated as caretaker at the local cemetery. Historically speaking, Benjamin cuts a rather nebulous figure. The 1920 U.S. Census lists his birthplace as Ohio, Mary's in Illinois. In earlier census records, Benjamin gave his occupation as "farmer." But he and his wife moved to Lincoln about 1905, leaving farming behind, presumably. During his eighteen remaining years in the city, Benjamin earned respect sufficient for a small but eye-catching obituary that—after describing his sudden and fatal collapse while visiting his daughter—praised him as a pioneer homesteader. He was also a prominent member of Grace Methodist Church. According to Perkins, Benjamin also owned the dubiously Sanitary Hotel as well as a livery stable and a brickyard. That is just about all we know about Benjamin. Unlike his son Frank, he seems to have lived an irreproachable life.

But it was Benjamin's architectural career that made an indelible impression on Perkins. He built Queen Anne-style houses; indeed, as Perkins recalled on many different occasions, his granddad had a full-bore obsession with them and constructed at least sixteen before he was through. Such rambunctiously eclectic Victorian houses could be found everywhere in and around Lincoln. Some were designed by professional architects, but many more were put up by builders who got their ideas from lavishly illustrated popular pattern books like *Palliser's American Cottage Homes* (1878), or *Shoppell's Modern Houses*, a quarterly launched in 1886. Many such publications offered complete mail-order plans that enabled any carpenter to construct the most elaborate flight of architectural fancy without specialized skill or knowledge. The "Queen Anne" house of the late nineteenth century bore little or no resemblance to domestic architectural styles of that monarch's reign. The name applied to a grab bag of styles ranging from Romanesque to Tudor and Moorish (with many stops between). All the designer had to do was reach in and grab a handful, which could be put together in almost infinite permutations and combinations. Anyone who wanted a fashionable but emphatically individualistic house need look no further.

Perkins described Benjamin's houses in vivid detail. "In the days when wheat was sold for a dollar a bushel, my grandfather built a house in Lincoln, Nebraska. It adjoined the estate of William Jennings Bryan [Populist and three-time loser for the Presidency]. In a magnificent gesture, my grandfather created

the house as a supreme example of the 'Monstrosity Decade.' It was constructed of red brick and jig-saw fretwork in wood with delicately fashioned half-moons, lacework, spools, spindles, fans, knobs, and machine-carved pillars. The structure arose from verandas, bay and dormer windows, past balconies, turrets and gables to a dome surmounted by ornamental lightning rods. The front door had a panel of red glass with a reindeer etched on it . . . For a short while the house was the show-place of the county seat—then Bryan built a house which completely eclipsed grandfather's.'"

Benjamin's mansion is long gone, and the Bryan House now sits awkwardly stranded between utilitarian red-brick buildings and parking lots on a hospital campus. Given Perkins' description, it is hard to imagine how the Bryan House could have topped Benjamin's exuberant gingerbread "monstrosity." Indeed, the Bryan House sports many of the same features (multiple gables, verandas, bay and dormer windows), though it has a tower instead of a dome and is massive and stately rather than delicate and lacy. No matter; Benjamin and Mary soon left that particular monstrosity and moved on, many times; Lincoln city directories list a different address for them nearly every year. According to Perkins, Benjamin would build one Queen Anne house to live in until he became tired of it and then built another to live in until he became tired of that one, too, sixteen times over. But Benjamin's Queen Anne fripperies became the building blocks of Perkins' art. As he quipped later, "If architecture is frozen music, then American construction from the Civil War period to about two decades before the Columbian Exposition in Chicago [1893] presented a concert of congealed 'breakdowns,' Virginia Reels, Sailor's Hornpipes and Highland flings, not to speak of cakewalks and can-cans."

Among all the lacework, spindles, and spools, there was one feature of Grandfather Benjamin's gingerbread house that impressed Perkins more than anything else: the outhouse. This was no ordinary shed. It was "the first brick outhouse in Nebraska, which also had turrets, dormers, and all the rest. It was built like a shapely woman," Perkins recalled. Within, the shapely edifice had wall coverings printed with "big red roses . . . And on the door . . . was a comb case and a mirror, so you could comb your hair when you left." There were bumblebees and wasps up in the rafters to provide "pleasant musical accompaniment on warm summer afternoons." And there was reading material: "Sears Roebuck catalogues laying conveniently on the seats. The holes were edged with velvet in consideration of frigid weather."

In a cheeky watercolor, much later, Perkins harkened back to those memories—manifestations of what he dubbed his "vigorous nostalgia"— representing six winged outhouses (albeit made of wood, not brick, and not at all shapely), ascending toward the heavens like angels, or rockets, their red roses now bundled into nosegays that float up alongside. Glimpses into two of the

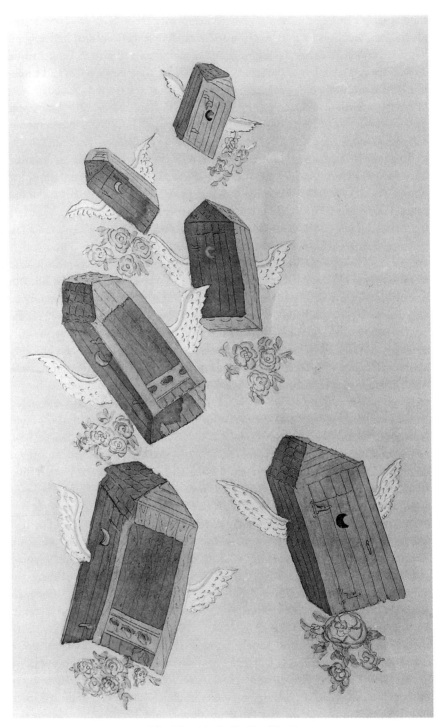

Celestial privies by Perkins Harnly

privies reveal that they are sociable three-seaters. Given that Perkins also did a watercolor of the Nativity that showed a furnace boiler giving birth to a tiny copy of itself, it's not too surprising that he would imagine outhouses as angels, or vice versa.

Back to Grandpa Benjamin's privy: that Sears mail-order catalogue reposing on the velvet-lined seat had more than one function. In the days before the indoor flush toilet converted Americans to rolls of manufactured toilet paper, such tomes, printed by the million on hundreds of pages of cheap paper, served as both entertainment and as hygienic necessity. Perkins told an interviewer, "We had a Sears Roebuck and a Montgomery Ward ... We loved, especially, the women's underwear, and the corsets and the brassieres and the girdles. And that part of the magazine was always the dirtiest, from being folded up so much." I wonder if "dirtiest" was a double entendre. Considering Perkins' indefatigable zest for potty humor, it's hardly out of the question.

Presumably, the cherished underwear pages didn't suffer the same fate as the sections where you would find baked bean pots, bottle brushes, steam gauges, hog-dipping tanks, lawn mowers, sleigh bells, or men's wallets. Perhaps they were scissored out and saved for enjoyment over the long term. Or, since the catalogues would arrive at least twice a year, there were always new lingerie delights to savor. Those ancient Sears underwear pages seem hopelessly stodgy today. But in an era of all-enveloping garments, they were titillating enough. They gave curious eyes tacit permission to peer beneath women's many outer layers and study their most intimate garments. In those pages, young Perkins could pore over bust enhancers embellished with ribbons and embroidery, clingy slips, brassieres, chemises, and corsets with frothy trimmings and highly engineered stays of "duplex watch spring steel." There was a double-page spread of fancy ladies' hose, each style encasing tiny feet and plump, curvy, disembodied legs set off by cascading ruffles—a fetishist's dream if ever there was one. There were also pictures of women's drawers, wide legs extravagantly edged in scalloped or zigzag eyelet lace. Each pair was modestly folded to conceal the so-called "open style" crotch from view.

Like Grandfather Benjamin's lacy woodwork, those frilly drawers became extensions of Perkins' identity. "It's high time for under-drawers to be immortalized," he wrote. "Whoever concocted up this idea is dear to my heart. A pair of ladies' lace panties has always been my personal trade mark." In the early 1930s, he painted a watercolor of a Victorian laundry room, with a boiler, a big pink crank-activated agitator, and a clothesline on which someone has hung up an enormous pair of extremely frilly drawers to dry. This is as close to a self-portrait as Perkins ever came, although several times he also painted scenes that included a funeral urn or cemetery monument inscribed with his name and with the ultimate date blank, for the time being.

Cemeteries were as close to Perkins' heart as lacy underpants, in fact. Many times, he would tell people about his other grandmother, his father's mother Mary (the one who didn't stay in bed for thirty years). "When I was very young," he wrote, "[she] took me with her on many visits to a charming little cemetery at Adams, Nebraska, where several defunct members of her family were permanently stationed there under well-groomed sod." The "ancient caretaker" kept a pet bull snake to terrorize the gophers that disfigured the lawn. It made a strong impression: "Perhaps my present psychological complexes might be attributed to the early cemetery and snake experiences," he mused. Later in Lincoln, when Mary wasn't busy at domestic pursuits in the current Queen Anne monstrosity, she would be at Wyuka Cemetery, where, despite her husband's wealth, she worked part-time as a caretaker. (Perkins in retrospect mixed Grandmother Mary up with the ancient caretaker in Adams. It's unlikely, in fact, that an affluent matron could conceivably take a job that entailed among other things actual grave-digging.) Mary had a reed organ in a little shed where they kept the shovels, Perkins recalled, and would play it for funeral processions. That part may be true. What's not in doubt is that cemeteries were special places where grandmother and grandson formed a powerful bond. And Perkins was fascinated from the start.

It's not hard to see why. Established in 1869 as Lincoln's official burial ground, Wyuka was modeled on Mount Auburn, the 1831 Boston cemetery that reconfigured the grim churchyard of yore as a romantic park where nature made death beautiful and brought consolation to the living. For farm-boy Perkins, whose exposure to art was at that time limited to theater drop curtains and the illustrations in the Sears catalogue, Wyuka must have been a wonderland—an outdoor sculpture museum, as romantic and melancholy as the place itself. Take the McDonald monument for the banker John and his wife Annie. There is a starkly simple sarcophagus on a raised platform. Leaning over it at one end is a female figure wrapped in gracefully swirling drapery. One sandaled foot peeks out under her skirt. She wears her hair in a classical chignon and props her chin on her hands as she bends mournfully over the McDonalds' stone coffin. It is a lovely and poetic sight. (As a widow, Annie McDonald threw "unusual" parties at her mansion. A frequent guest was William Frederick Cody, a.k.a. Buffalo Bill.) The sculptor is unknown. Annie may have commissioned or ordered the monument from some industrialized stone-cutting company, such as F. Barnicoat in Quincy, Massachusetts, whose catalogue illustrated melancholy maidens, sorrowing angels, and allegorical figures symbolizing meditation, remembrance or hope. There were scores of such companies all over the country, offering monuments in granite, limestone, marble, zinc, and bronze. Even Sears and Montgomery Ward published tombstone catalogues.

Monuments in the Wyuka cemetery ranged from the prosaic, poetic and sentimental to the occasionally sublime. There is the polished red-granite

column of the Winter family monument, commemorating "Our Morning Glory," little Irmgard Christine, who died at age four of diphtheria. Her portrait, an enlarged photograph burned into a porcelain plaque, shows a little girl with a solemn expression, enormous eyes, and glossy ringlets. Then there is the Nance monument, definitely on the more prosaic end of the scale. Memorial to Nebraska's fifth governor, it enshrines the bronze bust of Albinus Nance—bald-headed and moustachioed, with a double chin over a stiff collar—sheltered under a massive granite canopy supported by four squat, vaguely Doric columns. All over, there are more angels and maidens, obelisks short and tall, tree trunks, clasped hands, doves, wreaths, urns, crosses, and colonnades. One marker notes that the deceased was killed in a train wreck; another identifies William Rhea, a murderer. (A later murderer interred at Wyuka is the spree killer Charles Starkweather, who slaughtered eleven people in the late 1950s and sowed terror throughout the town.)

Grandmother Mary was a necrophiliac, Perkins said later. But by this, he didn't mean that Mary entertained fantasies about sex with dead bodies (though she may have, we can never know). "Necrophilia" in Perkins' mind meant a taste for death, which Mary passed along to him. Of course, in that sense most if not all middle-class Victorians were necrophiliacs, given that they developed and sustained an elaborate (and to us, morbid) culture surrounding death, its rituals, its material culture, its ever-presence in domestic and public life—as it was, indeed, in the unfortunate Frank Harnly family. By such measures, Mary was not unusual; in fact, you might say she was mainstream.

But her grandson pushed that taste for death into a full-blown obsession that shaped his art and propelled his life. He enjoyed shocking people by telling them straight out that he was a necrophiliac but would usually add that this compulsion was "not toward the corpse, but the . . . funeral atmosphere." "There is an awesome, poisonous glamor to a quiet, shady cemetery which I have never been able to shake off," Perkins wrote. ". . . it is from that early period when I came to see the accoutrements of death as beautiful." There was also an undercurrent of perverse eroticism in this obsession. Perkins confessed: "I am a Necrophile. Since earliest memory I've been intensely fascinated by all elements associated with the disposal of dead human bodies . . . Open graves, or crypts, attract the attention of the average person, but to me, they inspire wild reveries. I picture desirable, perfectly preserved young bodies that I might disinter, in the dead of night, with wind howling through the funeral trees and whistling around crumbling gravestones." But then he stops short, admitting that these are "childish fantasies, hangovers from Poe and 'Weird Tales' magazines." Or perhaps *Wuthering Heights*—one thinks of Heathcliff, with his wild black hair and snarling grimace, frantically trying to disinter Catherine Earnshaw's body in the dead of night. Only Perkins in *his* fantasy would more likely have been trying to dig up a beautiful young man.

Aside from her own necrophiliac propensities, which surely inclined more toward the sentimental than the perverse, Grandmother Mary was such a conventional woman that it is difficult to imagine her as Perkins' cemetery muse. There is very little to remember her by. Doubtless she wrote to her roving grandson after he left Nebraska for good, but whatever letters there were probably went up in smoke: "Once I cleaned out my closet which was crammed with paper sacks stuffed with an accumulation of two decades. I burned all of the stuff without looking at it. Up in smoke went my pass-port, birth certificate, parents' wedding picture, my first baby picture . . . Burning all that junk was like a mental catharsis. I even felt like burning my carcass. The closet is full again." Somehow, a single letter escaped the flames and survived intact through all of Perkins' strange journeys. It is postmarked January, 1932. This was when Perkins was abroad on his first trip to Europe. He was difficult to catch up with: forwarded by American Express, Grandmother Mary's letter wandered through Athens, Rome, Vienna, and Paris. At one point, someone scrawled "unclaimed" on the envelope, but somewhere it did catch up with Perkins.

Mary Harnly's letter is as homely and loving as any grandmother's letter could be. Her handwriting is crude, her sentences run-on, and her spelling and grammar shaky. She writes "injoy" and "tipewritten" and "you was." Perkins had been sending letters and cards, which Mary had tremendously injoyed. She tells Perkins about goings-on in and around Lincoln. The tiny town of Denton had had another fire and there was so little left of it that the next fire would take it all. One day downtown, she met one of Perkins' old friends from school days: "He is fat and nice looking he was such a homely boy he asked where you were said he remembered when you and he had had the last days of Pom Pae [Pompeii] and he just laughed like he always did." She wondered when Perkins would be coming back to his native land. "You have seen a lot and it is Something you can think of all your days and tell your grandchildren about when you are an old gray whiskered man," she told him. No doubt she pictured a grizzled Perkins in a rocking chair by the fire, with a grandchild on his knee. Nothing could have been further from what Perkins' future turned out to be, although he did in time become an old gray (but clean-shaven) man, full of X-rated stories hardly fit for tender ears.

If we are to believe Perkins (and there are certainly reasons not to, or not hook, line, and sinker, at any rate), his entire childhood and youth merited an X-rating. There were those sexual escapades with the animals on the farm. There was the lusty Mrs. Oltrogge next door, and her underage daughter. Perkins had sex with his sisters, too, he claimed; his grandma (which one he doesn't specify) caught him at it and kicked him out of the house. He told a different version of the purported eviction to his old friend Alexander King: "Grandma said, 'Willie!' She addressed our neighbor boy, 'What are you doing to my grandson?'

I said, 'He ain't doin' anything to me. I'm doing it to him.' She said, 'You git right out of my house, you masturbatin' scamp!' I got out and moved into a dump with blue oatmeal paper covered walls and a sanitary couch." Then there was Perkins' stint in the reform school, where Bert, the handsome, husky, and exceedingly randy fry cook taught him (and many other boys) how to be a queen.

I wonder if these tales hold any water at all. The fact that Grandfather Benjamin left Perkins a considerable fortune doesn't square with the self-portrait of the artist as a polymorphous pervert. Nor does his grandmother's loving letter that chased Perkins all over Europe. But his story of Bert the fry cook does ring true, or truer. If, having been caught with questionable people, Perkins was handed over to the juvenile court—as Julia Josephine asserted in her divorce suit—then he may well have passed some educational reform-school time in Bert's steamy kitchen. He told a variant reform-school story in which he was fifteen when committed to the Nebraska State Reformatory at Kearney; in this version, he escaped into the freezing night and luckily found a pig sty, where he slept between "two fat sows." Given the fact that Perkins was barely into his teens when his family began to disintegrate, it is little wonder that he started to act out; whatever borders had been in place before no longer contained him. It's impossible at this distance to know what young Perkins actually did, what he exaggerated in later retellings, or what he simply made up.

Whatever the case, Perkins (he claimed) had become a hardboiled libertine by the age of sixteen or so, when he went to work as an elevator boy on the night shift at the Lincoln Hotel. An actors' hotel for the theatrical Orpheum circuit, the Lincoln opened in 1908, adding two stories in 1911 and a grand entrance canopy in 1915. Long gone, it was distinctive enough in its day to be illustrated on postcards, where you can see it still as a grand Italianate building with paired arched windows, tiers of balconies, and corner towers. It had (according to one postcard) "218 Rooms, 160 with Bath. Circulating Ice Water in all Rooms." But according to the worldly Perkins, it was known about town as the "Riding Academy" and was full of prostitutes, "including me." The entrepreneurial elevator boy also pimped for India Clark, an uninhibited younger school friend whom he claimed to have married and who later followed him to Los Angeles, to New York and later still to Los Angeles again, by which point, Perkins said, he had no wish to re-cross "old charred bridges."

If we are to believe Perkins, pimping was the least of what went on in Lincoln, which in his telling amounted to a modern-day Sodom and Gomorrah. "There was a sizable Gay Set . . . during the teens and twenties," he wrote. "They were a closely knit sisterhood of exceedingly Nellie bitches and old Aunties and scads of wise trade." The most notorious queen, son of the First National Bank's president, lived in an Italian villa with "naked statues of Greek Gods in the yard which horrified the natives no end." When he cruised, he carried a portable

phonograph. "He'd set the music box on the sidewalk, start a record playing and dance the dying swan or Specter of the Rose." Handsome, well-hung and stylish, he unfortunately had a "pussy" that "felt like it was made of cardboard and lined with old newspapers." His socialite mother, who rode around in a chauffeur-driven eggplant-colored town car, excused her son's scandalous behavior as "eccentric"—the term "used by the local populace in those days instead of cocksucker or bunghole artist." Whenever the eccentric son was arrested—which was often—his mother bailed him out, subsequently eclipsing the whole embarrassing incident "by ordering more naked Greek statues from the Pompeiian House in New York."

In this account, Perkins salaciously detailed the carnal activities that regularly took place in the vicinity of "Daniel Chester French's statue of Lincoln on the Capitol grounds." He also offered a colorful inventory of the various characters involved: Coalyard Kate (who took her trade to the Rock Island coal yard), Georgette Crepe, Broomstick Anne, Fainting Bertha (who would sidle up to some attractive target, pretend to faint, and then grope him and pick his pocket while he was administering first aid), Cocaine Lil, Mary Queen of Sluts, and Victrola, along with "ten Sarah Bernhardts" all competing for the local trade. It almost goes without saying that in fashioning these spirited tales Perkins edited out the darker dimensions of desperately marginal lives that were in reality dangerous and difficult. It was a coping mechanism that allowed him to keep his mask up before the world and to control his own story.

Back to Sarah Bernhardt: there may have been ten ersatz Bernhardts in Lincoln, but then the real Sarah Bernhardt came to town. The Lincoln Hotel lived on in Perkins' memory, and in many, many subsequent retellings, because it was there that he met—and stole from—his eternal idol, one of the greatest actresses of the age and one of the most dazzling. Famous for a defiantly unconventional lifestyle, the red-headed tragedienne chewed up scenery on both sides of the Atlantic and toured the United States nine times over the course of her long career. She undertook her final tour in the fall of 1916, wanting to make money but also hoping to persuade America to enter into the Great War in Europe. On this trip, which lasted until the fall of 1918, Bernhardt traveled to ninety-nine cities—including Lincoln and nearby Omaha. Wherever she went, she was greeted by rapturous applause, even though she delivered all her lines in French.

Sitting in the balcony of the Orpheum Theater in Lincoln, Perkins the elevator boy saw her on the stage and was transported. She held the audience enraptured, he recalled, "by the incomparable magic of her presence and golden voice." He had already seen her films, or at least the 1912 *Queen Elizabeth*. "Sarah was always fainting," he wrote. "The pile of cushions in the foreground are there for the purpose of breaking her pseudo fall. In . . .'Queen Elizabeth' she wound

up her pantomime by fainting and tumbling down onto a pile of cushions." You can now enjoy that very scene on YouTube. Bernhardt spends several minutes flinging her arms about as ladies in waiting surge forward to support her. Finally, she flops precipitously face down onto a prodigious heap of cushions, as the intertitle announces "Sic transit Gloria mundi." So love-stricken was young Perkins that he wrote—with scrupulous care, in ink—a poem to his goddess, including the lines "In my dreams I've been with you,/In your dreams now I'll seek./The Devine into the Devine./Power unto Power." Spelling was never Perkins' strong suit, but his ardor was unquenchable. The chance to see her in the flesh, to hear that golden voice (even though he couldn't understand a word) was probably one of the greatest thrills of his young life.

He learned an important lesson about art and illusion, though, when he saw the Divine Sarah up close at the Lincoln Hotel. In 1915, Bernhardt had an operation to amputate her right leg above the knee, which osteoarthritis had made intolerably painful. From then on, she performed seated, the stump covered with a lap robe. In the glare of the spotlights, wearing an open-necked silk shirt, her hair dyed red, she looked young, Perkins remembered. One night after the show, however, when Perkins was on duty at the Lincoln Hotel, in came the ancient star in a wicker chair, with a nurse and a male attendant ready to take her to her room upstairs. But a fuse had blown and the elevator wasn't running. Sarah must be elevated nonetheless! Imperiously called to assist, Perkins hoisted up one side of the chair, with Bernhardt's man holding the other, and "helped carry the world's greatest actress up four flights of stairs" all the while getting "a dirty bawling out in French for not handling my side of the chair in a proper manner." Up close, the idol proved to have feet, or one of them at any rate, of clay. "What a disagreeable old bitch," he wrote. "Ugly as sin, while only minutes before SHE held an audience enraptured by the incomparable magic of her presence . . ." On another occasion, Perkins described the event in even less flattering terms. He "lugged the old girl upstairs," he said. In keeping with the Lincoln Hotel's pretensions, the stairs were white marble with golden Cupids. There was a large and ornate mirror on the landing, and when the two helpers paused there to catch their breath, the Divine Sarah preened and primped before the glass, fluffing her henna-dyed hair and flashing her rotten teeth. When she was satisfied, the two helpers lugged her the rest of the way up.

Smarting from the tongue-lashing *à la française*, Perkins carried out a little act of revenge the next day. During the matinee hour, he managed to sneak into Bernhardt's hotel room, where he found a "gorgeous box of chocolates." He opened the box and put all of the bonbons from the bottom layer in his pocket, leaving the star with only the top. When Bernhardt left town, Perkins followed her to the railroad station. In what was clearly her habitual deportment, she was "yelling and carrying on in French," he said. But there remained one more

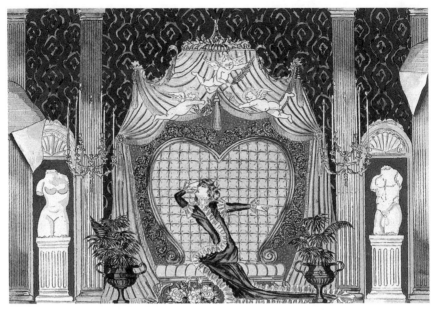

Perkins' idol Sarah Bernhardt in a dramatic moment

twinge of schadenfreude: Bernhardt was given three Pullman coaches with her name, which certainly sounds quite grand. Once upon a time, though, Perkins asserted, she'd had a whole train.

Like Grandfather Benjamin's Queen Anne monstrosities, Bernhardt was an ornate, flamboyant, and crumbling relic of the past. And like them, she became a vital part of Perkins' persona. All his life, he worshipped the legendary star. He sometimes even signed his letters "Né Sarah Bernhardt," as if he were Sarah born again. And he visited her grave in Père Lachaise Cemetery every time he passed through Paris. A watercolor Perkins made decades later highlights the star's charismatic presence: in clinging black with white ruffles and a long train, Bernhardt sits askew on a heart-shaped sofa, head flung back in mock hysteria as she points behind her in the direction of a Herculean sculpted torso on a classical pedestal. Above her flutter three cherubs bearing tributes to her genius: a laurel wreath, a palm branch, and a torch.

Perkins shared a Bernhardt connection with fellow Nebraskan Willa Cather. A celebrated critic and novelist, Cather had seen Bernhardt as early as 1892 and had written eloquently on the star's magnetic persona on stage. Of course, a great many Nebraskans had thrilled to the legendary actress' performances. But few had also had Willa Cather's younger sister, Elsie, as their high school English teacher in Lincoln. Elsie was new at the job, in fact: by my reckoning, the Smith College graduate, only eleven years older than Perkins, began teaching at Lincoln High School in 1919 or 1920, when Perkins was a junior or senior.

This would be a matter of little note, except for the fact that in 1920, when he must have been in Elsie's class, Perkins won an honorable mention for a design he created in a contest for the best "Better English Week" design.

Better English Week was a busy affair. There was a tag day at the school, when teachers and students alike were "tagged" if they made a mistake in their English. (One knows that Perkins' grandmother Mary would have been plastered with such tags had she been there.) There were pertinent rhymes and limericks to keep the subject at the forefront all week. There were two assemblies, the second featuring a certain Dr. Bixby of the *State Journal* staff; his speech revolved around the statement that there were six kinds of English: "good, better, best, bad, beastly, and abominable." There is no record of what Perkins' poster looked like. There is also no record that Perkins ever graduated from Lincoln High. Except for that one report on the poster contest, he never appears in the yearbooks of 1919, 1920, or 1921, the latest he could conceivably have finished. He simply disappears from Lincoln, save for one more reference in the 1922 *Lincoln City Directory*, listing him (as Perkins Harnley, that extra "e" casting a bit of confusion) as a clerk at Rector's Pharmacy. After that, he is gone.

This is where Willa Cather comes in, again. In 1963, the State of Nebraska honored its Pulitzer-Prize-winning native daughter with a portrait bust that was placed in the Hall of Fame on the second floor of the State Capitol. The bronze bust is a downright, no-frills production depicting a woman with strong features, a square jaw, and a faraway look (her nose, however, has been rubbed to a shine by successive generations of visitors to the Hall, which also enshrines Father Edward J. Flanagan, founder of Boys' Town, William "Buffalo Bill" Cody, and the Native American Chief Red Cloud). The sculptor was Paul Swan, who hailed from Crab Orchard, Nebraska, but had become a man of the world far beyond the state's borders. What does Paul Swan have to do with Perkins? Quite a bit, as it turns out. Most importantly, Swan was Perkins' ticket out of Lincoln in 1922, Hollywood-bound.

Born in 1883 in Ashland, Illinois, Paul Swan moved with his parents and ever-growing brood of siblings to a farm in Crab Orchard in 1886. Like Perkins, Swan told the same stories with many variations many times over while hewing pretty consistently to key essentials. By all accounts, Paul (like cow-hating Perkins) was not cut out to be a farm lad, although he later made much of his identity as a ploughboy from the plains and regaled interviewers with tales of rugged early days, when he learned to "handle a spade and hoe and ax, hold a plow, ride a horse and run and swim and wrestle." He would have been a good farmer, he claimed. Once, though, he confided that "the only job his parents could trust him to execute successfully was milking cows, where he didn't have to keep his mind on [his] work." His attempts to escape the farm began at age twelve, when he ran away the first time. By 1910, he was a budding artist in New

York. By the teens, he had made himself over into the "most Beautiful Man in the World" whose "Greek" dances in scanty costumes brought him international renown and notoriety.

It is difficult to imagine a surname more perfectly suited to the person who bore it. Like the bird, Swan was known for his exquisite grace of pose and movement. He was swanlike in another way, too. Except for very subtle differences, male and female swans are quite difficult to tell apart. Analogously, Paul Swan seemed to mix the masculine with the feminine in about equal measure, though depending on what he wore, he could seem more one or more the other. The fact that he was pictured in a newspaper article on the Suffragette ideal man—whose harmonious physique would be that of the ancient Greeks and not those of the modern prize ring—is telling, too. "Beautiful" rather than handsome, he seemed to combine the best of male and female in one perfect package. So appealingly un-brutish and unthreatening was Swan that he was cast as Iolaus to lead seven maidens in the dance finale of the 1913 *Lysistrata* adaptation staged by the Women's Political Union in New York. Chosen because of his "resemblance to a Greek god," Swan "danced in a baby leopard costume that gave cause to the good suffragists to sit on the edge of their chairs and be shocked." And also, I suspect, enraptured and aroused.

A newspaper photograph shows Swan in that revealing scrap of an outfit— whether from a baby leopard or dubbed "baby" because there was so little of it, or

Paul Swan in his trademark leopard skin

because it was *for* a baby, is unclear. Up on tiptoes, he displays his finely muscled legs, arches his neck, and raises a languid arm on high. With flowers in his hair and bold maquillage, Swan is both man and woman (according to the norms of the time, of course). Other photographs from about the same time represent the dancer in stylized Egyptian profile pose ("Displaying the Exquisite Grace and Suppleness of His Form"), in a Greek tunic ("As Narcissus, the Beautiful Youth Who Fell in Love With His Own Image") and in comparison with the *Hermes* of Praxiteles, "to Whom the People of Athens Compared Paul Swan."

Indeed, everything "Greek" about Swan actually came more or less directly from the source. On the money he had saved in New York by painting portraits of the sultry Russian actress Alla Nazimova (who will come to play an important part in Perkins' story), he traveled to Europe and Egypt, which he found "intellectually interesting." But Greece, he told everyone who would listen, "was one long ecstasy." He studied in Athens with the sculptor Thomas Thermopolis and danced for the first time at a fête organized by his teacher. Athenians reportedly worshipped at the shrine of Swan's beauty and proclaimed him the reincarnation of a Greek god or at least an ancient Greek hero—sometimes Apollo, sometimes Hermes, often Narcissus, never Hercules. People couldn't leave him alone: "The masses followed him on the streets, and when he entered a café he was the center of all interest." Had there been paparazzi then, they would surely have hounded Swan to distraction. As it was, he claimed that the "continued ovation" finally impelled him to leave the city of his second birth.

We can get at least a vague idea of Swan's dance style in the 1916 Pluragraph film *Diana the Huntress,* in which he appears as the god Pan. In the first scene, the goddess Diana in filmy drapery stands upon the crescent moon and shoots an arrow down to earth, where her nymphs await her. As they fall, the arrows turn into flowers, whereupon Diana magically appears. The nymphs—all with long, tumbling curls and flowing classical robes—dance around her in a joyous ring. Asleep in a tree, Pan wakes to Diana's voice and jumps—very gracefully indeed—down from the branches to find her. In a leopard-skin tunic, little horns on his head, Swan/Pan capers, frolics, and skips through the forest, but the goddess is always out of sight. He comes to a pool (in Central Park in real life), wades in, and agitates the water as he dances half-submerged. Clambering out, he prances among the trees, playing his Pan pipes, still seeking the elusive goddess and her retinue. He comes to a glade— still no goddess!—and sinks disconsolately to the ground. Suddenly, beams of the goddess' bright moonlight shine down; he reaches up, then lies back to fall asleep once more. Not surprisingly, Swan also played Apollo in the same movie.

Swan's Pan dance in *Diana* evokes that of the great Russian dancer Vaslav Nijinsky in *The Afternoon of a Faun*, one of his signature roles. Indeed, the story line is similar in that it also involves a woodland being, half man, half goat, in pursuit of some nymphs who have aroused his desire; the dance culminates in the

faun's erotic embrace not of a nymph but of her scarf left behind. Swan adulated his counterpart and was even deemed Nijinsky's successor. But if Swan's Pan dance is representative of his style, there is no comparison. Not without talent, Swan was largely self-taught, and in *Diana* he gambols about with what looks like improvisational glee. There are very few films of Nijinsky dancing, and they are fleeting, mere seconds in length. But the tiny fragments from *Afternoon of a Faun*—Nijinsky in a skin-tight, piebald-patterned leotard with a jaunty little tail—reveal the disciplined fluidity, skill, and power that come from years of training. But both Nijinsky and Swan were men of a particular cultural moment.

Nijinsky's faun and Swan's various roles as Iolaus, or Pan, or some ancient Egyptian prince all share an impulse—ubiquitous at that time—to flee complicated, messy modernity and travel back to a more primitive and innocent time or state of being. The same impulse animated rebellious dancer Isadora Duncan, buoyed the fame of the Prussian strongman Eugen Sandow around the turn of the century, and gave birth to Edgar Rice Burroughs' fantasy jungle hero, Tarzan, in the teens. Barefoot in a tunic, Duncan sought to recapture and embody the Greek spirit in her dances. Sandow, emulating the masculine Greek ideal, built his body to heroic proportions, and in photographs and even film impersonated the muscular gods and heroes of the ancient world. Differently but analogously primitive, Tarzan of the Apes was a modern man propelled by circumstance into a regressive state of nature.

The real Sandow and the fictional Tarzan alike were ultra-masculine, Sandow a muscular bodybuilder, Tarzan a powerful athlete. Like Swan, both on occasion appeared in leopard-skin loincloths. Of course, the spotted skin in itself connoted the wild and primitive; that was a given, as was the implication (and the fiction) that the wearer himself had stalked, slain, and skinned his quarry to make his savage garment. Then too, in the days of black-and-white photography and film, the pattern stood out, easily identifiable as leopard, whereas a plain skin *might* be lion, but might equally well be horsehide or some other pelt pretending to be from a big cat. (On occasion, Swan did wear loincloths that were innocent of spots but becomingly tattered and equally revealing.)

It is hard to imagine the lissome Swan as a mighty hunter, however. Rather, the leopard skin connected him—the Greek god reincarnated—with Dionysus, the deity of wine, erotic pleasure, sensuous abandon, and frenzied ecstasy. Often represented riding a leopard (his animal attribute) or wearing its skin, Dionysus was no manly muscle-bound hero or jungle athlete. Smooth-skinned and beardless, surrounded by women—nymphs and Maenads—he was described by writers of classical antiquity as "the womanly one," or "the womanly stranger," or even as a "man-womanish" hybrid. Dionysian androgyny suited Swan very well. In his spotted pelt, moving with supple, almost feline grace, he was the antithesis of the Sandows and Tarzans of the day.

How beautiful was Paul Swan? It is hard to decide from old photographs—especially when he's been busy with eyeliner and lipstick. Writers sometimes described his facial features as chiseled, and perhaps that was the key to appreciating his looks: in the right light, and at the right angle, his head really could have been plucked from the shoulders of an antique Apollo or Hermes. Considering the racism so endemic to Western culture then and now, his clean-lined, classical whiteness surely counted. But at the same time, Swan's beauty was complicated; it was both a gift and a curse, especially in modern America. "In New York I'm a freak," Swan said, "but in Athens I was a sensation." He was used to being considered a freak: ". . . a Willy boy, anything of the sort you like."

In certain places, his looks created unease and confusion. Long before Perkins met him, Swan, not yet famous, spent a few months in Lincoln, where he made a modest splash. "He picked up an acquaintanceship among the young men of the city," reported one source, "who openly referred to him as a bit 'girlish.' He did not confine his drawing and painting to paper and canvas but was accused by his friends of painting his lips and blacking his eyebrows. 'My idea of him,' said one of his friends, 'was that he thought he was mighty handsome and was a trifle vain about it. Anyhow he devoted all sorts of time to his personal appearance.'" This went radically against the norms of masculinity in force at the time. Only *women* were supposed to preen before the glass.

It was also partly a matter how of Swan chose to present himself. He could dress up as a beauty, as a pretty boy, or as a "regular" man, and he could be any of those things depending on time and place. Bisexual, he had male lovers but was also married, to Helen Gavit from Albany, New York, and had two daughters, none of whom he saw very often. Once, a female journalist came to call and found him wearing a kimono and pajamas, which she found "a bit overwhelming." But another, Florence E. Yoder, found Swan reassuringly "regular." He had a "natural boy grin," and wore "regular" clothes. In fact, so "normal" did he seem that: "Aside from an occasional reminder due to glimpses of the actual facial beauty of my vis-à-vis, I would not have remembered that the rather short young man dressed in a dark blue suit with a soft shirt, collar, and neat black bow tie, was other than an ordinary chap and due no special awe." Soft, short, neat, ordinary: the photograph accompanying the article bears this out. In his civvies, Swan might be any good-looking young bank clerk or salesman.

Swan's own self-portrait, from about 1920, seems bent on playing down his beauty, instead emphasizing the square jaw, thick brows, and strong chin associated at that time with conventional masculinity. True, he has a dreamy look, a touch of rouge, and a flowing, open-collared shirt that no bank clerk would ever wear on the job or (probably) off it. But the drab brown palette and harsh lighting outweigh or at least balance any hints of effeminacy. Mannish or womanish, Dionysus or Apollo, beauty or freak, Swan was tremendously

attractive to women. One time, in Paris, he made headlines when a Mademoiselle Dherleys, "dressed only in a string of pearls," danced with "Paul Swan, lady-like Terpsichorean" and chased him "all around the café . . . It was the wildest dance wild Paris ever saw."

Another lady in beads was Gloria Swanson, who shared a syllable with the most beautiful man in the world and who at least briefly enchanted Perkins the elevator boy, when he wasn't worshipping at Sarah Bernhardt's altar. "My room in Lincoln (1919–20)," he wrote, "was papered with magazine pictures of Her. She was either in a bath tub or struggling with many yards of pearls." He was probably thinking of Swanson's role in Cecil B. DeMille's *Male and Female* of 1919, in which the young star, encrusted in pearls and wearing an extravagant white peacock headdress, is thrown to the lions during a fantasy flashback to ancient Babylon. A colorized photograph, perhaps a lobby card, shows Swanson before the king, whose high sculpted crown and bejeweled satin trunks could have come right out of Paul Swan's wardrobe for one of his exotic performances that didn't involve a leopard skin.

But no doubt the leopard skin was in evidence when Paul Swan returned to Lincoln in 1918 for the first time since he had left the state to seek fame as artist and dancer. He performed "classic dances" at the Orpheum Theatre on June 11 to raise money in support of the "Food for France Fund," a benefit organized by the National League for Women's Service. A couple of months later, Sarah Bernhardt, with her own patriotic agenda, would appear at the same theater during her last American tour. In 1922, Swan was back in town. He had been invited to show his work in the Second Annual Nebraska Artists Exhibition in October of that year; reportedly, he received more attention there than any other artist.

And this, finally, is where Perkins meets Swan. At age eighty-plus, looking far back through the haze of time, he regaled his young Hollywood friends with the story of that encounter and its aftermath. Swan hailed (as we already know) from Crab Orchard, Nebraska, Perkins told them. He went to Paris and became a matinee idol. He was a classical dancer and a good painter but had questionable taste. Perkins—now working in a candy store and perhaps also moonlighting as a bellhop—"ran into him" one midnight in 1922, when Swan was staying at the Lincoln Hotel. Perkins claimed that he went there to tell Swan how much he liked his paintings. On an earlier occasion, though, Perkins declared that "she [i.e., Swan] painted badly and danced worse."

What Perkins didn't divulge to his young listeners was where this midnight encounter took place, and what ensued. But on that earlier occasion Perkins alleged that he had been Swan's "supreme love." The Most Beautiful Man even wrote Perkins an extravagantly flowery love poem, which begins: "In the dead of night you came unheralded and unknown," and ends by comparing the love

object's "sweet face" breaking through the gloom with "a camel driver's plaintive flute" mounting over "windswept sands." It may be the most romantic rapture Perkins ever inspired. In the end, what they did, or didn't, do, in or out of Swan's bedroom, would not matter a great deal in the big picture, nor would Swan matter to us at all—except for the fact that when he left Lincoln in November 1922 to make his way to Hollywood, he took Perkins with him. It was, Perkins quipped, "a pure White Slave act on the part of that old Nebraska fairy."

Dead Movie Stars

PERKINS HAD NEVER BEEN ANYWHERE OUTSIDE OF Nebraska. Paul Swan, who *had* been to many distant lands, was now taking his pretty protégé to a new distant land of make-believe. It was only the early 1920s, but already Hollywood was the locus of modern glamour, exoticism, and excess. Swan hoped to break into the movies and become a star. It is unclear what Perkins hoped, but the chance to escape Lincoln and go west with the most beautiful man in the world wasn't something to pass up. Life was hardly glamorous at first: Swan, with Perkins in tow, moved into an Inglewood apartment with his wife and two daughters before relocating (without Perkins) to Laguna Beach, where he capitalized on his celebrity.

Swan signed a contract to play the captain of the Pharaoh's Guard in Cecil B. DeMille's epic, *The Ten Commandments,* but after refusing to train black men to play dancing slaves in the movie he was booted off the set. Although we might be tempted to construe this refusal as a moral stand of sorts against the perniciously racist conflation of blackness and bondage, in reality it was only that Swan thought the "clumsy Negroes" too comically awkward to master the bodily discipline required by the role. In the film, he can still be seen ceremoniously striding up to the haughty Ramses, kneeling crisply with his sword, rising, and backing out of the frame, all in profile, like a proper painted Egyptian on the wall of an ancient tomb. Swan also tried to land the lead in the 1925 blockbuster *Ben-Hur,* but that part went to swashbuckling Latin heartthrob Ramon Novarro; Swan was cast as one of many extras.

And until Andy Warhol starred Swan—by then a decrepit old man, his beauty in ruins, his dancing painful to behold—in a suite of underground movies in the 1960s, that was the end of Swan's film career. After *Ben-Hur,* Swan headed back, or retreated, to New York, where he continued to dance, paint, and sculpt, also spending much of the 1930s in Paris until the onset of war forced his return. In 1940, he settled into a studio at Carnegie Hall, where he would live out most of his remaining years. The studio had once been home to Charles Dana Gibson, creator of that perfect American beauty, the Gibson Girl. It was almost too serendipitous that the self-created perfect American *male* beauty, Paul Swan, should be his successor. (Paul Swan had fifteen *more* minutes of fame, post-Warhol, in 2019, when the play *Paul Swan Is Dead and Gone* by Swan's great-niece, Claire Kiechel, had a brief but attention-getting run at a theater far off Broadway.)

Perkins in later years seldom mentioned Swan without derision. For him, Swan would always be "that Old Fairy from Nebraska." Thus, Perkins' account of

his flight with Swan went like this: "I worked as a soda squirt and met Paul Swan, the old Fairy from Nebraska. *She* took me to L.A. I tried to git in the Movies, but I did better in a cafeteria." "The term 'MESS' was invented especially to apply to Paul," Perkins jibed. "He was 25 until the age of sixty. He made up stinkin and often told me to get away from the mirror when he was viewing himself because I made him look too old." The relationship itself died very young, though: "On the third morning of our living together he kicked me out of bed saying that he didn't love me anymore. He did me a favor because I was fed up with him anyway . . . a young vacuum cleaner salesman took my place as the great love in Paul's life."

Swan's ideal of beauty, that "great sappy dream," said Perkins, "was okay in 1919 because then we didn't know any better. A Queer could flop around a stage advertising his bitchdom and pass it off as ART." In a letter he wrote decades later, Perkins reminisced about his first visit to Vienna, in 1931. Ambling about through dirty snow one "gloomy, depressing" day, he had found a store that sold Kellogg's All-Bran and American magazines. Whether he bought a box of the fibrous stuff he didn't say, but he did purchase a copy of the *Pictorial Review* "having on its cover a picture of Paul Swan, 'That Old Fairy From Nebraska,' . . . the one who painted curli cues [sic] all over his body where the muscles should have been. Ha Ha." Given that Perkins in 1966 could have described himself in much the same terms—by then he was, after all, an old fairy from Nebraska himself—perhaps he still felt some affection for Swan, who had the courage, or the blind narcissism, to flaunt his androgynous beauty for all the world to see. At the very least, Perkins should have been grateful to Swan for enabling his flight from the Cornhusker State.

What was an erstwhile elevator boy to do in the new land of Los Angeles? Perkins claimed that he had left Lincoln to study art, but just as Swan had failed to get the role of Ben-Hur, he, Perkins, failed to study art. With Swan's help, he got temporary work as a researcher for the production of *Ben-Hur*. At least that's how he described the job to a reporter covering Ramon Novarro's funeral in 1968. The one-time *Ben-Hur* star had invited two young hustlers, brothers, to his Laurel Canyon home for a sex party. Instead, the pair tortured and killed him with almost unimaginable cruelty as they tried to get the old man to divulge the hiding place of a nonexistent fortune. Perkins was one of the mourners at the funeral home where Novarro's body lay. He told the *Los Angeles Times* reporter that he "had come from Nebraska to do the historical research for the epic and remembered its dashing moustachioed star as 'a wonderful man who gave a lot of glamour to Hollywood.'"

As Perkins privately confessed, the actual "research" he'd carried out required little—nothing, actually—in the way of proficiency. Paul Swan's buddy "worked at METRO, it was not MGM then and was separated from a corn field by a two strand barbed wire fence." This buddy "got me the job of carrying books from the public library down town back to Culver City. That's my role of research worker." In the early 1920s, Perkins had known Novarro casually through other friends. "He

was good looking and very manly," he recalled. "Just why he had two young men in his house who killed him is something I can't understand. Raymon [sic] was very religious and was buried in a monk's robe. Anyway the police nabbed the killers."

So, courtesy of the still-young "fairy from Nebraska," here was Perkins, suddenly living at the westernmost edge of the continent. Sources yield only a few focused glimpses of him in 1920s Los Angeles, and there are many blanks. But there is enough to spin an improbable tale and prompt wonderment at the way an erstwhile elevator boy from a provincial capital could so completely transcend his origins and fashion himself anew. Of course, that was what nearly everyone who migrated to Hollywood did. It was expected. But still, the gap between Perkins in Nebraska and Perkins in California yawns very widely indeed, starting with his first dwelling place, a rented butler's quarters in an Edwardian mansion not far from the present campus of the University of Southern California. "I had a silver service of seventy-two pieces," he reminisced. "I had a rosewood spinet, the cutest kitchen you ever saw, a yellow marble funeral urn containing the incinerated remains of Joe Huff, an aviator who was killed by falling in his open plane onto Santa Monica Pier." There is no record of such a crash. Possibly Perkins was thinking of Archibald Hoxsey, a celebrated pilot whose plane plunged from seven thousand feet in the sky down to Dominguez Field in 1910. Who, or what, was in the urn will never be known. Perkins later moved a few blocks away to a "little white tower on Estrella St." when his old Lincoln girlfriend or possibly ex-wife (or future wife) India Clark showed up and Perkins (so he claimed) resumed his pimping career while India had three children "from unknown sources."

We first *see* Perkins in Los Angeles through the starry eyes of a teenager who would go on to become one of the great innovators in modern dance: José Limón. Born in 1908 in Culiacán, Mexico, Limón fled the Revolution with his family in 1915 and settled in Los Angeles, where he attended Lincoln High School—just as Perkins had, only in Nebraska. Here is how Perkins recalled the beginning of their friendship: "I was a dish scraper in the Colonial Cafeteria, Los Angeles. The Tray wiper was Archie Schloker a student at Lincoln High School. Archie told me about an interesting boy in his class. The boy's name was José Limón, an Art and Music student. Archie wanted me to meet [him] . . . Meeting José was momentous. He impressed me as being an eagle ready to take off for mountain heights. I'd never seen such vibrant, enthusiastic deportment as displayed by this handsome, brown skin. We fell into one another's emotional orbit which became a permanent situation." Perkins in turn introduced José to his cousin, Don Forbes, and Don's friend, Fernando Felix, allegedly (but not provenly) the cousin of Maria Félix, the gorgeous and fiery Mexican movie star.

We will meet Don Forbes momentarily. But first, here are young José's impressions of the odd threesome that welcomed him into their circle: "In my last year of high school I became acquainted with . . . three young men, aspiring artists,

living the strangely fascinating lives of aesthetes, Bohemians, and rebels. They were slightly older than I was and seemed very mature and worldly-wise. I would be invited to their studio for 'evenings of enchantment.' By candlelight, sitting on a studio couch or sprawled on the floor, I would listen wide-eyed while they read Omar Khayyam, Lord Dunsany, Oscar Wilde, Baudelaire. Sometimes, one of the three, whose name was Don Forbes, would play, on an old, tinny upright piano, not only Debussy and Satie but also a terrifying composer called Schoenberg. Bourgeois society and its values, pretensions, and hypocrisies were not merely dissected, but dismembered and annihilated. To my alarm I found myself listening and, then, after much discomfort, beginning to agree."

Evenings of enchantment! Oscar Wilde, Charles Baudelaire, and Arnold Schoenberg! How did Perkins, son of Frank the pony-beater, become an aesthete and rebel? Omar Khayyam's works may well have been available in Lincoln: his *Rubaiyat*, in the widely read Edmund Fitzgerald translation, was a recourse for doubting souls craving spirituality in the post-Darwinian decades. So might the works of Anglo-Irish author Lord Dunsany—a.k.a. Edward Plunkett, 18th Baron of Dunsany—a prolific, popular, and highly acclaimed writer of florid fantasy tales. But might the upright middle-class reading public in Lincoln have cultivated even a nodding acquaintance with the poetry of Charles Baudelaire, whose *Les Fleurs du Mal* (Flowers of Evil) had been condemned as dangerously immoral and decadent? And did the library in Lincoln even *own* a copy of anything by Oscar Wilde, whose infamous trial and conviction in 1895 for what was euphemistically labeled indecency (and, less euphemistically at that time, sodomy) made his name synonymous with scandal, degeneration, and perversion? Whatever the case, I doubt that the English syllabus of Willa Cather's sister included any of the above.

Perhaps it was Don Forbes who introduced Perkins to the literature of fantasy and decadence. Born Emery Abraham Forbes in 1905, in Auburn, Nebraska, Perkins' cousin ended up at about age ten in a Lincoln orphanage when his mother, a washerwoman, was no longer able to care for him. This orphanage was an unusual one, if Forbes' experience there can be taken as typical (which it probably wasn't). According to a newspaper article that probably relied on facts Forbes himself supplied, "He was a precocious boy who spent much time reading. During his seven-year stay at the orphanage, between jobs of yardwork and furnace tending, he steeped himself in such melancholy writers as Ibsen and Dostoyevsky. He was also unusually interested in music and was given lessons at the conservatory here. With money he earned he bought an old piano and practiced willingly for long hours." That explains Schoenberg.

Perkins' account of Forbes' early days is more colorful: "His Mother's maiden-name was Shickley [or possibly Carson], partly feeble-minded, his father died a drunkard ... His mother was a religious fanatic, worked as a hired girl, was unstable and on public charity much of the time. All of her worldly belongings were the

contents of a rattan suitcase. She was a hell-fire Methodist." The rattan suitcase was a sight in itself: "She'd tear down the street carrying the suitcase with underwear hanging out and a bag of pop corn in one hand, her eyes like black bullet holes, her gait like a camel's lope and her righteous indignation mounting as she stopped to bawl out some kid for smoking a cigarette, 'You're goin' to Hell!'" There was plenty of fire—hellish and otherwise—in Don's early life. When Don was nine years old, Perkins reported, "he was left alone in the squalid, dilapidated shack, which was their Auburn home, and to amuse himself he tossed a lighted kerosene lamp into the air playing as if he were a circus juggler. The lamp exploded and set fire to the house. Neighbors hurriedly extinguished the blaze before Mrs. Forbes returned from work at the laundry . . . They ate cold, smoke-flavored beans, went to bed under water-soaked blankets and wept in one another's arms, pitying themselves, cursing the rich and abandoning all hope for a better mode of life." Don's paternal grandfather having frozen to death—horses and all—one night when driving his sleigh to town, the unhappy Forbes family was cursed by fire and ice alike. Changing his name to Don (never Donald), Forbes ran away from the orphanage in 1922 after only two years of high school; a generous meat-packer's wife, for whom he had done some odd jobs, gave him the money to make his escape. "The rest of his education was, he said, got at the Los Angeles Public Library." Where, presumably, he might have discovered Wilde and Baudelaire.

Don also briefly explored the raptures of erotic love with budding movie star William Haines. Employed for the time being as an usher at the California Theatre in downtown Los Angeles, where *Three Wise Fools,* Haines' fourth movie, was playing in 1923, Don encountered the star himself sitting in the balcony. "Haines put his hand on the rail when Don was going by and Don kissed it," according to Fernando Felix. According to Perkins, Haines saw Don and asked 'Who hires the help around here? They certainly have an eye for beauty.'" The two had a brief fling. "Don went home with the handsome young actor and they sucked, fucked, and rimmed 'till the cows came home. Then Don borrowed fifty dollars from Haines and never saw him again." That was a typical pattern. Again according to Perkins, Haines in his room on West 7th Street "had a Victrola and a lovely Satsuma vase. That's all of the elegance he owned at the time. Later after making several million bucks he opened the most swank interior decorating establishment in the city." Haines had actually been fired from MGM when he refused to enter into a so-called lavender marriage to mask his homosexuality from the public. He ran the decorating business (which included designing interiors for Ronald and Nancy Reagan and many other celebrities) with his life partner Jimmy Shields, who, unable to go on alone after Haines' death in 1973, overdosed on sleeping pills.

As for Fernando Felix, he remains a somewhat shadowy presence. Like José Limón, he was of the Mexican bourgeoisie. His family owned "haciendas and sugar refineries in Sonora," Limón wrote. But he had "rebelled against his

background and upbringing" and—taking the teenager aside and adding his arguments and admonitions in Spanish—urged his young compatriot José to do the same and to cast his lot with the artists ranked in opposition against the stodgy philistines. Perkins described Felix as a very rich person in the sense of possessing an overwhelming love of the extremely perverse, the beautiful, and the wonderful. He could "squeeze more curious ingredients out of apparently ordinary situations than could Marquis de Sade." He was also Don Forbes' "one great love," according to Perkins, although Forbes throughout his short life had multiple romantic (or just sexual) entanglements with men and women alike.

Beyond their evenings of enchantment, the young aesthete-rebels engaged in surprisingly—or refreshingly—wholesome daylight pleasures. For the Nebraska refugees in particular, coastal Los Angeles, with its beautiful shoreline, steep bluffs and deep canyons, offered a stunning contrast to the prairie flatlands. "Don, José, Felix and I," Perkins related, "gathered watercress along the creek mentioned in 'A Single Man.' We used to hike to the beach on Sundays and cut through the hills which in 1925 were barren of habitation. The cress [was] growing in the shallow water and along the banks. I was working at the Colonial Cafeteria and always stole enough grub to feed the gang. We had marvelous salads with the cress chopped up with persimmons, mangos and peanuts." It is an idyllic vignette evoking the time before "habitations" steadily encroached upon the landscape.

But what of Perkins' reference to *A Single Man*? This is the title of Christopher Isherwood's 1964 novel, which Perkins—on an old friend's recommendation—must have read as soon as he could get his hands on a copy (the watercress letter is dated August 6, and the *New York Review of Books* published its review of the novel on August 20). Born in England, Isherwood (1904–1986) had come to Los Angeles in 1939 after a peripatetic gay life in Weimar Germany and other ports of call. Best known in the U.S. for his *Berlin Stories* (1945) that inspired the Broadway musical and the film *Cabaret*, Isherwood taught English at Los Angeles State College in the 1950s and '60s while living near the ocean on the edge of Santa Monica Canyon with his much younger lover, Don Bachardy. In the semi-autobiographical *A Single Man*, he narrated one day in the life (and mind) of George, an introspective college professor mourning his lover Jim, dead in a car crash. George's house is on Camphor Tree Lane near the ocean; he and Jim fell in love with it "because you could only get to it by the bridge across the creek; the surrounding trees and the steep bushy cliff behind it shut it in like a house in a forest clearing." One of the two signs posted on the street "told you not to eat the watercress which grew along the bed of the creek, because the water was polluted. (The original colonists had been eating it for years; and George and Jim tried some of it and it tasted delicious and nothing happened.)"

It is almost as if Perkins and his friends were walking in tracks that hadn't been made yet and eating the cress that would be tainted only many years in the future. It's not clear if Perkins knew Isherwood well, but they had crossed

paths: "I was once a member of the Vedanta Society For The West organized by Isherwood, Aldus [sic] Huxley, Swami Bramananda and a well-known English Philosopher, a cadaverous man with a goatee," he wrote. Perkins' history is a bit wobbly, given that Huxley was a follower of Swami Prabhavananda, who founded the Vedanta Society of the West; Swami Brahmananda being the head of the Ramakrishna Order that actively worked to expand and export the order and its teachings. The cadaverous man was none other than the philosopher, historian, and mystic George Heard, who along with Huxley experimented with LSD years before psychedelia's guru Timothy Leary discovered it.

Isherwood remained faithful to Vedantic spiritual practice to the end of his life; Perkins by 1964 had rejected it, along with a succession of other religious dabblings, to which we'll return in time. But his analysis of *A Single Man* is worth considering. "I have intellectual and emotional reactions stir[r]ed by the book's contents which would not be experienced by a hetero who has no previous personal awareness of the author," he wrote. There was no question the novel was a work of superb craftsmanship: Isherwood could write about absolutely nothing and make it readable. Perkins also found the book "obviously" autobiographical, the author describing himself "to a T." The writer's frank earthiness, however, clashed with the idealism that had purportedly elevated him above the "lower tendencies of lust, emotion, and other frailties associated with unevolved persons." Perkins went on: "This book clearly indicates to me that the author has gone into the philosophical front door and right out the back door. And gained nothing in the sense of overcoming so called animalistic tendencies . . . He has come right back to his starting point and freely admits to himself that Man's dream of a personal immortality of Universal dimensions is a lot of bull shit." This, Perkins asserted, was what he had read "between the lines."

As to the subject, Isherwood's tale put him in mind of Thomas Mann's *Death in Venice* (which Perkins spelled "Venus," possibly with tongue in cheek). "One would swear that the author of this sensitive work was a queer himself, but we know that Mann was a man, a genius of unprecedented ability to penetrate the soul of human nature contrary to his own." By contrast, Isherwood was only spewing out his personal dilemmas under a too-thin disguise of art. Yet despite the work's flaws, Perkins saw through them to something deeper. Beyond its value—or lack thereof—as entertainment or instruction, Isherwood's story cried out "the old, old tale of youth's dream lost . . . it is the final facing of the truth. And truth in a physical sense is not sheer lyrical mood but an unwiped asshole."

In the course of his critique, Perkins could not resist a personal jab: "I was shocked to see the drawing of Isherwood on the back of the dust jacket. Quite a homely old man. Twenty years ago he was a striking beauty. He reminded me of Rupert Brooks. Or a young [Richard] Halliburton [the glamorous and doomed gay adventurer, who will make an appearance further along]." On the surface, Perkins wrote, Isherwood

was a highly intelligent and self-controlled "old Queen" (or "old Auntie"). But "beneath the veneer of intellectualism and prestige a deviate is a deviate and has exactly the same emotional reactions as does a cheap 42nd St he-whore. The only difference is that the former . . . practices the mis-use of the generative function with more <u>refinement</u>." Under the skin, all "deviates" were alike, from that "old Fairy" Paul Swan or that "old Auntie" Isherwood to the cheap "he-whore" in Times Square.

Perkins' use of the pejorative "deviate" suggests a certain ambivalence toward his own queer sexual makeup, or queerness more generally—if not outright self-loathing induced by a social, moral, and political climate that condemned anything falling outside the boundaries of what were prescribed as iron-clad heterosexual norms. But Perkins didn't necessarily follow that script. For him, the queer state was merely one among many possible—and natural—sexual orientations, neither superior nor inferior, normal or abnormal. In the end, being queer was merely "a mighty messy proposition with no practical solution, but some highly impractical ones." Certainly in 1920s Hollywood, sexual preferences and sexual practices ran the entire gamut of options.

Perkins later claimed that he went to Hollywood because he had heard about the glamour of the stars, which in the end turned out to be mere "illusion." Of course it was, but how powerful and seductive! He had soaked the glamour up from afar, in Lincoln, where he'd seen, among others, whatever Bernhardt films came through town, W.P. Griffith's notorious *Birth of a Nation* (1915), and Cecil B. DeMille's 1917 mystery thriller, *The Devil-Stone.*

Equally important to Perkins' education were the new movie magazines that supplied all those pearls-and-bubble-bath Gloria Swanson photographs he stuck to the walls of his room in Lincoln. Enormously popular, these magazines delivered up stories and images of Hollywood as an earthly paradise of beauty, affluence, pleasure, and infinite possibility. In the August 1918 issue of *Motion Picture Magazine,* Perkins could read about movie star Marion Davies, with her "soft gold, careless hair," her "wide and star-fringed eyes," her "veritable child's pink mouth" and all the other attributes that added up to her air of exquisite delicacy. The next month, he might enjoy a description of Bill Russell in "resplendent Western makeup," including nickel-studded belt and leather cuffs, beautiful leather boots, silver spurs, and—the pièce de résistance, perhaps—the "silken cowboy hanky" tied about his muscular throat. Everyone in Hollywood had a "gorgeous wristwatch and a handsome automobile." One Henry King had a "$4,200 Mercer of a beautiful dust color with scarlet wheels"; star Mary Miles Minter was the happy owner of a new Packard in the "prettiest peacock blue with peacock green wheels" and leather cushions and curtains to match. Not for Hollywood's elite was the generic black Model T Ford. Every issue, moreover, was replete with photographic galleries of perfectly beautiful women and perfectly handsome men, plus scores of advertisements for products that promised to bring such perfection into ordinary lives: face creams, lash thickeners,

nose-shapers, manly fitness programs. For Perkins, as for thousands of others, Hollywood, a glowing mirage, beckoned alluringly—and deceptively.

Aside from those enchanted evenings of Wilde, Baudelaire, and Lord Dunsany, Perkins' life in Hollywood—lugging books from the library for his *Ben-Hur* "research" job, cleaning dishes at the Colonial Cafeteria—was pretty lackluster. But settling down in the movie capital just when the seamier side of life there came under attack and, increasingly, began to make headlines, Perkins soon plunged vicariously—and sometimes directly—into the tawdrier side of Hollywood celebrity culture, which even by Jazz Age standards was wildly unrestrained, roiling with sex, glitz, excess, drink, drugs, and death. Given his taste for death, indeed, Perkins arrived in Tinsel Town just at the right time.

In September 1921, there was the Fatty Arbuckle scandal involving the death of the young starlet Virginia Rappe; Arbuckle (a huge, and hugely popular, star, once a plumber's helper before his "discovery" by Hollywood) had allegedly gotten her drunk at a wild party in San Francisco and attacked her violently behind a locked bedroom door. Rappe died five days later. Arbuckle was acquitted after three trials, but his career lay in ruins. Then in 1922 there was the mysterious murder of the Hollywood director William Desmond Taylor, shot to death in his study. Never solved, the crime and its aftermath opened up a Pandora's Box of sex-and-drugs rumors, with the tabloids portraying Hollywood as a place where everyone had something, or many things, to hide. 1922 was also the year when the dashing heartthrob Wallace Reid entered a sanitarium to undergo a cure for morphine addiction. Reid, who starred in a series of movies about fast cars, including *Double Speed* (1920), and *Too Much Speed* (1921), had been injured while filming *The Valley of the Giants* in 1919. A probably well-intentioned morphine prescription soon led to a chronic and ultimately destructive habit.

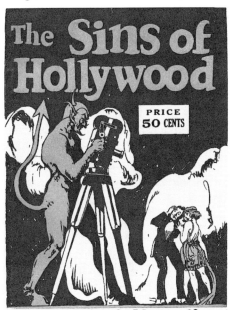

An Exposé of Movie Vice!

The Devil takes aim at Hollywood sinners, 1922

Following closely on the heels of such shocking but sensational revelations was the May 1922 publication of the scurrilous exposé *The Sins of Hollywood*, the cover adorned with the image of a red devil aiming a movie camera at a young couple caught in some shameful act.

The indignant author—"A Hollywood Newspaper Man"—thundered that the "mock heroes and heroines" of the screen had been pictured for box office purposes as "the living symbols of all the virtues," whereas in reality they were pursuing "lives of wild debauchery" fueled by alcohol and—even more dreadful—drugs of every description.

Many of the outrageous goings-on chronicled in *The Sins of Hollywood* seem pretty tame today. The title of one chapter—"Sodom Outdone"—enticingly dangles the promise of revelations that would make the "scarlet sins of Sodom and Babylon, of Rome and Pompeii fade into a pale, pale yellow!" But the scarlet sins of the modern movie-land are at best a pale, pale pink. There is a mock wedding of two dogs, officiated by a "dignified man in clerical garb." The ceremony concluded, the dogs are unleashed and "before the assembled and unblushing young girls and their male escorts" the two canines enact a scene so "unspeakable" that the details can't be printed—even for the sake of truth. There are nude parties galore as well, and—more generally, throughout—sordid tales of marital infidelity, broken hearts, broken lives, and drunken revels without end. One of the most lurid chapters, the hysterically punctuated "Dope!", sketches the ruinous effects of drug use—opium, heroin, cocaine—on Hollywood's beautiful people, willing to try anything and everything "in the nature of what the jazz mad world knows as a 'kick.'" One of those people, indeed the purported mastermind behind the drug craze, is the thinly disguised Wallace Reid, dubbed "Walter," the "muchly adored heart-breaking star of the so-called 'manly' type," who in his delirious pursuit of drugged happiness in "Poppyland" has left a trail of ruin in his wake. In the book, Walter is "still the handsome young devil he always was. He gets away with it." He didn't, though. Several months after the publication of *The Sins of Hollywood*, Reid's wife had him committed; no longer a handsome young devil, he died on January 18, 1923. Thousands of grieving fans flocked to his funeral.

Perkins was one of them. "He was my heart throb at the time," he wrote, "and then in the same month Sarah Bernhardt died and I was completely shot." He added that "Wally's wife did a movie about Dope called Human Wreckage. He died from Dope." Perkins saw that movie, too. In it, he recalled, was a young mother "annoyed by her baby crying so she rubbed cocaine on the nipples of her breasts. This shut up the bawling kid. It would shut up most anyone." Perkins had been madly in love with Reid long before he left Lincoln; Reid was the "epitome of phallic power," the embodiment of everything Perkins wanted to be: "He was talented, rich, famous, and infinitely desirable . . . I would have debased to any degree just to behold the merest shadow of his person." When he learned of Reid's death, Perkins—at that point working as a clerk in a downtown hardware store—ran over to the funeral church during his lunch hour only to find a "line of mourners and rubber necks four abreast four blocks long. I simply stood and stared, half crazed." In the end, he had to run back to the store or lose his job. "That was the closest I ever got to

Wally Reid . . . Friends told me that Wally's casket was covered with purple velvet. There were silver bar handles. His face had spots. Perhaps it's just as well that I did not see him in death." But Perkins managed to preserve a sentimental souvenir of his heartthrob's last resting place, a dignified bronze urn in the mausoleum at Glendale's Forest Lawn cemetery (which years after he dubbed the "Disneyland of the dead"). On a pilgrimage to the shrine of his deceased idol, he dusted off the urn with a handkerchief, which he then kept as a relic in a little jewel box. He even got a picture of the urn and had it framed in "green velvet and antique shadow box effect on an easel." Long after, Perkins revisited the place and found the urn twisted on its pedestal as if someone had tried to unfasten it.

Even discounting the scurrilous semi-fictions of the tabloids, it's true that human wreckage lay all about in early Hollywood. Barbara La Marr, born plain Reatha Watson in the farm town of Yakima, Washington, was another notable casualty. For a brief interval one of the sultriest vamps on the silent screen, La Marr lived a peripatetic and tempestuous life that included five husbands (legitimate and otherwise), many extramarital affairs, and reckless enjoyment without limit. Once thrown out of Los Angeles by a judge who deemed her "too beautiful" (and dangerously seductive) to remain there, La Marr in 1920 had the good luck to visit the set where superstar Douglas Fairbanks was filming. Struck by her beauty, he arranged for a screen test, and soon La Marr was acting before the camera. She quickly rose to fame, director Fred Niblo describing her as someone who possessed "the most tremendous sex appeal of any woman on screen." Like Wallace Reid, La Marr was injured during filming—in her case, spraining an ankle on the set of *Souls for Sale*—and was given painkillers, including heroin, which, along with alcohol, cocaine, and fast times, eventually contributed to her disastrous collapse in July 1925. Confined to a sickroom in Altadena, she told the *Los Angeles Times* that she was "getting better" and would be "all right pretty soon." The photograph that accompanied the article showed the fading star in a lacy bed jacket, propped up on dainty pillows, haggard features all too visible beneath her makeup. La Marr died at age twenty-nine on January 30, 1926. The saddest thing about her, according to a friend, was not her death per se but her "swift, hot, violent life, that preyed vampire-like upon her beauty and allowed so much of her genius and womanliness to waste."

As with Reid, the day of La Marr's funeral was a mob scene. The *Los Angeles Times* reported that thousands of people fought "desperately" with police reserves guarding the Blue Funeral Home where La Marr lay in her casket. Five women fainted during the melee and narrowly escaped being trampled. When the funeral cortege set out for the cemetery, the crowd boiled over, and traffic ground to a halt while the police attempted to restore order. "Many hundreds rushed into the funeral parlor, although all objects of attraction to the morbid had been removed, even to the last floral wreath." The *Los Angeles Times* ran a photograph of the crowd, a sea of cloche hats, fedoras, craning necks, and eager eyes.

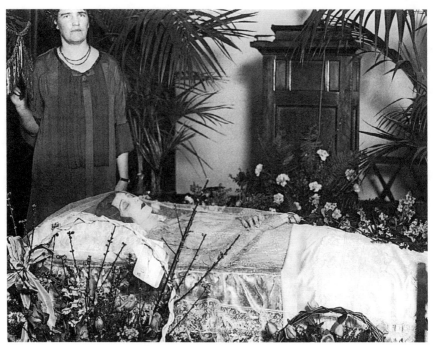

Barbara La Marr lying in state, 1926

For several days, La Marr had lain in state. Some forty thousand more decorous mourners and sensation-seekers had filed by her bier, where the "screen-land's beautiful lady of sorrow" reposed under a blanket of flowers, a long-stemmed, blood-red "baby" rose from a twelve-year-old fan in her hand. In the endless queue, movie stars and others of the Hollywood aristocracy mingled with "shop girls and business clerks." And cafeteria workers: Perkins was there. "She was so very beautiful," he wrote, "and they had her made up to within an inch of a window manikin." A contemporary photograph shows a sad-eyed woman standing over the star, who lies under a filmy veil, darkly painted lips and stenciled eyebrows visible through the lacy screen. She looks like a life-size china doll. Perkins may have flashed back on La Marr when he stood by the murdered Ramon Novarro's grave so many years later: Novarro and La Marr had played opposite each other in the 1924 silent drama *Thy Name Is Woman*, in which she died in his arms. Fifty years later, Perkins was still critiquing the undertaker's art when he went to the wake of Clara Bow, the silent-screen "It Girl" of the 1920s. She was, he wrote, "snugly arranged in a cream chiffon velvet lined five thousand dollar bronze casket . . . She looked no more than thirty five or forty . . . Her brown, dyed hair was in ringlets and her lips were painted bright red . . . she wore a pale blue dress and looked less cadaverish than most stiffs."

The next sensational and riotous funeral was that of screen idol Rudolph Valentino, suddenly succumbing to peritonitis in New York, where he had traveled

in August 1926 to publicize his latest movie, *The Son of the Sheik*, to the adoring crowds that then turned out in the unruly tens of thousands to view his body at Frank Campbell's Funeral Church in Manhattan. Perkins, of course, was not there, but he was among the many who paid tribute to the star in the afterlife. "When he died . . . the remains were sealed in [screen-writer] June Mathis' Vault in Hollywood Cemetery next to Paramount Studios . . . it is still there and visited by women from all over the world—including myself! Seldom are the pair of vases empty of floral tributes." Perkins went on to muse about the fleeting nature of fame. Valentino's ostentatious home, Falcon Lair, had been demolished for a freeway. (Perkins was a bit confused here: Valentino's first Hollywood home was "Villa Valentino" in Whitley Heights; it was bulldozed for the Hollywood Freeway in the early 1950s. As for Falcon Lair, it became one of tobacco heiress Doris Duke's many homes; she died there in 1993.) Now there was only his name "inscribed on a hunk of grey marble at the end of a corridor of a gloomy repository of notorious bones. He's in good company, most all of his contemporaries are with him."

Although Perkins may or may not have crossed paths with Valentino, nonetheless—albeit in a roundabout way—there was a connection, in that the star's second wife, Natacha Rambova, played a key role in *Salomé*, the 1923 silent film that would have significant future ramifications for the one-time elevator boy. Rambova, born humdrum Winifred Shaughnessy in Utah, had become the protégé (and, rumor had it, the lover) of the Russian-born actress, Alla Nazimova—Paul Swan's one-time idol—and designed both the costumes and the sets for Nazimova's wildly unconventional silent film, *Salomé*, in 1922. Nazimova, who came to conquer Hollywood in 1918, was an exotic curiosity—"a foreigner from the most foreign of all countries"—with an enigmatic edge. Every description emphasized her mercurial strangeness: "Nazimova! The very name conjures her up. Those slanting, shining, mesmeric eyes . . . The tangle of short, black hair, windblown . . . That scarlet, expressive, sad, laughing, cynical, wistful mouth . . . And the purring, lilting voice, whose accent is like some gorgeous jazz harmony you cannot forget." It must have been a guttural voice, too: Nazimova smoked cigarettes, in a long black or amber holder. In the days before the advertising industry convinced middle-class women that smoking and ladylike propriety were not mutually exclusive, Nazimova's habit branded her as a Bohemian artiste who played by her own rules. Her Sunset Boulevard mansion (dubbed "The Garden of Alla") was infamous as a setting for wild parties and decadent décor: lamps veiled in mauve and black, lavender divans, and violet velour draperies.

No wonder, then, that the lusty star was attracted to Oscar Wilde's scandalous one-act play *Salomé*. Published in 1891 in French and three years later in English, with erotically charged and seductively stylized black-and-white illustrations by Aubrey Beardsley, *Salomé* sparked controversy and fueled outrage. Sarah Bernhardt mounted a production of the play (herself at age forty-eight playing the title role

of the young virgin) for the 1892 London season, but it was cancelled when the Lord Chamberlain's office censored it. In 1918, Theda Bara—one of the first of the screen vamps—starred in a film adaptation that drew fire from the American religious establishment for its flagrant immorality. For the temperamental and sexually polymorphous Nazimova, *Salomé* was the perfect vehicle: erotic, steamy, and gory, it played dangerously with taboo themes, among them incest (Herod's lust for his virgin stepdaughter, actually also his niece, daughter of the brother murdered by Herod to take his wife and gain his throne), and necrophilia (Salomé kissing the Baptist's decapitated head). Plus, in Nazimova's version (she was the producer and uncredited co-director with her nominal husband Charles Bryant), it featured—allegedly—a predominantly gay cast. Oscar Wilde, sentenced in 1895 to two years of hard labor for what was described (evasively) as indecent behavior with men, would surely have been pleased.

Visually, *Salomé* is a stunning *tour de force*. Rambova's designs are for the most part in the spirit of Beardsley rather than literal imitations. The principal feature of the set is an ornate Art Nouveau grillwork of schematic flowers and twining stems, against which much of the action, such as it is, takes place. Heavily made up in maquillage and thick white powder, Nazimova—younger than Sarah Bernhardt in the same role but not by much—sports a succession of bizarre wigs (a curly mop with pearly beads, an angular platinum blonde bob) and outfits, ranging from a slinky tunic to a

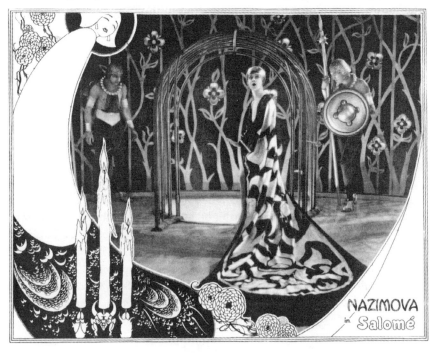

Alla Nazimova in her Aubrey Beardsley-inspired "Peacock Skirt" costume

show-stopping cape emblazoned with a bold black-and-white abstract design. Like the peacock skirt in Beardsley's illustration, it pools out smoothly over the floor as if it were made of oil. The bare-chested young Syrian—the captain of Herod's guard, who gazes at Salomé as if hypnotized—has fish-scale-patterned tights, a lumpy wig made of pom-pom balls, and nipples painted like targets.

The action is stylized and pantomimic, with many close-ups of Nazimova looking haughty or wistful, and much stately, ritualized movement. Herodias' pretty page boy fawns over the young Syrian in a way that is not terribly difficult to decode. King Herod is a lustfully panting, drooling clown, his wife Herodias a termagant in a fright wig. John the Baptist, in a fur loincloth, is appropriately emaciated and intense. Salomé's dance is adequate but hardly arousing; though Nazimova had many talents, dancing was not her strongest suit. But the final scene, in which Salomé kisses the severed head, is still shocking. Even though she conceals the grisly act behind her cloak, it is all too easy to imagine what is taking place. When at the very end Herod's soldiers at his command converge on Salomé to crush her under their shields, there is a moment of genuine gravitas that clashes oddly with earlier scenes that highlight the grotesque, the camp, or the merely outré.

The American public failed to appreciate either the decadent story or the daring style of the film, and *Salomé* was such a terrible flop that it was the beginning of the end of Nazimova's stardom in the movies. "*Salomé* is a theory printed in black and white rather than a photoplay," wrote one critic. "It is a painting deftly stroked upon the silversheet. There is nothing in Nazimova's grotesque acting to keep the Tired Business Man awake . . . But poets and dreamers will find imaginative delights in the weird settings and the still more weird acting depressing at times of ordinary folks." Another described the film—accurately—as a "hot house orchid of decadent passion." Viewers were warned: "this is bizarre stuff." Too much art, not enough entertainment, was the consensus. The moral, or immoral, aspects of *Salomé*, oddly, seemed not to disturb these two writers. Perhaps they figured that what happened on screen was not so much worse than what went on at your everyday tabloid-fodder Hollywood orgy.

But if the film had no appeal for the "Tired Business Man," its beauty and strangeness spoke eloquently to the "poets and dreamers" in the audience. It cast a romantic spell, for example, on dancer Pauline Koner, who saw *Salomé* when she was a teenager: "The Orient had always been my first love," she recalled. "I was saturated in stories of the Arabian nights . . . and swooned when I saw the beautiful Russian movie star Alla Nazimova in *Salomé*. To me, she was the ultimate in exotic beauty. In my private world, I was an Egyptian princess. My bedroom was my palace—my bed draped with silks and brocades. When I went to sleep, I . . . was lulled by the cool breeze as two imaginary Nubians waved peacock-feather fans on either side." *Salomé* was an invitation to a strange voyage that allowed "dreamers" to escape from humdrum convention, at least in fantasy.

Already an Oscar Wilde devotee, Perkins saw *Salomé* at the Los Angeles premiere and commented later on the "stunning, highly stylized backgrounds in black and silver taken from Beardsley drawings." He "loved these things but the public didn't," he said. And surely he relished its transgressions: the necrophilia, the perverse eroticism, the girlish men, the obvious drag queens among Herod's courtiers. Imagine Perkins, still in his "bitchhood," sitting rapt in the dark theater, listening to the quasi-*Afternoon of a Faun* score by Ulderico Marcelli, seeing the curtains part on Nazimova's perverse and subversive interpretation of Wilde's drama and Rambova's extravagant play on Beardsley's art. Like Pauline Koner, he let his imagination loose. More than likely he envisioned himself in one of those transgressive roles.

Later on, after a brief interval as a fashion designer in New York, Rambova acted on stage, wrote plays, conducted spiritualist séances, wrote about yoga, and ultimately became an Egyptologist whose collection of artifacts now reposes at the University of Utah Art Museum. Nazimova continued to act when she could on stage and in films and had many affairs (including one with Oscar Wilde's niece) but increasingly fell upon hard financial times. She lived out her last days in a rented villa on the premises of her former mansion, now the Garden of Allah— note the added "h"—hotel. As for Perkins, fifty-seven years later he finally saw *Salomé* again and there met the would-be love of his old-age life.

But what, indeed, did young dreamer Perkins imagine for himself in the *real* world? He had come to Hollywood, where he lived by day as a cafeteria drudge or store clerk and by night as a would-be aesthete/Bohemian. He had hiked the canyons and gathered watercress on the banks of the creek that one day Christopher Isherwood would put into his novel. He had heard and read the scurrilous gossip, seen the unglamorous sordid ends that came to some of the most beautiful and celebrated screen heartthrobs. He had examined their preserved and painted bodies on display and visited their graves. What more was there to do?

Happenstance came to the rescue. In 1927, Don Forbes moved to New York, a smitten and deluded would-be girlfriend having sent him a train ticket there. It was an advantageous time for him to leave, since he had recently been arrested for a transgression (in the basement men's toilet of a downtown pool hall) that involved a setup in which a "filthy old tramp with a heavy grey beard" had been the bait: Don had been "sucking a cock stuck through a hole in the partition of the booths. He was cought [sic] point blank by two detectives and hawled [sic] off to jail." Don had been released and placed in the custody of a Mrs. Long, a mysterious (because lost to history) older woman who had taken an interest in the young man from Nebraska. But when the free ticket to New York fell in his lap, Don bolted; he never went back to California.

A year or so later, José Limón, Fernando Felix, and Perkins headed to Gotham too, by various means. For Limón, leaving Los Angeles meant rejecting any

possibility of a conventional existence. A high school friend—Owen Jones—made an all-out effort to separate José from his "disreputable artist friends," who in their depravity had led the young Mexican émigré to read not only Oscar Wilde, but also Theodore Dreiser and Eugene O'Neill, and to see "lewd plays" starring the infamous Mae West. Doggedly pressuring José to keep to the straight and narrow, the upright Jones made his naïve friend feel more and more like a "monster of depravity." In the end, though, "depravity" won out, and José set out to join the "boys"—Perkins and the others—who had already moved to New York, putting behind them a Los Angeles that they found "increasingly backward and provincial." In New York, they boasted, they were discovering an "artistic paradise."

According to Perkins, Limón traveled to New York on a motorcycle, with Owen's brother, Edgar Jones. En route, as Perkins told it, Edgar was bitten by a rattlesnake, but José gave him first aid by sucking out the poison and all was well. We never see Owen, or Edgar, Jones again. José, though, wrote that he hitchhiked his way across the continent, getting rides from "truck drivers, salesmen, a young married couple, and college boys on vacation." As for Perkins, he tagged along on the Panama Mail Line, sailing (of course) through the Panama Canal. During the voyage, the head engineer taught him a method for inducing an erection in a reluctant penis: "very, very lightly tickle the tips of [the] nipples and the nerve is connected with the prick and the blood flows into the spongy phallic tissue quickly." In New York, José became a dancer. Don Forbes became a painter, a moocher, a doper, and, ultimately, a wreck. And in roundabout ways—via New York, Mexico, and Westport, Connecticut—Perkins became an artist.

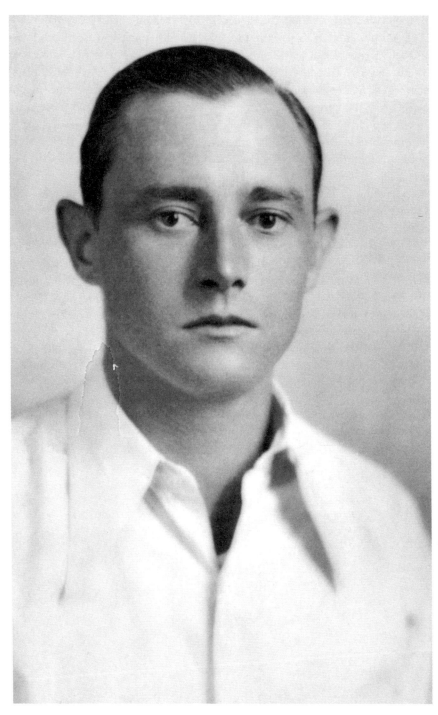

Perkins sitting for his passport photograph, 1930

What a Drag!

THE NEXT TIME WE SEE PERKINS IS IN HIS 1931 PASSPORT photograph. He is no longer wearing makeup, and his hair, flat and smooth, is brushed away from his forehead. Although he is twenty-nine years old, he looks exceedingly young. His cheeks are full, his eyes clear (and blank), his mouth small and neat. It is impossible to imagine what is in his head; he is inscrutable, expressionless. He wears a white shirt, open at the neck, with a rather dramatic spearpoint collar—just then coming into fashion. According to the passport application, he is five feet, ten inches tall. He has dark brown eyes and hair and no distinguishing marks or features. On the application, Perkins solemnly swears that he has never been married, and that his father Frank left this life on May 1, 1919—three years after the *actual* date of Frank's demise. Perkins plans to visit the British Isles, France, Germany, Italy, Switzerland, Holland, Belgium, and Austria in order to study. He gives his occupation as "commercial artist."

The passport was issued on September 8, 1931, and on September 11, Perkins embarked for Antwerp on the Red Star Line's *Pennland*. He returned on the same liner, sailing from Antwerp and arriving at the Port of New York on March 21, 1932. The Red Star Line published an advertisement showing the majestic *Pennland* putting out to sea; it is either dawn or sunset, because the sky and water are suffused with pink. What a thrill it must have been for the elevator boy and tray-wiper to sail on so grand a vessel, even after several years in glamorous Hollywood. Absent any other record (except his grandmother's wandering letter, which always arrived only after Perkins had already moved on to the next country), we have almost no idea what he did, where he stayed, or whom he met. We know only that he ogled celebrities at the Casino de Paris, where he saw the American film star Lilyan Tashman, in "silver brocade slippers and an opera length ermine cloak," stepping daintily into a taxi over mounds of curbside manure left by the Casino's troupe of performing ponies. He also spied the sensational and provocative African-American dancer Josephine Baker, who almost knocked him down as she elbowed her way through the lobby at intermission. And, of course, he visited Sarah Bernhardt's grave in the Père Lachaise cemetery, as he would on every subsequent trip to the City of Light. In fact, on that first occasion, Perkins said that his "very first trek" was to Père Lachaise to "contemplate the mysteries of fame and grandeur." (As for the *Pennland*, she became a troopship at the beginning of World War II; on April 25, 1941, she was bombed and sank in the Gulf of Athens.)

But what has Perkins been up to since moving to New York? He states that he is a commercial artist, but—except for one 1929 painting dating from Perkins'

New Orleans sojourn (of which more later on)—there's no sign of whatever work he may have done between 1928 and 1931, although he did (he claimed) attend a lecture course at the New York School of Interior Decoration in 1929. The Great Crash and the Depression may have skewed things for him. We *do* know something about what Don Forbes and Fernando Felix were up to. Forbes, Felix, and José Limón, plus an unnamed and no doubt temporary girlfriend, lived together at 101 Riverside Drive. Don and Felix's relationship was stormy, to say the least. Perkins recalled that they "fought like cats and dogs. Once they got in an argument over the Chinese Civilization of three thousand years ago and Don hit Felix over the head with a coal oil stove. Once he broke a rosewood rocking chair over his lover's head on account of being accused of stealing the laundry money to buy cigarettes . . . They despised one another's guts yet were as psychically aligned as Tristan und Isolde, the mystic marriage."

José, mirroring Perkins, became an elevator operator in a Wall Street skyscraper, though he soon left that job to model for a sculptress who "fell madly in love with his virility and shapely buttocks, which she said were 'sheer frozen music.'" Don was commissioned to design and paint dust jackets for a Brooklyn publisher. Felix got a job operating an IBM machine—an electric keypunch, or some sort of tabulating device, at the then-cutting edge of technology. Perkins was a "soda squirt" at the Westside Pharmacy. As he had in Los Angeles, so in New York he fed his friends: "After [José's] first appearance on the New York Stage," Perkins said, "I took him and Don to the Westside Pharmacy for snacks. The fountain and grill were my domain and I stuffed the boys with happiness." When he wasn't cruising for trade or drawing pictures, Don got into scrapes. On one occasion, a "fat detective" lured Don into a compromising position at the far end of the Forty-Second Street subway platform and promptly "hauled him off to jail" (albeit not until the illicit act had reached a satisfactory conclusion). According to Perkins, this was Don's fifth and last arrest: Don was broke and "was let go as incorrigible because no lawyer could get any money out of him."

Despite their tempestuous relationship, Don and Fernando Felix collaborated on a set of illustrations for the Russian writer Aleksandr Kuprin's *Sulamith: A Romance of Antiquity,* which was published in 1928 by Nicholas L. Brown in a limited edition of 1500. The illustrations are credited to "Forbes-Felix," making it impossible to sort out who did what, though Perkins later explained that Don did the outlines and Felix colored them in. Originally published in Russia in 1908, the novelette is an extravagantly colorful and steamy piece of exotic erotica based on the Biblical *Song of Songs.* In Kuprin's recasting, King Solomon at forty-five years of age is smitten with love, or lust, for the thirteen-year-old Sulamith, a "lowly maiden of the vineyard." He takes her as his concubine, and for a brief interval the two rapturously enjoy mad passionate ardors, until Sulamith is murdered at the bidding of Solomon's jealous queen, who has been compensating for her

consort's neglect by indulging in "secret orgies of perverted lust" with a coterie of priest-castrates devoted to serving the goddess Isis. Kuprin's prose is lush and languid: there are amethysts like early violets and jars of gray Arabian amber; there are diaphanous fabrics, sparkling wines, sweet melodies, heady perfumes. The king's eyes are dark as the darkest agate, "like the heavens on a moonless night in summer." Sulamith's flesh is like tawny, ripe fruit. The cruel and lecherous Queen has blue hair and green eyes like those of some powerful feline beast or punk rocker; she bestows "ferocious, sanguinary caresses" on the helpless bodies of her love-slaves.

Nicholas Brown had published an unillustrated edition of *Sulamith* in 1923, when the risqué passages of the story prompted one reviewer to comment that the "erotic frankness" of the tale "would win for the book an honored place on Everyman's little shelf of pornographia." Hardly pornographic by our standards, the Forbes-Felix illustrations carry an erotic and even perverse charge nonetheless in the way they visualize the story's atmosphere of clichéd Oriental sensuality, languor, and violence. In one, Solomon and Sulamith recline amorously together upon a divan patterned in orange-and-black tiger stripes and leopard spots and strewn with jade-green and bright yellow bolsters embroidered with blue twining flowers or black dots and crescents. The sloe-eyed lovers are as flat as paper dolls, their contours traced in sinuous lines. Behind them are scalloped and flame-like forms in ivory and the palest lavender. Pulsing with linear rhythms, the composition is intensely decorative and stylized. Forbes-Felix's Sulamith has flesh of a delicate pink—a decided departure from her tawny textual counterpart.

But there is one gruesome scene that adheres all too scrupulously to the text, in which a chosen sacrificial victim slices off his own genitals and "with a wail of pain and rapture" casts a "formless, bloody piece of flesh" at the feet of the goddess Isis while maddened priests chant "The Phallus! The Phallus! The Phallus!" In the illustration, an emaciated man, ghostly white, ascends a flight of stairs toward the goddess, or her effigy, a foreboding black silhouette spangled with golden stars and crowned with a horned diadem enclosing a yellow moon. Orange, red, and yellow flames flicker along the stairway and undulate around the figure of the goddess, who stands before a towering black shape that would be difficult to read as anything but phallic. The design is striking in its dramatic black-red color contrast, rigid symmetry, and decorative abstraction. But the pale figure strikes a discordant note: as he climbs upward, hot red blood courses down his legs and flows down the stairs. He throws back his head in agony and flings his bloody skeletal arms in the air. Between his legs is a hole.

Forbes-Felix's Art Deco style is very much of the moment: non-naturalistic, mannered, theatrical, schematic, and sleek, it is an eclectic and elegant mélange of ancient Egyptian, archaic Greek, Japanese, and Art Nouveau sources blended with machine-like precision. Playful, superficial, and frivolous, with its elongated

figures and graceful swooping lines, the style was synonymous with modern fashion, fantasy, and luxury: think greyhound, not bloodhound. Art Deco style was everywhere, as Perkins recalled much later when he happened to wander into a gallery showing the work of the celebrated Russian-French artist and designer Erté. "His Harper's covers were the rage in the teens and twenties," Perkins wrote. "He did the Paris Follies … fashion drawings for MGM. His studio was in Monte Carlo. He got six thousand dollars for a single sketch … I was influenced by his technique in the early 20's." Safe to say that Don Forbes and Fernando Felix were, too. But seldom if ever did Art Deco venture into savage rituals of self-mutilation. In Forbes-Felix's illustration, the style's refinement clashes brutally with the actual subject. It was probably just as well that the edition was limited to only the fifteen hundred private subscribers—whoever they were—for their own little shelves of pornographia. No doubt Alla Nazimova, too, would have loved it.

Being involved in the design of such a luxury product must have stirred Fernando Felix's book lust. As Perkins told it, his wanton friend "stole several thousand bucks worth of limited editions from New York's leading stores … when detectives traced him to a brownstone dump uptown, Felix buried the books, in a trunk, in the back yard. The damp soil caused them to mold and stick together." What Felix would have done with them had he not precipitated their destruction is uncertain. There was a brisk underground trade in stolen books and manuscripts, and perhaps he intended to sell them on the black market. Or maybe he simply craved them for their beauty: over the years, Perkins attempted to "replace Felix's coveted library of fine tomes to placate not his conscience but his aesthetic cravings." Felix's career as both bibliophile and illustrator was brief, however: he left New York for Mexico in 1929, although that's not the end of his role in this story: we'll encounter him again further down the narrative road.

But Perkins remained. Considering his own cravings, he arrived in New York at the right time. Hollywood, which had its own gay enclave, may have been dazzling, dissipated and depraved, but the eastern metropolis was an even hotter hotbed of everything that played to Perkins' interests and obsessions, with the possible exception of necrophilia. Homosexuality and effeminacy (in popular perception, the two were coextensive) were fashionable, though hardly safe from persecution. Gay men (and women) were out in the open, at least some of the time. Pansies and fairies were all the rage: one popular revue was called *Pansies on Parade*.

Perkins' queer persona came straight out of the interwar decades. His vocabulary alone testifies to that: every one of the terms he habitually used in his letters can be found in the gay slang glossary published in 1941 by the diligent sociologist G. Legman. We have already seen how Perkins regularly characterized Paul Swan as "that old fairy from Nebraska." "Fairy" was but one of many, many pejoratives in circulation in the 1920s and '30s—along with labels like "pansy," "faggot," "flit," "nance," and "yoo-hoo." A homosexual who desired a real—i.e.,

heterosexual—man was dubbed a "queen," whereas a young man might be a "belle" and an older one a "dowager." A man's crotch was a "basket," and anal sex earned the rather easily decodable label "browning." Decades later, Perkins was still dipping into that reservoir of vintage slang. Praising the florid decoration of a new Los Angeles cocktail lounge, Eddie's Basket, he explained that the latter "in queer jargon" meant the "male virile bulge." He described himself as just "a plain old panzy who loves pretty things and cock" and "a plush-hipped he-nancy." At some point in his life, there had been a "browning" queen, a gay young thing "who took my gorgeous Mexican husband away from me and caused my bitchy breakdown." (The identity of this gorgeous husband remains a mystery, as do details of the bitchy breakdown.) Perkins too was of that ilk: he was the inimitable "Mary, queen of sluts," and "one of the Twentieth Century's most notorious, low down, old queens."

But what of the low-down old queen's fashion sense? Hollywood had a lot to do with it—hardly surprising, given Nazimova's casting of purported drag queens as courtiers in *Salomé*. Tinsel Town offered ready-made personas for a wide range of styles, in fact. Perkins asserted that "Almost all queers hold an image of themselves as being a very grand duchess or an imperious [Tallulah] Bankhead. Another old warhorse was Elsie de Wolfe [the early twentieth-century celebrity decorator]. The Hollywood queens (artificial girls, I mean) used to tell, with bated breath, that they went to the same hairdresser who tinted Lady Mendl's tresses." (In 1926, De Wolfe—a lesbian—had entered into a marriage of convenience with the diplomat Sir Charles Mendl; we will see more of her in due time, when Perkins goes back to Hollywood.) Perkins went on, "Elsie cohorted with all of the elegant, pretentious male bitches in town. She chose the cleverest, most artistically gifted ones as her constant companions. You see, they felt alike about life. High drag and frou frou décor mixed with chi chi accents and a streak of shocking pink set the keynote for the exquisitely sisterly camaraderie." Queens could be literally queenly, or at least duchess-like, or they could be sultry vamps like Tallulah Bankhead, or, like De Wolfe's "bitches," they could simply go down what Perkins—ardent practitioner of high drag—described as his "satin and rhinestone lined alley."

By the time Perkins arrived in New York, drag was in the air and on stage—or off: the scandalous performer Mae West's controversial (to say the least) play, *The Drag* (1927) was raided by the police and shut down during the show's tryouts in Connecticut, before it even came anywhere near Broadway. Reportedly, West had recruited gay chorus boys from a Greenwich Village speakeasy to act in the play, and in the dialogue there were fairies, queens, and fags in abundance. The grand finale was a drag ball with "seventeen real-life fairies" onstage for the first time, dancing in their most extravagant ensembles. One exchange between two characters conveys something of the calculated outrageousness of the garb onstage: DUCHESS: "Oh, my goodness. I've got the most gorgeous new drag.

Black satin, very tight, with a long train of rhinestones." CLEM: "Wait till you see the creation I'm wearing, dearie. Virginal white, no back, with oceans of this and oceans of that, trimmed with excitement in front." (For all the play's sassy wit and ostensible frivolity, though, there is an ultimate underlying tragedy: the main character, Roland Kingsbury, is shot and killed by a former lover—who is also his father-in-law. To protect multiple reputations, the death is declared a suicide.)

Of course, Perkins couldn't have seen the play, even if he'd been in New York in 1927. But it's likely he heard about it. And there were drag balls and drag contests everywhere. One of the most popular and celebrated drag ball venues was the Hamilton Lodge (of the Grand United Order of Odd Fellows) at the Rockland Palace in Harlem. The lodge had held annual masquerade balls since 1869, but by the 1920s these events had become glittering spectacles of ultra-outrageous cross-dressing fashion. Reports on these affairs give us a much more detailed picture of transvestite chic. One article, in the *New York Amsterdam News*, dwelt on the sheer gorgeousness of the gowns worn by contestants, who somehow managed to project a look of luxurious high style even in the depths of the Depression. It was, according to one of the "muscular-shouldered, beautifully gowned creatures present, 'A gorgeous, thrilling spectacle—a veritable glimpse of fairyland—whoops!'" The pageant—attended by some seven thousand, black and white—started at 1:45 in the morning, with nearly a hundred impersonators striding onto the stage, throwing kisses and "snake-hipping." The first prize went to Bonnie Clark, who wore a "red and white satin gown. The long waist and crepe de chine left arm of the dress were covered with rhinestones, while three yards of red satin-velvet were used in the flare skirt which was bordered with a feather hem." Bonnie carried a large fan graced with eighteen feathers and wore "white rhinestone slippers." Other outfits were equally sumptuous. One impersonator—who refused to give his name but willingly disclosed his phone number—sported a "white satin dress with a black velvet long wrap lined with white satin," with a white fox collar. His hair had been lacquered white. Then there were black chiffon gowns, white bunny jackets, ermine shoulder straps, silver turbans, silver sequins, gold sequins, and cerise satin opera pumps.

Whether in fact or fiction, drag had a consistent and identifiable look, or looks. In *Venus Castina* (1928)—the first-ever history of drag—art critic C.J. Bulliet compared and contrasted the styles of two popular performers. Julian Eltinge, he wrote, learned the art of female dress from the alluring and voluptuous actress Lillian Russell. To women, Eltinge was "a fashion plate, just as any equally stunning-looking female would have been." But he wasn't wholly feminine, either. "There was always a lurking touch of male, poking the slightest bit of fun at the female. Women saw him as caricature. A distortion just enough to expose their little tricks." Bert Savoy, on the other hand, played a red-headed, wisecracking streetwalker. "His gowns were a burlesque of the gayest craze of the moment, exaggerated but still kept feminine.

Great jewels, ten times the size of whatever happened to be worn, would flash from his red wig or his fingers or his breast or his ankle."

Bert Savoy was so famous that he even made an appearance in fiction. The pseudonymous Robert Scully in *A Scarlet Pansy* detailed the "grand drag" worn by Miss Savoy, the "notorious female impersonator." In one scene, she makes a dramatic entrance "garbed in richest black, her red wig topped by a picture hat, her slender waist corseted till there was room only for her backbone and one lone intestine to pass through the narrowest part of the garment . . ." Another queen, a Russian, never appears in the evenings "except in grand drag à la duchess, with yards and yards of costly lace or velvet trailing along behind her." There is also a Little Egypt, the "couchee-couchee" who comes to a ship's dance "in a drag all gold and diamonds. What a wow! Prettiest thing there." Drag offered up a smorgasbord of sartorial possibilities.

For Perkins, high drag was an aggregate of all such things: big hair, big wigs, big breasts and curvaceous hips, low necklines, tiny waist, tight fit, long trains, vast picture hats loaded with plumes, clinging slinky satin, fluffy chiffon, velvet and lace, ruffles, flounces, and as many sequins and rhinestones as there were surfaces to attach them to. He worked hard to make a sensational impression and (he claimed) regularly captured first prize at the "Holloween" Drag at Young's Million Dollar Pier in Atlantic City. "My grandest outfit," he wrote, "was cloth of gold with an Elizabethan collar and long train. Three pecks of gold sequins weighed me down. I was so ravishing that when I walked into the ball room everyone dropped dead and I had the whole place to myself." Celebrating his victory, he went too far: "I got very drunk and woke up on the city dump without my prize-winning drag," he recalled. "All I had on were my satin heels and eyelashes." (If Perkins is to be believed, the same thing, minus the drag, happened to Don Forbes: he had gone up to Harlem "to a place called the Rib where you could wash down greasy spare ribs with buckets of beer and piss. Don got plastered as usual and woke up next morning in Central Park minus every stitch of his duds except his shoes.") How Don managed to get home Perkins did not say, but in his own case, a young man happened by, dragged Perkins out of his "disgrace" and, as Perkins recounted, "took me home[,] got into bed urging me to commit oral sodomy. I wanted to get buggered and slapped a big gob of cold cream in the rear." The good Samaritan not so inclined, he demanded his pants and prepared to walk out. "As he closed the door he turned to me and said 'You can lead a horse to water but you can't make him drink.' I gave him back his raincoat which he had loaned me . . . That was the beginning of my senility."

Fortunately for the historical record, there are photographs showing Perkins in his Lillian Russell/Bert Savoy mode of exuberant-excess-verging-on-caricature. In 1943, he posed for a portrait photograph in one of his highest drag getups. It is impossible to recognize him as Perkins. He is heavily made

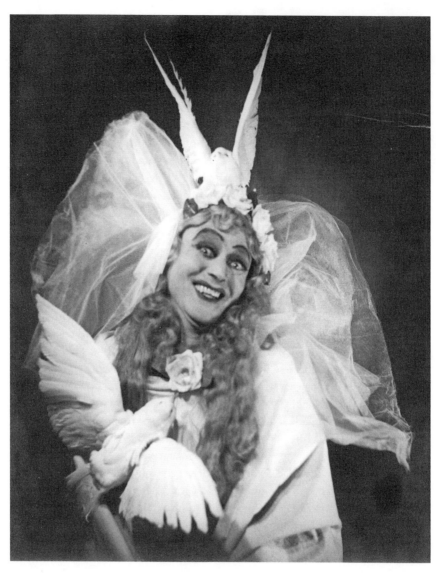

Perkins in Mary Pickford drag, 1943

up: eyebrows and eyelids darkly outlined and shadowed, emphatic lipstick. He sports a blond wig that spills down his bosom in waves and ringlets. Around his head is an aureole of tulle crowned by a white dove, wings forming a dramatic V; another dove, wings spread, is at his breast, along with a white rose. He seems to be wrapped up in a voluminous cloak of some sort. Is he a bride? A saint in heaven? The Virgin Mary? Whatever his identity, he is grinning madly, with a gleeful twinkle in his eyes. Another photograph (c. 1937) shows a different

look. Grinning just as madly, Perkins wears the same exaggerated makeup but a dark wig this time, done in a pompadour style and topped with ostrich plumes; around his shoulders is a fluffy, feathery boa. He wears a shiny bangle on one wrist and poses with gracefully crossed hands, one holding a champagne coupe and the other a cigarette. Decades later, Perkins showed the blond version—or vision—to his young Hollywood friends. "They messed their drawers," he wrote, "when seeing Granny Perkins in yards and yards of tulle in a circle of doves . . . The doves were stuffed. The blond wig came from Westmore [a dynasty of studio makeup artists and wigmakers; the patriarch, George, had been Rudolph Valentino's exclusive makeup stylist]."

However many other drag outfits Perkins may have fashioned for himself, we have only that scant handful of photographs. But in the 1930s, he drew a series of costume designs for drag ensembles that he may have worn or perhaps only fantasized about. They offer a vivid picture of Perkins' drag fashion sensibility. Each outfit has a name: "Splendor," "Indomitable," "Fascination," "Mystery," accompanied by a description. "Splendor" consists of a "flesh net torso, interwoven black satin ribbon, black lace overskirt, black satin underskirt, black plumes, diamond leaves, jet jewelry." Like all the others, the figure wearing this ensemble is like a paper doll, flat and frontal. She has a Cupid's-bow mouth and coyly downcast eyes with glossy lids. The bottom of her gown has a fishtail swoop, and her plumes are exuberantly over-scaled. Another, entitled "4:30 PM," includes "Turquoise velvet, pearls, sapphires, pale yellow plumes." Whereas "Splendor" has the sleek chic of a modern Hollywood gown, "4:30 PM" is straight out of the Gay Nineties. The paper-doll mannequin has an ample bosom and a cinched-in waist; her gown is studded with gems, and feather winglets sprout from her shoulders. Behind her trails an intricately ruffled stole. But everything else pales in significance next to the hat, which is a prodigious platter of plumes set off by ornate beaded flourishes. In Perkins' fantasy wardrobe, there are many other such hats, as big as cartwheels. A couple of them are even adorned with wide-eyed foxes, their bushy tails wrapped about the hat's crown.

Mae West, Perkins' other idol, was the chief inspiration for his fantasy drag couture. In her plays and subsequently in her Hollywood movies, the first in 1932, West sported what Perkins surely considered the absolute highest of high drag. In the 1934 *Belle of the Nineties*, designer Travis Banton dressed her in purest Gay Nineties style: form-fitting sequined and rhinestone-beaded sheaths that showed off her hourglass shape and cascaded down into yards of trailing froth, along with sumptuous feather boas, and gigantic plumed picture hats worn at a rakish angle. West played many variations on that sartorial theme, which in turn paid homage to the aforementioned Gilded Age singer and comic-operetta star Lillian Russell (1860–1922), whose lavish pearl-encrusted gowns and colossal hats were her signature look. Perkins adored her almost as much as he idolized Mae West.

But it was West's burlesque of femininity itself that inspired Perkins' admiration and emulation. "She's ridiculing and satirizing eroticism, making fun of our primal obsessions, rubbing it in," he wrote. "Also she is spoofing women's foibles by her extravagant exhibitionistic attire." And in the sartorial and sexual equivalent of a tongue-twister, West in Perkins' view should be thought of as "a female impersonating a female impersonator." Her campy mannerisms (slinking across a room, wriggling her hips, patting her platinum-blonde waves with one rhinestone-bedecked hand, batting her heavily fringed eyes at one or another hopelessly besotted admirer) ranked with those of the famous (male) female impersonators of the past, he said. To Perkins, Mae West was the "Eighth Wonder of the World," and—like the other seven—she was "architected to perfection." His drawing "The Mae West Effect" illustrates, or, perhaps more to the point, embodies that idea. It shows three fancy theater boxes stacked in tiers and filled with stout full-breasted women in evening gowns with plunging necklines. They take up so much room that there is barely space for their gentleman escorts. The boxes themselves, we soon realize, replicate the ladies' décolleté on a much larger scale.

Mae West was Perkins' goddess of drag, but it was another woman—equally though differently flamboyant—who inspired him to explore his Victorian memories and fantasies in his art—who, indeed, got him started painting in the first place. This muse was Rose O'Neill, notorious Bohemian, free-love advocate, ardent suffragist, poet, novelist, artist, and—most important of all— creator of the Kewpies, those super-cute and/or super-repellent androgynous and relentlessly upbeat naked babies that for at least two decades (1909–1930) were so stupendously popular that they earned their "mother" millions of dollars. Perkins' cousin Don Forbes forged the link with Rose, who also jump-started *his* painting career. The story is that in July, 1931, as guest of New York gallery owner Emily Francis, Don went to the Sunday opening of a local artists' exhibition in Westport, Connecticut. There he met Rose, who lived and partied in a highly unconventional mansion nearby. She invited him to tea the following Sunday. He went there and stayed for two years. Several months later, Perkins followed him and allegedly stayed two years as well.

Rose too had a Nebraska background, having spent her girlhood years in Omaha before venturing east at age nineteen to pursue a career in art. Oddly— given her eccentric and non-conformist life—she was convent-schooled in Omaha and in New York resided for three years with the nuns at the Convent of St. Regis before her first impulsive marriage to a handsome spendthrift. (It ended in divorce, as did her second, after which she deliberately and permanently foreswore marriage.) During her pre-Kewpie career, she drew cartoons for the popular satirical magazine *Puck* (where she was the only woman artist on the staff) and contributed illustrations to stories in the top women's magazines, such as *Ladies' Home Journal* and *Woman's Home Companion*.

Rose periodically retreated to Bonniebrook, the idyllically rustic Ozarks home near Branson, Missouri, where her family had moved before her father, an erstwhile book dealer, retreated into the wilds of Arkansas (surfacing later in California and elsewhere). At Bonniebrook, Rose claimed to have literally dreamed up the Kewpie at the suggestion of *Ladies' Home Journal* editor Edward Bok, who liked the Cupid head and tail pieces that she often drew for love stories and wanted her to make a series of them, with rhymes to accompany. "I invented the name for little Cupid," she wrote, "spelling it with a K because it seemed funnier." She thought about them so much that she had a dream about them: "They were all over my room, on my bed, and one perched on my hand. I awoke to see them everywhere." Accompanied by Rose's sprightly verses, the Kewpies made their debut in the 1909 Christmas edition of Bok's magazine. An instant hit, they made Rose the highest-paid woman illustrator of the day, and she became quite fabulously wealthy when, starting in 1912, the Kewpie Doll, in nine different sizes, went into production in Germany.

Kewpies were ubiquitous, appearing in magazines and in the children's books that Rose both wrote and illustrated. They were used to promote Jell-O, Colgate Toothpaste, and Kellogg's Corn Flakes. There were Kewpie door knockers, Kewpie soaps, Kewpie handkerchiefs, Kewpie dime banks, chocolate Kewpies, and Kewpie Kutouts, paper dolls designed to have both a front and a back side. The Hickman High School in Columbia, Missouri even adopted the Kewpie as its mascot. You may be dead-set against the wily ways of cuteness, but it is hard not to like the Kewpies, or at least not entirely to hate them. Like puppies, they have round, fat bellies that beg to be rubbed; unlike puppies, or human babies for that matter, they have no genitalia whatsoever. They have tiny blue wings, pointy blond topknots, starfish hands, pudgy red cheeks, and wide eyes that gaze demurely off to the side. And they can't stop smiling. One can hardly fault the Kewpies' good intentions: their sole purpose was "to teach people to be merry and kind at the same time." They were the Hello Kitties of their day, crossed with the Pillsbury Doughboy.

Kewpies came with different identities and roles. Nominally male, they were really gender-fluid. There was Chief Wag, who decorated his topknot with a little pennant bearing the letter K. Then there were the Kewpie Cook, the Kewpie Gardener, and the "Careful of His Voice" Kewpie, who wore a woolly cap and scarf but nothing else; yet another wore only "healthful overshoes" to protect his feet from "snow and ooze." Incongruously, there was also a soldier Kewpie (or Killer Kewpie, we might say) with a Civil War-era kepi, a sword, and a rifle. In Rose's cartoons and stories, the Kewpies were as buoyant as balloons, skipping, hovering, capering, bouncing, and somersaulting as they brought joy to children. The Kewpie doll—the ultimate bringer of happiness—came packaged in a box decorated with flying Kewpies and Rose's winning doggerel: "From Kewpie you'll not wish to part,/But, when you've learned his Smile by heart,/Just give that little

smile away/To everybody, every day/(And with each smile, I hope you'll feel/The Kewpish love of Rose O'Neill.)"

Rose pressed her Kewpies into political activism, too. A passionate proponent of women's right to vote and pursue a career, she marched in New York suffrage parades with her sister Callista; in one 1915 parade, she was selected to represent women illustrators. She created posters and postcards in support of the cause as well. One of them parodies Archibald Willard's famous *Spirit of '76*, replacing the stalwart Revolutionary War heroes with a trio of piccolo-playing, drum-pounding, smiling Kewpies (wearing aprons to signify that here, at least, they are nominally female). Instead of an American flag, they carry a yellow banner trumpeting "Votes for Women." But Rose was in deadly earnest. In the *New York Tribune*, she published a drawing that portrayed the present-day woman as a "child-bearing sheep." The title of the accompanying article unambiguously announced her position: "Woman's the Virtues, Man's the Stupidity, Is the Division the Gentle Inventor of Kewpies Makes." Enslaved by men, women had nothing to lose but their chains, or their apron strings.

Kewpies marching for women's right to vote, 1915

By then, Rose had successfully shed whatever chains may have restrained her, including the corset. In a 1907 portrait photograph (possibly taken in celebration of her second divorce that year), she sits at ease, one hand resting on the round table in the foreground. She gazes out, smiling ever so slightly. Her wavy hair tumbles unconfined over her shoulders, and her clothes are loose as well: over a simple dress, she wears a long, unfitted vest of Japanese fabric patterned with stylized dragons, phoenixes, and clouds. It is easy to see that there is no corset underneath those flowing garments. She is a woman unhampered by norms and conventions—rebellious against "harness and hair-pins"—the perfect embodiment of a free, Bohemian spirit. If there were any doubt about that, the smoldering cigarette (between her fingers at the far left edge) dispels it completely. In 1907, few if any conventional women smoked,

or allowed themselves to be seen doing it (always excepting Alla Nazimova, who was, of course, utterly unconventional). The famed advertising campaign featuring the tag "Blow some my way" was many years in the future.

Chains and corsets were one thing, but men per se were another. That is, Rose—despite repudiating marriage—nursed powerful and very physical desires, which she expressed through her "Sweet Monster" drawings, exhibited in 1921 in Paris

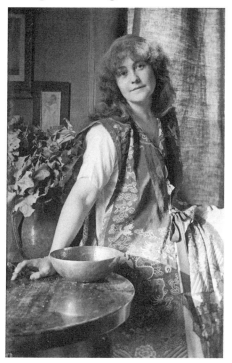

Rose O'Neill, happily uncorseted

(where she had taken classes at the studio of Auguste Rodin, or so the legend goes) and in New York the following year. Like the Kewpies, Rose's monsters are androgynous, or perhaps hermaphroditic. Unlike the Kewpies, they are deadly serious and erotically charged: large-bodied nude figures, they come from the realms of ancient myth—Celtic and Greek—and include fauns, centaurs, and various trolls and troglodytic creatures. "I seemed to be entranced by the idea of the rise of man from animal origins and was always drawing low slant-browed beings that pointed the road behind us," Rose wrote. She claimed that while she drew then, she had "ecstatic images of the up-surge of life from the 'ancestral slime'... monstrous shapes with their mysterious whisperings of natural forces and eons of developing time." In *Man in the Hand of Nature*, Man is a precious little doll—Kewpie-size—while Nature is an enormous rugged figure with a satyr's muscular hoofed legs, a woman's breasts, and horns swept back from a sloping brow and merging with a ropy mane that tumbles along a thick neck, "curved like a stallion's," as Rose said. In other drawings, titanic figures embrace and kiss so passionately that they seem like one body. Over and over, we see small men or little fauns resting in the arms or laps of huge maternal faunesses. The sweet monsters are fantastic, dreamy, and weirdly sexy.

In keeping with her free-spirit, free-love persona, Rose from 1914 on rented an apartment in Bohemian Greenwich Village on Washington Square South adjoining that of her devoted and equally free-spirited little sister Callista, Rose's self-appointed business manager. Around 1921 there were rumblings: their building might soon be pulled down. Seeking a retreat from New York in any case,

the sisters advertised for a place near Westport, Connecticut, at the time an artistic and literary haven. Rose wanted "trees and flowing water" as well as a place "with magic, necromancy, and a touch of terror." They settled on a "great square stucco-finished house" (with a leaky roof) on the Saugatuck River. It had been built by the painter Hugo Ballin, who had since decamped to Hollywood. Rose named the place "Castle Carabas" after the ogre's castle in the tale of Puss in Boots. She and her sister washed the walls of the forty-foot studio with dull gold and furnished the eleven rooms with old Italian chairs, Spanish tapestries, a Steinway grand piano, and a huge table they carved themselves. Rose decorated the sunken garden and its blue pool with a couple of her own sculptures: the two-ton, ten-foot *Embrace of the Tree* and the reclining *Faunesse*. "The entire place," Perkins wrote, "looked like a rummage sale held in the ruins of a Renaissance villa."

Once settled, the sisters proceeded to populate the place with artists, poets, musicians, and various other hangers-on. "The house was always full," Rose wrote. "I never knew where all the guests slept, though some stayed a year or two." Someone would be writing poetry in the kitchen, manuscripts in heaps across the table so that the things "that ordinarily go on kitchen tables were on a bench or the floor," and at breakfast time people carefully put their eggs and marmalade between the piles. On the western terrace, "books, pillows, rugs, tables, trays, and guests were moved for the afternoon and sunset light." It was an idyllic time.

Among the motley array of guests, as we know, were Don Forbes and his tagalong cousin Perkins. Rose must have been drawn to Forbes' brooding persona. With his high, balding forehead, deep-set eyes, and angular cheekbones, he certainly looked the part of the melancholy seeker. Or perhaps they bonded over a shared enthusiasm for Celtic myth and romance. As one writer noted, Rose's creations were not Greek, or not entirely so. "They have known the drifting fogs and the long nights of northern seas . . . They have heard the wail of the banshee and watched the fairies rise, like thin mist, out of the peat bogs . . . It is because of this that they are able to express us . . ." In Los Angeles, Don had taken to writing "poetry of romantic allure—the Celtic passion for lost causes and present ruin—plus their graphic illustrations—somewhat seasoned with theosophy." He may well have come across Rose's monsters, since they appeared as illustrations in her *Master-Mistress Poems*, published by Knopf in 1922.

Other than that, one wonders exactly why Rose wanted the chronically depressed and chronically negative Don around. His best friends—Perkins included—had little good to say about him. Perkins rated Don as "the most morose person I've ever known. He wept often. He felt so sorry for himself . . . He had the power to bring down the most optimistic, self controlled individual." When he was drunk, "which as most of the time," Don "would dominate the conversation by extremely negative, pessimistic raving and ranting . . . Everything was perfectly awful and everyone was an old cheap fuck. As he became increasingly plastered . . . [he] would yell louder . . .

saliva would flow from his great, greasy mouth and then he'd yell a series of terrible crescendos and pass out." And he was also, by nature and nurture, "a low-living selfish sponger." Yet Don must have had some strange magnetism or surly charm. Perhaps it was mainly that he so perfectly fleshed out the template of tortured genius. Rose described him as a "Column of fun with crown of thorns for capital." Much probably depended on whether the column or the thorns held sway.

When Don came to Castle Carabas, Rose furnished him with paint and canvas, and he did "a series of monstrous figures in low key colors." They probably weren't sweet ones, though. Clearly, this man was the perfect soul-mate for Rose, at least for a time. During his tenure at Carabas, Don also worked on drawings of wrestlers and scenes from Arthur Rimbaud's *A Season in Hell*. Later, Rose penned a prose portrait of Don at work and at play: "Don Forbes was painting in oils at a large canvas full of symbolic monsters dominated by a large plump goddess . . . Don was the dominating figure as he was tall as the gods (six feet four) and it took many yards of linen to keep him in smocks. He painted generously, so there was a lot of paint on the rug, the bookshelves, and high on the wall. Nobody else could put it so high. Every now and then, Don Forbes left his canvas, turned on the phonograph, and danced a rumba. At intervals, he . . . played Purcell or jazz on the piano, or some eighteenth-century music on the organ."

She devoted a paragraph to Perkins as well: "My enormous studio held a lot. Perk, a transient, was making a water-color of a very elderly pair of shoes he had found in the wood-box. The historic shoes had been left . . . by the Polish cleaning woman . . . We piled wood on them but we revered them. He had made a surrealist

Meemie O'Neill's wormy Victorian button boots

but dilapidated corset of the 90s, which he carried around in his luggage." Perkins claimed that the shoes had belonged to Rose's mother Meemie and had ended up in the garbage can, where they were invaded by worms. Perkins' painting shows the discarded Victorian button boots exactly so, worms wriggling in and out, one of them pinned decoratively on a stale bread crust as if it were some tempting hors d'oeuvre. As for the corset, perhaps it was part of Perkins' drag wardrobe. But Perkins claimed, improbably, that it belonged to Rose the romantic anti-corset rebel, who at Castle Carabas drifted about in voluminous red velvet robes over "Grecian-styled gowns of peach silk." Why the corset was surrealist, Rose did not explain, but when Perkins donned it on one occasion, Cousin Don yelled: "Put a house in it!" And so he did.

Perkins stated often that he, along with Don Forbes, stayed with Rose at Castle Carabas for two years—impossible to verify and likely exaggerated. As did many of Rose's guests, Perkins probably moved in and out and in again during that stretch of time. But he certainly spent enough time there to immerse himself in daily (and nightly) life. His impressions and recollections conjure up the image of a chaotic ménage quite different from the one Rose portrayed so nostalgically in her own memoirs. In essence, according to Perkins, Castle Carabas was a nuthouse.

Of course, we have to keep in mind always that Perkins is an unreliable narrator. Sometimes he stated that Rose's "fourteen" drawing rooms (in the eleven-room house) were uniformly coated in red radiator paint; at other times, he said they were covered in gold. On the other hand, he had little cause to embroider too heavily: there was no reason to exaggerate what was already sufficiently outré. Perkins thus dished on the romance between Rose and Cousin Don. "I was her guest because my cousin was her lover," he told one reporter. "Every morning he had to kiss her and he said it was like kissing a deep, dank tomb even though she took a boxful of breath sweeteners every night to get ready for this kiss in the morning." That musty kiss may have been the extent of their physical relations: another time, Perkins claimed that Don was Rose's "theoretical" lover; Don, he opined, was "mentally and physically incapable of having sexual intercourse with a female." Plus, "they were both alcoholics," he said, who "would start drinking at three PM and go till one in the morning." The drink of choice was gin. When Rose was intoxicated, Perkins wrote, she would sling one leg over the arm of her divan, throw back her head, and snore "like a locomotive." If this story is true (and there's corroboration for it), then no wonder that Rose had such a breath-mint habit.

Rose's flirty sister Callista, meanwhile, was angling for Perkins. One night, she invited herself into Perkins' bedroom (with its red or gold walls). She spread the long skirts of her evening gown over him, Perkins claimed, and then—perhaps because he didn't rise to the occasion—angrily dragged him down to Rose to complain that he had tried to get fresh, when it was really the other way around. Callista and Rose had their own interesting rituals, too. The sisters "used to place a phonograph in the bushes at Carabas and dance in the moonlight. They wore filmy white robes

and their dances consisted of mock kissing one another." They also had a "secret code composed of cat calls . . . 'Meau meau' could be heard all over the house. The intonation, inflection, short, sharp, or long drawn out cat calls indicated their meanings. The girls sounded like cats being screwed or being skinned."

There was a real cat, too, which likely added to the confusion. This was the blonde tabby Chinko, who had seven toes on each foot. Rose had "special little doors" built so that Chinko could freely come and go as he pleased. Mother "Meemie" O'Neill was there as well, with her wormy Victorian boots. But by far the most outrageously odd denizen of the Bohemian mansion was Rose's and Callista's younger brother, Clarence, or Clink, an eccentric if you wanted to be charitable, a fruitcake if you didn't. Let's start with Rose's description of her brother. "Not like anything else you would meet," Clink was "tall and light colored" and walked about with "a soft panther-like tread." He talked incessantly, "a constant flow, like a bird, of droll and unexpected utterances." One time at Carabas, she remembered, "he came into the big room and muttered: 'Thank God I haven't anything to say. Now let's see if I'll be frank enough to say it,' and went out." Harmless enough, we might think. But by other accounts, not so much. In the eyes of others, Clink was "a savant scarcely capable of caring for himself, with a penchant for wandering into guests' rooms in the middle of the night as well as arbitrarily frightening the house staff." Before coming to live with Rose and Callista at Castle Carabas, he had been in the Sheppard and Enoch Pratt psychiatric hospital—formerly Sheppard Asylum—in Baltimore, Maryland, long enough for the place to be listed as his address in the 1930 Federal census. Exactly what his diagnosis was is unclear, but he was obviously ill-equipped for living as an independent adult.

Perkins left detailed accounts of Clink's shenanigans at Castle Carabas: "[H]e believed he was an engineer & kept the fireplace roaring in winter AND summer. Regularly, every 3 weeks, he would set fire to the woods . . . and the Saugutuck Fire Dept. would come & put it out because they loved Rose so much . . . so they never apprehended him. In her heyday, she supported the town. Klink [Perkins' spelling] would also stand in the corner all day reading a book upside down; he would dress in an all rubber outfit & run around the outside of the house peering into the windows; then he'd disrobe & take a scimitar to the roof—to chase off the dragons." There was another incident involving actual violence, too. In 1921, Rose had purchased the Villa Narcissus in Capri from her doting fan, the octogenarian American painter Charles Caryl Coleman. She traveled and lived there from time to time in the 1920s; once she took Clink along, but "on the way back [in 1929] he attacked the ship's captain, who had him clapped in irons." After arriving in New York, Clink was committed to the Sheppard Asylum, where we find him in that 1930 census. Perkins related another version, in which Clink attacked the ship's captain on the *way* to Capri, making it necessary to take him off the ship at Plymouth to spend time in a "London crazy house while Rose proceeded on to her enchanted villa."

Rose, Callista, and Clink returned to Bonniebrook for good in 1937. A lifelong chain smoker, Rose (born in 1874) died in 1944; Callista followed her in 1946, leaving the hapless Clink alone in the rambling, woodsy Ozarks retreat that Rose had built, room by room, story by story, over the years. On a frigid January evening in 1947, Clink "tucked a box of kittens near the stove, building up the fire to keep them warm, before heading over the hill to eat supper at a neighbor's. By the time anyone saw the smoke, it was far too late." The house had burned to the ground. Although Clink for once hadn't meant to cause the conflagration, something about him tended to inflame things anyway. One wonders how the poor kittens fared. After that awful incident, we lose sight of Clink, who lived on until 1961.

Much later, Perkins regaled Mrs. Clay Cantwell (secretary at the time of the National Rose O'Neill Club in Branson, Missouri) with a full and salacious account of the goings-on at Carabas. "Although I had some idea of their social life at that time," Mrs. Cantwell responded, "I must say, it was rather mild compared to what you wrote. I know better now why the remaining family is so close mouthed about their specific activities." Whatever more Perkins wrote, it was spicy enough for Mrs. Cantwell to withhold it from her fellow O'Neill fans: "I don't believe most of the little ladies of the Club are ready for much of this," she noted, "so I shall handle it with care for the time being. Many of us know Rose drank a great deal . . . but that is discreetly, if ever, mentioned." That was not all. Mrs. Cantwell also divulged that "It has been hinted that Rose had a girl friend, one for whom she built a house . . . I hasten to add, there are only a few who have investigated enough to wonder about these things. The idolization of Rose as a charming, innocent beauty is fantastic." As Perkins summed it up, "She lived entirely in an illusion of sappy beauty. To her the world was a garden of sweet peas immersed in a pale lilac light with incense wafting from the windows of fairy castles."

Rose may well have been innocent about gay men even if she did have a "girl friend." Purportedly, she kicked Perkins out after the contretemps about Callista, but Perkins offered another explanation that sounds equally plausible, if not more so. "Once when Don went to town for trade," he related, "I inadvertently let the cat out of the bag and informed Rose and Callista that we were queer and went for men. Rose was shocked out of her wits." Then one of the other hangers-on "heard Don and José [who visited occasionally] carrying on in the next room and Rose got wind of that and she took a bottle of poison and went into the garden at the brim of a dry fountain basin and put on a dramatic act, pretending she was Hedda Gabler or Camille or Sappho or something." All the weekend guests rushed out to save her, "but Don and José and I were ordered out of the place and told never to darken her door again."

And yet once things cooled down, Rose still held Perkins, if not her faithless theoretical lover Don, in affectionate regard. In a letter hand-decorated with her trademark Kewpies, she wrote to "Darling Perk" that "Carabas loves you true and

treasures every moment of your stay and all your 'spriting' (pronounced sprite not sprit . . .) spriting by word of mouth, glorious laughter and beautiful witty lines on paper. You were one of the primest guests we ever had." For his part, Perkins acknowledged a great debt to Rose, who was instrumental to his development as an artist: "It was Rose," he wrote, "who initially established my style and subject matter for me. And to this day, I still do paintings similar to those created in Carabas."

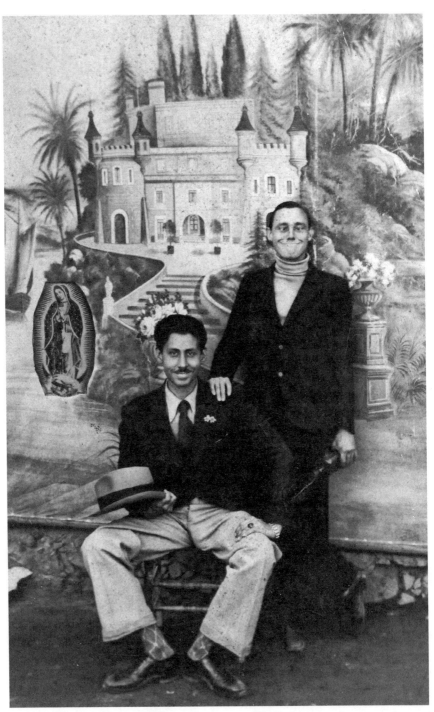

Perkins mugging it up with Fernando Felix in Mexico, 1933

Land of the Dead

ROM CARABAS CASTLE, PERKINS VENTURED, eventually, to Mexico. Typically in later accounts, his recollections of dates and places wavered and changed, so that it becomes challenging to pin things down with any confidence. Suffice it to say that he stayed and traveled in Mexico for an extended period from 1932 to 1933; we can be sure, at least, of that, since in April of 1933 Frances Toor, an American expatriate, mounted a show of Perkins' watercolors at her gallery in Mexico City.

There is also a handful of photographs. One of them, printed as a postcard, shows two young men: Fernando Felix and Perkins, posing before a painted backdrop that has been rolled down like a window blind in front of a masonry wall. The location may be what Perkins described as the "cemetery of Guadaloupe [sic]," where the two posed for a photograph. That doesn't get us very far, since there are countless churches and graveyards named for the Virgin of Guadalupe in Mexico. At any rate, Felix sits; Perkins stands jauntily, one hand on his companion's shoulder and the other holding what might be a beer bottle, top slanting down. Felix is handsome and exceedingly debonair; he smiles under a tidy little moustache, thick dark hair swept back from his forehead. Legs wide apart, in that pose now derided as manspreading, he wears a well-cut dark jacket with two tiny flowers in the lapel, holds a crisp fedora with a dark band, and rests his other hand—adorned with a large ring and a chunky metal watchband—on his thigh. His spotless trousers have wide cuffed bottoms, beneath which we can admire his argyle socks and well-polished shoes. Perkins sports a dark suit, a light-colored turtleneck, and a funny face: crossed eyes and goofy smirk. The painted background is like one of Perkins' beloved theatrical drop-curtains, with a medieval turreted castle surrounded by pines and palm trees, flowering urns, a sailboat and a hovering Virgin of Guadalupe, who looks as if she has just wafted into the wrong scene.

In another photograph, Perkins smiles giddily in the embrace of a man with rugged features and a mass of wavy hair lacquered to a high gloss. They stand together in a woodsy setting with a vaguely architectural ivy-draped structure behind them on the left. On the back, someone has written: "Lover Mexico," with the name "Fernando Feliz" [sic] crossed out. There is also a photograph of them, draped over each other behind a huge agave plant. In the final photograph, Perkins, his glossy lover, and hatted Felix sit together on the lip of an old well, the lover with arms flung about his companions' shoulders and all three with legs crossed in the same direction, as if they were in a chorus line. Behind them rises a rough masonry wall topped by a stumpy tower with arched openings on each side and a domed roof:

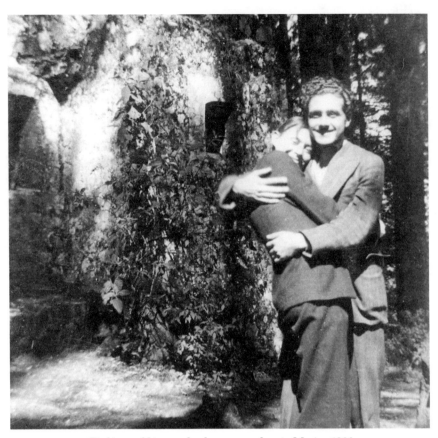

Perkins and his nameless lover somewhere in Mexico, 1933

this is the courtyard of the ruined eighteenth-century Carmelite monastery in the Desierto de los Leones, a national park high up in the Sierra de las Cruces southwest of Mexico City. The "Lover Mexico" photograph is set there as well, somewhere in the pine forests around the ruins. The friends must have gone there for a day trip, a retreat from the crowds and cacophony of the capital city.

Perkins was never clear as to exactly when and how the idea of visiting Mexico had materialized, but it must have been due largely to Fernando Felix, who (like José Limón) had left revolutionary Mexico for the United States and remained in exile while intense (and often murderous) political turmoil continued to plague his home country long after the Revolution per se had nominally ended. By the late 1920s, though, radical revolutionary fervor had ebbed, making way for a steadily increasing wave of American cultural tourists who wanted only to escape the Depression in the North and immerse themselves in what they perceived as an exotic, timeless, and authentic alternative to the ills of modernity and its attendant mechanization.

Books played an important role in the Mexican vogue: between 1920 and 1935, some sixty-five were published in the United States—guides, memoirs, histories—with the greatest concentration in the early 1930s. Several were popular hits, notably Stuart Chase's 1931 *Mexico, a Study of Two Americas*, which, with illustrations by Diego Rivera, stood high on the best seller list for six months. Chase's travelogue offered a detailed and colorful word-panorama of Mexican history, life, and culture, given added punch by comparison with that all-American city *Middletown* (Robert and Helen Lynd's systematic 1929 sociological study of the real town of Muncie, Indiana, thinly disguised). Other publications, like Frances Toor's periodical *Mexican Folkways* (1925–1937), burrowed deep into traditional customs and crafts: music, fiestas, foodways, myths, rituals. All of these resources played an active role in shaping American expectations and perceptions of what they would see and experience south of the border.

As a Mexican national, Felix, of course, was an insider despite his years as an expatriate. But for ex-Nebraskan Perkins, Mexico proved to be a strange new land indeed and Fernando Felix a sexy and idiosyncratic guide. For Perkins in particular, the magic and allure of Mexico probably boiled down to the pervasive notion—amounting to a cliché—that it was at bottom, and had been since time immemorial, a land of death. Socialite Leone B. Moats, who with her wealthy businessman husband lived in Mexico City for some twenty years, reported on a day in the ancient silver town of Taxco (where Perkins would stay for a time), when she sat in the blazing hot plaza drowsily watching the Indians and listening to their velvety voices: "[T]hese same people," she wrote, "or others so much like them as to make in the end no difference, had been there, just like that for generations and for generations, waiting perfectly confidently, perfectly tranquilly, and with exquisite manners, for death. . . To us life is the reality; to them, the reality is death." It was pretty much the same with other writers. Edith Mackie and Sheldon Dick echoed Moats in asserting that in Mexico "All life and all death are vividly present: a little closer than we are used to seeing them." And Carleton Beals, writing of a generic, all-purpose "Mexican," asserted that "The Mexican has a jocular camaraderie with the major mysteries, be they death or God. He does not set too great a store on his life. He wears life like a flower behind the ear, to be tossed to the seductive siren, Adventure, the stately dame known as Pride, to winged Victory, or the debonair Goddess, Courage." What applied to Mexican life extended as well to art, as was vividly apparent in the crude broadside prints and other ephemera by the popular graphic artist Guadalupe Posada: "He makes skull-grinning Death live, quarrel, booze, dance, weep, love—an orchestration of clean white bones, shaded off into the dark cosmos, into the sinister murkiness of things living."

For the many chroniclers hailing from El Norte, the Day of the Dead proved particularly fascinating and baffling. Anita Brenner, another American whose scholarly and popular writings reflected her extensive study of ancient and modern

Mexican society and culture, described the Day of the Dead as a national holiday for skulls, which pervaded visual and material cultures alike, going all the way from Pre-Columbian times to the present: "There are skulls in monolith of lava, miniature of gold and crystal, mask of obsidian and jade; skulls carved on walls, moulded upon pots, traced on scrolls, woven into garments; . . . filled out around whistles, savings-banks, rattles, bells, holiday masks and jewels; woodcut and etched on ballads; strung into drinking-shop decorations; made into candies and toys." In Mexico City, grotesquerie reigned: Fashionable pastry shops advertised "Buy Your Dead Men's Bread Here," and turned their fancy displays into "ranks and pyramids of skulls, miniature and life-size and bigger than that, luscent [sic] white, or creamy, with maraschino cherries for eyes and syrupy grins on their mouths, and rows of fine gold teeth." People picnicked in graveyards as if they were at home, turning tombs into banquet tables laden with food and banks of flowers. Vendors sold figurines of carpenters, murderers, poets, generals, bullfighters, and nuns: all of them stripped down to the bones. "One hardly knows, and one does not mind, the difference between dead and alive, past and present, fantasy and data," wrote Brenner. And if this intimate acquaintance with death was shocking to the European, to the Mexican it was "no mood of futility that broods in this way over death, but a rather a concern with death because of a passion for life."

Other commentators mined the same vein, Carleton Beals, for example, describing the holiday in florid prose: "On the Day of the Dead, [the Mexican] buys skeleton jumping jacks; the dusky sweetheart buys her lover a skull stickpin with gleaming ruby eyes; . . . and the whole family picnics on the graves of their ancestors, carousing and getting drunk." Today, the artifacts and rituals of the Day of the Dead are much more familiar in the North. In ethnic boutiques and museum gift shops, you can buy cartoony skeleton figurines in a great variety of tableaux: getting married, giving birth, baking cakes, playing in mariachi bands. There are Steampunk skeletons, chef skeletons, dog skeletons. They are almost as common, and commonplace, as zombies. But in the 1920s and '30s, they struck American travelers and commentators, or most of them presumably, as unsettling and bafflingly bizarre.

And then there were the mummies, notably those once hidden in a crypt within the former monastery of El Carmen in Mexico City, as well as the mummies of Guanajuato, unceremoniously dug up in the nineteenth century after their respective families failed to pay a tax for continuing upkeep. The revolutionary Zapatistas had made the grisly discovery at El Carmen around 1917, when they pried open the crypt. After that, the mummies, undisturbed, were forgotten once again until the late 1920s. Eventually rediscovered by the locals, they were placed in velvet-lined glass-lidded coffins—like Snow White, or, more apropos perhaps, Dracula—and put on display in 1929, when the place opened officially as a museum. Ever the connoisseur, Perkins commented that some of the Guanajuato

mummies were well preserved and some perfectly hideous (which they are, though with a more than a touch of pathos). He saw the El Carmen mummies, too, and, much later, would seek out mummies during his travels far and wide. It was always a great treat for him, he said, given his necrophiliac inclinations, and the Mexican mummies, with their grotesquely distorted faces, desiccated limbs, and tattered raiment, did not disappoint. Among the many highlights were "A bride wearing a long white net veil and high, yellow button shoes hung upside down on a hook," and a "skeleton dressed in a blue serge suit, white shirt, polka dot neck tie and black cotton socks," one of which Felix kept as a souvenir after emptying it of "a little pile of clean white bones." It is hardly any wonder that in Mexico Perkins found himself in his element.

As so often the case with Perkins, it's not clear exactly when he left for Mexico (though according to Don Forbes, he was there by November 1932) or how long he stayed, or where he went when he was in the country. He claimed to have been there for two years, which would date his sojourn from late 1932 to roughly the end of 1934. But by December 1933 he had to have been back in New York, where his Mexican watercolors and his early Rose O'Neill-inspired satirical Victorian drawings had their American debut at Julien Levy's gallery. Conceivably, Perkins could have traveled back and forth once or twice or even more. It may not really matter. Those four photographs taken in Mexico suggest that he spent at least part of his time going on pleasure trips with Fernando Felix and his own nameless "Lover" with the lustrous hair. Strange to say, Perkins never learned more than a few words of Spanish, or so he claimed, depending on Felix to be his interpreter and translator. He said at one point that he lived in a rooming house in Mexico City with Felix and while there visited the Palacio de Bellas Artes—the grand opera house—with its prodigious Tiffany Studios stained-glass drop curtain depicting the lush valley of Mexico and the volcanos Popocatépetl and Iztaccihuatl against an iridescent sky.

At another point, though, Perkins lived in the picturesque mountain village of Taxco, where he had somehow managed to buy a house. And here is where we must once again backtrack, or sidetrack, to Don Forbes, who had begun to paint in 1930 after a trip to Mexico, where he "apparently was much impressed by the cruel images of mythical deities to whom was once offered human sacrifice." Don had blazed the way to Taxco because of a chance encounter on the stairs of a New York subway entrance. "One afternoon in the early Fall of 192[8]," wrote Perkins, "Don and I were aimlessly prowling along 42nd St and he saw a fat ass descending into the subway at the Times building. A fat ass always had a strong magnetic attraction. He caught up with the fat ass and found it belonged to William Spratling, instructor of Architecture at Tulane University at New Orleans ... on the subway Don and Bill began gabbing ... Spratling fell in love with Don and they partied and Don stayed with him for a while in Taxco." In fact, there is even

a telegram Spratling sent to Don on March 26, 1929: "Leaving tomorrow night train expecting you in Mexico City within week if any way possible to arrange could send fifty towards trip can promise bed board warm welcome . . . will meet you affectionately yours—Bill." Photographs of Spratling show him as quite a trim figure. Once again, Perkins possibly stretched, or padded, the truth.

But this was true: "Spratling had a house at Taxco Mexico where he spent his vacations and later retired to his Mexican abode, opened a gift shop for tourists and became rich." A silver-mining town established in the sixteenth century, Taxco had only recently become, as socialite Leone Moats put it, "the haven of artists and intellectuals" who had moved there "*en masse* and renovated native houses." Most influential of these from an economic as well as cultural standpoint was Spratling (among many other things, he had been at one time William Faulkner's roommate in New Orleans), who played a major role in revitalizing Taxco silver craftsmanship. That revival, plus the 1931 completion of a new highway from Mexico City, catalyzed the boom in Bohemian (or arty) tourism. Everyone agreed that Taxco lacked nothing a tourist could desire. Heath Bowman described its "Little red-tiled houses marching up the mountain side, spreading out in a semicircle about the great pink-stone church. Its twin pointed towers, its blue and yellow majolica dome glitter in the sunlight, contrasting so vividly with the black-green clump of trees . . . White walls and dull red-sienna tiles everywhere: there is no variation. We wind through a narrow cobbled street, houses piled one above the other on our right, falling away below us on the other side." The American poet Witter Bynner praised the town's "cobblestoned lanes leading always up and up into a hundred little heavens, all at strange angles, and the huge ornate church standing in the center like the giant parent of eight other smaller churches." As for the expatriate population, though, opinions were mixed, with Bynner weighing in on the negative side, writing that the American households in Taxco were "all semi-crazy and completely drunken."

By the time Perkins got there, of course, Don Forbes was long gone: "Don used Bill," wrote Perkins. "He mooched and mooched until Bill got tired and threw Don out." Don returned to New York by way of New Orleans; Perkins joined him there late in 1929 after the Young's Million-Dollar-Pier drag contest debacle. For a while, Perkins and Don shared an apartment in "the attic of an ancient house back of the cathedral"; Perkins worked as a busboy, and Don, along with a couple of friends, did little beyond mooching and "talked all night," keeping the sole wage-earner awake until, exasperated, Perkins "got real sore and threw out the blab guts." The chief New Orleans highlight for Perkins was one of the ancient graveyards with above-ground tombs and five-tiered crypts where he could view skeletal remains, the brick having been knocked out by grave-robbers. He later did a watercolor depicting the place as a chaotic jumble of temple-fronted monuments, cast-iron tracery, a skull or two, and one of the crypts, inscribed with the word "Full." That was as far south as Perkins made it, until his own Mexican adventure.

The Forbes-Spratling connection explains why Perkins ended up in Taxco. His house must have looked like many others, including Spratling's; it had a lush and beautiful garden, a cook, and a woman who came to clean. Perkins recalled that he had spent a great deal of time studying the architecture of the church, where "at noon little boys would climb up to the bell tower and ring the bells." The architecture was well worth study. Heath Bowman explained that technically the so-called "Churrigueresque" style as expressed in the Taxco church means "the Spanish adaptation of the Baroque, or late Renaissance. Actually, it means that anything goes. From the great oaken door rise twisted columns, cupids, bishops, saints, to the clock and the patron saint, Santa Prisca, at the top." As for the towers, so riotously encrusted were they with fantastic ornament that there was simply no way to describe the effect; it was one of muchness upon muchness. Perhaps the style appealed to Perkins for just that reason: in its own colonial-architectural way, it was the equivalent of drag.

That same church inspired Hart Crane's last poem. The prematurely ravaged poet—as intoxicated, chaotic, and full of rage as Don Forbes—had traveled to Mexico on a Guggenheim fellowship, arriving in Taxco in the spring of 1931 following "a scene of spectacular drunkenness, unpaid taxi and café bills, and the involvement of the Mexico City police, the American embassy, and the local representative of the [Guggenheim] foundation." Crane stayed at Spratling's until he was caught attempting to seduce an Indian boy. He was jailed overnight and permanently banned from the town during evening hours. Before that, though, Crane had been deliriously and (of course) drunkenly involved in his first heterosexual affair, with Peggy Cowley, the soon-to-be-divorced wife of Malcolm Cowley, chronicler of American expatriate modernists—think Gertrude Stein and Ezra Pound. The morning after their first night together, Crane began work on his poem, "The Broken Tower," inspired by the tolling of the Santa Prisca bells during the Christmas festivities. Soon after, following a night of insomnia, Crane walked to the Taxco village square and there "met the old Indian bellringer on his way to the church of St. Prisca, who invited him up to the tower to help ring the bells." As the poet pulled on the rope, "the sun rose as it had for the past million years over the mountains," sending him into an ecstatic frenzy: "Have you nor heard, have you not seen that corps/Of shadows in the tower, whose shoulders sway/Antiphonal carillons launched before/The stars are caught and hived in the sun's ray?"

Crane worked on the poem for three months while continuing his ever more turbulent and toxic affair with Cowley. The pair left Mexico on the ocean liner *Orizaba* in April 1932. After a brief stop in Havana, though, Crane—who had been beaten up by some of the ship's crew after making advances on one of them— jumped overboard and plunged to his death in the waters below just after eight bells had sounded the noon hour. Perkins surely knew of the poet's tumultuous Taxco story, noting on one occasion that Don Forbes might have been a low-living

selfish sponger, but at least he "didn't try particularly to emulate Hart Crane in his dissipations." (It is tempting, nonetheless, to imagine that Don's 1932 *Marine Burial*, now in the Museum of Nebraska Art, might be an allusion to Crane's death; in it, a contorted muscular male figure vigorously rings a bell as another, partially obscured by the first, tumbles downward.) It may have been a coincidence that Perkins, like Crane, was so powerfully drawn to Santa Prisca's tower and pealing bells. There is no doubt at all, though, that he and Spratling knew each other too; a letter to Spratling from Don's would-be biographer, William Horace Littleton (of whom much more later on), mentions Perkins as a known quantity. Other than that, Perkins, stealing like a shadow into and out of Taxco, never even gets a cameo role in any of the extant writing on Spratling. At some point, Perkins lost his Taxco house, which was sold to recoup back taxes.

But to return to Perkins' cultural encounter: if Colonial churches, with all their Baroque excess, were the architectural equivalent of drag, there was richer, stranger drag inside, that of the hyper-realistic carved and polychromed statues: Christ, the Virgin Mary, and an endless parade of saints and martyrs, often life-size, with human or horsehair wigs, glass eyes, real eyelashes, crystal tears, ivory teeth, fingernails and toenails of bone or horn, and sumptuous bejeweled costumes of silk, velvet, and lace, complete in some cases with underwear. Many even had entire wardrobes so that they could wear garments and accessories to coordinate with particular holy days or seasons of the liturgical calendar. Some, like puppets, had articulated limbs so that they could assume different poses and attitudes, as in the case of the suffering *Cristos* figures that during Holy Week might be crucified, taken down, laid in an ornate coffin, and placed in a side chapel underneath the altar table for worshippers to contemplate until it was time for it to be taken out and crucified again a year later. Particular care was taken with *Cristos* figures— crowned with thorns, chained to stakes (with real ropes), whipped and tortured— to heighten the effect of their agony, with torrents of painted blood emanating from scores of cuts and gashes, and open wounds molded with cork and gesso to "make ripped flesh and spilling blood realistic to the viewer."

The whole point of such realism—which had its roots in seventeenth-century Spain—was to give holy (and wholly imaginary) figures such vivid and convincing life that they would "shock the senses and stir the soul" of the worshipper and bring the heavenly so palpably down to earth as to compel blind faith and unquestioning devotion. Or—for example, in the case of the nineteenth-century French critic Théophile Gautier viewing the crucified Christ effigy in the cathedral of Burgos, Spain—*disbelief*. So ultra-naturalistic was this figure (alleged by the monks to be made of human skin) that it required "no great effort of the imagination to believe the legend that this miraculous figure bleeds every Friday." But it made Gauthier intensely uneasy: "Nothing can be more lugubrious or more disagreeable to behold than this crucified phantom with its ghastly life-like look and its death-

like stillness. The skin, of a brownish, rusty tinge, is streaked with long lines of blood, which are so well imitated that you might almost think that they were actually trickling down."

(As an aside, I can vouch for the morbid attraction of such dead-alive effigies. When I was a kid, I used to go to confession or Mass occasionally at the French-Canadian cathedral of St. Anne down the hill from our house in Fall River, Massachusetts. In one of the side altars there was a glass coffin containing the wax figure of a young Roman martyr who had been flogged to death in the third century C.E. Robed in red velvet, white satin, and lace, the figure lay with head flung back on a pillow. Her face was deathly pale; her glass eyes rolled heavenward, and her long brown hair—real hair—tumbled in disarray. Her exposed forearms and shins were flecked and streaked with gobbets of blood. It was hard to believe that this wasn't a real dead body, or, alternatively, a gorier Sleeping Beauty along the lines of Madame Tussaud's famous eighteenth-century waxwork, lacking only the mechanism that created the illusion of breathing. But this obscure saint *could* have started breathing, so utterly real did it appear. Perhaps she was just asleep, too! I could never get enough of this uncanny figure. It was mesmerizing, chilling, and irresistibly fascinating.)

In Mexico, those effigies—of the tortured or dead Christ, along with various saints, Virgins and Christ child figures—became Perkins' own obsession. During his south of the border sojourn, he produced about one hundred watercolors (though sometimes he claimed two hundred and twenty-five) of these so-called *santos*—also known as *bultos*—carefully documenting their sumptuous attire and learning their legends from Fernando Felix, who traveled along with him. Perkins typed up these stories and descriptions in a document he titled "Encyclopedia of Mexican Santos' Wardrobes and Legends as told by Fernando Felix." It is no accident that the "wardrobes" preceded the "legends": Perkins was mostly interested in the former, and the "Encyclopedia," nominally by Felix, sounds more like Perkins; Felix may have provided the stories, but Perkins freely transposed them into his own voice, lavishly describing each outfit as if he were reporting on a drag ball.

St. Roque, in Cholula's Nuestra Señora de los Remedios Church (which had been built by the Spanish at the summit of an ancient pyramid) was nattily and anachronistically attired "in a black sateen dressing gown, white turban, white buckskin oxfords with yellow soles and brass headed nails in rubber heels." His companion, a pig, had "an ear of real corn tied around its neck." The obscure Saint Rustic, displayed in a glass case in the church of Santa Clara, was robed in "pink, blue and green with an over mantle of deep purple and holds a green palm of martyrdom in her hands. She is smiling happily although there is an enormous bloody gash from ear to ear." Then there was the ubiquitous Virgin of Solitude—*La Soledad*—who "is always well dressed in black, covered with jewels, wears earrings, holds a lace handkerchief and crystal tears are on her cheeks." At one time,

Perkins added, "she disappeared from her church and was found in the Lesser National Virgins Pawn Shop."

But these magnificently caparisoned figures had feet, if they had them at all, of clay, or, more likely, wood. At the National Museum in Mexico City, Perkins saw a mannequin that showed the understructure of the "celebrated and miraculous Virgins" which supported "the lavish gowns of brocades and jewels." In Perkins' rendering of this figure, we see that the Virgin's body with its articulated arms extends only to mid-hip; the rest of her is just an open cage of wooden slats nailed to a round base. Attached to one of the slats is her single foot, made to protrude from beneath the robes that would ordinarily conceal her anatomical absences. But here, all is exposed. It is like going behind the scenes in the theater. As the critic Enrique Asunsolo put it, the sweet, sad face of the Virgin "becomes nothing but the crown of a triangle of riches—gold, jewels, mantillas, laces, quilted stuffs—the Siamese bride of the Almighty . . . Suddenly, under the sleight-of-hand genius of Harnly, we realize that with the undressing of that marvel we find . . . theatrical sawdust."

Perkins' undressed Virgin, cover of brochure for the exhibition at Frances Toor's Gallery in Mexico City, 1933

Even figures of Christ on the cross often had more than a plain loincloth. Describing the famous Black Christ in Mexico City's Metropolitan Cathedral, Perkins noted that "The white muslin eyelet embroidered flounced drawers are the same as seen on almost all of the nude figures of El Senior Christo in the entire country. God, you see, is very modest . . . when I traveled over the whole land I did not see a single Christ image without drawers. Usually the pants are pinned with large safety pins. The wigs are very moth eaten and dusty and some times they have rhinestone brooches fastened into the hair." Given that fancy flounced drawers were also Perkins' own emblem, it is no wonder that he was attracted to these figures.

But he was also drawn to their pain, so vividly rendered by their makers. In 1933, four of Perkins' Mexican watercolors were reproduced on the front page of

the *American Weekly,* a Sunday supplement published by the Hearst Corporation. The tone of the accompanying text suggests that Perkins supplied much of the information: "The Indian artist almost invariably emphasizes the sufferings and torture of the Saviour," it said. "He is always the Mutilated One, the Crucified, never the Messiah of Good Will and Happiness. Often he is shown after He was crowned with thorns and cruelly flogged at the pillar. He is sometimes dressed in dark velvet, His hands bound with golden ropes and tassels. In some cases diamond brooches glitter in His dark locks. The wounds inflicted by the whips and weapons of the Roman soldiers are painted brilliant red." "Apparently," the text continued, "many of the artists are trying to represent fine clothes rather than figures." Even if clothes were not much in evidence, Mexican artists usually made the Savior "look like a man of wealth and social position . . . but suffering the last extremes of insult and ill treatment."

In his paintings, Perkins translated the three-dimensional subjects into flat, linear, brightly colored designs that seem intent on capturing something of the simplicity attributed to their supposedly "primitive" makers. In one, Christ appears crowned with thorns and bound to a column; he wears what looks like a dark velvet robe with a deep fringe. In another, his body—near-nude except for a pair of roomy drawers—lies contorted and blood-streaked in a gold-and-glass coffin. Perkins' images, ironically, are far less realistic than the uncannily dead-alive originals. It is as if he was keen to capture something of the vernacular or folk-arty aspect of the figures and the anonymous artists and wardrobe stylists who made them; his own style, we might say, is *faux* folk.

There was nothing unusual about this. It was a time when avant-garde American and Mexican artists alike were turning to folk art as antidote to modernity as well as an untapped source of authentic and uncorrupted expression that promised to revitalize contemporary painting, sculpture, and craft. The American photographer Paul Strand traveled in Mexico during the same period as Perkins and, like Perkins, found *santos* sculpture compelling. He produced several exquisite images of the suffering Christ much as Perkins described the type: robed in velvet, bound with silky cord, bewigged, and gazing out, or down, with mournful glistening eyes, or hanging on a cross bleeding profusely but nonetheless modestly covered with a sumptuously flowered loincloth of velvet and lace that looks as if it would rather be covering a cushy armchair. During and after the Revolution, the Mexican government tried assiduously to secularize society and undercut the church's hold on the faithful. But religion, deeply embedded as well as intricately entwined with Pre-Columbian beliefs and practices, held on tenaciously, especially among the indigenous population. For Strand, photographs of the tortured *Cristo* figures may have been metaphorical. Making veiled reference to the suffering Indian, they carried a political charge and spoke to the darker side of the Revolution.

But Perkins' suffering *Cristos*—consistent with his own proclivities—are much more about death and dying per se than anything even covertly political. Among the flotsam and jetsam salvaged by Tom Huckabee is another group of tiny sepia photographs taken in Mexico, depicting an actual crucifixion with a real man—not just a realistic life-size doll—up on the cross, with a crown of real thorns and what appear to be real nails in his hands and feet, a real gash in his chest, real pain, and real blood. Of course, it could still be convincing make-believe, but you can see that the sufferer has been on that cross for quite a long time, judging by the painfully bulging veins in his legs. The four images show the man in different poses and varying extremes of agony; in one, his contorted body—a zigzag of skinny limbs—echoes that of the Black Christ. The fifth photograph, taken from a low angle, is of a veiled woman in voluminous Biblical robes; eyes closed, she holds out one hand as if imploring some sort of mercy. The setting is a grassy clearing edged by scrubby brush and trees. It could be anywhere.

More than likely, the photographs were taken at a passion play, the annual, and age-old, Holy Week performance that still takes place all over Mexico to reenact the last days of Christ, from his entry into Jerusalem on Palm Sunday to his torture, trial, death, and resurrection. Folklorist Frances Toor, who witnessed a number of these pageants, noted that "Formerly the entire story of the Passion was so realistically dramatized that it is said a living Christ was nailed to the cross in some villages." Now, she maintained, it was considerably tamer. Yet clearly *some* passion plays went full-out for literal realism as, indeed, they still do; recently in Cacalotenango, a small town west of Taxco, the play was acted out with slavish attention to authenticity, pain, and gore. As one eyewitness notes, the "whippings, flagellations and crucifixion actually occur live in front of spectators who are warned to stay clear of the action to avoid getting hurt."

Did Perkins or one of his friends take these photographs? Did he buy them somewhere as a set (the same number, 778, is stamped on the backs of all five)? There's no way of knowing. Cheap and shiny though they may be, they are reminiscent of the arty platinum prints made by the wealthy closeted Boston aesthete F. Holland Day in the waning years of the nineteenth century. Casting himself as Christ, Day starved himself almost to a skeleton for the crucifixion scenes and grew out his hair and beard in preparation for his self-appointed role. In the photographs, Day hangs from a lofty cross; below are Roman guards in helmets and breechclouts, or robed figures staring up at him in grief.

In our own time, it is almost impossible *not* to see Day's crucifixion tableaux as queer expression; as one photo historian put it, Day's sacred photographs are, among other things, an exploration of the "potential [homo] eroticism of religious ecstasy." Given that for indigenous Mexicans Christ's mutilated body, alive or dead, established his iconic status as an "afflicted deity for a profoundly afflicted people," it is not much of a leap to accept the analogous idea that for closeted gay

men the tortured body of Christ—or the arrow-riddled martyr St. Sebastian—was charged with symbolism as well, connoting the pain and suffering of those whose sexual orientation made them vulnerable to persecution and worse.

Whether Perkins' acquisition of his own set of crucifixion photographs was driven by an identification with the savior's naked and pain-racked body is anybody's guess. Then again, the intrinsic morbidity of the scene had exactly the graveyard overtones that Perkins relished in life and art. Indeed, we can position those photographs on a seamless continuum with the artist's own renderings of the same torments inscribed on the gruesomely realistic effigies he found so irresistible. In Mexico, Perkins had thoroughly internalized the idea that, as he put it, "Mexico is drenched in a long history of human slaughter." In that context, a live crucifixion was to be understood as simply another manifestation of that deathly history.

How Perkins came to exhibit his *santos* paintings (as well as a group of satirical Victorian scenes) at Frances Toor's Mexico City gallery is something of a mystery, but it puts him in the middle of an expatriate and native Mexican cultural circle that played a major role in the study and appreciation of Mexican traditional arts—and that also staunchly supported the Marxist aims of the Revolution. Toor (1890–1956), born in Minsk, Belarus, but raised in upstate New York, had come to Mexico in 1922 to study Spanish but ended up staying there to learn about indigenous culture after her first encounter with folk art at an exhibition sponsored by the Ministry of Industry, Commerce, and Labor. In 1925, she launched *Mexican Folkways,* and in short order the firebrand muralist and notorious Communist Diego Rivera was on the masthead as art editor. In 1931, she opened her gallery in an elegant modernist building designed by the Irish-Mexican architect Juan O'Gorman. It was here, in April 1933, that Perkins had his show. Given Toor's knowledge and promotion of folk art, it makes a certain sense that she wanted to exhibit Perkins' paintings of actual vernacular sculptural objects rendered with ersatz naïveté by a self-taught (but hardly naïve) fellow American.

Perkins may have gained entrée into Toor's orbit through O'Gorman, whom he knew during whatever length of time he was in Mexico City. More famously, O'Gorman in 1931 had designed the linked house and studio of Diego Rivera and his now-iconic wife, the artist Frida Kahlo. Perhaps Fernando Felix, with his artistic proclivities, was the link. Toor herself was a magnet; author Lesley Byrd Simpson recalled that Toor held "a kind of salon at the top of a crazy apartment building on Abraham Gonzalez, resembling the Leaning Tower of Pisa, which one ascended by an elevator like an inclined plane railway. The floors slanted correspondingly, and one rather expected the rickety structure to collapse when Diego's immense bulk slid to the lower end of the room." At Toor's, you could meet a "whole constellation" of celebrities, including Juan O'Gorman, caricaturist Miguel Covarrubias, and muralist David Siqueiros. It was a lively scene, with Rufino Tamayo and Angel Salas playing

and singing "the shocking ballads of the Revolution, which had to compete with the roar of conversation." Perkins must have gone to some of those parties, or perhaps to similar gatherings in local bars. How much he was able to participate in any of those loud verbal free-for-alls is anybody's guess, and in any event, he would only have been able to converse in English.

At one party, Perkins met Frida Kahlo. He vividly recalled her evening gown of blue and white checked cambric and remarked that she was "terribly snobbish," yet nice to him since he was "a friend of her friend from New York." Who that friend was we'll never know. What struck Perkins as snobbishness may have been merely reserve on Kahlo's part. She was only in her twenties and just beginning to emerge as an artist to be reckoned with. It's tricky to figure out just when this party may have taken place, since Frida was out of the country for long stretches in the early 1930s, when Diego Rivera worked on commissioned murals first in San Francisco, then Detroit, and finally New York, where the artist's insistence on putting and keeping Vladimir Lenin's portrait in his grand mural for the new Rockefeller Center complex resulted in his abrupt dismissal and the subsequent destruction of the work, which was drilled from the wall. Alternatively, Perkins could have met Kahlo *in* New York in the late 1930s; Julien Levy, the art dealer who gave Perkins his first New York show (the one with Joseph Cornell, who *did* become famous) was arranging Frida's 1938 New York exhibition—her first solo show, anywhere, in fact—and she traveled there for the occasion.

Like Perkins, Frida too was, in a sense, a drag artist who created her inimitable look by adopting native ethnic dress. In the late 1930s, the American artist Addison Burbank (relative of the horticulturalist Luther Burbank) called on Diego and Frida in Mexico City. First he chatted with Rivera in the painter's "cheerless, harsh" studio and the next day went to Frida's house (the two artists, on the brink of divorce, maintained separate domiciles; by then, Frida had established herself in Casa Azul, her family home). Burbank was stunned by Frida's beauty, her persona, and her "morbid originality." Standing there in her flowery patio, this "Artist of Death" looked "glowingly, youthfully alive," he wrote. "She was dressed in full Tehuana costume, with a yellow and purple *huipil* and a full flounced skirt. Her black hair was tightly braided and wound about her head after the immemorial manner of the Indians . . . She was—oh, hell!—breath-taking." Burbank followed her to her "creepy studio where Death makes a continuous holiday" and looked around in some trepidation, commenting on the life-size double self-portrait—*The Two Fridas*—in which each Frida wore her heart on her blouse, with one artery hanging loose and dripping blood and another twining about and roping the Frida doubles together. Other paintings hung about the walls were equally macabre, including one of "the birth of a still-born baby which left nothing to the imagination." It is a pity that Frida and Perkins didn't hit it off. Surely she would have found much to enjoy in Perkins' exhibition at Toor's gallery—had she been in town.

The show went up and came down in April 1933 and was reviewed by the poet and critic Enrique Asunsolo, who gave the work a close and thoughtful reading. Asunsolo first learned of Perkins' work from a mutual friend, the American would-be writer Edwin Wemple, who much later ended up in his hometown of Charlottesville, Virginia, where he became a dedicated pothead and wrote voluminous but never-published essays on "cocksucking, philosophy, Beatniks, and Rimbaud." (Ed will appear twice more in this chronicle before Perkins' race is run.) Asunsolo might have interviewed Perkins, too, since in his review he made mention of the artist's plans to go back to New York, publish an annotated album of his work, and return soon after to Mexico. Perkins' artistic excess, as Asunsolo saw it, was well matched by the critic's own torrential prose: ". . . in the autumn of 32 in Mexico, [Harnly] finds in the altars that tragic grotesqueness which he has always pursued, but here respected in the realm of divinity. His inexplicable affection for all that religion denotes, awakens not as a reverent symbol, but like the meeting of the ingenuous sincerity of the Indian which views again his new gods with the attributes of the discarded ones, the expressions as well as the clothing, misconceived and candidly placed in an erroneous form." In other words, Perkins, like the indigenous artists charged with sculpting and painting the pantheon of Catholic saints, transformed the *santos* he drew by rendering them with (in his case) his own satirical cartoonish style.

Perkins' renditions of Christ figures called forth more purple prose, slightly jumbled in translation: "His artistic love overflows, his enthusiasm drowns him . . . Indefatigably he transports to paper all the superabundance of emotion which claims his attention. Christ, the leader of the Saints, he sees with the cruel intention of Huichilobos [the Aztec god of war and human sacrifice]. More blood is not possible; made more into bits; more dead than a corpse; forced down out of his divinity to give him a living look . . . of terror and of grief . . . White, green, brown or black are now dressed in those rich and variegated colors which the unstinting mercy of the Indian dictates to him. Orange, magenta and verones [brilliant green] are orgiastically combined with the gold, silver, old-rose and lemon, heavy with miracles [votive offerings], puerile offerings. Eyes, hearts, legs, animals, become the idol for the devotion for the almighty masculine fetish." Running out of breath at last, Asunsolo concluded: "There will be someone to propose him for the hall of fame and someone to condemn him to the electric chair, but I do not fear that in the face of his work there will be anyone who is indifferent."

The article included several illustrations of Perkins' *santos*, including another *Cristo* with bloody flesh and lacy drawers, a figure billed as a *santo* but resembling a desiccated mummy (complete with baggy beribboned skivvies), and a *santo* of San Simon, wearing a lumpy modern suit fastened with a safety pin. Since the reproduction is black-and-white, we should let Perkins color it in. "San Simon looks like a good natured bum who has been eating regularly but has not been

so lucky with his clothes," he wrote. "He sports a yellow straw bonnet with red feathers and red streamers of tassels, a Bull Fighter's shirt, red flannel evening suit with tail coat and baggy trousers . . . He helped our Lord with the cross and actually deserves to be better dressed for this good deed." San Simon's hands—the size of hams—dangle almost to his knees, and all ten toes poke through his holey socks. He looks as if he could use all the spare change (if any) that churchgoers may have dropped into his donation box.

There is no record that Perkins sold many, or any, of his paintings in Mexico City. But somehow, he had enough money to afford the one hundred and four dollars he spent at the Mexico City National Pawn Shop for a gold St. Joseph medal in a sunburst surrounded by fifteen seed pearls. This medal was set in a frame of gold acanthus leaves in a shadow box of rose velvet. It came with a story. It had once belonged to the Empress Carlota, wife of Maximilian, the puppet Emperor put upon the Mexican throne in April 1864 by Napoleon III of France. Maximilian's reign lasted only three years before the Mexicans overthrew his government executed him by firing squad on June 19, 1867. Maximilian had given the medal to Carlota, who, Perkins explained, "went insane and died in Paris" after her imperial husband's sordid end. The medal, he claimed, went to a lady in waiting and was passed down in her family until it was hocked and not redeemed. Carlota, the sister of Congo despoiler King Leopold of Belgium, did not die in Paris, but she was indisputably insane, believing to the end that she was still the Empress of Mexico. "Her bridal dress, faded flowers, and a feathered Mexican idol hung on her wall. She was reported to spend her days talking to a life-size doll in imperial robes." Carlota died at last in her chateau outside of Brussels, in 1927, "muttering madly about imaginary kingdoms and dynasties to the very end." If the St. Joseph medal really had been Carlota's, it is a wonder how or why it managed to get all the way from Brussels to Mexico City in time for Perkins to buy it in 1933. Certainly there wasn't much time for it to pass down through any family, either. It was more than likely a tale fabricated to give the medal an aura of romance and tragedy.

When Perkins returned to New York, he sold much of his Mexican output at auction, he said, to benefit the Humphrey-Weidman dance company. That might have been where media magnate William Randolph Hearst saw and purchased the works reproduced on the *American Weekly* cover. In 1935, Perkins had one last exhibition of forty remaining Mexican *santos* watercolors at the Delphic Studios in New York. This gallery was established by Alma Reed, a San Francisco journalist and activist who visited the Yucatan Peninsula in the early 1920s and there entered into a passionate love affair with the state's populist governor, Felipe Carrillo Puerto, who styled himself the "Abraham Lincoln" of Mexico. The two planned to marry, but the wedding never came about: on January 3, 1924, Puerto was executed, or, to put it more bluntly, assassinated, by a firing squad acting at

the behest of a reactionary group—the Delahuertista Rebellion—that sought to restore the old colonial order, which among other things involved the re-enslavement of the oppressed Maya. In the late 1920s Reed became the champion of the radical Mexican muralist José Clemente Orozco and organized his first exhibition in 1928 at her Greenwich Village apartment; soon after, she established the Delphic Studios at 724 Fifth Avenue (now directly across the street from Trump Tower, which she and Orozco would have considered deeply ironic).

Although Reed used the gallery mainly to promote Orozco, Perkins' exhibition somehow came about. It may have been through Ed Wemple's intervention, which seems plausible, given that Wemple wrote the short and very colorful essay in the brochure that accompanied the show. Perhaps trying to go Asunsolo one better, Wemple dubbed Perkins "the bull-fighter of saints who has not only mastered holy death but made it his toy." There was in his work "a definite talent for dress-making and a considerable suggestion of cookery. Witness his inspired lace-panties; his blood-spatters as tasty and unmorbid as red icing squeezed over glazed flesh and bound with sterilized chiffon." Reed's patronage didn't deter Perkins from saying snarky things about her. He claimed that she "never took a bath" and that she always "wore a hat in the house and was loaded with jingling costume jewelry." He also accused her of being a "sloppy, tasteless moocher" and a greedy, rattle-brained gourmand. Given that Perkins claimed Don Forbes as the source of these observations, it is hard not to conclude that the pot in question was merely calling the kettle black.

In spite of the fact that Perkins had announced his plans to return to Mexico once he had exhibited his work in New York, he never did, and the watercolors he did there are scattered to the winds. But the place, and the people, made for vivid and occasionally risqué memories, particularly where Fernando Felix was involved. Perkins' recollections of Felix, in fact, fill in at least some of the many remaining gaps in his Mexico story. Perkins described Felix as "a very rich person in the sense of possessing an overwhelming love of the extremely perverse, the beautiful, and the wonderful." He was also a "vain old queen" with "the belly of a bull and the soul of a poet." Perhaps "perverse" was the most apposite adjective, though: "Within that swarthy cranium resides the essence of magnificent perversity," crowed Perkins. "Who else has ever rimmed a horse? Who has ever done trade in a public swimming pool? And on a crowded bus! He took off the sock [as we've learned] from a year-dead body in a mildewed coffin stored in a vault back of the church of the Queen of Latin America. He, however, did not do the corpse for trade." Felix painted, too, in the same vein he had explored in the Forbes-Felix illustrations for *Sulamith*, only raunchier in the extreme. "His ideas are strikingly outrageous: an ape's asshole and an orchid, an Indian woman tearing out her baby from you know where and blood all over the place, lobster red orthopediac [sic] women picking idlewies (?) [edelweiss] from white snow-covered Alps, a fat-assed

Christ getting browned." Judging by Perkins' description, Felix could have been queer masculinity's answer to Frida Kahlo. Not one of these paintings has come to light; perhaps some well-meaning, respectable member of Felix's family thought it better to dispose of them.

With age, Felix may have subsided into a tamer version of himself. At least that's the sense Perkins conveyed when his old Mexican friend visited him in Los Angeles some thirty years later. "We had a very pleasant visit," Perkins wrote. "I had no time or means of getting Felix around but he did pretty well for himself. Few travelers have done any better. My goodness. I've been here for twenty years . . . and haven't done or seen a hundredth as much as Felix dug up in a few days. He is a rare personality and full of the most fascinating information about his wonderful native land." Felix may have been seeking out trade, visiting museums, or simply touring the town. But no doubt the two spent a great deal of time reminiscing about art, sex, and death in Mexico three decades earlier.

One wonders, too, if either Felix or Perkins knew that Frances Toor (who had died in 1956) lay buried with another woman—her partner Carrie I. Gibson— in the Hollywood Forever Cemetery. Perkins had been there more than once to visit the resting place of Rudolph Valentino and other movie stars. Nothing is known of Carrie Gibson or the relationship she had with Toor, and Toor, of course, had disappeared from Perkins' life once he returned to New York. It was oddly fitting, though, that this small but vital fragment of his time in Mexico should have ended up so close to him in the city where, from 1943, he would spend the last four decades of his life. But before that, Perkins still had a decade to go in the Empire City.

Fat Queens and Victorian Monstrosities

F OR PERKINS, 1933 WAS A BANNER YEAR. HE HAD HAD his first-ever exhibition at Frances Toor's studio in April, and in mid-December—back from Mexico—he had his inaugural New York show at Julien Levy's fledgling gallery on Madison Avenue. Levy—a Harvard dropout (albeit only one semester short of graduation) who had met the maverick Dada avatar Marcel Duchamp and traveled with him to France in 1927—spent three years in Paris among the Surrealists and assorted modernist radicals. On returning to New York, he decided to open a gallery, where he almost immediately began to promote Surrealism; his show in early 1932, *Surrealist Paintings, Drawings, and Photographs*, featuring Salvador Dali and Max Ernst, among others, was *almost* the first Surrealist exhibition in the U.S. The Wadsworth Athenaeum in Hartford, Connecticut was *the* first, by a nose; it had opened its Surrealism exhibition on November 15, 1931. But Levy's offering, of which the highlight was no doubt Dali's now-iconic *Persistence of Memory*, with its limp watches (and other limp things) in an airless desert landscape, was a headline-grabbing sensation. *Persistence*, in fact, had already appeared in the Hartford exhibition, but after all, it was bound to get more press in New York.

Soon after his own return to New York, Perkins had met Alexander King, the bombastic Vienna-born jack-of-all-cultural-trades who some thirty years later would be the subject of a florid thumbnail sketch in *Time* as "an ex-illustrator, ex-cartoonist, ex-adman, ex-editor, ex-playwright, ex-dope addict . . . ex-painter . . . ex-husband to three wives and an ex-Viennese of sufficient age (60) to remember muttonchopped Emperor Franz Joseph." The loquacious and gregarious King—a dandy and raconteur—knew everyone, and it was he who introduced Perkins to Levy. The gallerist was sufficiently taken by the artist's quirky *santos* and Victorian gewgaws that he included him in a late-December exhibition, along with works by Henri de Toulouse-Lautrec, Harry Brown, and the poetic visionary collage- and object-maker Joseph Cornell. It was the first and probably last time that Perkins would cross paths with Cornell, who, as noted earlier, went on to steadily increasing fame while Perkins ultimately erased himself.

Perkins made a watercolor announcing the exhibition and featuring an ornately framed, purple-velvet-lined placard in which "Watercolors by Perkins Harnly" gets top billing, followed in conspicuously smaller font by the names of the other three artists that shared the space. A bright blue and highly theatrical tasseled curtain has been drawn back with a flourish to reveal the announcement. The placard leans against, or has fallen upon, an outrageously

elaborate Victorian settee with intricately undulating wood-carving, tufted purple upholstery, and gold fringe. The settee in turn stands on a hooked rug. In what little space remains, there is the lopsided bust of a Native American with two arrows crisscrossing his clavicles, and a twisty golden chandelier with three fluted blue lights. There is something about the imagery that suggests spoofery, and there is no evidence that Levy used it to promote the exhibition. Indeed, it seems more self-promotional than anything, since in 1933, surely, Toulouse-Lautrec was more famous than Harry Brown (who turned out a number of clever *New Yorker* covers in the 1930s), Perkins, or Cornell, whose only other show anywhere had been in Levy's gallery the previous year. (That show, "The Objects of Joseph Cornell," had taken place in the fall of 1932; Levy also included his early collages in the January 1932 *Surréalisme* exhibition.)

Judging by the reviews, Perkins' watercolors of cartoony Victorian subjects attracted more attention than anything else in the exhibition. Modernist architects, designers, and cultural critics had been engaging in a concerted attack on Victorian houses and everything in them for more than a decade. Clean lines, sleek surfaces, and pristine geometry defined the new fashion, displacing (and explicitly rejecting) the fussy complexity, clutter, darkness and dust associated with Victorian domestic architecture and décor—all of which Perkins crammed into his paintings, plus (in many) a voluptuous Gay Nineties whore (his term)—or drag queen.

Stylish Stout is a perfect example. Sold to a local socialite and lost to view (except, fortunately, for one contemporary reproduction), it features an extremely well-upholstered and curvaceous woman decked out in one of Perkins' enormous tilted hats, a stiff sequined corset that could pass for body armor, filmy scalloped drawers, lace-up boots with very high heels, a fancy furled parasol, and an overload of jewelry. She supports herself against a tufted, tasseled settee that looks like a close relative of the one in the exhibition announcement and stands with one boot planted on what appears to be a log, as if she has just vanquished it in a brawl. From the upper left corner droops a fringed and tasseled curtain—another echo of the exhibition announcement—and behind everything else is the very scene before which Perkins not long since had posed for that photograph with Fernando Felix: castle, lake, sailboat, and flower-filled urns, all the same, albeit minus the Virgin of Guadalupe. If she *is* there, the settee blocks our view. It is not too big a stretch to imagine that the voluptuous whore is (like all the others) Perkins' alter ego, his fantasized queenly self. That, and the backdrop, copied so literally, hint that *Stylish Stout* slyly references Perkins' Mexican days and escapades while pretending to be something else entirely. Of course the connection would have been known only to Perkins and whatever small handful of friends were in on it. Certainly Mrs. Hugo Barklay, who bought the painting as "the central decorative motif for a Victorian room in her Long Island home," never knew what she was actually getting. On the other hand, copying—as from the Sears catalogue—was

Stylish Stout, *exhibited at Perkins' joint show with Joseph Cornell
at the Julien Levy Gallery in December, 1933*

intrinsic to Perkins' modus operandi. One might even say that he painted the
same whore and the same Victorian décor throughout his life, in every conceivable
permutation and variation. Only in his later years did he branch out, and then not
terribly far. Thus, whether or not *Stylish Stout* looks back on Mexico remains an
open question. Maybe Perkins simply liked that backdrop, with its resemblance to
the theatrical drop curtains that had so impressed him as a boy.

THE GAY NINETIES

Perkins' trademark Gay Nineties corset squeezing a Victorian mansion to death in 1933

There were numerous other watercolors along the same lines, including the quasi-surrealist corset/house conceived during Perkins' Rose O'Neill period. Dubbed "The Gay Nineties," it traveled with Perkins to Mexico and, with a number of other Victorian-themed works, went on display at Frances Toor's studio; indeed, it was one of the illustrations, and the only one featuring Victoriana, in Enrique Asunsolo's published review of the show. The concept is actually quite simple: a corset has clamped itself around a house—an eclectic late nineteenth-century mishmash of gables, finials, wraparound veranda, cupola, classical columns, bulbous balusters, and bits of gingerbread—and like a python squeezes it into a precarious assemblage of broken bits. It could be a comment on Victorian sexual repression and the stranglehold of bourgeois respectability in domestic life. Or perhaps it eroticizes that same realm. Given Perkins' own lurid Nebraska past, and his grandfather's Queen Anne-style architectural extravaganzas, there might also be a touch here of tongue-in-cheek Oedipal revenge.

Looking at Perkins' Victorian fantasies through a Freudian prism, Asunsolo himself took it as given that there was an Oedipal complex operating in and through the imagery. "That furniture, forgotten, desperately old fashioned, brought down from the attic of the subconscious which clings deeply to the solitude of infancy," he wrote, tracing Perkins' artistic ancestry back to the decadent Art Nouveau sensibility of Aubrey Beardsley. To be sure, Perkins communicated the vitality, excess, and extravagance of that not-so-long-ago age. But underneath, there was something more disturbing. "If we follow in the footsteps of his amusements, we can tumble down like a trapeze artist and hurt our heads ... [and] lacerate ourselves against the same memories and childhood dreams which have hurt him. Thus it is that his game is always truculent—comedy, crime, flirt, the morgue, dancing to the same measure of the waltz which gives us the rhythm of our infancy. To know him is always a danger, since he likes everything that society has decided to despise, odd quixoticisms of super-realism [i.e., surrealism] which explain with ease and almost with cynicism his neurotic perspective, making the public responsible for it and accusing every individual of hiding hypocritically the same crime."

Asunsolo's fevered prose notwithstanding, he made the same case as did Perkins himself when talking about the past and its hold on his imagination. "My very soul belonged to 1880–1910. It still does." His own youth—1910–1920—spanned what he christened the "Monstrosity Decade." "Monstrosity," in fact, was a widely circulated pejorative for late nineteenth-century styles. Many a critic disparaged all things Victorian as "monstrosities" as well as horrors, atrocities, and "fearsome rubbish." The catalogue of monstrosities included "antimacassars, lambrequins, gilded rolling pins, stuffed owls, wax flowers and hair wreaths," and nearly everything else: slippery horsehair upholstery, dark walnut woodwork, polar bear rugs, Brussels carpets: all things that Perkins loved, hated, and mocked in his art. Perhaps for him "monstrosity" had a double meaning, connoting those

material Victorian horrors as well as the childhood horrors he had himself survived. A number of other painters, among them Edward Hopper and Charles Burchfield, were also drawn to Victorian houses around that time. Indeed, it was a new trend, noted sarcastically by the *New York Times*, which laid the blame squarely on "certain bitter young painters and writers who fasten upon the houses of their childhood, depicting them in the aspect of obstructive demons destroying precious individualities." But Perkins' Victoriana may have been more complicated in its mix of humor, love, hate, excess, and erotica.

Asunsolo was the only critic who made an effort to burrow down to the psychological bedrock beneath Perkins' obsession with Victoriana. Everyone else simply marveled at the sheer profusion of things that he stuffed into his paintings. "It is as though some long forgotten theatrical storehouse had disgorged its contents for Mr. Harnly's especial benefit," wrote the *Herald Tribune* reporter, "and the collection of curiosities he has painted is truly amazing. Quilted couches, ancient stoves and filigree chandeliers, picture-display easels, antiquated sewing machines and deer-horn chairs all are among the weird paraphernalia which he serves up in his pictures." Perkins' watercolor "extravaganzas" delving into "odd Americana" made Levy's gallery a "giddy place" to be at present, wrote *Times* critic Howard Devree. Joseph Cornell's surrealist objects, arranged in bottles and boxes, also contributed to the general atmosphere of weirdness and whimsy. On the surface, it would have seemed that Perkins—loud, queer, gregarious, garrulous, uninhibited—had nothing in common with Cornell—quiet, straight, bashful, tongue-tied, and repressed. Yet they shared some common ground. Both were self-taught, and both ransacked the Victorian attic—literally and figuratively—to collect the raw materials for their art.

Employed as a textile salesman in New York, Cornell would roam and comb through second-hand bookstores, antique stores, dime stores, and junk shops, amassing an enormous accumulation of flotsam and jetsam. Perkins' territory, as we know, was virtual rather than material, yet nonetheless an equally vast repository: old Sears catalogues and other illustrated ephemera. In 1932–33, Cornell fashioned a number of assemblages sealed within that most Victorian (and, in the early twentieth century, most detested) parlor ornament of all, the bell jar, which would be filled with colorful taxidermy birds, dried flowers, fantastic objects made of shells, hair, or wax, and fanciful scenes in miniature. One of Cornell's bell jars from about 1932 contained a disembodied mannequin's hand holding a black disk imprinted with the image of a rose disconcertingly equipped with a staring eye; around the base are scattered doll-house forks, knives, and spoons, and one tiny silver slipper. Cornell also cut out figures from Victorian chromolithographs—such as advertisements or Christmas cards—and re-contextualized them. A box he constructed sometime around 1933 featured an old-fashioned "snow maiden" with pink wings and a basket of snowdrops, set

against a spray of dried flowers and a square of dark blue paper spangled with a galaxy of silvery stars. By poetic juxtaposition, Cornell transformed his Victorian rubbish into objects of mystery and enchantment—nouns no one would apply to Perkins' Victorian tableaux with their blowsy showgirls and their delight in sheer overload. Yet there they were, Cornell's reveries and Perkins' monstrosities, creating that giddy atmosphere in tandem.

Differences notwithstanding, Perkins and Cornell struck up an acquaintance over the duration of the show. "We hung around Levy's gallery together," Perkins recalled, ". . . And I was rather startled by his work. I didn't see what it had to do with painting or art . . . Because the first thing I saw was a row of Mason jars that they can fruit in. And in the Mason jars were squares of plastic film in different colors. And these sticks, these matches that you light fireplaces with . . . and that's all there was." He described Cornell's materials as "just a bunch of trash, a bunch of junk. And he would take a little angel out, or a plastic ball, or a broken glass, and put them all together in a little box." Although Perkins found Cornell's objects baffling, the two became "a bit used to one another," and Cornell even offered (without success) to trade one of his objects for Perkins' Mexican watercolor of the Virgin Mary covered with apples. To Perkins, Cornell himself was nearly as baffling as his art, but he came to appreciate the eccentric "oddball," and as the relationship warmed, they would have little chats, "mostly about Salvador Dali." "Simply, Joseph was a 'good soul,'" Perkins wrote many years later. "His personality was not of the rambunctious type . . . a lot of his little boxes were fragments of childish nostalgia. He had a peculiar knack for spotting quaint nicknacks [sic] that would serve his purpose, tiny things long forgotten by the average person." Not for very many years would Perkins finally "get" what Cornell was trying to achieve.

While the Levy exhibition did not vault Perkins into the art-world stratosphere, it launched him into a low but steady orbit that proved critical to his survival as an artist in Depression-era New York. "I have always been very proud of having had the privilege of showing for the first time in your gallery," he wrote to Levy. "The fact has helped me many times in many ways. It has aided me in demanding attention, respect and positions." Those positions included art- or interior-design teaching stints at the Young Men's Hebrew Association, the Brooklyn Museum, and the Benjamin Franklin High School. But the Levy "charm" went further, Perkins claimed, landing him a spot at the Index of American Design. To what extent that Levy "charm" actually assisted Perkins in obtaining that appointment is impossible to measure.

(While teaching the YMHA course, Perkins enjoyed a fleeting taste of old money when one of his students, "an elderly lady with a hearing aid" entertained him at her ancestral home. "She introduced me to several of her neighbors who were descendants of notable Early American families," he later wrote. "I had to listen to reams of boastful ancestral lineage. If one was not of that noble and heroic

clique he wasn't worth the mud on the front door foot scraper." So voluble were these genealogical ramblings that Perkins had no chance to tell them of his own "distinguished lineage. Horse thieves and two bit prostitutes. Splashed with a very delicate shade of lavender." While all this went on, his hostess—or her chauffeur, more likely—drove Perkins around to "behold the vast manorial estates of famous actors, writers, and people who have the knack for making a lot of dough . . . I fortunately met a man up there whose principal occupation in life is identifying old cannon balls. And that was the only reference to balls which occurred on that momentous occasion.")

Perkins told various stories about various people who had used their influence to help him secure the Index job. In one version, Perkins recalled that all of his New York friends were on the New Deal's "Home Relief," and he wanted "to be in fashion. So I got on Home Relief for $7.50 a week." One thing followed another, and, with the help of a shifting cast of characters (depending on which Perkins story you hear), he was hired on to the Index to create a series of watercolors depicting late-Victorian and Edwardian interiors. In fact, the opportunity may have come about because Perkins had already been brought into the Federal Art Project of the Works Progress Administration, which employed hundreds of artists nationwide to produce easel paintings, murals, and sculptures that were widely distributed to a range of institutions like public schools, post offices, and hospitals. The Metropolitan Museum of Art has two of Perkins' FAP paintings in its collections, courtesy of the New York City WPA, though they have, to my knowledge, seldom or never been out of storage. One of them is a night scene depicting the classicizing façade of the 14th Street Theatre (demolished in 1938); the other, titled *1886*, is further up Perkins' alley: a tall Mansard-roofed pile with steep turrets, jutting corner bays, and elaborate trimmings. Luridly illuminated against a dark sky, it looks very disquieting indeed. Perkins' Index work, however, was a far more ambitious and extensive undertaking.

A unit of the FAP, the Index of American Design (launched in the fall of 1935) employed American artists to record objects representative of the nation's cultural heritage and the history of American decorative arts, in particular the traditional arts and crafts of the pre-industrial era as well as productions of the early manufactory. The brain child of textile designer Ruth Reeves and Romana Javitz, head of the New York Public Library Picture Collection, the Index was a preservation project with a nationalistic and didactic purpose: to create a visual compendium that would define American identity while at the same time serving as an educational resource. Who decided *what* should represent the native tradition was to a significant degree a matter of taste, and of bias toward what were then seen as the naïve, untutored, and authentic efforts of the "folk." By no coincidence, numerous American collectors had not long since begun to seek out folk art, which, in the words of the FAP head Holger Cahill, exemplified

the "sincere childlike expressions" of the common people; such art went "straight to essentials of art, rhythm, design, balance, proportion," which the folk artist felt "instinctively." Newly prestigious, folk art would now become a standard for modern American artists and designers; it would instruct them, inspire them, and wean them away from Europe's powerful artistic sway. As critic Edward Alden Jewell put it, "the past becomes, as it should always be, an intrinsic part of the living stream of native cultural expression."

Over the seven years of its existence, the Index employed up to a thousand artists nationwide, though not more than four hundred at any given time. Altogether, those artists executed more than eighteen thousand paintings and drawings based directly on original examples. Many were commercial artists or designers, or others who had failed to make the cut for more elite projects: easel paintings and murals. Their mandate was to produce renderings of chosen objects as accurate and meticulously realistic as was humanly possible. They worked in watercolor, gouache, crayon, and graphite, producing images of weathervanes, figureheads, toys, textiles, ceramics, wood carving, bonnets, pants, dresses, shoes, cast iron, molded glass, tobacco store wooden Indians, duck decoys, and carousel animals, as well as artifacts representing the traditions of Pennsylvania German communities along with Shaker furniture and a smattering of objects from the Spanish Southwest.

To achieve maximum precision and uniformity in their renderings, artists were obliged to erase every vestige of their individuality. FAP head Cahill's cardinal rule was "Respect for the object" in order to achieve "an impersonality, a faithfulness, and an objective beauty" stripped of all "artiness." Indeed, Index artists recorded objects with what was perceived as a "camera-like precision" that even today looks uncanny. How could a human create an image that looked for all the world like a photograph? Although the Index actually did employ photographers to document certain types of craft, as well as interiors, the vast bulk of images produced were hand-drawn and hand-painted. Paradoxically—given the unremitting stress on exactitude—Cahill and others argued that the camera was simply incapable of revealing "the essential character and quality of objects as the artist can." The best drawings, he stated, "while maintaining complete fidelity to the object" had "the individuality that characterized a work of art."

It's true, in fact, that most of the renderings (all of them now in the National Gallery of Art), in which the object in question appears against a blank white background, do look a bit more like art than photography, yet they are strikingly impersonal. John Tarantino's *Milk Pan*, for instance, presents a frontal view of this humble domestic object made of putty-colored stoneware, with stubby handles, a lovely symmetrical curving lip, and highly stylized brushed-on cobalt fronds for decoration. A glimpse of the vessel's brown interior reveals grooves left by the potter's wheel. The closer you look, the more you can see every mark, every little

speckle, bump, or flaw in the clay surface. By the same token, Beverly Chichester's *Doll Bed Appliqué Patchwork Quilt* might be taken for the original itself, so precise and so illusionistic is the technique. Not a stitch is left out. In neither example, nor in any others, is there any trace of artistic idiosyncrasy, any sign of a personal touch. The only individual note is the artist's signature.

All of which highlights Perkins' strikingly anomalous contributions to the Index. The vast majority of Index renderings are of objects deemed authentically American: things viewed nostalgically as having been made by artisans whose material culture—whether they were making quilts, tables, clocks, weathervanes, or silver teapots—was untainted by the falsity, excess, and questionable taste ushered in by the age of mass industrial production. Perkins, by contrast, reveled in those very things deemed hideous and repugnant by the tastemakers, and, rather than single objects isolated against blank space, he conceived and rendered entire Victorian interiors. According to Perkins, no one suggested his subjects and no one directly supervised him. "Instinct" alone inspired his selections. "My point of view was so dissimilar to that of the other artists that it was a curiosity," he wrote.

One reason why Perkins alone—of all the hundreds of artists on the Index—enjoyed such freedom may have been a single key connection in the shape of Lloyd Rollins, a graduate of Harvard's museum program who handled allocations of WPA artworks to schools, hospitals, and other institutions. Described by Perkins as "an old queer" who collected "Victorian stuff," Rollins may well have pulled strings to get Perkins a place in the Index's artistic stable. "That old fairy was very clever and very good," Perkins recalled, noting that Rollins did a lot to help him. Rollins collected swirl glass, he added, and had a house full of it. Rollins, in fact, had a house full of everything: mutual friend Whitney Norcross Morgan (of whom more as we go along) went to a party one evening at Rollins' apartment on Murray Hill and wrote that the place was growing "more and more crowded with Victorian furniture and bric-a-brac," including "an interesting collection of old shaving mugs." Amidst it all, Rollins found room for "an attractive pet Scotchman," too. Perkins could hardly have wished for a better sponsor.

And given his proclivities, he could hardly have had a more congenial assignment. He loved the work: the project was his "life blood," his "precious baby." It was also labor-intensive in the extreme. Perkins recalled that "On the WPA I had all the time in the world. Every plate took four weeks at fourteen hours a day seven days a week to paint . . . just one took four hundred hours to render so meticulously and none took less than two hundred hours." The process, he noted, went by the name of "inch painting. An inch a day. A lot of them were painted with spit. In fact almost all of the Index renderings were done with saliva. The artist holds the water color brush in his mouth when doing fine work under a magnifying glass." The paper size varies, but Perkins' Index works are overall quite large, some measuring as much as twenty-two by thirty-one inches, so it's

easy to believe that covering all that surface area in such painstaking detail would take many, many hours: "I don't like to be reminded of the mental states I endured while executing the water-color interiors," he said. "I'd rather forget the painful moods and emotional helplessness accompanying each seizure of labor. Yet each subject reeks with joy." The joy, of course, lay in Perkins' love-hate perspective on the Victorian decades. The things he depicted may have been excessive, hideous, and gaudy, but he lavished such care on every one of those inches that surely it was, in the end, a labor of love, manifest, for example, in the way he so faithfully depicted every thread in an intricately patterned lace curtain, every petal of a potted peony. The results are anything but dry and stiff, though: transparent washes and buoyant rhythms give each one of the interiors life and energy.

Although Perkins did a couple of room "portraits," including a look inside a turn-of-the-century El station, most of his twenty-six Index interiors were composites, with individual objects and details drawn from any number of sources to create the effect of a whole. But in extreme contrast to, say, the sleekly efficient hand-wrought simplicity of a Shaker ladderback chair designed to tilt without scratching the floor, any Perkins chair was so ornate, so overstuffed, so garish, so encumbered with tortuous carving, fringe, and tassels, that it might as well have been rigged out in full drag. Indeed, the majority of Perkins' interiors are like that: whole rooms in drag, exuberantly overstuffed, over-ornamented, be-plumed, be-frilled, and bedizened in a regular orgy of overload. His perceptions, Perkins said, were "twisted" in regard to selecting major items. They had to be in the spirit of a 1900 Sears, Roebuck or Montgomery Ward catalogue, "especially the ladies' underwear section."

While some of his Index interiors are relatively straight-faced, Perkins' self-confessed "strong, innate sense of the ridiculous and 'CAMP'" (in the sense of outlandish and deliberate artistic exaggeration) pervades many more, though only close scrutiny will reveal the visual zingers the artist so enjoyed planting here and there. In *Townhouse Parlor, 1869*, for example, there are no jokes, or, if they're there, Perkins hid them well. But it is crammed with thoroughly researched period details: the Rococo Revival (also known as Belter, for the cabinetmaker who popularized the style) carved rosewood and yellow satin settee and matching chairs, the wax or paper roses under a bell jar (shades of Cornell) atop a pedestal table draped in gold-fringed red velvet, the filigreed crown molding, the soaring pier glass, the theatrical window draperies with ball fringe and tassels, the delicately patterned lace curtain panels (probably manufactured), the chandelier dripping crystal prisms, the potted palm on its own fancy pedestal. The static symmetry of the arrangement underscores the room's formality. Yet even in such a pretentious setting, Perkins' humor lurks. On the floor sprawls a huge polar bear rug, with an open red maw, fierce fangs, glaring eyes and a savagely snarling snout. On the wall facing it is a portrait of jowly Queen Victoria gazing into the distance as if doing

her best to ignore the beast below. Although trophy rugs of this sort were all too common in upper-crust Victorian homes, this bear is so large and ferocious and incongruous that it might as well be the Abominable Snowman, as outrageously out of context as King Kong on top of the Empire State Building.

Most of the Index artists signed their work; Perkins did not. "Frankly there isn't room for a name or even initials due to the all-over patterns," he commented. "I don't wish to spoil the atmosphere by sticking in personal graffittee [sic]. It is more vain to act in contrary fashion. If my name is part of a design such as a tombstone or cast iron stove I'll use it." One painting, *Photographer's Studio*, *is* signed—not by Perkins but by Nicholas Zupa, another Index artist whose work was ordinarily confined to renderings of bell jars or wall pockets. In *Photographer's Studio*, Zupa painted the flowers on the trellis prop. "I was glad to share such a wee amount of space, the closest the dear soul would ever get to immortality. Ha." However, Perkins did have his own way of sneaking his coded signature into the picture.

If you decide to pick up Perkins' joke trail, you soon begin to spot the bread crumbs. In *Rural Kitchen*, which boasts a cast-iron "Yukon" brand range even more elaborately worked than any rosewood Belter parlor suite, a fat Sears Roebuck catalogue—Perkins' primary encyclopedia of all things decorative and functional—lies on the floor under the drop-leaf table in the foreground. Over on the right near the coal bin is a mousetrap positioned directly in front of a hole in the baseboard. In *Photographer's Studio*, we see the same setup—mousetrap (this time with a moribund rodent, firmly clamped in place), baseboard, hole—and in the encyclopedic *Grocery Store*, with its crumpled shopping lists, extinguished cigars, and brown paper bags, there is yet another hole, directly beneath the mail slot, although the trap for some reason sits at a distance atop a barrel of salt pickles. The traps are subtle indications that "Perkins was here," since on occasion he used a baited rat trap for a signature (this of course begs the question if his Index traps are for rats or mice, but we'll not split hairs here).

Perkins' *El Station* was based on the Sixth Avenue/50th Street Station still intact and in use when he rendered it for the Index. But as one of his "room portraits," it is intended to present a detailed inventory of the station interior at the turn of the twentieth century. Everything is here: the imposingly large pot-bellied stove with a coal bucket by its side, windows with stained-glass borders and transom panels, ticket booth, cast-iron ceiling brackets, bare hanging bulbs, slatted benches, spittoons, red and green signal lanterns, a fare box, and cleaning tools. Although the room is vacant, a porter's cap slung on the picket-fence barricade and a lady's frilly parasol leaning on a rattan suitcase are signs of recent occupancy. Despite a broom, a mop, and a bucket, the room isn't particularly tidy; an empty whiskey bottle lies under the barricade, and there are several sheaves of rumpled newspapers, some of them, notably the "Hobo News," with clearly legible

headlines and advertisements: "The Light of your life. 10¢ Dutch Masters," "Child Wants Steinway." The "Hobo News" date, though, is our tip-off that Perkins was here: Sunday, October 14, 1901 was his birthday. And yet, faintly visible through the window at the back of the room, you can just make out the Chrysler Building, a modernist landmark only in existence since 1930. With that detail, Perkins created an impossible time warp. Is it 1901, or 1935, or, somehow, both, in the Perkins Twilight Zone?

Even wilier is the *Dentist's Operating Room* (there is also a *Dentist's Waiting Room*, but the operating room is more fun). Like the El Station but even more so, this room catalogues everything: the drill mechanism, the tools and beakers and treadles and tubes and retorts, the cabinet with all its shallow drawers, the poster showing the triumph of scientific dentistry in the form of a scantily clad allegorical female crouched upon a gigantic set of false teeth and raising a champagne coupe as if it were the Statue of Liberty's torch. But the setting is also oddly domestic, with the stuffed owl, the bookshelves, the lace curtains, the wallpaper frieze in a calla lily pattern, the colorful carpet and—especially—the patient's chair and dentist's stool with the red-velvet-and-tassel upholstery. It seems like a cross between a living room and a torture chamber. But the more you look, the more torture comes to the fore: on the carpet between the drill treadle and the chair lies a pair of tooth forceps surrounded by sixteen teeth: molars, canines, incisors—half a mouthful's worth. If you look very closely out the window, you'll see the Perkins punch line. Beneath the hanging "Painless Dentist" sign outside is a boy with his dog; both have their jaws bound up in rags as if they had the mumps. On the wall below the sign, the boy has just scrawled the word "Liar." The dentist's operating room may be one of the funniest images in the entire corpus of the Index, which—except for Perkins—was seldom less than deadly serious and sincere.

Perkins' favorite calling card, though, consisted of the Gay Nineties female accessories so dear to his heart. On a draped pedestal table in *Photographer's Studio* reposes one of Perkins' extravagant drag-queen hats, adorned with ostrich plumes and red roses. A pair of long white gloves droops over the edge of the table, a fancy parasol leans against it, and on the floor below it is a lady's folding fan. Then there are the bedrooms, all of them obviously belonging to women. In the airy blue *Bedroom, 1882*, as in other Perkins interiors, there are signs of occupation: a nightgown draped over a tasseled chair, a coy glimpse of a chamber pot under the bed with its lacy counterpane, and on the floor in the opposite corner a bouquet of roses and an envelope sealed with a red Valentine heart. Hanging on the window wall is a print or painting of a voluptuous reclining nude, which might be more at home in a saloon; beneath are two small portraits—a boy and a girl—in a single frame. The bedside rug bears the likeness of a Saint Bernard, who seems to be gazing mournfully at the nightgown as if waiting for someone to fill it. There is also a dog rug in a different *Bedroom, 1882*, and, on the marble-topped table,

another valentine-sealed envelope next to a kerosene lamp, its two glass globes decorated with fat pink roses. The curtains and the counterpane are extravaganzas of frothy lace, and the plump bed pillows are decorated with prodigious pink bows like presents waiting to be unwrapped.

Even more elaborate is Perkins' *Boudoir*, which he crammed with details that enable us to fill in the room's absent owner. The overstuffed chaise longue and the dressing table (its mirror reflecting a figurine of the Venus de Milo) are done in rich blue and gold fabrics; the two lampshades, in frilly pink with huge bows, could easily double as hats. On the chair near the window rests a mandolin, and next to the chaise, on a curvy-legged side table, are wilting white roses in a golden vase, along with an empty champagne coupe. Below on the carpet is an open box of candy (prompting thoughts of the bonbons that young Perkins claimed to have filched from Sarah Bernhardt's bedroom at the Lincoln Hotel). On the table's lower shelf sit three books. We can read their titles: *Fanny Hill* (by John Cleland), *Decameron* (Bocaccio), and *Droll Stories* (Honoré de Balzac)—earthy tales of carnal pleasures, lust, and (in the case of *Fanny Hill*) outright hard-core pornography, albeit in polite eighteenth-century English. Under the table is a small picture of yet another dog (there are at least two others, though you have to look very hard to find the third, peeking out under the fringed hem on the right side of the vanity).

Almost in the exact center of the composition is a picture easel, which displays an oval bust-length portrait of a woman with a pompadour hairstyle, plunging neckline, and lavish jewelry. Pinned on the wall behind her is a map of the globe, and above that, a painting of a square-rigged steamer—bearing the French flag—with a jaunty sailor's cap slung onto the upper right-hand corner of the frame. Another little French flag hangs over the portrait on the easel, tempting us to make up a story about the lady holding a torch for her sailor boy now far away at sea. But perhaps she has been profiting by his absence: upon and underneath her dressing-table stool lie black net stockings, recently shed, and a pair of high heels, one shoe tipped to reveal the hole in the sole, ever so subtly suggesting that she's a street walker. Or perhaps she only wore out her shoes pacing the aisles of fancy department stores. But the other material clues, in particular the bawdy books, suggest otherwise.

There is, however, another possibility. Perkins put such lacy stockings on many of his Gay Nineties whores, early and late. Like the rat trap, they were a signal, in this case, that all might not be as it first appeared. Perkins' buxom women are not necessarily female; more often than not, they portray a "fat Queen posing as an American beauty." How can we be sure? One of Perkins' unrealized paintings is of a graveyard with coffin from which a plump leg in a black lace stocking protrudes, as if the undead occupant is trying to make an escape before being interred beneath the nearby "Harnly" monument with its trumpet-blowing angel. Perkins himself, then, is surely the "fat Queen"—his alter ego—whose trace is everywhere in the *Boudoir* and other Victorian interiors. (Perkins made

Above: Perkins' "Fat Queen" alter ego escaping from premature burial
Below: "Peace on Earth": pinup Christmas card, c. 1935

Peace on Earth

Perkins Harnly

many other "fat queen" images, in the mold of 1930s pinups. He had at least one of them printed for a Christmas card; it features a buxom, ostensibly female figure, her hair in curlers, arching back over the keyboard of an ornate player piano and sporting long underwear—with a convenient trap-door bottom— high heels, shiny eyeshadow, and chunky jewelry; above her in a round frame is the Victorian painter John Frederick Herring's 1848 *Pharaoh's Chariot Horses*, who roll their eyeballs as they ogle the ample bosom just below.) Fantasized spaces that carried the aesthetic of rampant excess to extremes, Perkins' Victorian rooms—campy rooms,

rooms in drag—were fantasy spaces where *he* could dream of being *she*. Of course this applied only to intimate domestic settings; public spaces, such as the barber shop or the El station, were no-play zones requiring subtler touches.

Perkins' Index watercolors had something of an afterlife. They were exhibited in New York, notably at the Metropolitan Museum of Art in June, 1941 and in October, 1942. Some were reproduced in popular style and fashion magazines. As noted, earlier commentary on late-Victorian décor (of "unhappy memory") had been ferociously derogatory, indiscriminately slinging attack words like "gobby," clumsy, tumid, atrocious, dreary, dreadful, depraved, stupid, abysmal, perverse, aberrant, brutal, and abominable (for starters). But by the late 1930s, attitudes had softened into tolerant amusement or even grudging admission that there might be *something* worth saving from the period. The 1941 Metropolitan Museum of Art show, titled *As We Were*, was a broad survey of examples of "fine craftsmanship and original design" in glass, ceramics, textiles, and woodcarvings, as well as folk art of the Pennsylvania Germans and the American Southwest, always emphasizing the "fine quality of design inherent in the objects made under the handicraft system of production." Perkins' watercolors, representing "Victoriana," were selected to illustrate American taste of the period 1860 to 1910, when "rugged individualists, driven by a restless eclecticism that knew no bounds and fled from discipline, were ransacking as much of the decorative past as they could lay hands on . . . for self-expression."

However, the October 1942 exhibition, "I Remember That: An Exhibition of Interiors of a Generation Ago," gave exclusive pride of place to Perkins. In the accompanying illustrated pamphlet, Benjamin Knotts (then the current National Coordinator of the Index) in his brief introduction sounded that new note of reluctant appreciation: "The drawings . . . are amusing, but are not intended to ridicule . . . Those of us who were brought up in similar surroundings will probably feel nostalgia . . ." Knotts also marveled that—given the overcrowded rooms and bulky clothing of that earlier period—it was surprising how much bric-a-brac had survived and found its way to second-hand dealers and "into the hands of the lady decorators." A quick aside: Perkins' bric-a-brac made a strong impression on fabled *New Yorker* cartoonist and illustrator Saul Steinberg, who had fled Fascist anti-Semitism in Europe. Only just arrived in New York, Steinberg visited "I Remember That" and found in Perkins' exuberantly excessive renderings a model for his own approach: "the pointed linking of a subject (manic overdecoration) to a suitable representational technique (the page crammed with detail from corner to corner)." In old *New Yorker*s, the ghost of Perkins Harnly lingers on.

But back to the reassessment of Victoriana: Ruby Ross Wood, one of those "lady decorators," wrote commentary to accompany a set of color reproductions from "I Remember That" in *Vogue*'s "Americana" issue of February, 1943. It may have been Perkins' finest moment in the media spotlight. In her choice of title,

Wood set the tone right away: the period 1880–1910 celebrated in the Victorian watercolors was "Acidly Ugly, but with an Engaging Charm." Careful to point out that Perkins' interiors were "shown as a record of the time, not as art," Wood conceded that the late-Victorian era "had its points. It was the pleasantest of all periods to live in, the ugliest to look at." A generation earlier, she wrote, she and fellow decorators had put on an "Exhibition of Bad Taste," selecting things of the 1880s and 1890s for their "absurdity." The prize exhibit was "a Venus de Milo with a clock in her stomach," and there were many other "choice items," including "a collection of moustache-cups, one inscribed Grandma; musical rocking-chairs; painted tins depicting calla-lilies and cattails, and so on." Everyone who saw the show thought it was "very funny." And yet within a short time, Wood recalled, "I had a number of clients who were collecting just such Victoriana. It wasn't long before I was finding a certain enchantment in it, myself. Now, that period is far enough in the past to have achieved a dignity . . . no, not dignity, but an engaging charm of its own." The charm also lay in the fact that "what with depleted incomes, and priorities, and all the exasperations of wartime," Victorian furniture and bric-a-brac was affordable, and all you really needed to do to update it was to pare away at least some of the excess: strip tassels from curtains and upholstery, rid furniture of bric-a-brac shelves and brackets, and remove rockers from chairs.

The ambivalent-yet-enthusiastic reception of "I Remember That" may have gotten a boost from the theater and the movies. According to *House and Garden*, the MGM picture *Gone with the Wind* had an almost instantaneous impact on the "American romantic trend," no doubt aided by the magazine's full-color feature of *Gone with the Wind* interiors in its "Deep South Double Number," published in November 1939, the year the movie was released to largely rapturous audiences. Then there was the celebrated actress Helen Hayes, who played the lead role in the hit production of *Victoria Regina*, which premiered in New York at the Broadhurst Theater in December, 1935, and ran for three years (including one revival). A collector of Victorian memorabilia, Hayes set about furnishing "Pretty Penny," her 1858 Italianate mansion in Nyack, New York, in proper period style. "What more natural . . . that, the role and the collections coinciding, she should furnish her house in the Victorian manner?" queried the *House and Garden* reporter who toured the place in 1936. This writer described and illustrated each of the actress' splendid Victorian rooms, ending with the bedroom, where the "crowning achievement" was the bed, "with its headboard made from a Victorian sofa." Above it was "a great gilt valance" (resembling a gigantic crown), from which hung theatrically draped "curtains of ice-blue moiré fringed with glass balls." Dead center between the valance and the sofa-headboard was a circular portrait of the young Queen Victoria herself. The accompanying photograph, shot head-on, accentuated the rigid symmetry of the arrangement and cropped the mattress so that the sofa looked like a sofa, rather

than a bed. If the illustration of the bedroom had been a watercolor rather than a photograph, it would dovetail almost seamlessly with Perkins' *Townhouse Parlor, 1869*, right down to the portrait of Queen Victoria (albeit considerably aged). By happy coincidence, *House and Garden* published an illustration of *Townhouse Parlor* a couple of years after its piece on Hayes' Nyack home. Take the polar bear rug away, and Perkins' parlor would fit right into Pretty Penny.

Hayes and her playwright husband Charles MacArthur viewed their décor much as Perkins did his: their crystal chandeliers and bell jars were "Victorian gimcracks," which they did not take seriously. On the other hand, their "fine pictures by Renoir and Degas" were Art, and the couple took those very seriously indeed. Victorian things were not art but, rather, vehicles for sentimental, psychological, or nostalgic journeys. If Hayes had been a twenty-first-century millennial, her taste for Victoriana would surely have had an ironic edge (as with a current subcultural fad for home decorating with Victorian taxidermy, preferably arrangements of stuffed animals in dramatic or humorous situations, such as kitten weddings or rabbit tea parties.) Ambivalent, amused affection did the same duty in the 1930s. ("Pretty Penny," so-called because of the couple's enormous remodeling outlay after purchasing the house in 1932, was the subject of a commissioned house "portrait" by grumpy Edward Hopper, well-known then and now for his paintings of foreboding Victorian mansions. Talk show host Rosie O'Donnell bought and refurbished the place in 1996, three years after Hayes' death, but she sold it again in 2000.)

But there is more to the story of Perkins' *Townhouse, 1869*. It was the second painting he did for the Index (the first being the rural kitchen with Perkins' artistic Bible, that is, the Sears catalogue, under the table). This red parlor, he claimed, was in a brownstone once owned by one of his dearest all-time idols: the sumptuously buxom stage star, Lillian Russell. By the time Perkins arrived in New York, Russell was long gone, and the old brownstone had become a boarding house. In 1930, Perkins rented a room there; in fact, it was that same red parlor. His descriptions of it are precise: "I forget when she died; 1922, I think. She had become very stout. Still, that wonderful face . . . she had the whole house, which was five stories, and very narrow . . . the entrance had a very fancy vestibule. And the parlor was on the left-hand side . . . The floor was green carpet, all over carpet. And it had a polar bear skin . . . which was very smart, and clean in those days. It wasn't full of moths. And the walls were red flock wallpaper, moiré watermark . . . and the windows were very tall, very tall, and they had lace curtains, genuine Victorian."

Whenever he talked about the house, Perkins gave the address as 353 West 27th Street (*House and Garden* got it wrong, saying in the *Townhouse* caption that the place was on West 23rd). That entire block has been obliterated, but there remains a photograph, in which we can see that the townhouse was part of a row in the mid-century Italianate style, with flat façades, imposing

doorways, and heavy bracketed cornices. In two of the upper-story windows, there are heaps of bedding on the sills; someone has placed them there to air out. But did Lillian Russell ever live on West 27th Street? We know that she had homes on West 43rd, West 57th, and West 77th, but there seems to be no trace of a connection with West 27th. We may be dealing with a bit of Perkins embroidery, especially since the *Townhouse* watercolor purports to represent a typical Victorian parlor as it looked in 1869—when Lillian Russell was all of eight years old and nowhere near Manhattan. The room itself was certainly real, to judge by his detailed rundown of its contents. But wait: before Perkins moved in, there was no flamboyant Belter furniture. The settee and chairs came from the parlor of his grandmother's Queen Anne extravaganza, or one of them, in Lincoln, Nebraska (or so he said).

Was there ever an actual Victorian settee in the red parlor? Perkins could have used pictures of Belter chairs and settees just as he plumbed the Sears catalogue for so many other models of bygone fashions in furniture and décor. But it seems that the settee did exist. Many years later, Perkins photographed one of his typical fantasy boudoir paintings and sent it to a friend, commenting that "The inclosed fat lady is called 'Sweet Dreams.' She is lying on a John Henry Belter hand carved rosewood settee, about 1830 [in fact, no earlier than c. 1850, but we won't quibble]. It was the first laminated wood in America. I had this piece and a pair of small pull-up chairs in my Victorian parlor at 353 West 27th St. N.Y.C. It was Lillian Russell's home . . . The settee was last heard of in the Brooklyn Museum, on loan for a show. Who ever got hold of the settee inherited tons of bed bugs to boot." It turns out that the enormous rock-crystal chandelier belonged to Perkins, too; he had bought it for sixty-two dollars at an auction of the contents from a Gilded Age mansion slated for demolition on Long Island. "It had been converted from whale oil to gas," he wrote. "I gave it to my W.P.A. Projects boss." Surely the recipient was Lloyd Rollins, the "old queer" who collected Victoriana.

Was there anything inherently queer about Victorian décor? The acclaimed Iowa regionalist painter Grant Wood—he of deathless *American Gothic* fame— was of the same stripe as Perkins and Lloyd Rollins. Art historian Erika Doss writes of Wood's "camp sensibility of artifice, exaggeration, and comic subversion that intentionally disturbed normative assumptions about taste, value, nature, and gender and sexual identity" and expressed itself in the artist's parodic send-ups of Victorian taste. Notably, Wood decorated the Iowa City clubhouse of the Society for the Prevention of Cruelty to Speakers (which he had organized to entertain visiting University of Iowa lecturers) in "the worst style of the late Victorian period," including "cabbage rose wallpaper, floral carpeting, upholstered furniture with arms fashioned from animal horns, a parlor organ, a stuffed canary under a glass bell jar, Currier & Ives prints, and cross-stitch samplers spouting sappy homilies." That same inventory might just as aptly extend to Perkins' Index interiors. And

Wood even used a beat-up 1903 Sears, Roebuck mail-order catalogue for details of everything from farm wagons to fabric designs. It's a pity that the twain—both Midwesterners—never met.

Of course, a taste for Victoriana didn't *necessarily* connote "gay." Scholar David Halperin argues that there were, and are, gay men "who are passionate and committed modernists, who instinctively hate ornament, Victorian fussiness, and period detail." Certainly Bill Alexander's Hangover House, which we'll see in the next chapter, is a vehement example of that. As another case in point, Perkins' friend Whitney Morgan was picked up on one occasion outside the Whitney Museum (no relation) by a man who invited him home to pose for a drawing (plus sex, probably). Whitney duly went along and soon after described the man's apartment on West 8th Street as "done in the Hollywood modern style" and looking like "a setting for a movie orgy, gray satin curtains, an enormous bed with a gray satin cover on it, and many modern what-nots around the wall covered with ash-trays and semi-erotic pieces of sculpture like those absurd Rodins." Whitney departed "around 11 after having had a glass of ginger ale. It was really quite amusing, and I suppose I shall see him several times more and then probably never again," he wrote.

It's hardly surprising that Whitney looked down on Hollywood modern. A New England blueblood and Harvard graduate, Whitney gravitated toward period pieces and was something of a connoisseur, so much so, indeed, that he contemplated writing a history of nineteenth-century furniture, "not a detailed history . . . but just a resumé of the general movements, neoclassic, neo gothic, Eastlake & the Pre Raphaelites, neo Renaissance & Baroque, & finally Art Nouveau and perhaps Mission." Whitney's mother was keen to set him up in the antique business and gave him a "generous allowance" to buy things for stock. Accordingly (although he never did go into the business) he purchased, among other things, "a nice box veneered in light wood . . . with an ivory knob and ebony keyhole escutcheon," and a "Victorian lamp with a curious pottery stem which looks like either a tree-trunk or a rope with fringe around the bottom." He was always on the lookout for campy Victoriana. One Sunday in 1935, he went to the Anderson Galleries to see the "'Superb Furnishings of Mrs. Cooper Hewitt' . . . There were some quite entertaining pieces of 19th century furniture one of those paper mâché tables inlaid with mother-of-pearl by which I was especially impressed." No wonder: such tables were marvels of controlled frenzy in the form of elaborate, lustrous designs overflowing with richly colored flowers and birds bordered with swags, curlicues, and lacy foliage.

But still, what was queer about Victoriana, anyway? Or, rather, why was Victoriana queer? Certainly its association with lady decorators and the like came into play. And perhaps the fact that the moderns relentlessly spurned and savaged Victorian style played a role as well: Perkins and like-minded

connoisseurs embraced all those outmoded sofas and bell jars because they—like homosexuals—were hidden away in attics (or closets), thrown onto the junk heap, reviled, and mercilessly mocked. The outrageous gay performer Liberace, for one, had an almost maternal concern for the old things that he rescued and loved. "They don't really belong to me; they belong to the world," he said. "... somewhere, somehow, they had been abandoned and not cared for. Then I came along and saw a broken chair ... or a forgotten antique that cried out to be saved." The taste for Victoriana may not have been exclusively gay, but in the 1930s and after many gay men embraced it with zeal. Victorian interiors became havens and distinctive emblems of identity; within them, it was possible to evade the censorious and often treacherous world outside and become, simply, one's own queer self. And in Perkins' case, Victorian style—dredged from the depths of his subconscious mind—in a very real sense embodied his own interiority. That was the essence of what he dubbed his distinctive "vigorous nostalgia": not simply a wistful backward glance, it was an active and ongoing assertion of his fundamental selfhood.

The Gay Thirties

I T WAS PERKINS' CORSET HOUSE—THE GIGANTIC WASP-waisted corset mashing a Victorian mansion into a pile of shapely rubble—that opened the door, so to speak, to the New York art world and widened the overlapping circles of his various social orbits. Had there been no corset house, in all probability there would have been no Julien Levy show, no Index of American Design, and in the end, no return to Hollywood (to which we'll turn in due time.) It took one singular pair of eyes—Alexander King's—to appreciate the subversive humor of Perkins' ever-so-slightly-racy fantasy. Perkins, as ever, told different stories about how their first meeting came about but hewed closest to the facts in a letter to King's widow many years after. "In the Mexican collection," he wrote, "I had a painting of Christ in jail. I took my work to my friends' studio, the Charles Weidman Doris Humphrey school. Their pianist composer, a young Jewish fellow, it may have been Aaron Copland or some such like musician . . . roared when he saw the Christ in jail and asked me if Alexander King had seen it. I had just returned from Mexico that afternoon and of course Alex hadn't seen it. I was quite familiar with King. I had purchased . . . all of [King's] *Americana* magazines. So it was the Christ picture that brought Alex and me together. He was not impressed by that . . . It was the corset around the house that struck him. He howled when he first saw it, and used it in the very next issue . . . He ditched a political illustration of his and substituted the corset which he labeled 'The Elegant Eighties.' From that time on we were inseparable." The actual title used in *Americana* was "The Gay Nineties," but close enough. And the composer was not Aaron Copland (or George Gershwin, as Perkins sometimes claimed) but Lehman Engel, a young musical prodigy from Mississippi who would go on to a distinguished career composing bouncy Broadway show tunes and serious operas.

Born Alexander Rosenfeld in turn-of-the-century Vienna, King emigrated to New York with his family in 1913 and at some point decided to give himself the more majestic surname by which he became known. In the 1920s, he became a prolific illustrator of limited-edition classics and other occasionally risqué books, including C.J. Bulliet's *Venus Castina* and François Rabelais' *Gargantua*, one illustration in the latter featuring a scene depicting the bare-bottomed giant on a chamber pot, picking his nose while onlookers hold theirs. Although King later wrote four lengthy (and often maddeningly digressive) memoirs, nowhere did he relate how and why he decided to launch *Americana*, a heavily illustrated satirical

monthly that attacked nearly every aspect of modern life, modern politics, and modern institutions, playing no favorites and subjecting all to caricatural pictorial rhetoric so caustic that one magazine editor denounced it as "unpleasantly sadistic," or so said cultural critic Gilbert Seldes, then on *Americana*'s editorial team. Other readers may have had the same objections; whatever the case, *Americana*, first published in November 1932, ran a total of seventeen issues before it folded and King went on to become an associate editor at *Life* and, in the 1940s, a morphine addict whose treatment took place at the federal government's so-called Narcotic Farm established in 1935 in Lexington, Kentucky. (Both a prison and a hospital for kicking the habit, the institution also hosted beat writer William S. Burroughs and a veritable big band of jazz musicians, including Charlie Parker, Sonny Rollins, and Chet Baker.)

Quite possibly King's inspiration for *Americana* came from George Grosz, the angry Berlin Dadaist whose coruscating caricatures of German decadence in the teens and twenties seethed with scorn and hatred. From June to October 1932, Grosz taught at the Art Students League in New York, returning to Germany only to flee the country (and its new strongman Adolf Hitler) for good in January 1933. Grosz had no teaching experience and was "still pretty much at war with the English language." When he met King, it must have been a relief to commune with a fellow native speaker and graphic artist who shared Grosz's cynical perspective on contemporary mores.

Having been involved in the creation of upstart, ephemeral Dada publications in the 1920s, Grosz may well have furnished King with a model for his own magazine. Indeed, Grosz's reputation for savage, no-holds-barred pictorial assault had preceded him. As early as 1927, his name began to appear in English-language journals. One critic extolled the way Grosz "tore the mask" from the "unclean lives" of the German bourgeoisie and military caste, shredding their "false semblance of ethics and morality" and exposing, judging, and branding the "decayed, work-eaten and lust-torn social body"; another saw the artist's drawings as "X-rays" that pitilessly revealed the "underworlds in the bodies and souls of men and women." In his memoirs, Grosz recalled that King was the "only person who took me as I was" and trimmed "neither my wings nor my fingernails: 'Scratch their eyes out, George,' he would say to me, 'the harder, the better!'" Ironically, or perhaps just oddly, Grosz trimmed his wings and claws himself; the ire that had fueled his rage in Germany quickly cooled in America. Eventually he moved to the Long Island suburbs, where he lived with his family in a two-story stucco house and tacked *Saturday Evening Post* covers by Norman Rockwell on his studio walls.

But in November 1932, Grosz's name appeared in *Americana*'s inaugural issue as associate editor alongside Alexander King's as Editor; the other associate was the aforementioned Gilbert Seldes, zealous defender of popular culture and former editor of the modernist magazine *The Dial*, where in 1922 he had published

T.S. Eliot's *The Wasteland*. The new journal's editorial statement immediately threw down the gauntlet, claiming adherence to no political party or ideology and announcing: "We are Americans who believe that our civilization exudes a miasmic stench and that we had better prepare to give it a decent but rapid burial. We are the laughing morticians of the present." The first issue was a mixed bag of relatively innocuous pictorial humor under such rubrics as "Etiquette," "Theatre," and "Modern Art" (an artist in the process of painting a Cubist abstraction while nude models with nothing to do lounge all around the studio), and harder-hitting cartoons such as the sardonically titled "Buddies," depicting a police thug with a rifle, bayonetting an unarmed veteran during the July 1932 Bonus Army riots in Washington, D.C. (17,000 World War I veterans and their families had organized a protest in Washington, D.C. to demand bonuses the government had promised but failed to deliver when they fell due; forced to vacate their camp near the Capitol, they returned defiantly, only to be set upon by the police). Grosz's two illustrations already lack the edge that had fueled his work in Germany; the best he could manage was a cartoon entitled "Genesis"—"So God created man in his own image"—representing a bourgeois couple, the man with a cigar and a cold, calculating expression, the woman with a pinched look of discontent. King himself did the cover, which depicted a glamorous socialite lighting her cigarette from one that is clamped between the lips of a decapitated yet somehow still debonair male head held aloft on a tray by a buxom African-American maid clutching a straight razor.

Interspersed with the cartoons within the magazine were satirical pieces by Seldes and his Harvard friend E.E. Cummings. Cummings' contribution was a mock debate between Herbert Hoover ("Hooses") and Franklin Roosevelt ("Boosevelt"), using majestic Biblical cadences: "Blessed are they that agitate, for they shall be clubbed. Blessed are the prosperous, for they shall be around the corner." Seldes' "Short History of a Depression" is a sequence of bitter quips: "April 6, 1930. It was all the fault of Europe. Congress continues to play with the tariff. April 20, 1930. Purely psychological . . . May 17, 1930. Prosperity fails to keep date with President Hoover. Reported eaten by bears . . . August 16, 1930: Satisfaction expressed in knowledge that this is the greatest depression in history and we are suffering more than anyone else," and so on. The inaugural issue ended with the cartoon of a legless army veteran selling pencils next to a sign that proclaims "The Army Builds Men!" The remaining sixteen issues were of the same ilk as the first.

The early failure of *Americana* may have been due to its incoherent identity. With its send-ups of modern social mores, it was a sort of louche *New Yorker* (indeed, *New Yorker* cartoonists occasionally made an appearance there); in its weaponized satire, it edged nearer the ferociously radical (and much longer-lived: 1926–1948) leftist magazine *The New Masses*, which relentlessly savaged capitalism and fascism in text and pictures alike. Perhaps the best way to describe *Americana* would be as a kind

of *Mad Magazine* before its time. It was just the right venue for Perkins' own more or less affectionate ridicule of the Victorian past. There's an irony here, too, in that he was to become involved with the utterly antithetical category of Americana that the Index of American Design would soon set out to celebrate and preserve: quilts, weathervanes, Shaker baskets, ships' figureheads.

After the corset house, Perkins' most ambitious *Americana* contribution was *Down Memory Lane*, a two-page spread featuring eight cartoons that riffed on old-fashioned popular songs. In "The Old Gray Mare Ain't What She Used to Be," a bony horse lies prostrate on the floor of a fancy Victorian dining room dominated by a massive and elaborate chandelier. "In the Good Old Summer Time" features seven blowsy Harnly whores, plus their madam, all of them be-plumed and bejeweled but wearing little else, crammed together at the window and struggling for a breath of fresh air, which will be hard to come by given the trash heap directly below them: bedsprings, a discarded lampshade, old milk bottles, food scraps, and what appears to be a rat, dead or alive, climbing or falling into a garbage can. Around the buxom figures, nightgowns, stockings, and underwear flap on clotheslines or droop from the fire escape. It is not exactly the world evoked by the original lyrics, which sing of birds, trees, and fragrant breezes.

Somewhat more subversive is "The Lost Chord," a send-up of Sir Arthur Sullivan's wistful hymn about finding, and losing, a chord of such transcendent beauty that the composer knows he will only ever hear it again when he's died and gone to heaven. In Perkins' version, a buxom woman lies drunk or simply overcome beneath a parlor organ that tilts as if there's just been an earthquake. Perkins' foreshortening is so extreme that almost all we can see is the woman's ample bottom in a pair of billowing drawers, her sturdy stockinged calves, and the worn-out soles of her shoes. Her corset laces have snapped, too, leading one to wonder if Perkins meant to throw a chord/cord pun into the mix. Whatever the case, his sendup of Sullivan's solemn and reverent song is cheeky in every way.

Equally cheeky, and more personal perhaps, is "Silver Threads among the Gold,"

Drag queen au naturel, one of Perkins' satirical send-ups of Victoriana published in Americana, *1933*

wryly visualizing the syrupy but affecting love song that promises eternal youthful devotion to the beloved no matter how gray the hair becomes or how faded the bloom; the ravages of age will never chill true love. Perkins turned all that sentiment inside out. In his lampoon, a frowsy and completely bald woman in a transparent negligee and earrings sits at a rickety Art Nouveau dressing table as she grooms her wig with a fancy brush. Her pose and startled look suggest that she has just now noticed those tell-tale threads of silver. That is the obvious absurdity, of course: wigs don't go gray on their own. But surely the cartoon also hints at something else: the bald head, minus the earrings, would fit quite seamlessly on the shoulders of a man in a business suit. The flabby body and the droopy breasts could plausibly be those of some portly old fellow as well. This might be the drag queen *au naturel*, before the corset, the wig, the trailing gown, the rhinestones, and the plumed hat have worked their transformative magic. Ancient harridan or queen behind the scenes? Surely Perkins intended such double meanings. Revisiting his 1930s work years later, he noted (characteristically) that his "campy ones"—such as the "fat lady sitting on a beef steak to draw out the pain from her sore ass"—were of a nature that "only a queen might get the hang of."

During his brief tenure at *Americana* Perkins may or may not have gotten to know George Grosz; he never mentions the ex-Dadaist in his letters or reminiscences. But King was absolutely central to his life. A photograph taken about 1930 suggests the Viennese émigré's devil-may-care charm. Squinting into

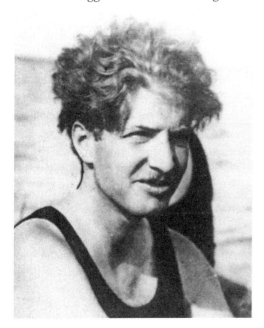

Alexander King in his youthful glory

the seaside sun in his modest Jazz Age bathing attire, he has a mop of exuberantly wavy hair and just the beginning of an impish smirk. Perkins and many others seem to have responded to what Perkins called King's "suave personality" and "magic aura." But it was King's "perverse sense of humor and daring expressiveness" that drew Perkins into his orbit. "He was often ill," Perkins recalled: ". . . I used to visit him when he was laid up in bed and then his affection came to the fore. He called me 'Dear, darling, Perky Pore' and other endearing names." Then living with Nettie, his first wife (of three), King

held court in his apartment "which was then called Grand Central Station due to the mess of humanity that hung around soaking up Alex's smart cracks and profound wit." More, "Alex was eternally surrounded by hangers on—dozens of them. He knew every bum in town and everyone else."

Through King, Perkins also became friendly with Al Hirschfeld, the iconic cartoonist whose stylishly witty images of actors and celebrities of every stripe became almost as famous as the subjects themselves. "I visited Al many times," Perkins wrote, "when he lived with [the actress] Paula Laurence. They were copycats. They served rye bread, jack cheese, and tea with lemon exactly as did Alex's two wives and mistress. It was a traditional ceremony late at night after Alex had exhausted his verbal repertoire for the evening." For his part, Hirschfeld was ambivalent about King, calling him "a swindler, thief, and hopelessly addicted dope fiend," in addition to being a marvelous raconteur and self-styled genius. Much later, Hirschfeld produced a caricature of King with his third and final wife, Margie, for the cover of their stand-up comedy album *Love and Hisses*: it shows King with his signature pink bow tie, cigarette in hand, lips pursed under the little Continental moustache, ready to launch into an anecdote, while the much younger Margie, Beatnik hair flowing, gazes at her husband with a manic grin.

Then, in the midst of the good times, everything changed: Perkins introduced Alex to Fred Becker, a graphic artist employed by the WPA and at the moment completely immersed in the New York jazz scene, which provided the raw material for his lively cartoons of hep-cat musicians. Even though Perkins recalled that it was "usually the three of us," Becker "became Alex's favorite, eclipsing me. They were as thick as two cats peeing through a straw." A decade younger than Perkins, Becker was the son of a silent movie actor and had just arrived from Hollywood. He must have met Perkins through Don Forbes, who at that time lived across the hall from Becker in "Slaughterhouse Alley," a squalid tenement on East 11th Street where chickens were butchered every morning at 6:30, their death squawks shocking tenants awake. Everyone lived there: "novelists, poets, painters, gays, alcoholics, drug addicts, marijuana salesmen" (luckily for Don), and on occasion, even ordinary citizens. Alexander King, Becker noted, was practically without formal education, but he had read everything that had ever been printed—and committed it to memory." King was "one of the great talkers of all time," and his profound influence on Becker was both "good and bad." If only Becker had gone into more detail about both.

We don't know if those close and affectionate relationships included sex, either. More likely, given King's wife-and-mistress track record, he assumed the role of worldly mentor and guide, opening doors for his younger protégés. Of course, King could have been bisexual, but there is never a hint of that in anyone's recollections or in his own memoirs. Indeed, he was something of a homophobe (which of course wouldn't necessarily disqualify him as bisexual), writing snidely

of "pansy interior decorators" who had antique shops on Third Avenue and dressed in velvet vests and high-button, cloth-topped shoes.

Despite various careers and his not inconsiderable output as an illustrator, King came to be known mostly as an unparalleled raconteur, which in the TV age paved the way for his frequent appearances on the Jack Paar show. According to Al Hirschfeld, it was at his suggestion that King parlayed an appearance on the Paar show in order to promote his first book, which, having hit the bookstores during a newspaper strike, was on the verge of disappearing from the shelves. When King made his TV debut, Hirschfeld "listened with horror to his friend's tasteless conversation. But Paar loved King and so did the audience. He became an overnight celebrity and within three weeks his book was on the best-seller list." You can still see and hear bits of the celebrated raconteur on line. On the Jack Paar show that aired on November 4, 1963, for example, King strolls onto the set, dapper and nonchalant, and launches into a monologic succession of stories: about pigeons in New York and their foul droppings; about all his female fans; about selling pressure cookers in Manhattan's "silk stocking" neighborhood only to have one of them explode while he's doing a demo in the apartment of a fetching young model; about movie star Elizabeth Taylor's terrible makeup, and so on. He has a slightly guttural voice and a pronounced Viennese accent. He often pats his hair. He frequently reduces Paar to fits of helpless laughter. King's next three memoirs also became best-sellers as a result of his TV appearances—of which the books seem like equivalents, in print: concatenations of long, rambling, and often acerbic anecdotes, one after another and another, all strung like beads on an almost endless chain. They are like chocolate truffles: a couple are delicious, but you don't want to eat a whole box at one time.

One truffle to savor, though, is King's account of Kewpie creator Rose O'Neill. Perkins introduced them to each other and supplied many if not most of the details concerning the Kewpie creator and life at Castle Carabas. King had written the piece for *The New Yorker*, but editor Harold Ross demanded so many changes that when the article finally appeared, it had been totally "devitalized." In his memoirs, King had his chance to revisit the subject. "When I first met her," he wrote, "she was a plumpish, fair-haired, pink-and-white bundle of tallowy undulance—a sort of grownup Kewpie . . . I never saw her dressed in anything but velvet, and most of the gowns she wore were encumbered with long, dust-scattering trains . . . these creations of hers were likely to be speckled with a picturesque scattering of food and fruit stains, because most of the time Rosie's pale-blue vision was so far off scanning the distant mountaintops of fairyland that she simply couldn't be bothered to keep track of such vulgar, splashy things as bean soup and prune juice." He sketched a few more details and then related an anecdote involving Rose's long velvet train, which caught fire while she standing before the hearth reciting her poetry to "twenty-some-odd assembled nitwits" who were listening so raptly

that they failed to yell "Fire!," leaving it to King to sound the alarm, whereupon Rose "with one queenly gesture swished [the train] out of the furnace. Then, quite unalarmed, more like a Spanish dancer doing a flamenco, she stepped on the still burning frills a couple of times, looked up at me reproachfully, and calmly went on with her reading." For the rest of the evening, King was persona non grata at Castle Carabas. As for the "nauseatingly cute" Kewpies, King derided them as "sexless horrors."

Also in King's social network (and, at least peripherally, Perkins') was the author, adventurer, sadist, and putative cannibal William Seabrook, who, for better or worse, was the first to introduce the figure of the zombie to American readers in his travelogue, *The Magic Island* (1929), a sensational and lurid book about Haiti, which "created the matrix of the popular understanding of voodoo" and soon spawned the first zombie movie, *The White Zombie* (1932) starring Bela Lugosi of Dracula fame as a goes-without-saying-sinister voodoo master. The theatrical release poster shows a pair of glaring green eyes and clenched green hands, and proclaims: "With this zombie grip he made her perform his every desire." That statement wouldn't be all that much off the mark for Seabrook himself. In the 1930s, purporting to conduct experiments in extrasensory perception, he lured young women to his estate in Rhinebeck, New York, and subjected them to horrendous ordeals in which they would be stripped of their clothing, masked, tied up, locked in a small cage for three or more days, and allowed to express themselves only by making animal noises. If they didn't follow instructions, Seabrook happily whipped them. Seabrook's ex-wife, writer Marjorie Worthington, dubbed these dubious activities the "Lizzie in chains" sessions.

While Seabrook had actually spent time in Haiti collecting information and observing voodoo rituals, *The Magic Island*, in the words of cultural scholar Jamie Jameson, is "hopelessly compromised by shallow patriotic shibboleths and mired in racist stereotypes, but at least Seabrook is candid about his intentions, chief among them simply to tell good stories." Alexander King did the illustrations for *The Magic Island* in the same spirit. Today, King's pictures are painful to see; nearly every one of them presents Haitians—alive or zombie dead—as grotesque stereotypes with huge bulging lips and savage or vacuous expressions; they march with Death or play jungle drums or suckle at the breasts of a corpulent horned she-devil, the "dark mother of mysteries." With their murky atmosphere and harsh flashes of light, King's illustrations convey the sense of Haiti as an isle of the dead, or, rather, the undead.

King and Seabrook became acquainted during the production of *The Magic Island*, and King took credit for "the blatant shock value of my drawings," which (credibly) had "a decided influence on the quite phenomenal sales." He had deeply mixed feelings about Seabrook, a "huge, stub-nosed, fleshy man" and a confirmed alcoholic whose 1935 book *Asylum* chronicled his eight-month habit-kicking

ordeal in a Westchester mental hospital and strangely foreshadowed King's own struggles at the Narcotic Farm a decade or so later. Already notorious for his ever more sensational tales of exotic and violent lands, Seabrook crossed the line when *The Ladies' Home Journal* contracted with him to publish installments on his next book, *Jungle Ways*, which, as King related, "all ended up in a sort of debacle. If you've ever read *Jungle Ways*, you know that in it he tells of living for quite a spell with a certain cannibal tribe a little south of Timbuktu. Well, it seems that a few of his friends had concluded a successful raid on one of the neighboring tribes and were now busy preparing some of their human victims for the festive table." Seabrook eagerly decided to participate. "He tells us in his book how he stopped smoking a couple of days . . . so his palate would be clean and receptive to the novel taste sensation. He finally tells what the human chop looked like as it slowly broiled over the flames, and in conclusion he reports that the flavor was not entirely unlike the taste of roast veal." Not surprisingly, *The Ladies' Home Journal* decided to skip that installment, leaving Seabrook in a rage. "It's an arbitrary dictatorship over man's mind," he fumed to King, who replied that one really couldn't blame the journal; it was a family magazine after all, and even if they did print recipes, there were clear (if unspoken) limits beyond which they quite reasonably would never go.

Along with *Americana*, Seabrook's *Magic Island* introduced Perkins to King before he'd met him in the flesh; indeed, for some reason he had "purchased several copies" of the book. No doubt he found Seabrook's lurid tome irresistible because of its focus on death—albeit hardly of the sort Americans were accustomed to. In some ways, he and Seabrook were brothers under the skin. King once more: "[Bill] was always fascinated by death because he was something of a necrophile." Seabrook, however, was suicidal (he finally killed himself with an overdose of sleeping pills in 1945), whereas Perkins was merely an ardent aficionado of death and all of its trappings.

In 1940, *Time* magazine dubbed Seabrook the "Richard Halliburton of the Occult." That was about right: the dashing and fearless adventurer Halliburton had been everywhere: he had swum the Panama Canal, had almost fallen out of a biplane when attempting to take the first aerial photograph of Mount Everest, and had deliberately plunged not once but twice for good measure into the Sacred Cenote of Chichen Itza—a.k.a. the Mayan Well of Death—just to find out how it must have felt to the virgins who were sacrificed there so that he could imagine and credibly describe their horrifying fate. He wrote about these and countless other exotic and dangerous adventures in a string of phenomenally popular books. (I adored his *Book of Marvels* when I was a kid; Halliburton often used the style of direct address so that you felt as if you were right there at his side, creeping by torchlight through the bowels of the Great Pyramid or attempting to sneak into Mecca in Arabic robes.) Halliburton's adventures, however, were squeaky

clean; there were no zombies, no frenzied, erotic jungle rituals, no hermaphroditic oracles of the dead. It was high adventure with no sex.

But there was reportedly plenty of sex in Halliburton's private life, and here is where we circle back to Perkins and his saturnine cousin, Don Forbes, who met Halliburton's soon-to-be lover Paul Mooney in New York in the late 1920s. Mooney, raised in Washington, D.C., had moved to New York in the mid-1920s after completing all of one semester at Catholic University. Although by 1929 he had moved on and established himself in Los Angeles, he often returned to New York, where, in 1930, he met William Alexander Levy, a Brooklynite and architect-in-the-making (because of endemic anti-Semitism in the U.S., he soon dropped the "Levy" and became plain William, more often Bill, Alexander; later, in Los Angeles, he would play a central role in Perkins' life) whose family owned a rustic getaway near Coxsackie village in upstate New York. The property passed into Bill's hands after his parents died, and with Paul as guiding light, he remade it into "The Farm," an all-male art colony where the members went nude (nudism was just coming into vogue under the pretext of physical fitness and regeneration in the open air) and, when they weren't sunbathing or skinny-dipping, engaged in various creative pursuits: painting, composing, writing (clothing optional). Fresh from "theoretically" servicing Rose O'Neill, Don Forbes visited, along with his painter friend Leslie Powell and the lyricist John La Touche. There are photographs of Mooney and his buddies posing naked in a forest setting, like transgender versions of the Three Graces. Given such activities, the name of the nearby village could hardly have been more serendipitous.

Richard Halliburton was never one of the Coxsackie crowd. Mooney met the swashbuckling traveler—whose cousin Erle founded the oil company that one day Vice President Dick Cheney would run—in Los Angeles in the early 1930s (reportedly it was L.A.; however, the evidence is scrappy, and the two may have met almost anywhere else as well) and soon became the adventurer's lover and ghostwriter. In the thirties, Halliburton with Mooney in tow continued to travel around the world, but as the decade advanced, the adventurer—anxious about diminishing sales figures and at long last yearning for a more settled life—began seriously to think about home, his own home, in California, where he could live in classic triangular fashion with lover Mooney and the latter's lover, Bill Alexander. Who better to design it than Bill, a fledgling architect who spent six weeks at maverick genius Frank Lloyd Wright's Taliesin compound in Wisconsin but couldn't afford the tuition to stay longer and worked for a short time with Raymond Hood (Art Deco stylist who was the senior architect at Rockefeller Center) and Ely Jacques Kahn, in whose offices the fledgling writer, rabid individualist, and proto-libertarian Ayn Rand toiled for several months to gather experience and ideas for her 1943 novel *The Fountainhead*, about an architect who blows up a major project-in-progress rather than compromise his vision and integrity by allowing changes to the design. Bill believed that Rand

Bill Alexander as a fledgling architect, c. 1936

had *him* in mind as the model for the uncompromising architect, but Frank Lloyd Wright was her actual source of inspiration.

Scanty training and experience proved no obstacle to Bill Alexander, who enthusiastically accepted the job of designing and building Halliburton's new house on a narrow ridge five hundred vertiginous feet above Laguna Beach. The result—completed in 1937—was a bold concrete and cantilevered steel structure poised somewhat heart-stoppingly at the very edge of the cliff and looking, from above, like a Cubist sculpture, all interpenetrating planes and delicately calibrated asymmetry. The ocean and mountain views from the huge living-room windows were spectacular, of course, and the place boasted a garbage disposal and a dumbwaiter among other technological niceties. But the bedroom wing was unique, featuring as it did three bedrooms in a row, one for each housemate/lover. Halliburton's— the biggest and fanciest—had its own bathroom, but the other two shared a single bath, situated between them. It was an unprecedented venture into what has more recently been dubbed queer space; that is, a configuration of the domestic interior to reflect and express social and sexual relationships neither defined nor confined by the conventions or assumptions underlying the middle-class nuclear familial model. What could or did go on between and among the three bedrooms is anybody's guess.

Halliburton named the place Hangover House because of the way it literally overhung the precipice. In a subtle, in-group way, the name also (possibly) alluded to Mooney's immoderate drinking habits. But the trio didn't hang together there for long: barely more than a year later (and a mere thirty days, total, in residence), Halliburton was on his way to Hong Kong to superintend the construction of his new Chinese junk, the *Sea Dragon*, and finish it in time to sail the 9,000 miles to San Francisco for the opening of the Golden Gate International Exposition. With Mooney and a crew of thirteen (plus two Chow puppies), he set sail on March 3, 1939. Caught in a deadly typhoon, the *Sea Dragon* sank in the China Sea, and

Halliburton, Mooney, the crew, and the luckless puppies were never seen again. Halliburton's parents liquidated the estate, and Hangover House was sold.

After that, Bill Alexander divided his time between New York and Los Angeles until moving to the West Coast city for good after World War II. He designed and built more houses, including his own perilously cantilevered "House in Space" in the Hollywood Hills, but eventually he quit architecture and opened The Mart, an exotic import and antiques boutique in West Hollywood where he would on occasion exhibit Perkins' watercolors. In 1939, he remodeled the emigré composer Arnold Schoenberg's Brentwood studio. The two became fast friends, Schoenberg even dedicating his *Piano Concerto, Op. 42* to Alexander in 1943. Which brings us back to Don Forbes, playing Schoenberg on his tinny upright piano in Los Angeles around 1921, years before the composer himself—having fled Hitler—settled in Brentwood, across the street from Shirley Temple. Perhaps Don taught Bill to appreciate Schoenberg during conversations and concerts at Coxsackie. Whatever the nature of their relationship, Bill Alexander and Don Forbes maintained the connection; in 1946, Bill signed on as Don's agent, and in 1947 Don was in residence, again (albeit briefly), at Bill's house in Coxsackie.

We get a glimpse of Bill's sybaritic post-Hangover life in New York in a letter written by Jean Paul Slusser, a painter (and first director of the University of Michigan Museum of Art) who carried on an extensive correspondence with William Horace Littlefield, the artist who nourished, or suffered, an undying obsession with Don Forbes. Jean Paul wrote: "Something in the nature of coincidence holds in the case of the architect, now called Alexander, who at one time was Don Forbes' agent. This gentleman . . . is extremely well known to my friend Al (you know, the jolly Austrian-American boy I wanted to bring out to meet you on a summer trip). When Al and I were passing through New York a few years ago . . . Al was invited for the evening at this man's apartment. It was a hot night in late August, but perhaps even that did not quite explain the quaint custom which obtained that evening. Each guest as he came in was asked to remove every stitch of his clothing, and did so, for the most part with enthusiasm. It was a dimly lit scene of moving and shifting torsos, with strange groupings and couplings of figures as in something imagined by Doré [Gustave Doré, nineteenth-century master of phantasmagorical nocturnal underworldly scenes]. Al is a pretty physical type and ready for almost anything; I should say he had a strong stomach. He came home at a fairly early hour, muttering something about the all-pervading smell of sweat, or could it have been of something else; anyhow he didn't like it." All that sounds risqué, to say the least. But given that Bill Alexander enjoyed being nude anywhere he could get away with it (remember the nude lifestyle at "The Farm," for starters), perhaps asking guests to strip nude for his party was routine. "Bill," writes Halliburton scholar Gerry Max, "had nicely shaped legs, and even in his eighties like to wear the minimum number of clothes required by law."

There is no record whether Don Forbes was there, or if—beyond Coxsackie—he frolicked at any other naked Bill Alexander revel. How Littlefield may have responded to Jean Paul Slusser's memory of Alexander's sweaty soirée is a mystery, too. But there is no mystery surrounding Littlefield's consuming and complicated passion for Don. The two met early in 1931 in New York at a gallery opening for an exhibition of Littlefield's recent paintings; they hit it off, and soon after, Don wrote, "I would love to come up to Boston and see you for a few days or day—I dident see enuf of you—here—write and tell me when to come—if—you can put me up a day or so—maybe I could pose as you say—cause I m quite broke—and couldent afford a hotel even for a day—I want to see you though—its hard to find people who are nice as you." Don's peculiar orthography and punctuation seem to have been deliberate; in his letters he invariably spelled "too" as "to" and spelled a few other words phonetically as well. And perhaps he just didn't like apostrophes. In any event, Don did manage to convey himself to Littlefield's apartment in an elegant red-brick Beacon Street townhouse, where he made a drawing of his host reclining in the nude. No doubt Littlefield reciprocated. What else went on is not recorded. But from that time until Don's death in 1951—and many years thereafter—Littlefield remained in thrall to the wayward would-be genius.

The only child of a Boston physician and an accomplished horsewoman, Littlefield graduated from Harvard University in 1924 and promptly set out for France, where he hoped to study and launch his artistic career. Although at one point he shared a Paris apartment-cum-studio with the printmaker Stanley William Hayter—who in 1927 founded the justly renowned *Atelier 17,* for decades a hotbed of modernist innovation in graphic art—Littlefield spent a great deal of time roaming about France with Nicholas Podiapolski, a muscular dancer who also served as frequent model. Until switching to abstraction in the late 1940s, Littlefield in his art sang the masculine body electric; his first success was a portfolio, published by Éditions des

William (Bill) Horace Littlefield in St. Tropez, 1928

Quartre Chemins, featuring six lithographs of near-nude boxers rendered in a lively linear style with just a hint of Cubist angularity. Littlefield's endeavors yielded little or no income, however, and back in Massachusetts his parents wearied of paying their son's bills and began to wonder about his sexual orientation. In June 1928, his mother Annie sent a vitriolic reply to Littlefield's most recent letter, which she had found utterly "disgusting" given "ALL THE MONEY we have sent you" only to be asked for more. And, she went on, "Who is this Nicholas—is he with you ALL the time? Does he cost you anything . . . or what is the matter—why are you so short?" Annie wasn't through: if her son was so destitute, maybe it would be better after all for him to "come back to a REAL COUNTRY where emigrants, ignoramuses &c, from Europe and the scum of the earth, can come here and make money." She signed off, not very lovingly, as "Always your loving mother but quite put out with your apparent shiftlessness."

Littlefield finally returned home in 1929 and made a promising start. Cultured socialite Mrs. John D. Rockefeller bought some drawings, and in 1931 there was the one-man show at the John Becker Galleries on Madison Avenue, where he first met Don Forbes. Littlefield was also befriended by fellow Harvard alumnus and dance impresario Lincoln Kirstein, who commissioned a portrait as well as stage sets for the American Ballet's first two productions, *Serenade* and *Mozartiana*. The portrait, life-size, depicted Kirstein standing nonchalantly, barefoot, in a hipshot pose and wearing a sailor suit with the jacket open to reveal a lean but muscular torso. Gazing pensively down, he makes an arrestingly sexy figure. Whether Kirstein liked the portrait or not is unknown, but at the time of his death it was found banished to the basement of his house on 19th Street. It went to Kirstein's heir Freddy Maddox and on Freddy's death, it was sold at auction for $13,000 to an unknown buyer.

Littlefield continued in that homoerotic vein through the 1930s and beyond. He cloaked his own ardent desires in themes drawn from classical mythology, turning out a long succession of heroic masculine nudes (and the occasional female) as well-muscled and crisply drawn satyrs, gods, and heroes, fighting, flying, or triumphing over enemies. A 1935 photograph shows Littlefield sitting before his rendering of a strapping nymph; he has high cheekbones, a strong chin, a thatch of floppy hair, and a faraway gaze. He may be troubled, too: in February, 1933, his father Samuel at age sixty-three had died of cancer; eight months later, his mother committed suicide in a pointedly gory gesture, stabbing herself in the stomach with an eight-inch stiletto. Her frantically scrawled suicide note must have stabbed her son, metaphorically, to the heart. "Maybe I have failed," she wrote. "I lost all when [Samuel] died. I can see now that I am incapable of carrying on and best be out of my son's way—who is putting his <u>all</u> in his <u>Art</u>—with what interest from <u>anyone! Alas!</u>"

More than two decades later, Littlefield's grief and anger still tormented him. His father, he said, had suffered horribly, finally starving slowly to death after the cancer

made it impossible for him to eat. It had all started with stomach ulcers, which Littlefield attributed to "the constant pattern of family quarrels" that took place at mealtimes. He laid the blame at his mother's feet: she should have been "ruled with a firmer hand." "She must have realized the situation was all of her own making. So the guilt produced her own retribution, death at her own hands." The tragic drama had "forever alienated" him from "any confidence in women . . . I cannot endure their inconstancy. I lack any respect. I am prejudiced enough to observe he gave her a square deal and she gave him a raw deal." Perhaps the calamity pushed Littlefield over the bitter edge; he came to be known and feared for his sharp tongue and bellicose critical offensives. When he attacked the character of the Kirstein protégé, Russian painter Pavel Tchelichew, Kirstein retorted: "As for his odious character, it's not a patch on yours . . . You seem to have no idea that you too can behave like an sob." And he penned such a poisonous screed to the collector James Thrall Soby that the latter shot back: "I don't know how to answer your disagreeable letter of Aug. 31 except to say that I don't agree with a word of it."

Despite their caustic exchanges, Littlefield hoped that Kirstein's support would vault him into the front ranks of contemporary art, but while the impresario commissioned a handful of other works, most of Littlefield's income came from portraits, and, for a few years, murals under the aegis of the Works Progress Administration. After serving in the army during World War II, Littlefield retreated to Falmouth, Massachusetts—where he had inherited the summer house and barn that had once been his mother's riding academy—opened a gallery and framing shop, and abandoned figuration for abstraction. When he died in 1969, he left behind more than three thousand of his own paintings, prints, and drawings. He also left reams of writing and correspondence that trace his unending efforts to understand Don Forbes and introduce his art to the world, or, at the very least, to Falmouth.

Like nearly everyone else who knew Don, Littlefield had little positive to say about him, yet—as with Rose O'Neill—could not resist his strangely, perversely powerful allure. Littlefield commented on Don's "morose and sardonic manner," his "abrupt talk" consisting of "wandering exposition[s] of involved observations without rational bounds" and non sequiturs blurted out of "emotional necessity." Worse, Don was "extremely self-conscious, awkward in strange company, whom he viewed as potential enemies to be treated circumspectly with ingratiating politeness, while his friends could be safely abused . . . Sensitive to pin-pricks, he liberally dispensed verbal brick-bats, lacking all self-awareness." He could be scary, too: "Forbes has a mysterious power, a kind of terribilità . . . so intense it can seem frightening." Yet Don see-sawed constantly between "grim exaltation and devastating doubt" and—never moderate, always extreme—"insisted upon trying out every possible sensation including heroin, flagellation and sodomy, only to find his body had conformist scruples, intolerances."

He also attempted suicide, at least once, in 1938. Whitney Morgan reported that "Don is in the psychopathic ward at Bellevue as a result of having drunk a

tumbler-full of bichloride of mercury Wednesday evening. He had been drinking a lot and had already taken the stuff and was vomiting it up when Bruce [Elliott, another friend, a photographer] called on him late in the evening. Bruce . . . made him drink milk which is supposed to be an antidote for practically everything, I believe, and then somewhat against his will took him to Bellevue as soon as it became light." Several in Don's circle, if it could be called that, were convinced that the suicide attempt had been "directly caused by psychoanalysis," surely not an intended result of the process, unless it had forced Don to face repressed traumas, or to discover something intolerable about his mental and emotional makeup. Monroe Wheeler also weighed in: "I am horrified to hear that Donald Forbes is being psychoanalyzed," he fulminated, "the more so because Freud himself said that it was extremely dangerous to tamper with the artistic temperament, and that in normalizing the emotions the creative impulse is often destroyed." Wheeler, then Director of Publications at the Museum of Modern Art and soon to be the first Director of Exhibitions there, added that he considered Don to be a "man of prodigious talent—probably America's best contemporary Expressionist painter."

Could Don have stood tall in American art history as a major expressionist? Certainly for a spell he had Monroe Wheeler's attention; Wheeler purchased Don's portrait of his mad Nebraska mother, commissioned a portrait of the poet Glenway Westcott—Wheeler's lifelong partner—and included Forbes' portrait of José Limón in his 1942 MoMA exhibition *20th Century Portraits*. If that was Don's moment, a moment that may have led to more than a toehold in the art world, it was so fleeting that it left not a trace. Perhaps Don chose the wrong moment to fling one of his manic tirades in Wheeler's direction, or Wheeler reassessed Don's talent and potential. The Limón portrait was in MoMA's collection in 1942; it was later deaccessioned. There is no record of the Glenway Westcott portrait, if Don ever even began it. But his work could be powerful.

Not surprisingly, Don was drawn to doomed beauty and tragic figures from Greek mythology. Commissioned by Littlefield in the mid-1930s, he painted the death of Adonis (and a companion piece depicting Venus mourning her lost love, gored by a wild boar); the metamorphosis of the murdered Hyacinthus from whose blood bloomed the flower that bears his name; and Orpheus, or rather his decapitated head (a self-portrait), floating down river Hebrus upon his lyre, bound for the island of Lesbos. Don rendered them with bulky torsos and contorted limbs (except for Orpheus, of course, who no longer had them), livid flesh, crude dark contours, and turbid hues, as in the figure of Adonis, whose bluish body is set off by heavy folds of smoldering wine-red drapery. As one of Don's very few commentators noted, "His is not the light of the sun . . . his normal atmosphere is that of tragic shadow." For good measure, this critic threw in "almost gangrenous colors" and the sense of a "strange sickness" that Don's paintings seemed to exude.

Symbols recur in many of Don's works: anvils, anchors, broken wheels, millstones, chains, and bells, all of them suggestive of inhibitory, repressive, or hostile forces: anvils and hammers to beat molten metal into shape, millstones, anchors, and chains to break, confine, and constrict, broken wheels stuck in mud, bells to sound alarm. The title of one lost painting, *Blocked Passage,* says it all. Even Don's landscapes were fraught with psychic gloom. In *Forest Edge,* which Whitney Morgan gave to the Worcester Art Museum, the foreground is an inchoate swirl of autumnal leaves, rocks, and water; farther back on the left are muted yellow tree trunks surmounted by clouds of dingy green foliage. Opposite them is the startling apparition of a rusted locomotive engine, green tendrils encroaching on the cowcatcher, smokestack, and boiler. So dark it is like a stained-glass window at twilight, *Forest Edge* is, perhaps, a glimpse into Don's own troubled interior.

Like Bill Littlefield, Don also produced a number of homoerotic nudes in the 1930s. Littlefield described one of them—*Standing Male Nude (Ralph)*—as a work that transformed the model, a "rat-faced" German sailor, into Don's "favored type of squarejawed muscle man . . . [a] gangster type." And indeed, Ralph in Don's rendering is a confrontational figure who pulls at a tobacco pipe and glares out at us. He has a heavyweight boxer's (or gladiator's) hard, thick body, built up with slashes and blobs of mottled reds, greens and yellows. As it happens, the photograph on which Don based his portrayal still exists, showing Ralph Amman standing nude in the same pose, in front of a flowery curtain. Ralph is hardly "rat-faced," although his features are softer and rounder in real life; in the painting, Don gave him a bulging square jaw, brawnier muscles, a considerably more impressive penis, and a forbidding glare.

Even Don's still-life paintings could be threatening or at least unsettling: *Roses Around the Pit* (last seen on the art market in 2019) sounds innocuous enough until you realize that the flowers are scattered around the edge of a hole in which someone, or some *thing,* has deposited a turd. Less scatological but no less disturbing is a still life Don produced while employed by the Federal Art Project of the WPA. It is a collection of what at first seem like all-too-familiar clichés, easy to decode: a watermelon, a banjo, a polka-dot bandana, and a paddle-wheel steamboat, together signifying the old moonlight-and-magnolias South, cotton culture, and the legacies of slavery. It almost seems as if Don's painting is an uncritical celebration of all that, until you notice the thick rope—suggestive of a lynching—hanging like a snake from a tree in the background and realize that it is an excoriation.

Don's friends—Littlefield chief among them—worked tirelessly in the 1930s and 1940s to promote his work, secure him shows, and connect him with cultural power brokers like Monroe Wheeler. But their efforts resulted in few gains for Don over the long term; a handful of his paintings entered museum collections but seem almost never to be on view (and others, like the Limón portrait, may well have been deaccessioned). Perhaps it was simply the wrong time: when

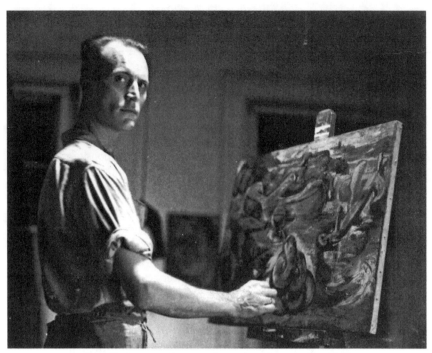

Don Forbes at work on a snake-and-anchor painting, 1937

Alfred Stieglitz, that avatar of modernism, happened to see a few examples of Don's work, he reportedly expressed his surprise "'that anyone should be painting like that <u>today</u>.'" Or, equally likely, Don's self-identification with the murderer Raskolnikov—protagonist of Fyodor Dostoevsky's *Crime and Punishment*—made it impossible for him to move in any one direction. As Littlefield put it in his convoluted way: "The thesis of alternates of equal validity, thereby producing inanition and inertia, or inability to decide to do anything, make self-realization into an extremely complicated and infinitely desirable substance of things hoped for and forever seemingly denied." In other words, "self-destruction" became the ultimate and only possible "self-realization." Or, as Perkins put it, Don was "like a dog sitting on its balls and yelping from the pain but too lazy to get off."

There are photographs of Don that trace the arc of his later life and career. In one, from 1937, he stands at an easel working on one of his anchor paintings, which has a coiled snake in the foreground. Tall, bony, and balding, Don, at home, is in his rolled-up shirtsleeves. He looks out at us with a solemn expression; he has prominent cheekbones and a piercing gaze enhanced by the dramatic lighting. In another from the same session, Don has turned back to his canvas; we can see his paint-spattered apron in this one and get a sense of his surroundings: a curtainless window, a battered wicker armchair, and what looks like a bottle of Chianti appropriated as a candle holder, in true Bohemian fashion. Then we jump

to 1946, when Don has finally made it back to Mexico almost for the last time. Hands in pockets, he slouches in front of the Orizaba church in Boca del Rio, casually dressed, fedora deeply shading his eyes. In the last, taken around 1947 or later, he sits outside, perhaps on a terrace, and turns from the easel to meet our eyes, but there is something blurry about him, and the painting he's working on is an innocuous portrait of a young woman; there are no snakes, chains, anchors, or musclemen to be seen. He is much balder now. He has four more years to live.

Don Forbes lived a chaotic, intemperate, and needy life in the 1930s and '40s. He painted hard, drank hard, and partied hard. He also read Melville and attended performances of avant-garde operas, notably Virgil Thomson's *Four Saints in Three Acts*, with a libretto by Gertrude Stein, an all-black cast, and cellophane sets by the oddball socialite Florine Stettheimer. Don's verdict: "perfectly swell." Aside from such pithy nuggets of cultural criticism, his scribbled letters almost invariably include importunate pleas for money, just enough to tide him over—till the next letter. He lived in a dizzying succession of slummy apartments and fleabag hotels in New York and elsewhere; according to a list compiled by Littlefield, Don had in excess of forty changes of address from 1929 till the time of his death in 1951. For a time he settled down in the Chelsea Hotel, later renowned for having welcomed so many famous characters, Bob Dylan, Allen Ginsberg, and Andy Warhol's Factory regulars among them. In 1940, he was living "in a basement room in a rather sordid old house full of tipsy old ladies who run up and down the corridors with thundermugs [chamber pots] and for whom you some times have to unlock the door because they can't find the keyhole." But Don was a resourceful decorator no matter how lean the budget. As Whitney Morgan reported in 1934, "Don's room is very amusing just now. He has put up valances of fringed funny-papers along the mantle and shelf over the wash-bowl and has rolls of player piano music as window shades and has ceiling lights draped with black festoons and artificial roses. He has bentwood chairs of the sort Corbusier likes and there is a shelf made of fancy pressed paper to hold combs and brushes beside the mirror. Suspended from the top of one of the window sashes there is a gilded wooden cupid who is hanging by one foot from a gilded wood drapery."

Victoriana aficionado Whitney Norcross Morgan was among the small clutch of loyal (and often beleaguered) friends who supported and somehow tolerated Don. Ten years younger than Bill Littlefield, Whitney too was a Harvard graduate who had moved to New York to find a niche in the art world. During the 1930s and 1940s, he worked at a number of commercial galleries before finally settling down as a librarian in Hartford, Connecticut. Based in Worcester, Massachusetts, the Norcross branch of Whitney's family ran a successful—even distinguished—construction company that built Henry Hobson Richardson's masterpiece, Trinity Church, in Boston and also my own alma mater, the ornate and majestic French Renaissance-style B.M.C. Durfee High School in Fall River, Massachusetts,

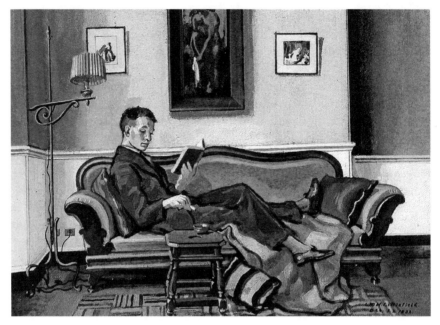

Whitney Norcross Morgan looking professorial in Bill Littlefield's 1932 portrait

where I used to sneak up with a skeleton key to the bell tower to play the carillon. No businessman and certainly no builder, Whitney shuttled from one job to the next, sampling New York life and culture from top to bottom; his voluminous correspondence with Littlefield paints a rich picture of life and culture in the predominantly gay community that made up his world.

Littlefield's 1932 portrait of Whitney depicts him as a bookish introvert reclining in a lavender-gray suit on a dusky pink Victorian settee. With a somewhat quizzical or supercilious expression, he holds an open volume in one hand and taps his cigarette over an ashtray with the other. He seems to be a connoisseur of Americana: in addition to the sofa, there is a colorful geometric hooked rug on the floor, and behind him a wrought-iron floor lamp that looks like the product of an old-time forge. On the wall above hangs a large painting of a dark-skinned near-nude athlete of some sort: a clue to the sitter's sexual orientation, which is further confirmed by Whitney's red necktie, at that time a covert signal of gay identity. Don Forbes did a Whitney portrait, too, a closeup in which the subject has a pensive look, eyes magnified by a pair of round spectacles of the sort we associate with 1920s intellectuals and businessmen. In Bill Littlefield's papers there is also a tiny 1930s snapshot of Whitney reading a book at home in his New York apartment amongst various antiques: a pair of American Empire side chairs, with curvy crest rails and splats, a pedestal table, and what looks like a country-style neoclassical bureau with round wooden drawer pulls. There are pictures on the

walls, but they are too blurry to make out. All together, these portrayals illustrate Whitney's persona, described by one acquaintance as "interesting, professorial, like an Oxford Don, yes like . . . a Dickens character."

Shuttling from one job to the next, the professorial Whitney sampled New York from top to bottom; his voluminous correspondence with Littlefield paints a rich picture of life and culture in the predominantly gay community that made up his world. Verbose and opinionated, he kept up a running commentary about all aspects of his gallery jobs, every art exhibition, every performance, and every movie he saw. To relieve the tedium of dealing with fussy buyers who wanted to coordinate their art with their sofas, he made mildly subversive interventions, as when he "spent quite a long time one afternoon trying to persuade a lady who was buying bird-prints into selecting ones representing buzzards, vultures, hawks, and eagles, but with no success for she finally picked out a collection of hummingbirds, parrots, and pheasants"— the better to complement her no doubt flowery chintz-covered living-room décor.

In October 1938, Whitney reported that he had gone to see Pavel Tchelitchew's stupendous 1938 *Phenomena*—a lurid pictorial epic (now in the Tretyakov Gallery in Moscow) in which the Russian artist's lover Charles Henri Ford appears as Spider Boy and composer Virgil Thomson as a limbless human torso, along with actual circus performers like Mushroom Head and Bird-Girl—and "didn't care for it at all. Very crowded and confused, and harsh and disagreeable in color." The painter redeemed himself, somewhat, with a "rather interesting series of bedroom scenes with nude leopard-spotted boys lolling in spring rockers and women in incandescent pink nighties . . . sitting on lace-tangled red plush sofas." It is a bit puzzling that Whitney so intensely detested *Phenomena*, given that he himself also went to freak shows—in the 1930s, the 14th Street freak show was still a thriving attraction—and collected photographs of notable freaks such as the celebrity midgets, Major Atom and Nellie Keeler, "age 12, height 28 inches, weight 12 pounds . . . sitting in a swing which is covered with rose vines." Whitney cultivated a fascination, too, with hard-boiled crime stories and gruesome murders such as that of ten-year-old Grace Budd, victim of the serial killer Albert Fish, who cut her body into bite-size pieces, the better to savor them for his dinner.

Whitney was a voracious if (inevitably) critical consumer of movies. Instead of being swept away (like most of the many millions who saw it) by *Gone with the Wind*, he found the epic blockbuster "too long" and laden with "many cheap effects . . . silhouettes against gaudy sunsets, etc." Another time, he took Don Forbes to the vast and opulent Roxy, the so-called Cathedral of the Motion Picture, to see the movie version of the 1916 runaway hit musical *Chu Chin Chow*, a sumptuous Orientalizing fantasy based on the tale of "Ali Baba and the Forty Thieves" and replete with every imaginable cliché about the East. Nonetheless, for Whitney, it fell far short: "I found the film very dull. As I told Don, the producers had done nothing to the Oriental subject matter to bring it home to Western audiences.

There were no brass beds, which I understand are such a feature of Royal residences in the Near East nor bad Baroque decorations. Also curiously enough no eunuchs were for sale in the very elaborately staged slave market scene."The theater itself—not even a decade old in 1934—also disappointed: it was "now rather tarnished but still just as vulgar and ugly in that inimitable Jewish way," he wrote. Here, almost needless to say, but it must be said nonetheless, we get an unpleasant glimpse into the ingrained anti-Semitism that infected Whitney and the rest of his class. That, of course, didn't prevent him from enjoying (or not) all the Hollywood films that came out of studios established and run by Jewish moguls.

Whitney and Perkins went to movies together, too, one time along with Whitney's friend (and probably lover-of-the-moment) Jesse, an erstwhile blacksmith from Minnesota who was now a busboy at the budget cafeteria, Bickford's. Whitney reported that Perkins "got along fine with Jesse as they had so much restaurant experience in common." Whitney's taste in busboys meshed with gay cafeteria culture: as scholar George Chauncey has described it, these eateries, including the famous Automat, were popular among homosexuals, who in such places felt free to "'let their hair down' . . . and meet other gay people who accepted them as gay." Indeed, in Whitney's world, it was hardly unusual for working-class gay men—elevator boys (as Perkins had been), cooks and waiters, laundry workers, sailors—to consort with educated if not always affluent elites, aesthetes, and assorted bluebloods. Such types seem to have been very much to Whitney's taste: in 1937, he went to an opening of Tchelitchew portraits at Julien Levy's gallery, where he enjoyed several images of "pretty elevator boys."

Artists like Bill Littlefield also sought out well-built working-class men to pose for them, but (as with the old cliché about studio shenanigans involving female models and lust-crazed artists) there may have been more to it. In 1930, Littlefield's friend Pat Codyre, then working at the brand-new Museum of Modern Art as curator, sought out potential models for Littlefield's boxer and wrestler subjects. "Listen do you want this Nat Susskind or not—I think that you would find him okay. He is not the bruiser type, rather poetic looking, heavy mop of wavy black hair." Codyre also offered a couple of prize-fighters; one of them was "exotic enough" to love Oscar Wilde, but the other was "a mere pug just looks blood and fists, and Heaven knows what else." (Codyre left MoMA under a cloud, joined the Communist Party, was expelled, joined the merchant marine, and drowned when his ship went down in the South China Sea.)

There is no evidence that Perkins and Whitney were anything more than friends, but Whitney took an interest in his career and even entertained thoughts of editing Perkins' "Bella Flower" manuscript—the name being among Perkins' labels for his curvaceous Victorian whores (or drag queens) lounging in their boudoirs with boxes of candy and pictures of sailors. Whitney found that he couldn't stick to it: " . . . it needs to be changed so much that I don't quite feel like undertaking it. The narrative

is very confusing and there are no breaks to indicate change of scene, etc. and much of it seems rather dull and meaningless. But it really is quite a good idea and has occasional very grand passages." Perkins made various attempts at novel-writing, all of them riddled with the same problems Whitney pointed out. Whitney also took an active and less judgmental interest in Perkins' artwork and brokered an appointment with Monroe Wheeler, who liked the drawings and watercolors "very much and took Perkins' name and address. We took a few theater interiors, 8 of the Bella Flower illustrations, about a dozen of the popular song pictures, and few Mexican Saints, etc." Nothing came of it in the end, however.

But Perkins was in the end peripheral to the periphery of the Whitney Morgan-Bill Littlefield circle. Like so many others, Whitney was more strongly drawn to the enthralling, tempestuous, and infinitely, pathologically problematic Don. Whitney's letters to Bill Littlefield make frequent references to Don and the things they did together. They went on long walks, one time strolling after dinner through New York's market district; Don liked "the piles of peach baskets . . . and curious lumpy bags of vegetables, the lamps and stoves . . ." Another evening, they walked over the East River to Long Island City and "through that romantic territory of vacant lots full of abandoned machinery & old carts & automobiles . . . Don was very much taken with it and spoke of going there to draw." Wherever he roamed, with or without Whitney, Don gravitated toward all things junky. Littlefield explained that perhaps this was "an extension of childhood when [Don] stole and collected things from trash heaps in alleys, string, tin foil & parts of mechanical objects . . . machinery and all kinds of hardware fascinated him no end. Hardware stores he found entrancing, and the ruins of massive masonry absolutely enthralling."

Whitney was one of the few friends whom Don didn't attack with his signature verbal brickbats. But the unruly and wayward Nebraskan could at times—many times—be an embarrassment, to put it mildly. Once, as Bill Littlefield told it, Whitney took a college friend to call on Forbes and was "somewhat chagrined to find him in bed with a large negro . . . Whitney was somewhat put out and lectured [Don] severely . . . he might at least try not to be so . . . unregenerate and be nicer to people he doesn't like that might buy his pictures." Littlefield added, "For a while I felt threatened by a visit from said Forbes which I hardly think I could handle without having a whip around as he enjoys persecution so much, and that would be bad for me (to hell with him)." Once Don visited Whitney in Worcester, where the latter—an only child—periodically retreated to see his mother. It did not go well: "Doubtless Don has told you about his visit here with me and its abrupt end. The sudden change from sex, anarchy and pessimism back to gardening, birdlife and sound Republican sweetness and light has been a difficult adjustment for me and today for the first time I feel at all calm." Why Don left so suddenly Whitney didn't explain.

Don could contrive to be less abrasive on occasion: in 1938, he spent a weekend at the home of Marian Willard, an affluent New Yorker who as a young woman had attended pioneering psychoanalyst Carl Jung's lectures in Switzerland, where she also discovered the art of Paul Klee. Klee exemplified what Willard sought: "she looked for 'a personal statement as well as a vision of the universal.' A guidepost, she said, was the kind of 'probing into the unconscious' that she found in the painting of Paul Klee, the writing of James Joyce and the psychoanalytic research of Carl Jung." The East River Gallery (later the Willard Gallery) she established in 1936 was meant to put those guiding principles into action by offering a "place for nurturing 'the creative spirit' of an artist over a long period of time regardless of the pressures of the marketplace." Among the dozens of artists she showed at the gallery were the Pacific Northwest mystics Mark Tobey and Morris Graves, the sculptor David Smith—whose caustic antiwar *Medals for Dishonor* debuted there in 1940—and Don Forbes, early in 1942.

Possibly heeding Whitney's admonition, Don during that weekend getaway managed to be nice (or not rude, anyway) to Marian Willard; she commissioned at least two portraits. One of them Don completed during a weekend at her parents' Long Island country house, which offered a dramatically different environment from Don's invariably squalid surroundings. Whitney described what went on: the house, completely empty, was "a full size copy of the chateau of Meudon," which Miss Willard (as everyone called her) eschewed in favor of the "little gate keeper's lodge . . . full of Klees and Kandinskys and books on art and psychoanalysis." Over that weekend, "Don painted another portrait of her . . . and said it was very strange and that he couldn't tell whether she liked it or not. When the maid saw it she said 'Why, Mr. Forbes, I thought you were a painter.'" Maybe the portrait was unflattering, or maybe it turned Miss Willard into a genuine fright, like the portrait of Don's mother in his 1942 one-man show at Willard's gallery. *Newsweek* commented that "the most striking oil" in the exhibition was that selfsame portrait of his mother, "a hard-bitten, stringy-haired farm woman painted from memory." Don had one more exhibition, a memorial show, at the Willard gallery in 1952; this time the *New York Times* described Don as a "tragic artist," which indeed, by that time, he was.

In the 1940s, Don gradually fell apart. He had been in, then out, then again in the WPA Federal Art Project, mostly, it seems, proposing murals that were never realized (although he also somehow managed to produce a considerable number of paintings, which likely ended up in dumpsters when the tide of critical and institutional taste turned toward abstraction). When the focus shifted to war work, he became a welder in a defense plant, "on the difficult 'swing' shift" which meant that he had "little time to do any painting." However, his 1942 Willard Gallery exhibition resulted in an unexpected windfall: a Mrs. Effie Moud, Superintendent of the State Home for Dependent Children in Lincoln, happened to read the *Newsweek* review and eventually discovered that Don was, in fact, Emery Abraham Forbes, who when he fled Nebraska for California "had left behind, in a trust fund, a

sum of money he had earned by working on a farm." Down to his last quarter, Don learned of the "$200 awaiting him at the Lincoln orphanage for so many years."

Of course the two hundred dollars were soon exhausted, and Don scraped along, working at a small manufactory doing carpentry, drinking too much, and borrowing money from long-suffering friends. In 1946, though, he traveled to Mexico, thanks to Bill Alexander, who seems to have covered most if not all of Don's expenses. Don wanted to see Fernando Felix "once more before I kicked off" but soon found that they now had almost nothing in common. Felix had become more and more respectable and bourgeois; Don had in equal measure become an embarrassing bum in Felix's

Don Forbes looking out of place in Mexico, 1946

eyes—and an "ugly toothless drunken" one to boot. Their alienation reached the breaking point when the two were walking along a street in Mexico City and "happened to notice a stunning new all white giant English auto and [Felix] suddenly said peevishly 'how come you never made more of yourself?'" and proceeded to answer his own question: "'its because you drink and use dope and automatically disagree with anyone who offers sensible advice.'" Don answered in kind: why had Felix become "a distinguished looking old queen living off his friends and not doing a thing but occasional cruising and talking about queer people and their endless tiresome affairs—a fellow who used to

have sense, wit, and vitality." Felix left, leaving Don with the suit he had pressured him to buy in a futile effort to civilize him; for his part, Don declared, "I am sorry I ever got the suit." There is a photograph of Don wearing it, somewhere in Mexico; stiff and sullen, he looks like a businessman who has been mysteriously teleported out of his office into a strange land and has no idea where, or who, he is.

Before the rift, Don had stayed in an apartment with Felix and a roommate nicknamed "Nacho." Noting that Nacho was a "sort of conscious 'Beauty'" and "nuts about English portrait painting and Chippendale furniture," Don portrayed him "like a kept boy of the late 18th century . . . like an enlarged miniature." Don didn't think much of the result: ". . . it stinks it doesnt even look like him . . . thank god its

over." Don was a great deal more enthusiastic about his large canvas depicting an Aztec "victim ready for sacrifice, dressed as a god . . . They would feed and amuse a guy they had picked out, for a year, then they would let him have a fine orgy with beautiful dames, liquor, music, etc. and finally . . . sacrifice him by ripping his heart out," as he described it with perhaps a bit too much relish. The picture, he went on, was "a great heavy legged young man squatting in a formal posture—all covered with feathers and jewels." The imagery must have been coded in some fashion: Don wrote that "ordinary art lovers' would find it corny." His naked figures, he went on, "give me away, which kills my work with normal people. They might think I'm a purely pornographic painter . . . have to sell that sort of thing to a special audience." What the giveaway was, only Don knew, though possibly, or in part, it had to do with his "penchant for fat men," as Perkins put it; his letters about Don are peppered with references to his cousin's taste for "messy fat-assed queens."

Despite knowing almost no Spanish (and refusing to learn more), having dental problems (only five upper teeth remaining, which does not speak well of his Russian-born dentist, whose patients had included Vladimir Lenin), and not being able to find a safe and steady supply of marijuana, Don loved Mexico with a passion. "This country is like a big living permanent exhibition," he wrote. "Suddenly you come upon a completely 'out of the world' scene or a complete change of climate, landscape, costume, music—a couple of hours away." Even in Mexico City there were thrilling sights: " . . . right outside of this building where I live is a market, hundreds of barefooted people some in blankets and peasant clothes . . . all kinds of hats on women and men milling around selling . . . selling everything fruits, flowers, meat, second hand stuff . . . and all cooking, eating, drinking, sleeping, shouting at each other—while automobiles speed thru the confusion . . ." This sounds almost like a guidebook paragraph, but Don's ardor was real. In the end, though, even Mexico was no substitute for his lack. He got lonesome, he said, "but then I always was I guess. I never met the one I want, and it looks like I never will—I just keep on living because I can't help it."

Don had gone to Mexico, he wrote, to live and paint and "to get rid of some ghosts." Ever haunted, he more than likely brought them back with him to New York. But there, he finally met, if not the one he wanted, the one in whose company he would spend his remaining feckless years. This was yet another Bill, last name Hunter, whom Don had first encountered at Bill Alexander's Coxsackie hideaway. The two somehow bonded on the instant, possibly because each recognized something of himself in the other. According to Whitney Morgan, Bill Hunter "was then a dancing teacher at Arthur Murray's or some such place, but had previously been in the theatre wing or whatever that organization was that used to send entertainers around to amuse the soldiers during the war. I rather think he'd been in the Philippines or other places in the Pacific in this connection, and that he was discharged for bad behavior. Before that, I think he may have been a chorus boy."

Don had made plans to visit acquaintances in Provincetown, but his attraction to Hunter was so strong that he "didn't go . . . after all. Apparently he and this Bill Hunter are so happy together down at Coxsackie that [it] make[s] Bill [Alexander] and other people he brings up there feel rather uncomfortable and unwelcome." Eventually, the two moved back to New York and began living together in a sequence of cold-water flats from which they were regularly evicted for non-payment of rent; Whitney reported early in 1948 that they were "Living very uncomfortably . . . at 717 Second Avenue. The place is heated by an oil stove and they've not been able to get kerosene lately, waterpipes frozen etc etc." Hunter found what was undoubtedly very temporary work reading to a blind lady, while Don tried to create pictures of cowboys that he hoped to sell to magazines specializing in tales of the mythic Wild West.

But Hunter had another skill: puppetry, which he somehow leveraged to get a job at Marble Hall in Rye, New York, a "keep-fit coop for well-to-do middle aged Jewesses," as Whitney described it; Hunter in turn "persuaded them they should have an art teacher." Marble Hall, which Don and Hunter derisively dubbed the "milk farm," was a sixty-room Renaissance-style mansion on the shore of Long Island Sound and said to be "one of the finest country homes in America," boasting a two-story ballroom complete with its own organ, and such opulent touches as crystal chandeliers, gilt wall sconces, and massive fireplaces. It was, supposedly, a legendary place, constructed for rubber barons early in the twentieth century and then purchased by movie mogul Jack Warner, who allowed "the house and its scenic grounds" to be used as locales for the filming of Alfred Hitchcock's 1940 film adaptation of Daphne Du Maurier's moody thriller, *Rebecca*. Unfortunately for that romantic connection (or confection), Albert Warner, Jack's brother, bought the place from the president of the American Metal Company for two million dollars in pre-Crash 1929, and anyone who has seen *Rebecca* can tell you that Manderley, the mysterious De Winter mansion, is a dark and brooding Gothic pile rather than a light-filled classical villa with formal gardens and tennis courts. When Hunter and Don went there, it had only recently been converted into a spa; a postcard from 1953 advertises the place as a "Modern Dream Castle," beckoning oversize tired ladies to "RELAX . . . to REDUCE . . . to BUILD-UP . . . or simply to get away from it all."

That last blurry Don photograph was taken at Marble Hall. He is probably suffering from an advanced case of ennui. Whitney wrote that Don was "pretty bored" out there on Long Island: "No one is really interested in painting there. He had 12 puppets 2 feet high, all portraits of people on the staff, the heads cast in plastic wood." Every Wednesday and Saturday he and Bill Hunter did "this same little play." It never got more exciting than that: months later, Whitney visited Marble Hall to find Don "giving 4 women painting lessons & Bill was giving 8 women canasta lessons." More and more, when he did have a chance to think about the course of his artistic development, Don was tempted to go totally abstract: he wrote that he loved Hans Hoffman and Willem de Kooning even though he had a long way to go

before he could measure up to them. Standing in his way was his current occupation: "I am so god Damn busy with this job—teaching amateur women painters to paint very corny pictures at this milk farm—also nursing myself—an[d] my ulcer, lousy break." By this time, Bill Hunter was on the road with his marionette show; Don complained that he hadn't seen "anyone" for ages. The ulcer proved his undoing. Sometime in late September or very early October, 1951, Don underwent surgery to remove it—probably along with half his stomach in those days before medical science figured out better ways to treat the condition. Don seemed to be recovering well, but on October 4, he died of a pulmonary embolism.

The aftermath was as chaotic, and inconclusive, as Don's life had been. Although Don had lived mostly at Marble Hall, he and Hunter maintained—if that's the right word—a rundown fourth-floor walk-up apartment on East 39th Street. The power had been switched off after a fire and never restored: what electricity there was came from "a fixture in the hall" someone had tapped into. Needless to say, perhaps, neither Don nor Bill Hunter kept up with the rent, and after Don's death, the landlord ordered an eviction. Everything they had there was dumped on the sidewalk, hauled to a warehouse by the Bureau of Encumbrances, and auctioned off. Whitney, along with Hunter, bought the lot for $15.00, for many years keeping "that horrid little chest of drawers . . . and the sketchbook and a blanket which says Hotel McAlpin on it." Hunter somehow got possession of various personal papers, including a sketchbook and a photograph of Don's mother, but "in a drunken moment left [them] in a barroom"; they were never recovered. As if Hunter wasn't already sufficiently soused, after that episode he "started drinking heavily, transforming Forbes' Memorial Show at the Willard Gallery . . . into a wake," an Irish one presumably. The brief catalogue essay was written by one Christopher Lazare, who in the 1940s was the occasional lover and, apparently, full-time drug pusher for Klaus Mann, son of Nobel laureate Thomas Mann and an author in his own right, who in 1949 died of a sleeping pill overdose in Cannes. Lazare was said to have returned to Vienna, where he either did or did not commit suicide. Hunter drifted west, ending up in California, where he kept on drinking.

Bill Littlefield worked doggedly to round up Don's paintings and compile biographical materials for the book he never wrote. "The more I document him the more baffled I get," he complained. "What one has of his life are bits and pieces, fragments, not what the French call 'oeuvre' . . . Each day I hopefully take up more letters to transcribe and by late evening feel dispersed, helpless and hopeless about it all. It seems as if the very facts melt away." It might be just as well that Littlefield didn't ever finish it, since he tended to become deeply tangled in psychoanalytical theory in the attempt to explain Don and went on for pages about introverts, extroverts, integration of personality, and symbolical self-destruction as self-affirmation. Maybe the best way to summarize Don is to heed one of his own favorite quips: "When the book of life is closed, it was that kind of story."

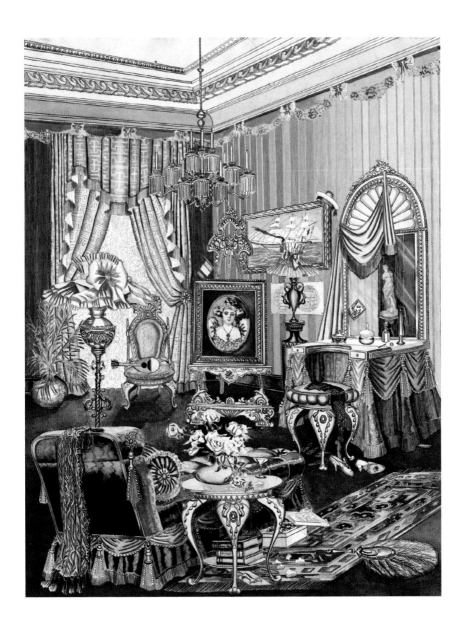

Perkins Harnly, Boudoir, 1902, *1935/1942.*
Index of American Design, Courtesy National Gallery of Art, Washington.

Perkins Harnly, Dentist's Operating Room, *1935/1942*.
Index of American Design, Courtesy National Gallery of Art, Washington.

Perkins Harnly, Cocktail Lounge, 1946, *1946.*
Index of American Design, Gift of Albert Lewin, Courtesy National Gallery of Art, Washington.

Perkins Harnly, Bedroom, 1940, *1946.*
Index of American Design, Gift of Albert Lewin, Courtesy National Gallery of Art, Washington.

Perkins Harnly, Raphael's Transfiguration, Hollywood Style, *c. 1972.*
Collection of Alan Warshaw.

Perkins Harnly, Flying Butts and Impossible Cow, *1972*
Collection of Alan Warshaw.

Perkins Harnly, Garage of a Funeral Parlor, 1917, *1946*.
Index of American Design, Gift of Albert Lewin, Courtesy National Gallery of Art, Washington.

Perkins Harnly, Funeral Parlor, 1895–1920, *1946.*
Index of American Design, Gift of Albert Lewin, Courtesy National Gallery of Art, Washington.

Flaming Families

POSSIBLY THE ONLY PERKINS FRIEND WHOSE LIFE was more chaotic and disastrous than Don's was Howard Taft Lorenz, who also lived in an exceptionally insalubrious cubbyhole at Slaughterhouse Alley during the WPA days when Don too had found a temporary perch there, along with Fred Becker, who had edged Perkins out of Alex King's inner circle. Lorenz shared two-thirds of his name with William Howard Taft, a cousin on his mother's side. Born to considerable wealth in Los Angeles, Lorenz started out as a stage and screen actor but (according to Perkins) "squandered his fortune enacting the role of opulent playboy in the capitols of Europe." Purportedly, he was once arrested as an "international diamond thief" who had haunted the "cocaine parlors and *mauvais lieux* of Berlin." Then, "paradoxically, he became a malnourished hobo . . . He lost his hearing in a street brawl, cheap patent dandruff remover caused all of his hair to fall out, permanently, bad food wrecked the lining of his stomach, and the Bowery-Greenwich Village gutters became his abode." Apparently, it wasn't only his hearing that Lorenz lost but also his mind. In another more candid document, Perkins stated that the brawl had erupted when Lorenz "told a strange man that he was beautiful whereupon the guy knocked Howard down, his head striking the curb." Subsequently, though his actual hearing was gone, "from that time on he heard voices, usually five, sometimes more." Howard also "had an invisible buddy named Walter. They were constant cohorts."

Lorenz lived in such extreme disorder that even Don Forbes and Hunter looked like model housekeepers by comparison. "Howard's quarters," Perkins recalled, "were crammed with rubbish and filth. A heap of plaster, fallen from the ceiling, had lain on the floor for over two years. Every horizontal surface in the dank room had been used as a palette. Finally, there was no space left in which he might set up his easel, so he painted his pictures out in the hall." With no training or background in art, Lorenz nonetheless managed somehow to get himself accepted in the Federal Art Project of the WPA and for several years turned out paintings that Whitney Morgan described as "halfway between [James] Ensor [the cynical Belgian fantasist of modern life as a grotesque carnival] and Rube Goldberg [the cartoonist who dreamed up impossibly complicated machines to perform the simplest imaginable tasks, like making toast or sharpening a pencil]". That is as good a characterization as any, though Perkins' runs a close second: "In general the pictures suggest a cross between 'Funny Paper' cartooning, in cheap calendar colors, and the pictorial documents of Hogarth."

Happy Birthday Gramma (1939; last seen on the art market) has all those features and more. The setting is a glaringly red manorial dining room where a large family—from patriarch on down to the most recent baby—gathers around a long table on which reposes an enormous birthday cake. There are ancestral portraits on the walls, a sideboard loaded with flowers and fruit, a butler, and a maid. So far, it sounds like something Norman Rockwell might paint for a *Saturday Evening Post* cover. But if so, Rockwell would have to be tripping out on mushrooms. Lorenz obliterated any sense of proportional scale or coherent space; the table is seen from above, but the various figures are rendered in something like reverse perspective, with the result that the patriarch, at the top, looms far larger than the mother at bottom in the foreground. The uniformed maid is doll-size, smaller than the family dog and diminutive, too, in relation to the huge, gesticulating baby at the very top of the picture. If the celebrants all stood up together, some would be a foot tall and others ten. Everything is rubbery, too: bodies, faces, bowed-out walls. In fact, the room looks as if it might start to spin and send everything flying in all directions. And everyone, including the dog, is cross-eyed. (As are nearly all the people, and cats and dogs, in all of Lorenz's pictures.) Then there is the hair: all around the ceiling cornice runs a "gigantic rope of braided hair," as Perkins recounted. This, he claimed, was the direct outgrowth of Lorenz's dandruff-remover baldness disaster, which "brought about an acute complex whereby he worshipped hair. He surrounded himself with dozens of various colored switches of human hair from the Ten Cent Store."

Lorenz's entire painting career began and ended with his WPA work. His last painting, according to Perkins, was "a typical jungle scene. A number of down trodden tramps are seated around a camp fire over which is cooking a typical can of stew. In the background, a freight train is plowing around a bend in the tracks, and overhead, lending a sacred character to the scene, are a pair of winged tramps in beatific attitudes of benediction." At some point after he stopped painting, Lorenz returned to Los Angeles for good (probably riding the rails hobo-style to get there). He seems to have become a ward of the state, or, as Perkins put it, a charity case. Like Don, he died of ulcers (again according to Perkins). He was cremated "at Evergreen cemetery, Los Angeles and his mother dug up fifty dollars for a niche." She gave Perkins the key, which he never used. Lorenz had been a "tiresome bore," an alcoholic who "wearied his friends unmercifully." Yet for a handful of years in Slaughterhouse Alley, he was a member of that same ramshackle family of more or less starving artists that included Don Forbes, Fred Becker, and Perkins, all of them kept afloat by the WPA.

Perkins' ramshackle family had many more branches. Lorenz, it turns out, wasn't the only ex-playboy in residence at Slaughterhouse Alley, although he may indeed have been the only ex-international alleged diamond thief. Ex-playboy Robert Clairmont—as notorious as Lorenz was obscure—was rich only in legend by the 1930s, but in the 1920s he had made waves and headlines as a spectacularly

devil-may-care spendthrift. Clairmont had started out as a soda jerk at the posh Pittsburgh Athletic Club, but after either teaching club member Sellers McKee Chandler to swim or saving him from drowning, or possibly both, he inherited half of the old bachelor's estate, which, depending on the source, amounted to anywhere from $350,000 to $5,000,000. Whatever the actual sum, Clairmont, now in New York, promptly invested his windfall in Wall Street and became even richer. He lavished money on the five commodious apartments he rented around town, on needy Greenwich Village artists and poets, and on wild Bohemian bacchanals. Clairmont's most infamous party, bar none, took place in his absence when early in 1928, the cartoonist Hans Stengel helped himself to Clairmont's studio in Greenwich Village and invited a few friends over to carouse. In the words of historian Albert Parry, the revelers came and "beheld tall black candles weirdly throwing their light and shadow upon Stengel's angular Wisconsin face." Around midnight, the host withdrew, eventually to be found dead in the bathroom, hanged from the top of the door frame by his belt. In lieu of a suicide note, Stengel left a macabre cartoon of his dangling dead body, complete with protruding tongue.

The following year the stock market crashed, leaving Clairmont with a handful of dollars and a few slim volumes of his own poetry, which the *New York Times* deemed "execrable." Perhaps the *Times* critic was put off by Clairmont's blunt modernist style, as exemplified by the poem "To Sylvia on Going through the P.R.R. Hudson Tubes": "If you/Dangle/Your hand/Outside the window/And grind your knuckles along the cement wall/Red blood/Will spurt/The bones of your hand will stick through your flesh/And your veins/Will/Burst." Critical scorn, however, did not hinder (and may well have helped fuel) Clairmont's possibly mock appointment to the exalted position of Greenwich Village's Poet Laureate in an induction ceremony that took place in the newly opened Village Vanguard (a former speakeasy that would soon become one of New York's fabled venues for avant-garde jazz).

In 1933, fellow poet Tom Boggs (yet another one of Rose O'Neill's arty part-time squatters at Castle Carabas; he once proclaimed Rose "the greatest woman since Bach") published a novelized biography of Clairmont's adventures in the hopes of raising money to aid the now-impoverished "Millionaire Playboy," but the book met with little success. As Perkins put it, Tom's "aid to Bob Clairmont . . . was negligible. They had an advance of four hundred bucks and they slapped out the most banal, trite, vapid mess of dull data imaginable . . . Soon after its publication Tom found copies in a junk shop." By the middle of the 1930s, down and out but still poetic, Clairmont was living at Slaughterhouse Alley with his artist wife Louise. Hailing from Waco, Texas, Louise Bartley had met Clairmont in Greenwich Village before she moved to Paris to study art. After the 1929 crash, Clairmont telegraphed her with the dire news that his millions had shrunk to a mere $150. "She cabled back to send her the $150 for steamer fare and she would come home and marry him."

We only get glimpses of Louise through the eyes of contemporaries, but there remains enough to sketch a likeness. Bill Littlefield described her as "superb, a magnificent big tall woman, large without being gross, utterly and elusively feminine." Of the so-called Black Irish type, she had "broad cheek bones, dark slit eyes, black hair . . . and the figure of a goddess . . . she was entrancing . . . I once watched her coming up the street toward my house . . . past some men working on telephone poles . . . and . . . the erotic liquefaction of her walk . . . almost tumbled them" from their perch as she passed by. Physically at least, Robert was a perfect match, "A large handsome man like Cary Grant" with "long black eyelashes and tumbled hair."

Louise managed to get close to Don Forbes without inciting torrents of his customary verbal abuse; indeed, she went where others feared to tread. "She took him just as he was, bitten fingernails, receding hair line, vulgar protrusive fleshy ears . . . hesitant, awkward and as if perpetually ill at ease." Compared with some of Don's escapades, their pastimes were almost wholesome. Once on a visit to Boston, Don lunched with Whitney Morgan and Louise (who seems to have moved on from the playboy millionaire by then), and drank "quite nice" bourbon and Coca-Cola. "Then we sat on the esplanade watching people rowing etc. After seeing some of them fairly close Don said he sometimes wishes people had electric light bulbs for heads . . . like those fine dress dummies in the shops on 14th St." They ate at venerable Durgin-Park—that Faneuil Hall institution famous for its rude waitresses, Boston baked beans, and prime rib—and ended the evening at the Ritz Bar drinking highballs.

In Littlefield's view, the "lovely Louise" was more than Don's alter ego: she was "what Jung describes as his Anima or soul." Whether they were ever lovers or not remains a mystery, but Don asserted that "We are almost a part of one another. In a way we really love one another, even across the sexual barrier. I guess I love Louise for one reason among many that she reminds me of a man I would [have] liked to have met and known." Of course Don was drawn to her; albeit of the female persuasion, she was his type—large and voluptuous, with a magnificently rounded bottom that on one occasion (after she and Don had been swimming nude) showed "charmingly" through her dress. If only Louise had not been a woman, Don's life might have turned out very differently. A comfortable and steadying presence, she was among the few who had the capacity to calm his troubled nature. But of course this is pure speculation; perhaps his troubles were beyond redemption.

Louise—struggling artist and wife of a millionaire pauper—picked up work wherever she could. Whitney Morgan reported that she was planning to paint a series of pictures of "Crimes Passionels" but had to shelve the project for the time being because she had "just about gotten a job demonstrating underwear or something in a five and ten cent store." Like nearly everyone in Slaughterhouse Alley, she managed to get herself on Home Relief and later created paintings under the aegis of the WPA. But husband Robert was an unruly handful. One Sunday in 1934, he "became very excited about a political argument he was

having with someone who was there named David Beardsley and under a strong conviction that there was to be a Japanese invasion almost instantly he rushed out into the street and broke the windshield of a passing automobile with his fists and rushed back with bloody hands, and followed by a lot of the Italian neighbors (who seemed to him to be Japanese), into the apartment to rescue Louise and David and a girl named Esther who was also there, from the Yellow Peril. Some of the Italians quickly summoned the police and he was taken to Bellevue where he was to be kept until this evening." Louise subsequently decided to remove Robert to Texas for the winter, but by spring or early summer of 1935 they had returned to Slaughterhouse Alley, or at least he had, Louise's movements and whereabouts at this time being uncertain.

Robert Clairmont remained a Greenwich Village fixture, for a number of years editing the poetry magazine *Pegasus* and reading his poems at the College of Complexes tavern. As for Louise, after an affair with Jack Levine—the Boston social realist painter of witheringly satirical attacks on the rich, corrupt, and famous—and after a last reunion with Don in Mexico, 1949, she returned to Texas, where in Dallas she became a self-described "Society Painter . . . not rich, but pretty good," married at least once, perhaps twice, and had a daughter whose own ex-husband (or one of them) wrote letters, supposedly in Arabic, that turned out to be gibberish.

In the early 1960s, Louise reconnected with Perkins in Los Angeles at Bill Alexander's modernist "House in Space," as he called it, which was distinctive for its boldly cantilevered design. Perkins was shocked to see how she had morphed from Rubenesque goddess into stout matron. "Just why anyone with the intelligence to create some of the world's best commercial décor for department stores could permit herself to get into such outlandish, outrageous, monstrous physical shape is beyond my strained comprehension," he ranted. "It is obviously caused by carelessness and 'I don't give a good goddamned fuck' attitude which she has always had in regards to everything. Eat and fuck has been her strict policy . . . Just lay and gollup up the grub." And yet, he conceded, that was the "unimportant superficial part of Louise." Of far more significance was her talent: "Her great wall decorations are astounding. Such stamina, humor, perseverance, and imagination. I didn't know Louise had it in her." (Precious little remains of her commercial work. I have found only one photograph, of the Camellia Room restaurant in the Joske department store that once stood on Alamo Plaza in San Antonio. Elegantly splayed across the walls are Louise's huge, stylized camellias. Restaurant and mural are long gone.)

Having praised Louise's talent, Perkins returned to her girth, remarking a bit too snidely: "Just how a cantilever balcony can support Louise without tipping over the house is beyond me. The concrete piling must be pretty strong. At least it was a test of your engineering and calculations." Back in Texas again, Louise reflected on her work, which in her own jaundiced view had become "lousier all the time." As for Dallas, she derided the city and its culture as "a large petrified chunk of whale

shit, made and ruined by Neiman-Marcusism," the latter presumably connoting pretentious luxury and crassly conspicuous consumerism.

But we're getting way ahead of ourselves; time to return to the 1930s and move to another corner of Perkins' world in the Village and elsewhere—that is, his life with a raffish company of modern dancers whose loosely familial structure, like that of Richard Halliburton, Paul Mooney, and Bill Alexander, offered another alternative, and challenge, to the nuclear norm. To set that stage, we have to track back one more time to Lincoln, Nebraska, where young Perkins and his friend Charles Weidman reportedly "played nasty out in the barn." Son of a fireman, who in 1905 was appointed Chief of all fire departments in the Panama Canal zone, and of a Midwest roller-skating champion—who in 1906 initiated divorce proceedings against the fireman after an unhappy sojourn in Panama—Charles was smitten with all things theatrical from an early age. In that same horse barn, or the back yard, or the Weidman living room, he mounted elaborate theatrical productions: fairy tales, fantasies, and even side shows, for which he made costumes of "brightly colored cheesecloth and Christmas tree tinsel," built his own scenery of "sized duck with watercolors," and performed such roles as "Fairalina Trusce, the World's Greatest Coloratura Soprano," gyrating wildly and singing at the top of his voice. By the time Charles reached high school age, he had amassed a prodigious wad of newspaper and magazine clippings and photographs of famous theatrical performers, which—along with shoes, underwear, socks, books, sheet music, food, and unnamed flotsam—he had stuffed into a briefcase that he carried everywhere. "Charles was never seen in Lincoln without his brief case," Perkins remembered, "and, during Art Class we would look through the contents of it and marvel at how he could collect so many items."

One of the photos was a portrait of Ruth St. Denis with the caption "High Priestess of the Dance Revealing a Sixth Sense—Beauty." Another photograph in the briefcase depicted the most beautiful man in the world, Paul Swan, arrayed, or disarrayed, in extremely scanty attire. Rumor had it that Swan and St. Denis— or Miss Ruth, as she was known—were a wedded pair, but only because gossip confused *Swan* with Miss Ruth's actual husband, the dancer Ted *Shawn*, billed in 1914 (the year of the marriage) as "the Handsomest Man in America," second only to the Most Beautiful, though it's worthwhile to note that Shawn, like Swan, also performed "ancient" Greek dances in a tiny leopard-skin loincloth.

Born workaday Ruth Dennis in Newark, New Jersey, Miss Ruth by 1914 was famous for her exotic modern dances, notably *Radha*, based on Indian temple dances and seeking both to express Hindu spirituality and induce a heady "delirium of the senses." Like the celebrated Isadora Duncan, Miss Ruth dispensed with the toe shoes and tutus of classical ballet, opting instead for bare feet and striking Oriental costumes featuring veils, fluttering draperies, and glittering bangles and beads. Her dance style was graceful and sinuous, with snaky arm movements;

sometimes she spun like a dervish in a whirl of colorful skirts. Ashcan artist Robert Henri painted her portrait, now in the Whitney Museum of American Art, in 1919; in it, Miss Ruth wears her Peacock Dance costume, all iridescent blues and greens, with encrustations of jewelry and a sweeping train patterned with the indigo and golden eyes of the peacock's tail. A dark-haired beauty, her pale skin rouged and painted, she looks like the classiest belly dancer who ever swung her hips. There's a hint of gender-bending, too: Miss Ruth wears the male's gorgeous plumage rather than the much drabber female's.

Charles and Perkins saw Miss Ruth and Ted Shawn in October 1916, when they danced at the Orpheum theater in Lincoln. That performance, according to Perkins, inspired and cemented Charles' decision to become a dancer. Ruth St. Denis, on the other hand, had started out skirt dancing, which was less actual dancing than the manipulation of voluminous draperies to create endlessly changing wave-like patterns. A drugstore poster that she chanced to see in 1904 changed all that: advertising Egyptian Deities cigarettes, it depicted the topless goddess Isis stiffly enthroned amidst majestic temple architecture and lush stands of lotus lilies. The image sparked a powerful dance epiphany: from then on, Miss Ruth would study, choreograph, and perform dances from the East (near, middle, and far). Indeed, having scrutinized the cigarette Isis, she immediately set about designing an Egyptian costume: a form-fitting bare-shouldered sheath, plus a bejeweled headband, necklace, armlets, bracelets, and many rings. Thus outfitted, she had herself photographed in the same pose as Isis enthroned: severely symmetrical and as still, rigid, and remote as if she herself were made of stone. Her Egyptian dances—solo and with Ted Shawn—are like ancient tomb frescoes come to life, all stiff profile or frontal poses and stylized, angular gestures.

Ruth St. Denis posing as an Egyptian deity, 1904

Whether she was impersonating an Indian temple girl, a Thai dancer, or a Japanese geisha, Miss Ruth strove for authenticity, but her performances and all the trappings were mashups that played on Western preconceptions and long-

established stereotypes then circulating through popular media. The very fact that her initial inspiration came from a cigarette poster speaks volumes. In real life, Miss Ruth's best-known and most notorious predecessor was Fatima (along with her many imitators, most of whom went by the moniker "Little Egypt"), whose sensuous belly dance—a.k.a. the Hoochie-Coochie—in the proto-theme-park "Streets of Cairo" installation (complete with camels) at the World's Columbian Exposition in Chicago, 1893, outraged prudish women and spurred many largely unsuccessful attempts at censorship. As one woman sputtered, "It was downright indecent. I saw women go out after the creatures had begun what they call their dance. I did not stay it through. I just couldn't."

Miss Ruth, however, succeeded in elevating such exotic dances to the level of art by infusing them with Eastern mysticism as she understood it, while managing still to preserve a hefty measure of sensuous allure—that "delirium of the senses" she sought to express. Were she starting out today, Miss Ruth would in all likelihood come under attack for flagrant and un-ironic colonialist cultural appropriation. But in the early twentieth century, Western societies by and large enjoyed the entitlements of power and appropriated as they chose—when they weren't outright plundering the patrimony of subjugated lands. Certainly, one can also make the argument that, however much we might now deplore such presumptive acts of "borrowing," they were transformative, revitalizing moribund art forms and fueling creative experimentation of all sorts.

Miss Ruth's appearance with Ted Shawn and their Denishawn Dance troupe at Lincoln's Orpheum Theater in October 1916 was the turning point of Charles Weidman's life: he decided on the instant to become a dancer, too. Perkins went with him on that occasion and probably saw the Denishawn Dancers in other performances, enough to gain a working knowledge of Miss Ruth's style and idiosyncrasies. "Her mother," he wrote, "was a Suffergette [sic] and paraded in Hoboken with a corset on a pole. The corset [unlike Perkins'] was stuffed with straw." Ruth, he went on, was always being photographed in niches. "Just give her a good niche to back into and she was happy. She would find a suitable niche and then have Pearl Wheeler, her dress maker, do a stunning outfit. 'What color?' asked Pearl. 'Pink, Dear!' was the inevitable answer. The costume, the niche and a series of beautiful photographs and then maybe she might get around to do a dance." There was also Ruth's turn as Miriam, sister of Moses, at the Berkeley Greek Theater in 1920. "Ted was Moses. He affected a long, white beard . . . She had a tambourine. Ted's turn came to speak some lines. He opened his mouth, drew in some air and a mouthful of whiskers almost choked him to death. To cover for choking Moses, Ruth did a hastily improvised number with her tambourine."

Miss Ruth and Ted Shawn established their first dance school in Los Angeles in 1915. For Charles Weidman, that was the new Mecca, and—having saved up money by working part-time at the local telephone company and crafting batik

lampshades to sell—he traveled to Los Angeles in May 1920. He trained and then toured worldwide with Denishawn until 1928, not long after the troupe had moved to New York with plans to settle and teach there. Along with dancer Doris Humphrey and piano accompanist/costume designer Pauline Lawrence, Charles was voted out of the organization for proposing seditious new dance ideas. That was his version of the split with Denishawn. *Their* version held that Charles and the other two had simply walked out—with half the Denishawn students—in order to form a new company. Denishawn broke up at the close of the 1931 season, Miss Ruth and Ted having agreed to separate (though they remained married and eventually celebrated their fiftieth anniversary together). According to Perkins, it was too late for Miss Ruth: "That old, fat-assed queen, Ted Shawn, ruined her as a fine Oriental dancer. He introduced a bunch of tasteless junk of less quality than her original concepts. He is not an active old Auntie. He is a philosopher and serious producer of male shindigs on a stage." Those "male shindigs" were performances by Shawn's new troupe, formed in 1933: Ted Shawn and his Men Dancers, Shawn's answer to what he perceived as the feminization of ballet. Until World War II, when most of the dancers joined the military, Shawn's troupe lived and worked at Jacob's Pillow, an old farm property in the Berkshire Mountains, where they created a sort of gay dance Utopia and, on tour, performed many of their numbers as close to nude as they could get away with. In many ways, it was like Coxsackie, only more athletic.

José Limón was of the same mind about ballet and masculinity, writing that ballet had been degraded at its very inception by association with the "highborn sycophants and courtiers" surrounding King Louis XIV. Since then, it had gone steadily downhill because of the "feminization" of its technique, and, presumably, the high visibility and celebrity of the prima ballerina, which so often seemed to relegate male dancers to heavy lifting. Perkins took credit for launching José's career. Intent on becoming an artist, Limón had taken lessons in Los Angeles and was determined to pursue that path in New York. Once there, though, he lapsed into gloom: he found that "everyone" was imitating the modern Parisian masters, from Renoir to Picasso. "By some perverse irony, perhaps as a reaction to this dominance by Paris, I found myself turning to El Greco, a painter largely ignored by my teachers in California. The more I studied his work, however, the more I came to the fatal recognition . . . that he had done all I hoped to do and done it supremely well. New York now became a cemetery, and I a lost soul in torment." Then, he found dance.

Perkins' version: "On impulse Don [Forbes] and I decided to have José meet Ted Shawn. Don had met Shawn in Texas while his dancers were on tour. We thought that it would be an amusing confrontation for the two most handsome men to get together. On the way to Shawn's studio we passed the Humphrey Weidman studio. We dropped in to say hello . . . we did not proceed to Ted Shawn's. José decided then and there to become a dancer." José's version: a girlfriend took him to a matinee dance recital in New York. "The house was packed. The lights dimmed,

and the curtains rose on a bare stage hung with black velour curtains . . . Suddenly, onto the stage . . . bounded an ineffable creature [the German modern dancer, Harald Kreutzberg] and his partner. Instantly and irrevocably, I was transformed. I knew with shocking suddenness that until then I had not been alive or, rather, that I had yet to be born." Perkins and Don, old friends with Charles Weidman from their high school days in Lincoln, "recommended that I look into the school recently established by Doris Humphrey and himself, and begin by training. I showed up immediately." There are other accounts with varying details, but it's still safe to say that Perkins (and Don) were instrumental in José's "birth," as he called it, into the new world, his world, of modern dance. Without their intercession, he might have spent his life failing to be the twentieth century's answer to El Greco. Or he may have become a dancer anyway but never met Charles, who was to be considerably more than a dance partner.

Limón's "beautiful physique and stunning Mexican features" powerfully impressed ruggedly handsome Charles, whom one critic described as the dancer who had defined the "stock characters of the classic comedy in the contemporary American idiom . . . the urchin boy, the symbol of our uncontrolled nature of a small boy, half satyr, half hooligan, who can fish and also shoot crap, the dandy who will abandon any fashion as soon as it becomes commonplace, who is the archetype of the American Man." Doris Humphrey for her part was equally arresting. Hailing from Oak Park, Illinois, Humphrey when José first saw her was a "radiant creature with the body of Botticelli's Primavera and [a] mass of red-gold hair flying behind her like a trail of fire as she leapt across the studio . . . she moved like a gazelle. She was the wind, a wave rushing to break on a rocky shore . . . a creature enamored of the air."

Chafing under Denishawn and constrained by the principals' archaic and mannered dance moves, Doris Humphrey on achieving independence developed her own free style, which in essence conceived of movement, pure movement, as sole justification in and of itself. Movement encapsulated idea, emotion, narrative and symbolism, and, like a top set spinning and winding down only to be set to spin once more, embodied the principle of fall and recovery that was the mainspring of her art and a metaphor for life itself, and death. It was also, as Humphrey conceived it, unequivocally American: dance originating from the spirit of a people who had to subdue a continent. Leaving aside the many, many ways that we post-moderns could puncture holes in the very idea of such conquest as an unequivocally heroic and noble enterprise, it is true nonetheless that Humphrey's concept of American dance was of the moment, the same moment that produced the Index of American Design, the WPA's *American Guide Series* and its oral histories intended to preserve American folklore and the recollections of former slaves. In that same spirit, Humphrey-Weidman created dances based on the Shakers, the legend of Paul Bunyan, and even the lynch mob's grisly bloodlust. While pre-World War II "modern dance" no

longer has much shock value, so familiar are its forms, it was, as Charles Weidman asserted, a revolt; he, along with Doris and José, was a "revolutionist." You can still see bits of those revolutionary performances from the 1930s in film clips and documentaries: Humphrey and her partner leaping, spinning, prancing, arching, swooping, collapsing, rising, bending, swaying, kicking, strutting, gliding, to the music of Bach or Lehman Engel. For his part, Limón, conscious of his own Mexican heritage, identified with and sought to emulate a bullfighter's power, elegance, and grace. Perkins observed that while José transformed certain aspects of the modern dance, it was in the attitudes of the hands that he really achieved something entirely new: "He broke away from the customary Ballet elegant-tea-cup positions. The flat unbent fingers became a trademark. There was no sugary porcelain shepherdess prettiness to anything he ever did."

The other major pioneer, of course, was Martha Graham, whose iconic name—like Isadora Duncan's—still reverberates in modern dance history. But the Humphrey-Weidman company, less well-known, were equally powerful forces for change. Graham's troupe and Doris Humphrey's were rivals, not surprisingly, but they respected each other—warily. José wrote of first seeing Graham: "I watched her spellbound dancing a solo—a dark woman, standing on a small pedestal,

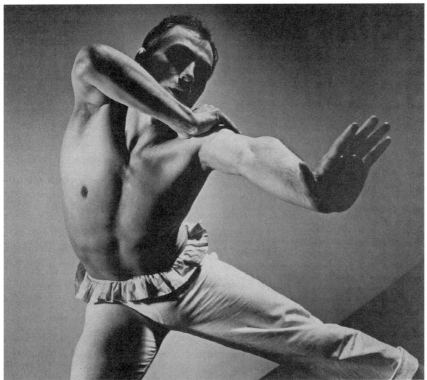

José Limón dancing the Mexican Suite, in Barbara Morgan's 1944 photograph

dressed in blood-red, addressing the universe, arms raised to the zenith." As much priestess as dancer, Graham rehearsed her troupe with "sacerdotal authority" and seemed always surrounded by a "hushed, almost religious atmosphere." Nothing could be further from Weidman's antic spirit: in one performance, he imitated Ted Shawn, appearing in "long white underwear with a green figleaf in the appropriate place . . . rushing around the stage like someone who has taken leave of his senses." It doesn't take much imagination to know that Perkins and the earnest Graham would never have gotten along. Whitney Morgan was unimpressed, too. After seeing Graham and her troupe at Carnegie Hall under the auspices of the radical magazine *The New Masses*, he commented that "It was all dreadfully intense and humorless. Horrible costumes. The pièce de résistance was 'American Document' which had an interlocutor who made wonderful speeches about 'We are three women, We are three million American women wanting love and babies,' etc. . . . while girls in mauve tunics stamped and pranced about."

For years, Perkins claimed, the dance world was his milieu: "I hung around the dancers all the time," he said. "I lived with them for fifteen years." Maybe not all the time, given Perkins' extended sojourns in Mexico and at Castle Carabas, but at least some of the time, when, that is, he wasn't living with an assortment of eccentric artist friends, waiting tables at a Jewish boarding house in Atlantic City, or acting as caretaker at the farm in Blairstown, New Jersey that Weidman had bought on the proceeds of a windfall from his choreographic work for the hit 1933 musical *As Thousands Cheer*, a medley of song-and-dance sketches based on the exploits and crotchets of socialites and celebrities. (*As Thousands Cheer* was also the very first Broadway show to give an African-American performer equal billing with the white cast; this was Ethel Waters, who played the part of Josephine Baker.) Suffice it to say that the "dance family," like Rose O'Neill's or Richard Halliburton's, was a decidedly Bohemian inversion of the normative dad-mom-children model, although there was, at least, one authentic child: Charles Humphrey Woodford, the son of Doris Humphrey and her spouse Charles Francis Woodford, a merchant seaman from Yorkshire whom the dancer had met on a Caribbean cruise ship in 1931; they married in June 1932. Both Charleses, father and son, were given nicknames so that they wouldn't be confused with Charles Weidman: Charles the elder became Leo, and Charles the Younger was "Pussy Boy," until he outgrew the moniker and became Humphrey.

Charles Humphrey Woodford later wrote that it had been his mother's idea in 1933 to have all the Humphrey-Weidman principals live together in the seven-room flat on West Tenth Street in Greenwich Village. "Today, I suppose, you would call it a commune, but then it was simply my family. José Limón and I were the youngest . . . the rest . . . consisted of my mother, Charles Weidman, my seafaring father . . . my German governess . . . Pauline Lawrence (eventually to become Pauline Limón), the cook/housekeepers Hermine and Susan (when

times were good), and various dancers, friends and relatives in need of a place to stay." Perkins was one of them, of course. The apartment resounded to the rattle of jackhammers outside and, inside, to the "groaning bass and tweedling treble" of José playing the pedal-powered organ he had purchased with his portion of the windfall from *As Thousands Cheer*. José's dance numbers in that revue had won him a number of fans, including "a very fat rich interior decorator" who "became enamored with José's various natural attributes and sent daisy-filled pumpkins backstage for the dancer's delectation."

The Blairstown farm, though, was all Charles' fantasy, albeit he had purchased the property in partnership with José. Ever since he was a boy, Charles had wanted to own a farm "with an antique house full of furniture and bric-a-brac characteristic of early American designs," Perkins recalled. "His father's house was crammed full of heavy carved teak wood furniture which he had purchased in the Panama Canal Zone when he was Fire Chief there." In Blairstown, though, Charles "realized all of his cherished dreams of early American architecture and artifacts." He bought "paneling of the Revolutionary Period in Boston, spinning wheels, statues of George Washington, an ironstone dinner service," and rooms full of early American furniture. It must have been like living inside a three-dimensional Index of American Design. Perkins helped with renovations and lived there as caretaker in 1939, when Weidman Senior, the Fire Chief, was also in residence. When he wasn't laying slate tiles or going to auctions to buy old, rusty hardware, Perkins had an exuberant and mostly priapic romance with the well-hung well-driller's assistant. "I did him in the attic," he recalled, "corn field, up in an apple tree, in the cellar, on top of a slate cliff back of the house, while bathing in a waterfall in the creek and in bed every night. I must have swallowed a gallon of delicious come . . ."

Less lubriciously, Perkins also babysat Pussy Boy "until he grew big enough to bawl me out stinkin'." Doris had a hand loom in the rehabilitated barn, and José tended the gardens. There is a photograph of the Dance Family, or some of them, standing on the steps of the farmhouse porch: Pussy Boy, with blond curls and a sulky face, smiling Charles Weidman looking vaguely gangsterish in a double-breasted suit with padded shoulders and wide lapels, Doris, all lofty brow and beaky nose, and sexy José sporting a summer beard.

In 1939, yet another Charles joined the Humphrey-Weidman ménage: Charles Hamilton Weasner, who "discovered" dance when he watched Weidman and José teaching a men's dance class at the New Jersey high school where he was employed as a math teacher. Weasner began taking classes at the company's New York studio, and by the summer of 1940, he was living with the family at Blairstown under his new and permanent name: Peter Hamilton. José was off in California giving classes at Mills College. When he returned from the West Coast, he and Charles had a violent quarrel, ending their relationship abruptly and for good. Although the Humphrey-Weidman company staggered on for a few years, the

Dance Family didn't survive the rupture, its various members scattering to other studios, other living arrangements, new places. Pussy Boy found it all mystifying: "One night at dinner my mother told me that I must never again mention Charles Weidman's name in José's presence. I didn't know why, but could only imagine that there would be an explosion if I did. I never learned what actually happened between José and Charles, but . . . Charles ceased to be a member of my 'family.'"

It was no mystery to the adults, however, although nobody came clean about the real cause: Weidman and José had been romantically as well as artistically involved, and when Charles took up with Peter Hamilton, tensions rose, conflict flared, and, after the final clash, there was nothing left to salvage. Perkins—albeit his memory was wobbly on certain points—threw his own light on the subject. José's "pin feathers," as he put it, "were beginning to itch. On a concert tour in the East they ran into a young blond dancer whom Charles called 'Little Mickey Rooney.' José wanted to leave and present himself on his own yet being eclipsed by this new youngster riled his innards . . . 'Little blond Mickey Rooney' took José's place in Charles' affections and dance direction." In fact Peter Hamilton/Charles Weasner, who never went back to teaching math, did indeed resemble the puckish movie star, in a generic way.

Meanwhile, Pauline Lawrence, who had often taken over the West Tenth Street apartment kitchen to cook huge vats of dye for costumes, made her move. "She'd been waiting for years for this glorious moment when she'd 'have him,'" Perkins said. The two married on October 3, 1941 (José being on the rebound and possibly hoping that marriage would allow him to avoid the draft if the U.S. got into the war, which it did, of course, barely more than two months later). Pauline, having "nabbed the object of her love quest," took over managing José and his career. In Perkins' opinion, José's dances without Weidman's "highly specialized funniness" became all too arty, incorporating instead "a lovely funeral parlor seriousness like wilted iris buds." Weidman and José never again spoke, but when Charles heard of José's death in 1972, he sent a bouquet of roses.

Perkins saw Charles again, a couple of decades later, in Los Angeles. He confided to Bill Alexander that he had avoided Charles "On general principles. We are not too close in heart values, never have been. It was José who brought us together. And Charles is always borrowing dough which he never repays. He owes me over a hundred bucks now. He doesn't forget about all the dough I squandered when he was in the chips, during his hey day, and he is slightly vindictive. He gets even by sporting the gorgeous piece of rough trade before my greedy eyes!!!! Ha." How Perkins had squandered Charles' money is a mystery, as is the identity of Charles' "gorgeous" boyfriend. The bitter breakup of José and Charles in the wake of the latter's betrayal with "little Mickey Rooney" (which was surely how José saw it) may have been the reason for Perkins' now-jaundiced view of his old Nebraska comrade in arms.

Given the intensity and intimacy of Perkins' life with the Dance Family, it is surprising that he never drew or painted works featuring dance in any form, unless you count his *Dance of the Underwear* inspired by *Swan Lake*. He had the idea in 1932 but didn't realize it for some thirty years. In it, he used "empty Long John underwear with wire coat hangers for heads in characteristic ballet poses against a realistic atmospheric background and a pair of red flannels taking the role of first ballerina in a spotlight." It is a lively and enthusiastically bizarre scene: the headless Long Johns cavort in front of a romantic background with a castle, but there is also a bright yellow disk dangling from a giant hanger on a line above dancing underwear; on it is a landscape that looks as if it had escaped from a spaghetti Western: cacti, a cow's skull, and an adobe shack advertising itself as a motel.

Perkins occasionally collaborated with the Humphrey-Weidman company on poster and set design, most notably in 1943, for Charles Weidman's *And Daddy Was a Fireman*, a dance comedy that paid tribute to the Fire Chief's life as a young man. The fact that Weidman Senior had died the previous year belied the production's light-hearted tone, but perhaps the humor helped Weidman Junior channel whatever grief he felt. Peter Hamilton, flaunting a long red scarf, played Fire— appropriately. Perkins' set designs were two-dimensional cutouts—complementing the cartoonish spoofery of the performance—and included an 1890s fire engine (very similar to the one he had rendered for the Index of American Design), a parlor melodeon inspired no doubt by José Limón's pedal-pumping organ or possibly Don Forbes' reed organ (a relative of the melodeon), and various other props. Perkins also designed an elaborate red-velvet-trimmed yellow frame to enclose Daddy's portrait on the wall. No images of the portrait seem to have survived, though there is a photograph of Charles in a firefighter's red shirt and Doris hoisting a frilly parasol while behind them stands the shiny engine, so well modeled that it almost seems to have grown a third dimension. Considering Perkins' troubled early history, one wonders if his own disturbing Daddy haunts the portrait as well.

By 1943, not only had the Dance Family disintegrated, but also the Index of American Design was no more, having been shut down by Congress in April 1942 after the U.S. entered the war effort and unemployment had ceased to pose a serious problem. Perkins' last watercolor for the project was *Cozy Corner*, which he left unfinished, the background a dense field of pencil notations that he never filled in, in addition to two blank picture frames in the middle, where he had intended to paint facsimiles of sepia photographs. The war, he said, had stunted everything cozy. In 1941–42, though, Perkins also taught a class on camouflage in the attic of a midtown fire station. How he mastered the principle of camouflage he never said, but he managed somehow to pull it off until Lloyd Rollins shut it down— allegedly—because Perkins had had a blowup with Rollins' "pet scotchman," as Whitney Morgan described Ian Duff McKnight. "We did scale models of installations to be camouflaged," Perkins recalled. "When they were completed

they were photographed before and after . . . Ian's had green saw dust which was supposed to represent grass. The saw dust turned out to look like cinders. He blamed me for not instructing him to do it properly. I got sore and loudly in front of the whole class said, 'I'm an instructor, not a wet nurse.'" Bellowing "You don't have to get nasty," Ian stormed out.

Perkins was reassigned to a defense plant, Crucible Steel of America in Harrison, New Jersey, after completing a stint in Brooklyn, training to work with sheet metal and graduating, he said, "with flying colors." Eventually, Rollins went on to a life of increasing obscurity in California, his home state, after failing at a venture to sell contemporary paintings in department stores across the nation. Ian Duff McKnight somehow became rich and went straight, living with a wife and three sons in Connecticut. Whether he took along his collection of swirl glass and his "car loads of early American furniture," Perkins did not say.

There is precious little documentation to tell us what Perkins *in the moment* was like, what he did, where he went. Much of his earlier story comes from the many letters he wrote decades later. But one remains that captures his voice as it really sounded in 1942: this is a long, chatty epistle to the now-married José Limón and Pauline "Pumba" Lawrence. Perkins began by noting that Don Forbes had asked him, Perkins, to write and explain why he and Don had failed to show up for a visit when they were expected. "Well, you ought to know darling DON. The green eyed monster ALCOHOL does strange and unexpected things when one becomes victim to its clutches. Go[d] do I love clutches! If I don't get one soon I'll go MAD. In falsetto . . . of course." Then follows a detailed account of a Saturday afternoon and evening at the apartment of India Clark, Perkins' old girlfriend from Lincoln. India had followed Perkins to Los Angeles and at some point had arrived in New York, where Alexander King had helped her with the red tape that enabled her to qualify for Home Relief. Perkins went to India's every Saturday for supper, he said. "I ate (ATE) and stayed overnight as usual," Perkins went on. "She had her eighth abortion last Wed. wasn't feeling so hot but ate in the good old Nebraska manner." The menu included "fried chicken, okra, string beans, mashed potatoes, hot drop biscuits, ice cream . . . Holloween [sic] cake, coffee and dirty talk. We ate till we were dead."

Then things became more than a bit bizarre, macabre, even. India went to bed and told Don all about her abortion. At some point, she "took her baby (about 2 inches long) it was a boy, and showed it to the kids and they took a match and tickled the little dicky and pried around the tiny perfect fingers etc." Whether Perkins meant India's own "kids"—there were two young girls there—or the adults in the room is unclear. Whatever the case, when the midwife came the next day to "clean out the rest of the crap," India read a detective story. Perkins admonished India, asking "why in hell she didn't get a batch of fish skins [condoms] and she said she liked f------ in the raw but would try a skin. The baby's papa is a nazi."

Meanwhile, after India nodded off Saturday night, Perkins and Don took the Lexington Avenue express and made their way to the Limóns' apartment on East 13th Street only to discover that they were not at home. So, "we went into the bar under you, the dirtiest one, and then went to the corner of 5th Ave. Schraft's to see if you might be putting on the feed bag in there, and while I was looking, one of Don's former husbands (Weight: 317) came along with four other questionable creatures (ALL DREAMY) and a lady who had an appointment with Helene Rubinstein the next day." Then "Don's fat friend took us in a cab, we each were given a pint of rum and told to go to work on it. Don had two pints. Getting him home was a problem. The sidewalks were terribly unruly." At 1:30 in the morning, Don and Perkins dropped in on some other friends only to find them out, too. "Then in the second bar, visited on the way home, Don dropped his glass of beer on the floor which embarrassed me, one of the few things that could, and I dragged him on upstairs and pulled off his clothes and he told me that life was futile and useless and that I should take an axe and disconnect him from further experience in this phase of cosmic root substance." Just to drive home the point, he added—hardly necessarily—that "Don felt terrible about everything."

Perkins asked José and Pumba if they had yet seen his one-man show of Index watercolors at the Metropolitan Museum of Art. "If not, why not. It looks sensational. I had my picture taken in front of the pictures just to prove that I was once in cerise toe shoes," leading one to wonder if he attended the exhibition in drag. Perkins mentioned that there was a booklet of twenty reproductions just coming off the press. Then, in a complete non sequitur, a joke: "A guy went to a hospital for an appendectomy. After the operation, the patient found his prick very sore and called the doctor. The doctor said, 'Well, as I performed the operation . . . my work was observed by a large group of interns and when I finished I had done such a brilliant job that they gave me a tremendous applause and as an encore I circumcised you." Finally, Perkins enclosed a newspaper clipping about a new beauty aid being marketed by the cosmetics company Coty in collaboration with MGM. This was a life mask that women could order and use to practice their makeup for different occasions, "one a natural, smooth makeup for her daytime work and the other super-glamorous for recreational hours."

The letter has a fast-paced, manic, improvisatory tone that is probably an accurate reflection of Perkins' conversational style. No wonder Rose O'Neill so appreciated his "spriting," that is, the way he could so effortlessly shift, or prance, from topic to topic, sprinkling scatological jokes as he went along and engaging in any number of madcap capers. Even the newspaper clipping fit the pattern: all unwittingly, it reflected Perkins' own practice of applying "super-glamorous" makeup—a mask of his own—when stepping out for an evening of drag. Coincidentally, that same clipping (all unwittingly, again) contained a hint of prophecy: in a few months' time, Perkins would be on a cross-country train, heading back to Los Angeles for his new job at the MGM studio in Culver City, California.

Gremlins in Hollywood

I N THE TINY BLACK-AND-WHITE HEAD SHOT THAT appears on Perkins' official "Motion Picture Employee" identification card, we see him at age forty-two with a studiously impassive expression, hair combed back flat against his head. He wears a dark jacket and striped tie, which—like his shirt collar—is off-kilter, as if he had donned it in a hurry. Beneath the crooked tie is his MGM employee number. On the front of the card are the usual bits of data: name, Social Security number, signature, counter-signature by whoever was in charge. Mug shot and text are framed in an elaborately engraved border with the icon of a movie camera contained in an oval at the top left. Reversing the card, we learn that Perkins is five feet, eight inches tall, weighs a trim 130 pounds, and has brown hair and eyes. There are two prints, of his left and right index fingers, which are also on file, we are told, with the Civilian Identification Bureau of the FBI. He hasn't changed a great deal since his passport photograph—except for the fact that he seems to have shrunk by two inches: in his 1931 passport application, he is five feet ten.

Perkins is back in Hollywood—thanks to his work for the Index of American Design. From October 1942 to April, 1943, twenty-two of his Victorian interiors were on display under the rubric "I Remember That" at the Metropolitan Museum of Art in New York. The exhibition brochure—that pamphlet Perkins

Perkins' MGM ID card, 1943

mentioned in the letter to José and Pumba—offered a capsule history of late Victorian design and set forth guidelines for visitors: "The drawings in this book are amusing, but are not intended to ridicule. Rather they record and give remembrance to a time and place. Those of us who were brought up in similar surroundings will probably feel nostalgia of one kind or another as we repeat to ourselves, 'I remember that.'" Visitors were encouraged to linger and look: as Perkins recalled, the paintings were hung along the walls of the mezzanine over the museum's great entrance hall, each of them spotlighted and even provided with a step stool to facilitate up-close, eye-level scrutiny.

If MGM director Albert Lewin hadn't happened upon "I Remember That" only days before the exhibition closed, Perkins may well have lived out his many remaining years in New York. But Lewin did see the show, just when he was deeply engaged in planning a film based on Oscar Wilde's notorious and controversial 1891 novel, *The Picture of Dorian Gray* (the first version, of thirteen chapters, was published in 1890 in *Lippincott's Magazine*), a Faustian tale in which the exquisitely beautiful antihero Dorian vows that he will do anything in the world—even sell his soul—if only he might remain young forever, while his portrait alone grows old. He gets his wish but soon sinks into irredeemable corruption, while the portrait—mirroring his wicked soul—becomes so progressively hideous that Dorian kills its creator, Basil Hallward, to keep him from revealing the truth about it. In the end, Dorian rends the canvas with a dagger in a desperate effort to destroy the evidence of his sins once and for all. But he himself falls back dead, the knife in his own heart, his own face now an ancient and hideous mask of evil. Magically, the portrait too undergoes a metamorphosis, becoming once again the reflection of Dorian's youthful beauty.

Lewin, a diminutive and scholarly aesthete with a master's degree in English literature from Harvard, was something of an odd man out in Hollywood in that he aspired to cinematic art rather than action, thrills, or romance. He had already directed *The Moon and Sixpence* (1942), based on Somerset Maugham's novel that was based in turn on the life of the artist Paul Gauguin. And he wanted *Dorian Gray* to be a real work of art in itself, in every respect. When he discovered Perkins' watercolors on the Metropolitan Museum's mezzanine, he had an epiphany of sorts: in Perkins' renderings, set in the same general period as Wilde's novel, Lewin perceived a style and sensibility that clicked with his own vision for the movie. He decided instantly that he needed Perkins on his team.

The director tracked Perkins down and made him an offer, reporting to his producer Pandro Berman: "Harnly can be, I believe, of very great value to us. He is extremely practical and is a trained interior decorator besides being a painter. I believe that if Gibbons [Cedric Gibbons, MGM's supervising art director and designer, in 1928, of the Oscar statuette] talked to him he would feel that he could fit into his department beautifully. He knows all about our period, in fact he is simply steeped in it and loves it. He is very keen to come out, and we can

make any sort of deal with him that we want. I think we could have him for his transportation and around $125.00 a week. He is at present working in a defense plant but is technically called a 'helper,' and says that he knows that this makes it possible for him to leave his job any time he wants."

Perkins jumped at Lewin's offer and soon was en route to Los Angeles on the Super Chief, the so-called "Train of the Stars." He must have taken an ordinary passenger train to Chicago, though, since the Super Chief departed from there on its westward journey. It's tempting to imagine, or hope, that he may have been on the same Chicago-Los Angeles train as the artists Ivan Le Lorraine and Malvin Marr Albright, identical twins whom Lewin hired to create the contrasting pictures of Dorian Gray for the movie, one representing Dorian in beautiful and ageless youth, the other revealing the putrescence of Dorian's soul, written horrifically on his body. Unfortunately for my wishful fantasy, it turns out that Ivan and Malvin didn't arrive in Hollywood until late October 1943, months after Perkins had made his journey across the continent. But surely these artists, who shared a taste for death and Victoriana, would have encountered each other on the sound stage or elsewhere on MGM's back lot. Or didn't they?

In April, 1943, Lewin had been on his way to New York, and Perkins, when he stopped in Chicago to meet Ivan Albright, "the one man who could create a painting which would give our audience a thrill of horror," the latter being "indispensable" to the movie. Ivan was without question the right man for the job. Since the late 1920s, he had been producing microscopically detailed paintings (the majority now in the Art Institute of Chicago) of men and women who looked as if they were in the final stages of disintegration. He depicted them with sad faces and livid flesh that bulged, sagged and puckered, every hair, every wart, every scab, every wrinkle rendered in sharp, hyper-realistic detail. These abject figures dwelt in dark rooms with battered, scarred, dusty furniture and pitilessly harsh overhead lighting that picked out and exaggerated every flaw.

Albright's work caused a sensation wherever it appeared. *Time* commented in 1941 that his portraits looked "as though their subjects had been removed from newly opened graves"; others thought that they looked like "drowned corpses" that had just been hauled out of the water after six weeks' worth of decomposition. Critics and viewers could hardly say enough about the repulsiveness of Ivan's people: they were living mummies, they belonged in a horror movie, they came straight out of Edgar Allan Poe. People found them fascinating or repellent in equal measure. No wonder Albert Lewin wanted this painter, and *only* this painter, to create the portrait of Dorian Gray's rotten, wicked body—and soul. In his introductory letter to Albright, he wrote: "The story requires a portrait of Dorian Gray first in his pristine loveliness and later in successive stages of degeneration. I know no painter alive,—I don't even know any dead painter, if one could be resurrected—capable of solving this problem as brilliantly as you."

Ivan and Malvin, born in 1897 in a south Chicago suburb, were the offspring of Adam Emory Albright, a successful Chicago painter whose bland impressionistic images of wholesome country boys—for which the twins reluctantly served as models—belied his own experience as an art student. (Adam was also the reason why each twin's middle name was that of a notable artist: the seventeenth-century classical landscapist, Claude Lorraine, and the late nineteenth-century painter of gory historical epics, Carl Marr.) Adam had studied under the Philadelphia realist Thomas Eakins, a controversial figure in his own right who painted bloody surgical operations, introduced nude models to mixed classes (and, scandalously, undraped *male* models to female-only classes) at the Pennsylvania Academy of the Fine Arts and made medical-grade dissection a fundamental part of his anatomy curriculum.

Eakins put young Adam Albright in charge of monitoring the dissecting room and managing the cadavers. Later, father Adam told his little twins grisly bedtime stories about the art students' dissecting-room hijinks and "chant[ed] the dead march to put them to sleep," as he told a writer for the fashion magazine *Harper's Bazaar*, where his memoir of teacher Eakins somewhat incongruously appeared. Ivan had plenty of gruesome anatomical experience, too: during World War I army service in Nantes, France, he filled three sketchbooks with painstakingly detailed drawings documenting the horrific wounds soldiers had received in battle.

Twin Malvin also became an artist, starting out as a sculptor but then switching to painting in the early 1930s. Working in twin studios in a renovated Methodist church in Warrenville, Illinois, the brothers shared an intensely symbiotic bond but were also ferociously competitive, leading Malvin to adopt the unpronounceable pen name, or brush name, of "Zsissly" so that in group-show brochures where his brother appeared at or near the top of the list, he could be at the very bottom, the whole alphabet standing between the two. Unfortunately for Malvin, Ivan was by far the better, and weirder, artist; Malvin's paintings were milder and considerably less scabrous. Fortunately for both twins, father Adam had made enough money through shrewd real estate investments, as well as his popular paintings, that neither twin had to concern himself with sales.

But to return to Albert Lewin's quest: arriving in Chicago, he was taken to Warrenville by a friend driving a shiny yellow Cadillac convertible. Ivan came running out to greet them. Lewin didn't know quite what to make of the man: "He is a little fellow, about my size but more corpulent," he wrote to Pandro Berman, "with straight gray hair, quick eyes behind spectacles, a sharp nose and a red face . . . He has a very shrewd look, as unlike the usual romantic notion of an artist as possible. He could very well be presiding over the cracker barrel in a small town grocery store. He smokes innumerable cigarettes, and his movements are as active and unpredictable as those of a humming bird." But when Malvin joined the party, things got even more confusing. Lewin wrote, "They have aged in an identical

way, and I was never quite sure I was talking to the right Albright." The twins regularly pretended to be each other; in fact, they claimed to have been switched at birth, making Ivan really Malvin, and vice versa. They were two halves of the same whole. After protracted negotiations, with Ivan initially demanding $75,000 but coming down at length to a more realistic sum, the deal was sealed. Malvin would accompany his brother and would undertake the young Dorian's portrait while Ivan concentrated on the horrific final picture for $10,000 plus expenses (which ultimately totaled another $10,000).

Ivan and Malvin had worked off and on in various Southern California locations in the 1920s; Perkins, as we know, had lived in Los Angeles for several years in the same decade and even worked in Culver City when engaged in his research job finding historical material (or just lugging books) for the production of *Ben-Hur*. But by the early 1940s, Hollywood was a much bigger business. Culver City's movie studios had expanded and multiplied, but MGM, founded in 1924, had the largest presence, and the largest footprint. With nearly two hundred buildings— including twenty-eight sound stages—on its vast 185-acre backlot, it was a self-contained, vertically integrated mini-city where some five thousand people worked to produce films bearing the studio's signature look of glamour, wealth, style, and class. That "look," of course, was the glossy veneer of what was in fact a bureaucratic and industrial complex with—just for starters—film laboratories, a camera and lighting department, a lumber mill, a foundry, machine shops, special-effects department, commissaries, stables, an electrical plant, a fifteen-warehouse wardrobe department, and even a roller dome. The main entrance, on West Washington Boulevard, boasted a majestic Corinthian colonnade; the sleek Art Deco Irving G. Thalberg Building was the executive and administrative center dominated by the all-powerful über-executive, Louis B. Mayer.

It is just about one hundred percent unlikely that Perkins crossed paths with Mayer. Indeed, one of the great puzzlers of Perkins' story is the question of what exactly he *did* do, and whom he met, over the course of his second stint in the movie business. The contract apparently called for him to do the continuity sketches, which he defined as "a small black and white drawing in pen and ink, graphite and charcoal, depicting the backgrounds, position of characters and lighting." These were used by the "director and camera man for aids in timing and composition and lighting." In other words, Perkins' principal task was to illustrate camera setups—visual backups for the script supervisor, who kept an exactingly detailed record of every arrangement. Given that there might be "1500, 2000 set-ups in the picture . . . all shot out of continuity" there had to be record of "where each individual shot" belonged in the overall "mosaic" of the picture. Everything had to match. Of Perkins' continuity sketches, there remains only a meager handful of photographs. However, the surviving images are identifiably views of *Dorian* sets, including portrait artist Basil Hallward's

Perkins' continuity sketch of Basil Hallward's studio in The Picture of Dorian Gray, *1944*

studio and an opulent dining room, scene of Dorian's marriage proposal to Hallward's innocent niece, Gladys.

Fresh off the Index of American Design, Perkins was indisputably an exacting detail man. But his own account of his working process suggests that Lewin, at least initially, sought his input concerning style and atmosphere as well as nuts and bolts. Perkins recalled that "For *Dorian* I ransacked through all the prop houses for acceptable décor and architectural motives. I worked hard on that and was rewarded accordingly." This squares with Lewin's reflection: "I was happy when you agreed to come to Hollywood to help me with 'The Picture of Dorian Gray.' During the preparation of the production, I found your ideas provocative and stimulating."

But what ideas were they? Considering the number of MGM designers and scenic artists who had a hand in producing Lewin's movie, it's a wonder that Perkins was allowed any measure of authority. There was, to begin and end with, Cedric Gibbons, head of the art department. Famous for the glossy Art Deco movie sets he created at MGM and legendary for his aloof and haughty demeanor, Gibbons was a debonair figure who drove around Hollywood in a flashy Duesenberg automobile and exercised supreme control over every aspect of design production. He would arrive at the studio wearing his signature gray homburg hat and gray gloves and stalk upstairs to his office, where, depending on

his mood, "he would take off or leave on the gloves. Removing his hat, he would say 'hello' to his secretary as the art department watched in awe."

Although Gibbons as Supervising Art Director always got top (and often sole) billing in the movie credits, the real work of realizing the look of any given film was carried out by a designated unit art director who supervised a crew of sketch artists, draftsmen, matte painters, set designers, set decorators and technicians in a highly structured organization where factory-like conditions were the norm. From his perch, Gibbons oversaw all operations but had actual contact with few but those directly below him. In the words of Boris Leven, who worked at MGM as a draftsman for a few months in 1938, "I almost never saw Cedric Gibbons in all that time . . . at MGM I never knew where the paint shop, the props, the carpenters were. I only knew where my desk was. You went to your desk, and then it was lunch time, and then you went home."

All this suggests that if Perkins enjoyed *carte blanche* in ransacking the prop houses, he must have done so with a special exemption granted by Lewin or Gibbons; otherwise, it is somewhat of a puzzle that an obscure neophyte who had not come up through the production ranks and had no experience whatsoever in film (always excepting his "research" for *Ben-Hur*) would be turned loose to come up with the right motifs, materials, and overall vision for the movie. However the assignment came about, Perkins had a great deal of ransacking to do. The main property department—housing a million objects—occupied a chunky four-story brick building on the studio's Main Street. On the top three floors was furniture for set dressing, from antiquity to modern times and beyond. On the ground floor were thousands of "hand props": clocks, dishes, doorknobs and latches, radios, phony money, trophy animal heads, guns (which had a room of their own). Photographs of the interior show hundreds of lamps in every style on shelves stretching into the far distance, and what seem like acres of Louis XVI furniture, used in the 1938 production of *Marie Antoinette*. Actor Jane Powell recalled that the prop department was "like a museum, a glorious collection of real and unreal, of every period, every style you could imagine." Or perhaps it was more like a department store, or an infinitely vast flea market. For Perkins, it may have been like walking into an encyclopedic and transhistorical Sears catalogue, realized in three dimensions.

There are only scraps and shadows to suggest Perkins' role in styling *Dorian*. In addition to the continuity sketches, there are some murky photographs of drawings that appear to be front elevations of scenic units, with architectural elements, furniture, and ornaments rendered in a flat, schematic fashion like diagrams or blueprints. Two of them, identified as Dorian Gray's bedroom, play on the sophisticated neoclassical English Regency style of the early nineteenth century; others are eclectic mixes of East and West. There are elegant chairs sporting legs in the form of winged griffins or sphinxes, voluminous drapery swags, tall paneled

double doors, vases and urns, low-slung tufted divans, moose trophy heads and standing taxidermy bears, grimacing Asian masks—perhaps Javanese or Japanese, seated Buddhas, intricate chandeliers, overloaded Victorian sideboards, potted topiary boxwood trees, and statues or decorative paintings of androgynous nude youths. Were these the things Perkins ransacked from the prop house?

Somewhat surprisingly for an author who lectured on taste and beauty in household decoration, Oscar Wilde said very little concrete about the architectural elements and décor of Dorian's mansion. Aside from the fact that the characters are always flinging themselves on handy couches or divans, we do not get much of an idea of Dorian's furnishings. There are touches of description here and there that suggest luxury and refinement: a bathroom paved in black onyx, olive satin curtains lined with shimmering blue, a screen of gilt Spanish leather, a little Florentine table, a pearl-colored octagonal stand, and a few other bagatelles—but nothing that adds up to a coherent mise-en-scène.

What should be the ideal ambience for Dorian, so beautiful, so heartless, so decadent? For Lewin, it was not just a matter of filling in a background. The novel was "merely a story of an exquisite character," he said, and he accordingly "got involved with making the picture exquisite," too. "I really went to town on every setup," he went on. "When you have two thousand set-ups in a picture, it can take rather long. I was even careful about the table linen and the cutlery and whatever was on the wall. All the upholstery was built for me . . . The picture was handsome because I took all that time and spent all that money." So obsessed was Lewin, according to Angela Lansbury, who played the tragic cabaret singer Sybil Vane in the movie, that even the food was authentic to the period, which delighted the actors who got to eat "pheasants *en gelée*" and other sumptuous treats after a shoot. All of the furniture was "for real," too, she said. Some was rented, some came from the MGM prop house, and some (though not all, as Lewin claimed) was indeed built specifically for the film. Lewin wanted exact period correctness in every way, she said. Nothing escaped his attention, down to the smallest details of costumes and jewelry.

We'll get back to the movie, its look, and its symbolism. But first, we have to catch up with the Albright twins. Part of Ivan's luggage was his eight-foot canvas, *The Door* (a nickname of sorts for the picture he officially titled, in characteristically overblown fashion, *That Which I Should Have Done I Did Not Do*), one of his most notorious paintings, depicting a warped and battered Victorian door adorned with a wilting funeral wreath of roses, callas, and lilies of the valley. A woman's hand—wrinkled and puffy—is poised above the elaborately worked knob, as if about to turn it, and from the keyhole comes an almost imperceptible wisp of blue smoke or vapor. When he first began to exhibit the painting (which took ten years to complete), Ivan framed it with a black velvet coffin lining edged by a wooden frame he had carved himself, with writhing silver-gilt nudes and handles on either

side. Crowds in Chicago, Washington, and New York could hardly get enough of it: *The Door* was a morbid sensation wherever it went. It was equally sensational in Hollywood. Ivan later told an interviewer that Albert Lewin—"a wonderful chap"—"had it in his office in the administration building for a while. After it had hung there for about four days, he said 'Ivan, take that damn picture out. They don't look at me any more. They come in to look at *The Door*.'" Ivan, accordingly, hung it in his studio, where it probably competed with his ever more gruesome portrait of Dorian.

Once installed at MGM, the twins became almost as sensational as *The Door* for their publicity-worthy antics. Scores of gossip columns reported on their hijinks, and articles in national magazines—*Life* and *Vogue*—further cemented their oddball celebrity. Constantly befuddling everyone who crossed their path, the twins, in their usual way, regularly pretended Ivan was Malvin and Malvin, Ivan; demanded arty purple (or blue, or green, depending on the source) velvet smocks (donned only when there were visitors around); and wore (on occasion) shaggy red fright wigs, allegedly to keep their bald pates warm when they worked in the studio, which was also well supplied with cases of whiskey. Photographs showed the two little men working on their respective portraits, modeled by life-size dummies, the young one of course sleek and handsome, the other leprous and disgusting. Malvin's young Dorian portrait, though, failed to make it into the movie; MGM brought in the Portuguese artist Henrique Medina—who happened to be in Los Angeles painting portraits of actresses and moguls—to create the one that actually appears in the film.

According to Angela Lansbury, the twins were delightful fellows who were there *all* the time during the shooting—which is a bit surprising given that Ivan's methodical and deliberate technique made his progress, such as it was, maddeningly slow. But their presence must have been diverting, not least because of their various soubriquets: they were dubbed gremlins, elves, pixies, and—best of all—gnomes, "pudgy, grey-haired, ruddy-faced, bright-eyed gnomes from a Disney fantasy." Felicitously, Albert Lewin, also short of stature, was known around the set (though probably not to his face) as the "Metro-Gnome."

Off set, the gnomes seem to have partied hard. Ivan and Malvin went to Lewin's house on the beach at Santa Monica on New Year's Eve, 1943. They "celebrated on quite a few bottles of champagne" and listened to composer Herbert Stothart (who wrote the score for *Dorian*) at the piano. That was the version he told young Helen McCabe, his current crush. Later he embroidered on the story in an interview: "I used to write a lot in Hollywood under the piano when I got drunk," he said. "Well, you see, there was Albert Lewin there . . . Every Saturday and Sunday they had these big cocktail parties. They never had writers there. They never had actors there . . . Maybe there'd be about thirty people present. [It's hard not to wonder, or hope, that Perkins was there too.] And Herb Stothart was there. He was a musical

The Albright Twins in their studio at MGM with mannequin of Dorian Gray in decay

chap; he had seventeen hits on Broadway. He'd get at the piano. Well, after, say, the Nth drink I used to think: what the hell can I do? So I only had to take my paper and pencil and crawl under the piano and come up with a piece of poetry all in forty seconds . . . Lewin would look at my poem and say, 'Damn it! It's pretty good anyhow.'"

Revelry aside, Ivan had studied Wilde's novel even before departing for Los Angeles, and he made detailed plans for the portrait. In his notes, he indicated

that he wanted his (and Malvin's) studio at MGM furnished "in period of Oscar Wilde's book in good taste and with some blue china around" and some perfumery bottles. Like Perkins, he too wanted to see "all the stage property of the period of Dorian Gray," although he probably didn't do his own ransacking. There had to be two sets of the same props for the portraits: a tall red tufted dressing screen, a small Regency table, a clock, an Aubusson carpet (or a copy thereof), a florid Victorian chair, and—as seen in shots of Dorian's main salon—a figure of the ancient Egyptian cat goddess Sekhmet, which exudes a mysterious and vaguely malignant aura. Ivan figured out how to transform his set of props into ghastly relics to match their owner: "I have had the settings for the later paintings aged and they have a machine at MGM that blows on rubber cobwebs and then they sprinkle on some kind of a dust that shows them up in a wonderful way," he wrote. Originally there were to be four versions of the portraits, degenerating through time, but Ivan painted so slowly that in the end there were only the two, the young one and the ancient. Ivan himself smashed the clock, and he also insisted on having real blood (the grisly residue of Basil Hallward's murder) to apply to the hands of Skeets Noyes, a bit player who modeled for Dorian whenever a real human was needed. The blood, Ivan asserted, wasn't the usual MGM canned red but real chicken's blood freshly wrung into a jar every day for a month at the MGM commissary. Ivan related that when he dabbled it on, "[Skeets'] face was a contortion more than Dorian Gray's face as the blood congealed and shrunk on his hand." If the whole of *Dorian Gray* had been in black-and-white, the authenticity of the blood would hardly matter. But since in the film the portrait appeared in blazing color, thanks to Technicolor inserts, the blood (in Ivan's view at least) had to be real. There's a lot of blood in the painting—on both of Dorian's hands, on his dagger, on the glove that he holds and on the one that's fallen onto the rumpled rug, on the table, on the Egyptian cat—blood everywhere, but whether chicken, human, or chemical no one can tell; it's just a lot of horror-movie gore.

Except for the Technicolor inserts (four in all) *The Picture of Dorian Gray* was filmed in black-and-white, like most movies at that time; color was still prohibitively costly. But Lewin had a plan to make the most of his limited palette: "I decided that everything was going to be black and white because of the good and evil symbolism. I packed it full of symbols," he declared. Accordingly, the director made the most of every opportunity to incorporate calculated light-dark contrast, for example in Dorian's gleaming floors with their crisp black-and-white checkerboard-and-chevron designs, and in the glossy black columns, the paneled black doors, tables, mirrors, and mantelpieces embellished with silvery reeding, wreaths, rosettes, and heraldic winged griffins. Even the black-and-white striped counterpane on Dorian's bed fits in. Then there are the torchière lamps, with black turbaned figures holding aloft their globes of light, and the antique and

Renaissance bronzes of draped maidens and nude men that read as jet-black on the screen. Almost always clad in evening dress with an opera cape and shiny top hat, Dorian himself—all pale, impassive face and sleek black hair—is as subtly sinister as Bela Lugosi in his signature Dracula tuxedo. The episodes that take place in the London slums are replete (more predictably) with looming shadows and glaring flashes of light. Whether viewers registered such abstract symbolism consciously or subliminally, or if it flew under their radar is an open question, but no observant eye could fail to note the evident care and thought that went into the choice, placement, and framing of the scenic elements.

The artworks that abundantly populate the sets play symbolic parts, too, in particular the classical antique and Renaissance sculptural figures that evoke the culture and practice of what was euphemistically termed "Greek love," i.e., the culture and practice of male-male sexual or non-sexual (Platonic) desire. There is never an overt indication of sexual attraction among the men—painter Basil Hallward, Dorian's insidious mentor Lord Henry, and Dorian himself—but Basil finds himself irresistibly drawn to the young man's beauty, even worships it, and by extension, him. Often referred to by Wilde as a "boy," or a "lad," Dorian is a bachelor (a code word often hinting at homosexuality), and even though he courts two women (causing the suicide of one), his most important relationship is with Lord Henry, an intellectual seducer who exposes the "boy" to decadent literature, does his Mephistophelian best to discourage him from marrying, and infects him with "subtle poisonous theories." All this plays out in the movie, but Lewin took care to emphasize Dorian's beautiful youth by pairing him in various scenes with two iconic Renaissance bronzes—by Donatello and Andrea del Verrocchio—of the Biblical boy hero David, slayer of the giant Goliath. Donatello's David, clad only in a rustic laurel-bedecked hat and tooled shin guards, stands on the ogre's decapitated head, one hand on his hip and the other clutching the hilt of an enormous sword. With his coiling ringlets, slender adolescent body, and hipshot pose, he straddles a fine line between male and female. Less sinuous than Donatello's, Verrocchio's David in his brief tunic is all adolescent angles but for his ever so slightly mounded breast buds, the nipples accentuated by embossed flowers. In one scene, Lewin drew a direct line between this David and Dorian, who stands facing a large round mirror in which we see the reflection of Verrocchio's figure—unmistakably Dorian's ambiguously sexed counterpart.

The film's creators and principals assumed that Dorian's uncertain sexual identity and the gay subtext of the story would fly right over the viewers' heads. Dorian's deeds and misdeeds take place off camera as indeed they did in Wilde's novel, except, of course, for the murder of Basil Hallward. Anything else is left to the imagination. But Ivan Albright was hardly in the dark when it came to deciphering Dorian's true nature. Like many artists, Ivan was not a great poet, to

put it charitably, but the poem—or more precisely, doggerel—that he scribbled on MGM stationery is unambiguous about Dorian's in-between sexuality:

The picture of Dorian Gray
Will have to be seen with an X-ray
For within the canvas may be
That which the naked eye cannot see.
I will quit before I make you nuts,
But on Dorian's face I am making plenty of guts
I have painted a fly on his fly.
And put astigmatism in his eye.
He looks like Boris Karloff on a stroll.
But has a female hipped walking roll.
And aging Englishman of him have I made He.
And he swings along like a half made She.

One wonders how many glasses of champagne that took, and whether Ivan composed this burst of poetic inspiration under Lewin's piano. In one of his notebooks, Ivan made two rough sketches mapping out the composition for the portrait. Below them, he scribbled: "Dorian with a green carnation." Although Ivan's Dorian ends up with a camellia boutonnière (which he also wears in the film; in the painting it lies bedraggled on the carpet), the green carnation—since Oscar Wilde's time an esoteric symbol of same-sex desire—points to Ivan's sense of the novel's, and the movie's, covert meanings.

Certainly Perkins was in no doubt whatsoever about those meanings. It's hard to imagine a production more in harmony with his own tastes, whether or not there was a green carnation anywhere in sight. Decades later, in one of the interviews recorded by his young friends on videotape, he started reminiscing about the movie. Perkins said that he had studied the script and knew it by heart. He went on to reveal that being "dreamy and imaginative" himself, he had a lot in common with Dorian Gray. He seems poised to elaborate. Then, maddeningly, there's a gap in the tape, and when Perkins resumes, he's talking about something else entirely. Likely we will never know more about his identification with Dorian, but there's little doubt that he was well able to imagine what Dorian might have been up to off-stage.

Reviewer Parker Tyler also knew what Dorian was up to, or should have been up to, in the movie. In what must surely be the most trenchant and fine-grained dissection of *The Picture of Dorian Gray*, Tyler—writing in the avant-garde magazine *View*—pegged the anti-hero as effeminate, passive, and narcissistic and compared the star, Hurd Hatfield, to Katherine Hepburn. Tyler, a pioneering practitioner of full-bore intellectually cogent film criticism, was co-author—with

Charles Henri Ford, founder and chief editor of *View*—of *The Young and the Evil*, an experimental novel about gay life in 1920s Greenwich Village, a topic so taboo that no publisher in the U.S. or Britain would touch it. When in 1933 the book did receive publication, in France, it was banned from the American market. (In the 1930s, Tyler crossed paths with Perkins' cousin Don Forbes; along with other artists and writers, they occupied living quarters at 204 W. 14th Street.) In his review, Tyler noted that Oscar Wilde was "attracted to the idea of pagan love as well as pagan philosophy—and we must not forget that the ideals of Greek antiquity tended to exalt the male above the female not only as to mental but also physical beauty. But Wilde was intelligent enough to realize the great danger of making such emotions into more than obscurely elegant pieces of pseudo historical-research . . . In his acts . . . Wilde had to move behind a screen."

Dorian Gray, Tyler argued, was meant by Wilde to be a peerlessly beautiful love object in the Platonic sense, but Hollywood, bowing to the "Morality of the Average Citizen," had made him a "typical young man-about-town who consistently goes whoring and gains an evil reputation as a seducer of wives." In this distortion, Tyler argued, Ivan Albright was a willing collaborator. Under his hands, the portrait of Dorian turned out to be a "scrawny old wolf with a pot belly, clothed with apocryphal festoons of sometimes shocking nature, cloth and articles of furniture sharing in the kind of swelling and cracking one associates with the decay and disease of the body." Art, said Tyler, "was implicitly offended," but all the same, a person could hardly help reacting with a certain thrill. "It is the way one usually reacts to zombies and werewolves from the jungles adjacent to Sunset Blvd. Ivan Le Lorraine Albright has given us, in his portrait of Dorian the Wicked, a compelling version of the American moral jungle from which all famous creeps, fundamentally, must be said to crepitate." Albright had turned Wilde's "Stunning Young God" into "the Awful Old Man."

Tyler had a point: Albright's *Dorian Gray* is so far over the top in its obsessively rendered repulsiveness that it is, indeed, *awful* both in the obsolete sense of terrifying and in the modern one of simply bad. It is a hallucination of rot, a visual cacophony of pustular gore, immersed in incoherent whorls of color. But its sudden gaudy apparition at the end of the movie does have shock value. Awfulness, too, is in the eye of the beholder. There is a photograph of Albright's painting back in Chicago in 1945, hanging in an exhibition at the Art Institute. In front of it, several young women, high school or college students perhaps, cringe and shudder in horror. Two years later, *Dorian* traveled to the Illinois State Fair; *Time* photographed a group of farmers there with their wives and children, grinning and sniggering before the portrait. "'That fellow,' says one, 'looks just like a dried-up crab apple under my tree back home.'" It's just possible that Perkins would have agreed. It may have been one of the campiest horror paintings he ever could have imagined. Or did he perhaps feel like Ivan's kindred spirit?

On the face of things, it would seem that Perkins and the Albrights (Ivan in particular) should have been destined to bond with each other. Ivan was an aficionado of Victoriana, funerary trappings, death and decay; Perkins, as we well know, shared those tastes, and more. Yet there is absolutely no extant record of any interactions, whatever they may or may not have been. In his letters, Ivan never says anything along the lines of "We met the most interesting oddball sketch artist on the set; he's going to take us around to all the best Hollywood graveyards and tell us about the time he carried Sarah Bernhardt upstairs." Nor does Perkins, in his uncharacteristically reticent recollections of the *Dorian Gray* period, ever mention Ivan (except just once, in passing), Malvin, or Ivan's horror-show final reveal of Dorian's festering soul. Perhaps they simply didn't intersect, although all three were around the set at various times. As noted, Angela Lansbury vividly remembered the twins' constant presence, and Perkins too must have been there, at least part of the time, since he later mentioned his "old friend Donna Reed," who played Dorian's fiancée Gladys. Of course, the twins may have considered themselves too much the exalted fine-art painters to hobnob with a lowly sketch artist (though at the very least, all three shared an interest in wigs). Indeed, Perkins was so much a member of the aesthetic rank and file that he didn't even get a mention in the movie's credits, whereas Ivan Albright got prominent billing (poor Malvin being bumped from the credits by Henrique Medina). Or was Perkins too ostentatiously gay for the emphatically straight (if bachelor) twins? Were the twins such scene-stealers that Perkins (who enjoyed scene-stealing in his own right) simply avoided their orbit?

In the end, Perkins is invisible—everywhere and nowhere—drifting like a ghost behind the scenes. We don't really even know what exactly he did beyond ransack the MGM prop house and produce those continuity sketches and set elevations. Sometimes he stated that he was on the job six months; other times, that it lasted two years. He almost always claimed to have done 225 continuity sketches, except once, when he said he'd made 216. On occasion, Perkins aggrandized his role at MGM, even asserting that he had "designed sets at MGM," *Dorian* being only one of his films. Given that production art was haphazardly preserved at best, it's probably impossible to sort out who did what or who took credit, though it's on the record that Cedric Gibbons assigned Hans Peters to design the sets, and Hugh Hunt and John Bonar were given the job of supplying authentic period trappings, bric-a-brac included. But Perkins did do *something*: he saved enough of his *Dorian* artwork to include a selection of the drawings in an exhibition at the Culver City Hotel in April, 1945. He even sent out fancy engraved invitations to the opening. (A couple of years later, he sent the *Dorian* sketches and a great deal of other ephemera to the New York Public Library, where they remained in the Artist Files until they were photographically transferred to microfiche. The originals were deaccessioned and remain untraced; most likely they were destroyed.)

Parker Tyler aside, *The Picture of Dorian Gray* received mostly positive critical notices and—while not a blockbuster—did well enough at the box office and would even have turned a modest profit if Lewin hadn't gone wildly over budget in shooting the film. For his next movie, *The Private Affairs of Bel Ami* (based on the Guy de Maupassant story of a womanizing social climber who comes to a bad end), Lewin held a contest to select an artist to paint *The Temptation of Saint Anthony*, which, like Dorian's portrait, was to be a Technicolor insert. Ivan was one of the contestants, along with a roster of surrealists; his version of the temptation is a hectic, lurid phantasmagoria of puffy blue nudes, frogs, insects, vermin, wild animals, and one glaring skull, all swarming around the body of the screaming saint. Ivan lost to the surrealist Max Ernst; the latter's winning entry made a negative impression on the film critic Bosley Crowther, who thought St. Anthony in his red robe looked like a "bad boiled lobster."

Ivan and Malvin returned to Warrenville, but not for long. In August 1946, Ivan married *Chicago Tribune* heiress Josephine Medill Patterson and spent most of his many remaining years in Maine or at Patterson's ranch in Wyoming. Malvin was bereft. Only recently, in Hollywood, a newspaper man had spent a day with the twins, "and they said then it was unlikely either would marry, as each needed the other in completing various works of art." It must have been a whirlwind courtship. A gossip column reported: "Malvin, the bachelor half of the identical and inseparable Albright twins, is missing his brother, Ivan, who is honeymooning . . . A fellow artist, seeing Malvin wandering lonely as a cloud on the near North Side, clapped him on the shoulder and said merrily: 'Since your divorce from your brother has your price in art gone up or down?' Malvin was not amused." Josephine claimed that Malvin, weeping uncontrollably, had accompanied the newly married pair on their honeymoon, but we have only her word for it. It is true, though, that Ivan's marriage did precipitate an irreparable rift. The twins severed all ties and reportedly never spoke again. Malvin eventually consoled himself for Ivan's betrayal by marrying his own newspaper heiress, Cornelia Fairbanks Ericourt, in 1954. Yet in the very end, the twins' bond drew them powerfully together again, at last: in 1983, the two died within weeks of each other.

As for Perkins, *Dorian* marked the beginning and the end of his career in the movies. Not surprisingly, he offered a variety of different explanations for leaving MGM. He told one interviewer: "I was humped over from working and I had round shoulders and wanted to get out . . . I went to work as a gardener in Baldwin Hill Village . . . and did manual labor." Then there was the "strike" explanation. In March 1945, more than ten thousand studio employees, including set decorators, carpenters, painters, and others went on a strike that lasted until October of that year, when riots erupted and escalated between picketers and strikebreakers outside the gates of the Warner Brothers studio. The strike ended a month later. Perkins

averred that "I was part of the strike at the movie studio and I was blackballed." In yet another version, Perkins claimed to have been "physically and emotionally exhausted, and unable to suppress the 'snakes, whores, and undertakers' which continually flooded into his memory, but which obviously had no place in a faithful, literal rendering of a bygone era, [he] quit. 'I was smoking three packs of cigarettes, and drinking a quart of gin a day,'" he told a reporter. This last tale has at least a faint ring of truth. It's safe to say for the moment that Perkins suffered some sort of burnout and left, or was fired. And he stopped painting for two decades: this is true—almost.

This is actually an emphatic "almost," since in 1946–47 Perkins produced thirty-three watercolors of interiors both vintage and modern. They were commissioned by Albert Lewin, who in 1947 gave them to the National Gallery of Art. There they joined the Index of American Design collection deposited in its entirety in 1944, after World War II put an unceremonious end to the project as the Treasury Department reallocated resources and personnel to war-related work. Officials at the gallery were eager to have the new additions; indeed, the curator of the Index collection wrote Perkins that "We should be pleased if Mr. Albert Lewin should offer to enlarge his gift to include an indefinite number of your paintings from the series . . ." Fired up, Perkins applied for a grant from the Guggenheim Foundation so that he might continue the series, but he didn't make the final cut.

For this new, or renewed, series, Perkins added to the taste categories he had already explored in earlier Index work, which had focused on the Victorian era and the "Monstrosity Decade 1910–20." Perkins revisited those periods—as in the "Mail Order Period, Vigorous Nostalgia, 1900"—but also ventured into "California Mission," and what he called "Regional Interblending, 1925–50," comprising such subcategories as "Plastic Period." Perkins was thorough: the new series included farm, industrial, and domestic interiors; hotel, club, and theater lobbies, and, finally, a very up-to-date Los Angeles cocktail lounge.

Like Perkins' earlier Index paintings, and even more so, the watercolors in the Lewin commission are intensely detailed composites—like miniature stage sets or dollhouse rooms—crammed with furnishings and accessories that Perkins researched or stumbled across in second-hand stores, mail-order catalogues, old magazines, a Los Angeles blacksmith shop, the Lyon Pony Express Museum in Arcadia, California, the MGM prop house, and a rental company that supplied studios with items like cuspidors and animal trophy heads. Some of them Perkins based on Charles Weidman's Blairstown farm; others were rooted in his Nebraska past and still others in his California present. Rendered in clear colors and tight, precise draftsmanship, all of the interiors (like those in the original Index series) are uninhabited yet evocative of human presence, as if only minutes before the occupants had rushed away or mysteriously vanished—instantaneously beamed,

perhaps, aboard some alien spacecraft. Their leavings lie scattered about: fallen flower petals, ticket stubs, peanut shells, Derby hats, half-smoked and still smoldering cigars, burnt-out matches, spools of thread, wet boots, crumpled sheets of paper, spilled ink, a slice of cherry pie. The most elusive unseen presence of all, though, is Perkins himself, invisible yet everywhere, telling stories through things, including his own story, hiding clues in plain sight much as he did in the earlier Index watercolors and probably more so.

Thus, in a one-room Nebraska schoolhouse, Perkins Harnly's name is chalked on the blackboard: he is on the program to do a recitation as part of the school's special Valentine's Day festivities. In the *California Mission Style Interior*—among a welter of blocky Craftsman furniture, stained glass, and Native American textiles, baskets, and pottery—a Kewpie doll stands smirking on top of a player piano; on the piano bench lies an assortment of sheet music, including the title page of "The Last Rose of Summer." A theater box displays a Sarah Bernhardt poster. A millinery shop shows off an extravaganza of large plumed, flowered, and bejeweled hats that all look as if they could have come out of Perkins' drag closet. Possibly reflecting his abiding interest in outhouses dating back to his grandfather's creations, there are several outhouses to be glimpsed through windows as well as—in the classier interiors—signs indicating the way to the "Ladies" and the "Gents" rooms.

The shift to the California present is abrupt. Aside from the modern industrial interiors, which we'll come to in due time, there is the 1946 cocktail lounge. Compared with the stiffly opulent Gilded Age bar that Perkins rendered for the Index of American Design, his cocktail lounge has a raffish and even somewhat seedy aspect despite the abundance of ultra-modern chrome, neon, and tinted glass. The curvy couch and chairs, upholstered in sculpted maroon and beige, offer clubby comfort. But the surroundings are tawdry: there are pinups on the walls—including George Petty's nude "Miss 1946 ½"—and machines dispensing candy, cigarettes, and nuts. There is a fat Wurlitzer jukebox with colored lights, swirly chrome, and a decorative peacock plaque. Look closely and you see that the musical selections are limited to songs by the popular crooners "Frank [Sinatra]" and "Bing [Crosby]." A pay phone hangs nearby. To the right and left of it, callers have scribbled numbers and appointment times on the wall. One wag has written "Wolf, that's me." Someone has extinguished several cigarettes on the jazzy green Art Deco carpet, and there are dirty glasses and bottles here and there. Blocking us in the right foreground is a flipperless pinball machine with the butt and trigger of a pistol for a plunger. Someone has left a half-drained glass of beer, an uncapped lipstick, and an open rouge compact on the glass top. Also tossed there is a newspaper, its one visible page an advertisement for "Fine Funerals" costing only sixty-eight dollars, with a choice of twenty-four different services and "everything at the time of sorrow." Perkins'

cocktail lounge is a *vanitas* in disguise, delivering the classic warning: "Enjoy yourself; it's later than you think."

Which leads to the big question: how did Perkins enjoy himself in and around Hollywood? On the surface, and initially, Perkins' Hollywood period beyond *Dorian Gray* seems to be a blank, from the mid-1940s up to the point when he renewed his friendship with Alexander King around 1960 and launched a copious correspondence with him. But that blank surface belies a social life that was both rich and strange.

Decorating with the Stars

O N A VISIT TO LOS ANGELES NOT LONG AGO I acquired a curious postcard. The front is divided into quadrants. In one is a fancy tufted purple headboard rising over plump pillows; in another is an equally fancy Victorian flower still life painting in an elaborate gold frame, along with a glimpse of purple drapery drawn back by a golden cord with multiple purple tassels; in the third is a deep purple door with a gold knocker and modernistic numerals indicating that this is Room Sixty-Three. But the fourth, in the upper right, is at first glance utterly incongruous. Here are three tiny men, two in bias-cut plaid shirts—one red, one green—and the third in solid blue. Their brassy yellow hair is molded into fantastic sculptural curls and spikes. Who in the world are they, and why are they here? It turns out that these are the Munchkins of the Lollipop League, welcoming Dorothy Gale to Oz after a Kansas tornado has deposited her and her house there, eliminating the Wicked Witch of the East in the process. The back of the postcard identifies the place as the Culver Hotel, "Home of the Munchkins during the *Wizard of Oz* (1939) filmed at the studios next door."

The studio was actually a few long blocks from the hotel, and among many unsubstantiated Munchkin rumors there is one alleging that there was a special underground tunnel through which the little people traveled to the studio and back every day (in fact, it was merely an established pedestrian underpass). Other more salacious rumors also swirled around the one-hundred-plus midgets MGM hired for the film and lodged in the hotel. They were said to have participated in such shockingly drunken orgies that a policeman had to be stationed on every floor to keep order. Cecil Truschel, at that time the Culver City police chief, exclaimed: "Hell, they were terrible . . . We never put them in jail, but hell, they were high strung." And Judy Garland, who famously played Dorothy in the film, claimed that the little people "got smashed every night, and they'd pick 'em up in butterfly nets." In truth, and for the most part, the actors who played the Munchkins were hard workers who had very little party time, but such raunchy canards, of course, had more staying power.

But why bring up the Munchkins? Because the Culver City Hotel was Perkins' home, too. He moved into his room, he said, on July 1, 1942 (in actuality, 1943; for some reason he misremembered the year), when a streetcar strike made it difficult to get to the studio. Once considered a skyscraper (all six floors of it), the Culver Hotel opened in 1924; its owner, Harry C. Culver, was a hustler and real estate developer—another Nebraskan, a farm boy from the town of Milford, not

far from Lincoln—who gave his name not only to the hotel but also to the town itself, which he incorporated in 1917. Unfailingly enterprising, Culver would take potential investors up to the lofty roof of his "skyscraper" and point out the various lots and opportunities for development. When movie studios began to set up shop in the town in the 1920s, the Culver Hotel was suddenly at the center of things, accommodating stars like Joan Crawford, Clark Gable, and Greta Garbo over the span of its glory years.

A blunt-nosed red-brick flatiron pile at the intersection of Washington and Culver Boulevards, the building is a freely interpreted Italianate in style, with quoins and other details in contrasting limestone, a grand limestone base with wide arched windows, and a jutting cornice. A 1938 photograph shows the hotel dominating the flat terrain all around it as if it really *were* a skyscraper. At its feet trundle Tin Lizzies, streamlined roadsters, and bulbous buses; on one side, telephone poles and railroad tracks shoot off into the distance, while on the other huddle low-lying commercial buildings housing drug stores and cafés. During the 1920s and '30s, nightclubs "sprouted up" along Washington Boulevard, and the Culver Hotel developed a reputation "as a locale for prostitution, gambling, and [until 1933, when Prohibition ended] illegal booze."

By the time Perkins arrived, the Munchkins were there only in legend, and the glamour was fading fast: "[T]he place had become a shambles," he said. "The rooms were filled with five and six dollar a week guests: whores, drunks, old beaten up extras from MGM." The elevator operator was "an old grip from the studio," and there were wartime workers, too: "Crum bums from Iowa, Oklahoma and points Easterly." The place "stank to high heaven." The whores and drunks fled in 1945, when Bo Roos, manager of the über-masculine cowboy/tough-guy movie star John Wayne, bought the place for Wayne as an investment (stories that Wayne won it by beating Charlie Chaplin at poker notwithstanding), and cleaned it up so stylishly that, as Perkins put it, "The prices went up from six bucks a week to twenty-four ... That did it! The place emptied." But Perkins stayed, taking a room with a bathroom down the hall. Several managers later, a Unity Church preacher took over the job and, in partnership with her "stuttering, half blind hubby ... kept out all of the whores and drunks," at least for a time.

The "drunks" included a number of celebrities. Living on a small MGM pension there when Perkins moved in was King Baggot, one of the first movie actors publicized as a leading man. Perkins remembered that the erstwhile star had "a small apartment full of empty beer cans and whiskey bottles," along with Campbell's Soup cans and soda cracker cartons. During the John Wayne years, the comedian Red Skelton had an office on the second floor with elegant fixtures, tubs of tropical trees, a mammoth desk, and a "bevy of secretaries." Perkins alleged that "the only thing Red ever did" there was "to git drunk." In a scene reminiscent of that night with Sarah Bernhardt, her wheelchair, and the non-functioning

elevator in Lincoln, Perkins told of a time when he "helped the elevator boy carry Skelton from a seat in the lobby up to his office and put him to sleep on a sofa." Perkins added that Skelton made for a heavy load. Why they didn't use the elevator remains a mystery. On another occasion, Skelton "tumbled down the steps and had to be carried out to his car." In his own right, Red Skelton made up for the disappointingly sober (in real life) Munchkins.

For a while, glamour reigned again. There were "fancily dressed ladies sporty looking gents" and black bartenders and chauffeurs. Perkins enjoyed being in a congenial atmosphere and "felt satisfaction by being vicariously in the midst of consequential goings on . . . drunkenness and diddling." But by the early 1960s, as he reported to Alexander King, "the hotel has reverted to its tacky, disheaveled [sic] conditions. The paint has fallen from the walls, the floors show through the carpets. Filth encrusts the sinks and tubs, the help hasn't been paid their salaries for months, the place has been in the red for years, and Roos is closing it . . ." In 1967, John Wayne donated the hotel to the YMCA. Perkins crowed, "the YMCA is my new landlord. I feel so refined and respectable." But after only a few years, the place was sold again. More than once, Perkins was sure that his Culver Hotel days were numbered; indeed, a fire in 1972 forced the eighty residents, Perkins included, to evacuate (strange to say, he never mentions this in any surviving records). But the place staggered on, and Perkins stayed. He stayed there for forty years, almost to the end of his life, abandoning his room only when he was too old and sick to take care of himself any longer. His room became part of himself, an extension of mind and body; he made it "an oasis of near flawless perfection . . . a haven of peace undefiled." Leaving it for good must have felt like having an amputation without anesthetic.

But we're jumping too far ahead again—now back to the 1940s. Perkins stated that when he was executing the sketches for *Dorian Gray*, he "worked every night until 1:00 in the studio. Because there was no place for me to go. I didn't know anybody." On the contrary, though, sometimes it seems as if he knew everybody, alive and dead. Sometimes he had mere brushes with fame, like the day he saw the old vaudevillian and comedian Jimmy Durante, known among other things for his dramatically large nose—his schnozzola, as he called it. "One morning," Perkins remembered, "he was sitting on the kerb at the studio and I said, 'Jimmy, would you like to see this newspaper?' Irritated, he said 'Why don't you let me live my own life?'" This was hardly a meaningful or important exchange. But Buster Keaton salvaged the occasion. He was standing there, "bouncing a red rubber ball against the stage. Smiling, he asked me 'do you want to play catch?' For a few minutes we tossed the ball back and forth most of the time missing it. Buster laughed."

Keaton had returned to MGM after drinking his way through the 1930s. Now sobered up, he hoped to reinvigorate his career, stalled in 1928 when he lost most

of his creative independence after signing with MGM. Prior to that, Keaton had made his own wildly successful films that revolved around his deadpan persona as the Great Stone Face—all huge dark eyes, chiseled cheekbones, and trademark flattened porkpie hat—who nimbly performed his own daring and even death-defying stunts and pratfalls. Born in Kansas to a touring vaudeville family that once included escape artist Harry Houdini in the troupe, Keaton learned the ropes of physical comedy as a boy. In his silent films, he slipped on peels, fell off ladders, fell from windows, swung perilously from awnings, slid down drain pipes and fire poles, ran the length of a train on the boxcar roofs, and nimbly tumbled his way in and out of countless dangerous (and funny) situations. At MGM in the early 1930s, he had acted in three movies with Jimmy Durante before being fired by the studio.

Beyond the game of catch, what relationship Buster Keaton had with Perkins remains a mystery, but nearly forty years later, he visited the star's grave in Forest Lawn with young future star and Keaton worshipper Bill Paxton. Regaling Bill (whom he worshipped in turn) with the ball-tossing story, Perkins commented: "At the time I never dreamed that I might some day stand on a hill high above the City and an imaginative youngster would lie on Buster's grave and entertain fanciful love images in the field of memories." The old man and the young one bonded over the dead man's burial spot: "I'm the only person you know to whom Buster's unseen being means so much," Perkins told him. "We were close together up on the hill and it would be sweet to recapture that fleeting mood."

Fleeting also was Perkins' puzzling relationship with director Vincente Minnelli, who in 1943 was shooting *Meet Me in St. Louis* at MGM. Burdened by his homely looks and a speech impediment, Minnelli found inspiration in Joseph and Elizabeth Pennell's biography of James McNeill Whistler, whose persona was as flamboyant as his paintings were subtle and subdued. Modeling himself on the dandified expatriate, Minnelli "reinvented himself as a Whistler type of man . . . an aesthete and man of the world." Perkins said that Minnelli hired him to work on *Meet Me In St. Louis*, which with its Victorian sets—and even eight elaborate Victorian house façades complete with gardens and lawns—should have been a perfect fit. Minnelli had a taste for Victoriana, too, which explains why he acquired Perkins' 1942 watercolor—alternatively titled *Caprice* or *The Golden Staircase*—depicting a be-plumed and bare-bottomed Bella Flower in a black lace corset and black lace stockings careening ass-first down a curvy and elaborately embellished banister amid a riot of coils, plush, fringe, tassels, and gilding. It is not clear if the painting was a gift or a sale.

Nothing else is clear, either. Asked about his movie experiences decades later, Perkins erupted, deriding Minnelli as "snotty and ugly as sin." Reportedly, the two quarreled, and Perkins stormed out of the studio, never to return. This gives us yet another (and completely unverifiable) explanation for why Perkins quit the movie business. Given Minnelli's own sexual proclivities, it's entirely possible that the

two had some sort of fling. Whatever it was, it ended in acrimony. It may also have been the reason Perkins swore off sex: he claimed that he gave that up, along with liquor and cigarettes, in 1944. Often, no doubt for effect, Perkins pushed the date of his avowed abstinence back to 1932, but given the rupture with Minnelli, 1944 makes more sense. Of course, there is no way to prove any of his statements about exactly when, and why, he embraced sobriety, celibacy, and freedom from nicotine.

Perkins' relationship with Albert Lewin continued, however. The two remained friendly enough that in the late 1950s, Perkins felt comfortable inviting Bill Alexander to go with him to Lewin's house in Santa Monica; he wanted Bill to see Lewin's collection of "American primitives" and other artworks in the director's collection. There is no record of how that visit went, but Perkins was sure that Lewin's spectacular beachfront house, designed by the modernist Richard Neutra, would "amuse" the designer of Richard Halliburton's Hangover House. Serendipitously, after Lewin moved back to New York around 1960, Perkins' idol Mae West bought the place and "allowed her pet monkeys to use it as a menagerie." Not surprisingly, the house fell into disrepair. Whether Perkins knew that West had colonized Lewin's former residence with obstreperous apes is not recorded.

Tangential to the world of the studios per se was a constellation of tastemakers, fallen celebrities, and decayed aristocrats around which Perkins moved in his own eccentric orbit. We can drop in on that world through Perkins' *Bedroom, 1940*, another watercolor that came out of the Lewin commission. The scene is a striking departure from the sedulously documented period rooms we have been peering into so far. It is hard to say exactly *what* style it is; rather, it appears to be the intimate, eclectic, and idiosyncratic refuge of someone whose habits and pastimes can be deduced from what the place contains. The room, with a high tray ceiling and delicately tinted lavender walls, is on the second floor, with windows looking out over palm trees and neighboring houses (Spanish Colonial and bungalow). The hardwood floor is well swept and mostly bare, but everything else is in a jumble, every surface strewn with a motley array: perfume bottles, a pincushion, a radio, a scale, letters, envelopes, knick-knacks, brushes and pens, and many portrait photographs of men and women casually propped or stacked here and there. The platform bed with its squashed pillows and exposed mattress is a mess. A dressing gown lies there in a heap; letters litter the fuzzy counterpane, and on the platform, along with more squashed pillows, sit a movie magazine, a basket crammed with papers, and a telephone, its wayward cord trailing haphazardly to the outlet behind the bed. On one of the chests of drawers are: a purse, a pencil, a key straggling out of its leather case, more mail, and a bottle of ink reposing in a black puddle that has begun to dribble down over the edge. Several empty picture frames stand near the bed, and facing the rear window is an easel with its back to us, and an armchair with yet another squashed pillow. At the foot of the bed is a small blue cradle, doll-size. A lace-trimmed black sleep mask is tucked inside.

The letters, it turns out on closer inspection, are quite legible, as are the addresses on the envelopes. The addressee is a Catherine d'Erlanger, who lives on North Wetherly Drive in Beverly Hills. She is a baroness. There are other names, too, on the various bits of paper: Tony, Cobina, Johnny, Elsie, Blu Blu, Anne. Who are these people? How did Perkins know them, or know about them? How did Perkins gain access to this woman's bedroom and her correspondence, anyway? Where to start?

"Tony" is the thread that allows us to begin unraveling this Perkins tangle. Among all the letters I have managed to round up, the only ones that refer to "Tony" were written by Perkins to his young friend (and old-age love object) Bill Paxton, whom Perkins regaled with his Hollywood memories. Early in 1982, Paxton had met the celebrated Hollywood designer Tony Duquette. On hearing of that encounter, Perkins wrote: "Did Tony tell you that I have known him since he was a kid? The last time I saw him was on Thanksgiving at his home on Sunset Drive. He was with two elderly ladies I don't know if they were relatives, perhaps aunts. Tony was preparing to accompany Lady Mendl on her last flight to Paris. I saw him again on his return from Europe with a big batch of antique doors from some old demolished palace . . . That was before Tony became rich and very famous . . . He was a cozy pal of the Baroness de Erlinger [sic]."

Clearly, Tony had paved the way for Perkins' entrée into the Baroness' home. But who was Tony, who was the Baroness, and how did they know each other? Born in Los Angeles, Tony Duquette attended the Chouinard School of Art and began his career doing installations for Bullock's department store and undertaking other such commercial decorative work. At one point, he freelanced for established interior decorators, notably William "Billy" Haines, with whom Don Forbes had enjoyed that brief fling in Los Angeles in the 1920s. Tony's big break came through the aforementioned legendary tastemaker Lady Mendl (a.k.a. Elsie de Wolfe), who so admired a centerpiece Tony had concocted for a dinner party in 1941 that she commissioned him to make her a "*meuble*." Tony (who, innocent of French, was initially puzzled as to just what a *meuble* might be) found a tall escritoire in a department store and proceeded to embellish it with stylized green and white patterns, shells, mirrors, an exuberance of sprouting emerald glass leaves, and grotesque posturing figures that seem like a cross between Javanese shadow puppets and bejeweled blackamoors. It is a cabinet of curiosities in its own right.

Lady Mendl was delighted. She became Tony's patron and launched his career, which ran from decorating for the stars to set and costume design for stage and screen (MGM in particular) as well as jewelry, bibelots, and even fantastical landscapes. There is a color photograph of Tony seated in the drawing room of Elsie's Beverly Hills house. In black tie, Tony relaxes against a pile of green and orange pillows on a low white divan. At his elbow is a bronze blackamoor holding

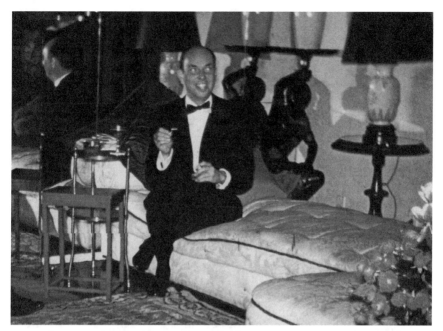

Tony Duquette enjoying himself hugely in Elsie de Wolfe's drawing room, c. 1945

aloft a shiny white vase on a tray. Holding a cigarette in one hand and a cocktail hors d'oeuvre in the other, boyish Tony has a high, bald dome of a forehead, protruding ears, and a toothy grin. He looks as if he's deliriously happy to be just where he is, under Elsie's wing.

Tony's well-known byline was "more is more" (in pointed contrast to modernist Mies van der Rohe's famous pronouncement, "less is more"), and there was almost no end to how much more he could stuff into any room. Yet the opulence of his interiors belied their true nature, which was in many cases faux. He painted surfaces to imitate malachite, lapis, and porphyry; he simulated jaguar spots, ermine tails, and angel wings: underneath they were cloth, plaster, wood, canvas, and pipe cleaners. But he used "real" materials as well, from nature: bones, coral, geodes, driftwood, and shells that he would gild and then use to encrust walls, screens and chandeliers. At Dawnridge, Tony's signature house in Beverly Hills, room after room is a feast, or perhaps a glut, for the senses: jewel-like colors and animal prints—zebra, leopard, tiger, cowhide—run rampant over chairs, couches, walls; there are Rococo costumed figurines, Buddhas and shrines, reliquaries, vases tall and short, blackamoor lamps and plant stands, dingy old Italian paintings, gilded or faux-malachite paneling, potted palms, taxidermy birds and animals (sometimes wearing fantastical outfits), and bibelots without number.

Tony had a pack-rat approach to decoration. He picked up treasures, real and replicated, from the MGM backlot when the studio purged the prop house;

he ransacked flea markets and junk stores. Observers, then and now (for the Duquette studio continues to this day under the supervision of Tony's protégé and heir, Hutton Wilkinson) either adore or deplore the aesthetic overload of Dawnridge, window designer Simon Doonan, for example, describing the place as "a decadent and delicious hellhole," while dealer R. Louis Bofferding observed that in daylight, "the house could be truly awful. But at night, under candlelight, it was magical." The house *is* awful in the sense that Ivan Albright's *Picture of Dorian Gray* is: it is a tour de force of quasi-hallucinogenic intensity, over-saturated colors, and pervasive, audacious excess.

Before Hutton Wilkinson, Tony's partner in decorative crime was the artist Elizabeth Johnstone, whom he married in 1949 and dubbed "Beegle," explaining that he came up with the nickname because "she has the industry of the bee and the soaring poetry of the eagle." Invariably wearing her hair (like an Alfred Hitchcock heroine) in "a tight chignon, in the shape of a golden croissant, at the back of her head," Beegle produced inoffensive paintings of wispy women in dreamy landscapes done in pastel hues and, among other accomplishments, created all the paintings supposed to be by Elizabeth Taylor in Vincente Minnelli's film *The Sandpiper.* Elsie de Wolfe and other celebrities also commissioned her work. Without Elsie,

Elsie de Wolfe and her poodle in front of the "meuble" designed for her by Tony Duquette, 1944

neither Tony nor Beegle would ever have become rich and famous.

There is a cartoon portrait of Elsie de Wolfe in *To the One I Love the Best*, the fulsome tribute authored by Ludwig Bemelmans, better known for his perennially popular *Madeline* picture books that chronicle the exploits of a spunky little French girl. Elsie sits on one of her low divans; behind her is a blackamoor figure holding up a vase on a tray: surely the same one—or its twin—that appears in the photograph of Tony Duquette. Elsie is seen in profile with one hand raised to her face as if she's contemplating some new decorating idea, or the theme of her next party. She is skinny, angular, and chic, with tiny feet in pointy shoes. Beside her is

one of her signature French poodles. Indeed, it is most likely Blu Blu, so named because reputedly Elsie dyed him to match her blue-rinsed hair, the latter a trend she pioneered in 1924. We see Elsie and Blu Blu again in a 1944 photograph where Lady Mendl sits serenely on a fancy bench in front of "The Meuble." It bears an affectionate inscription to "the one & only Tony Duquette."

Growing up in New York as Ella Anderson de Wolfe, Elsie fashioned herself into an international celebrity who threw legendary parties and surrounded herself with real and ersatz aristocrats (including that royal home-wrecker, the Duchess of Windsor, another one of Tony's clients)—in an unswerving effort to distance herself from a dreary childhood as an ugly duckling growing up in an ugly house. Although she had a forty-year relationship with the portly and majestic theatrical agent Elizabeth "Bessie" Marbury—their friends waggishly dubbed them the "Bachelors"—Elsie in 1926 entered into a surprise (and more than likely sexless) marriage with Sir Charles Mendl, a British attaché in Paris, and thus became Lady Mendl. Long before that, though, Elsie had cemented her status as a supreme arbiter of all things decorative with the 1913 publication of *The House in Good Taste*, which preached "Suitability, Simplicity, Proportion" and disdainfully swept all things cluttered, heavy, and Victorian into the dust heap of design history. Wintering in New York and summering in her Villa Trianon in Versailles, first with Bessie and later with Sir Charles, Elsie—adorned in designer gowns and her Cartier tiara of diamonds and aquamarines—partied up to the very eve of World War II, fleeing France with her husband and dogs in July 1940 and ending up in the house on Benedict Canyon Drive. Elsie promptly redecorated it and named it "After All"; in May 1941, her green, white, and gold living room was already on the cover of *House and Garden* (published by her friend Condé Nast).

Born perhaps in 1859 or 1865 or even 1870, Elsie by the 1930s was a very young old lady renowned for her hijinks and her health routines. Writing in 1936, *Time* magazine reported that at age eighty (or thereabouts), "Lady Charles Mendl . . . withered, bright-eyed Grand Old Woman of Franco-American socialites, was still doing back rolls, handstands, and cartwheels in the garden of her Villa Trianon in Versailles to keep '*young*'. . . The darling of effeminate young men, the envy of dowagers, old Lady Mendl claims to have won the title of the World's Best Dressed Woman at a cost of only $15,000 a year. She dyes her hair green, blue or pink and learned how to swim free-style at past 60." Elsie also did yoga, received regular colonic irrigations, and had injections of a serum made from the cells of embryonic goats. In 1938, *New Yorker* journalist Janet Flanner described her as "a lively little figure with artfully coiffed pale green hair, squirrel-brown eyes, and alert, inquiring, small chic face and neat tiny feet in low-heeled shoes. She has an air of being an eccentric, entertaining, highly compact, energetic personality . . . She wears chiefly blue and black, and used to adore beige. When she first looked at the Parthenon in Athens, she cried, 'It's beige—just my color!'"

In Perkins' *Bedroom, 1940* one of the several letters scattered about is from the Villa Trianon. It informs "Dear Catherine" that "We'll arrive in Hollywood on July 17. Anne is staying in France. Love, Elsie & Blu Blu." The letter is dated June 1, '20, but that's a ruse: it is 1940, and the Anne who's staying in France is almost certainly Anne Morgan, the financial titan J.P. Morgan's daughter. Anne had known Elsie and Bessie since 1903, when she had co-founded the elite women's Colony Club in New York, decorated by Elsie. A passionate philanthropist, Anne (along with Elsie and other socialites) campaigned for the rights of employees of the Triangle Shirtwaist Factory, notorious for the 1911 fire that claimed the lives of 146 garment workers, the majority of them young women. Living with Elsie and Bessie at the Villa Trianon (of which she was part owner) when World War I broke out, Anne plunged into relief efforts, converting the house's long gallery into a hospital ward and spearheading a campaign for humanitarian aid in France. She even inspired Elsie to serve as a volunteer nurse, a stint for which the tastemaker was awarded the Legion of Honor and the Croix de Guerre.

At the onset of World War II in France, Anne was there, launching a massive effort to evacuate and move hundreds of refugees who had been driven from their homes. But Elsie, more party animal than humanitarian, fled to Hollywood with Blu Blu (and her husband/appendage); Anne stayed behind. Elsie would return to France with Tony Duquette in tow after the war and would die there in 1950. Sir Charles survived her by eight years. His ashes were supposed to be placed in an urn to rest beside Elsie's, but, as Alfred Allan Lewis writes, "When the urn was brought to Père Lachaise [Cemetery] no sign was found of Elsie's remains. Nobody had bothered to pay the annual cemetery rental, and they had been disposed of—where, nobody knew."

In 1941 or thereabouts, probably not long after Elsie's arrival in Los Angeles, the Baroness d'Erlanger painted the ancient decorator's portrait and titled it *Lady Mendl, After All* (last seen at a Christie's auction in 1999, when it went for the bargain price of $2,530), which could be an allusion to Elsie's recent travails in exile, the title of her autobiography, or her Benedict Canyon Drive house, to which she had given the same name. The likeness is exceedingly flattering, showing Lady Mendl full-face in a cloche hat of tiny black and white flowers, and her signature necklace, a triple string of pearls. Behind her there is a leafless tree (since this is seasonless Los Angeles, it must be dead) garlanded with white tasseled ribbons and a row of crystal drops. Pushing or past eighty, Elsie has a perfectly smooth face (probably thanks to a recent facelift) and huge expressionless eyes.

The Baroness was a prolific amateur portraitist who painted cultural icons like her friend, the Russian composer Igor Stravinsky, along with assorted royals, movie stars and socialites. Born wealthy in Le Havre, she married the even wealthier French financier Émile, Baron d'Erlanger, and lived a life of fun, fashion, and occasional good works. The couple enjoyed a cosmopolitan lifestyle,

in London residing at 139 Piccadilly—once home to mad, bad, dangerous Lord Byron—and, near Venice, in the Renaissance architect Andreas Palladio's Villa Foscari, a.k.a Villa Malcontenta, a dream of classical harmony and perfection (belied by the sobriquet it purportedly acquired when an angry Foscari husband locked his wife up there for rebuffing his advances, or for her infidelity, or both). Traveling in international artistic and Bohemian circles, the Baroness knew not just Stravinsky but also Marcel Proust, Claude Debussy, the dancer Vladimir Nijinsky, and the ballet impresario Serge Diaghilev; she was present at the latter's deathbed in Venice, 1929. Known as "The Flame" or "La Fiamma" for her vivid red hair, the Baroness—regularly featured in society gossip columns—organized *tableaux vivants*, threw extravagant costume balls, and had various extramarital love affairs.

In paintings and photographs, we can track the Baroness from glamorous youth to raddled age. Philip de Laszlo depicted her as a classical muse of sorts, swathed in filmy drapery, strumming a harp, and gazing mistily into the infinite. A year later, still gazing into the distance, her hair loose and tumbling down her back, she appears in Renaissance finery as "Taste"—her costume in a Boer War fund-raising tableau vivant of The Five Senses at Her Majesty's Theater in London. More memorable and a great deal more modern is the 1924 portrait (now in the collection of the Smithsonian American Art Museum) made in Paris by the cross-dressing lesbian painter Romaine Brooks. Red hair now shorn in a fashionable bob, the majestic scarlet-lipped Baroness has discarded romantic trappings for a sweeping black cloak and a low-cut leopard-spotted evening frock. She also has a real wildcat, an ocelot whose baleful amber-eyed stare matches her own. Separated only by a flimsy barred partition, woman and cat seem like two sides of the same coin.

It's possible that the Baroness enjoyed her own flings in the lesbian circle of Brooks' longtime and relentlessly promiscuous partner, the expatriate American socialite and poet Natalie Barney. Not long after, Catherine bought the Villa Malcontenta with the critic Paul Rodocanochi and his lover Albert [Bertie] Clinton Landsberg, who also became hers. Budding fashion photographer Cecil Beaton visited "the scarlet-haired Baroness" there and found her in a magenta dressing gown with Bertie, gilding stone pumpkins in the garden. Yet another cosmopolitan man-about-town, the handsome Bertie sat for a pencil portrait by Picasso in 1922. He looks coolly composed and proper in his well-tailored suit, vest, and tie. But his outfit hides a very different reality: "His body," according to the cat-and-garden writer Beverley Nichols, "was covered from head to foot with tattoos of quite exceptional obscenity. I cannot recall them in detail because the only occasion when he revealed them to me, on a sultry afternoon in a bedroom of the villa, a fleeting glance was more than enough." Presumably, the Baroness was able to appreciate them at leisure.

When the baroness sat for Romaine Brooks' portrait, she was in her late fifties. We see the Baroness again in 1930, in a *Tatler* caricature of partygoers in Venice. Her daughter, Princesse Jean de Faucigny Lucinge, a.k.a. Baba—a lissome Betty Boop figure in a tank top and bell-bottoms—has eyes only for the serpentine seminude dancer Serge Lifar who stretches at her feet (and who also attended Elsie De Wolfe's Circus Balls at the Villa Trianon in the 1930s). The Baroness herself is utterly unlike the queenly figure in the Brooks picture: she is exceedingly squat and stout, with a double chin and a raggedy short haircut under a wide-brimmed hat. This was more or less how she looked when she arrived in Los Angeles in 1940—like Lady Mendl fleeing Europe at the onset of the war, but unlike her a very recent widow, the Baron having died in 1939.

Refashioning herself as a cat lady, amateur portraitist, and nightclub owner, the Baroness became an eccentric, known, among other things, for the prodigious disorder of her surroundings. Cecil Beaton, now an international celebrity, paid a visit to the house on Benedict Canyon Drive—with Greta Garbo in tow—and found the Baroness in bizarre decline. "In her days of grandeur," he wrote, "Catherine lived in Byron's house ... but now her money has been 'frozen,' and her emeralds stolen from their hiding place (sewn in a cushion by one of the 'naughty boys' she likes to have around her). Greta was, at first, somewhat aghast at the litter, salvaged from the past, of broken Venetian glass and shells, the cluttered mess of eighteenth-century scraps, witchballs, metal fringes and brocades, and the vast collection of Catherine's own paintings of her friends, all looking like waxworks. Whereas Catherine could find delightful rubbish in the markets of Venice, Paris, or London, here she must rely upon the stalls onto which the worst Hollywood junk was thrown out of studio 'prop' departments. Catherine had lost her eye for this sort of thing, and the mess was interspersed with cans and cartons of patent foods." Catherine took the pair outside to admire her patio wall, which had a parapet of stacked green beer bottles that she referred to as "cabochon emeralds." Then "two naked young men appeared. 'These are my Greek gods,' Catherine said, by way of introduction. She showed us her latest scrapbook made of clippings from tawdry magazines, which she intended to sell at vast sums to the research department of Columbia Pictures."

So legendary was her penchant for disorder that "Baroness d'Erlanger's bedroom" became a trope for extreme domestic disarray. Sometime in the 1940s, starlet and socialite Jean Howard photographed scenes of Catherine at work painting in her studio-bedroom. (The photograph is in an album of Baroness memorabilia that somehow ended up in the National Portrait Gallery in London.) The place is vastly messier than it is in Perkins' rendition but is recognizably the same, with the collages of photographs and other images tacked up on the walls, surfaces overflowing with bottles, brushes, paint tubes, vases, heaped and crumpled papers, and every other kind of flotsam and jetsam. We even get a glimpse of the

furry bedspread. In another photograph, the Baroness is in bed with a very large and formidable cat (though not an ocelot), likely the one that sleeps in the blue cat's cradle seen in Perkins' painting. So notorious was Catherine's penchant for felines that she was known half-jokingly as "La Baroness des Chats." As for the young naked men—her Greek gods—one of them may have been the "handsome, charming, and gay" Irishman Johnny Walsh. Catherine so adored Johnny that she bought the Café Gala on Sunset Boulevard as a venue where he could perform his vast repertoire of Broadway hit songs. Perkins knew all about the place; in his painting of the Baroness' bedroom, references to the Gala and to Johnny appear on a couple of the scattered letters. (The café, which was tacitly and very decorously gay,

*Catherine, Baroness d'Erlanger, relaxing
on the patio of her Hollywood home*

acquired the cheeky nickname "Cafégeleh," derived from the Yiddish "faygeleh," that is, a gay man. In later years, it became the home of Wolfgang Puck's restaurant Spago, the "it" place to eat and drink in fin-de-siècle Hollywood.)

Perkins' depiction of the Baroness' disheveled bedroom portrays an entire world—the campy world frequented by Hollywood decorators and party-givers—in code. It is also a proxy portrait of the Baroness herself. By the 1940s, she had become as stout as Elsie De Wolfe was slender; she dyed her hair as red as Elsie dyed hers blue, or green, or pink. In nearly every way, the Baroness was Elsie's antithesis. One thing they had in common, though, was a fondness for tiaras. Elsie wore hers regularly at her many glamorous bashes. The Baroness occasionally wore hers around the house: we see her in photographs, relaxing in her Hollywood patio in a blowsy printed housedress, aggressively inelegant ankle socks, and a high, emphatically regal diamond tiara. The tiara didn't impress Perkins, who nonetheless claimed the Baroness as a close acquaintance. He described her rather ungraciously as "an old bag whose hubby built the Egyptian Railroad" (not exactly, though he was involved in railway construction in other African countries) but at the same time appreciated her role as "a great hostess for the Gay Set, those of known talent."

The other thing the Baroness and Lady Mendl (and Perkins) had in common was Tony Duquette. Many of Tony's best antiques, in fact, came from the Baroness, who, despite the theft of her emeralds, had a comfortable fortune but nonetheless believed she was one step from the poorhouse. According to Tony, "If you got her on a poor day, you could buy the most amazing treasures from her for almost nothing." For her part, the Baroness cut up eighteenth-century prints and used them to make découpage panels, which she then "Duquetteized" by gluing rhinestones all over them. The Baroness died in 1959 and left the house to Johnny Walsh. In 1963 her old friend Igor Stravinsky, who lived at 1260 North Wetherly, moved a few doors down into the Baroness' old house at 1218.

Tony—who was everywhere and knew everyone in late 1940s Hollywood—also ushered Perkins into the home of coloratura soprano, movie actor, society gossip columnist, and celebrated hostess Cobina Wright to portray the interior of her "spectacular party room, decorated by Tony," as the artist told Bill Paxton many years later. George Platt Lynes photographed this "spectacular" room for the October, 1947 issue of *House and Garden*. Tony touched up the décor around 1951, but the basic elements are already here: rich purplish-red tonalities, figural lamps featuring an elaborately dressed and gem-studded Rococo couple, deep plushy sofas, and an overmantel *trophée* of bundled musical instruments—violin, guitar, lute, trumpets—all dipped in plaster and painted white, as if they were the ghosts of themselves. Perkins must not have been happy with his rendition of the party room, even though Tony liked it. "I don't remember why I turned over the painting and made another one on the back," he mused.

Perkins had a baron, too: the Baron Adolph de Meyer, who in earlier and more prosperous days had pioneered fashion photography in *Vogue* and *Harper's Bazaar*. Indeed, on numerous occasions, he had photographed Elsie de Wolfe in his signature blurry and atmospheric Pictorialist style evocative of artistic refinement. An aristocrat of dubious lineage, he was a cosmopolitan gay aesthete who married a like-minded aristocratic lesbian said to be the illegitimate daughter of England's Edward VII. In socialite New Yorker Florine Stettheimer's 1923 portrait of the Baron, now in the Baltimore Museum of Art, we see him elegantly dressed in a dinner jacket with blue quilted cuffs and lapels, a dotted pink vest, tapered gray trousers, and spats on his slender pointed feet. He has one elbow on a narrow black stand that supports a bell jar full of dried or wax flowers; to the right, a red ermine-trimmed robe lies upon a poufy pink armchair with a flower-embroidered footstool. His camera stands there as well, the black focusing hood replaced with a length of black lace. With a dramatic tasseled blue curtain and a spotlight shining down on him from on high, he is every inch the exquisite star of his own show.

One might even suggest that he was Elsie de Wolfe in drag: for a time, "his hair was dyed blue and he drove a car to match it." But the Baron's fortunes came to a dismal end when modernist hard-edge fashion photography made his romantic

style obsolete. De Meyer lost his position at *Harper's Bazaar* in 1932, not long after the death of his wife, and scraped along in Paris until the threat of war drove him to the United States in 1938. Like Elsie and the Baroness and many others, he ended up in Hollywood, much of his work left behind and ultimately lost.

Perkins somehow struck up an acquaintance with the ruined Baron, who by then, "no longer an arty social lion," as Perkins described it, "lived in poverty in a dingy bungalow in the Hollywood Hills." He claimed on several occasions that he was with the Baron "the night he caught a cold that developed into a malady that killed him [on January 6, 1946]." The Baron's cremated remains were placed in Forest Lawn, where Perkins on Memorial Day, 1965, took flowers to put on the grave: "In the entrance lawn at the cemetery there was a huge tent with information desks and filing cabinets," he recalled. "I inquired as to the location of de Meyer's grave. 'The Utilitary Columbarium,' said a pleasant young lady. 'In the Great Mausoleum.' I went to the half mile long, rambling structure and inquired of a guard as to the location of the 'Utilitary Columbarium.' 'Right here,' he pointed to the door of a broom closet under the stairway. He unlocked the bronze door and pointed to a small cardboard box, bearing a label, set between some Dutch Cleanser, dust rags, and brass polish. 'What does it cost to be placed here' I asked. 'Twenty five dollars.'" (Later, when he was becoming just a bit addled, Perkins misremembered and said that the Baron's ashes had been placed *in* a Dutch Cleanser box.)

Dutch Cleanser aside, the sight of the Baron's humble resting place sparked a flood of memories along the lines of "how the mighty are fallen," Perkins enumerating the high points of the photographer's illustrious career and reflecting on the obscurity that later befell him. "His only close friend was a young Austrian [actually, German] count, a rare beauty, who worked in a garage in Santa Monica." The "count," in fact, was Ernest Frohlich—a.k.a. Baron Ernest Frohlich de Meyer—who had been the elder Baron's chauffeur and lover in France; they had met when Frohlich was seventeen and the Baron in his sixties. The Baron subsequently adopted Frohlich and made him an honorary (but utterly ersatz) baron, too. In one re-telling, Perkins characterized Frohlich as an "army colonel," probably because he'd heard of Frohlich's December 1941 arrest as a suspected spy (the first of the war) in Los Angeles; he had been lingering, or lurking, around the Harbor Defense Area in the uniform of a U.S. Army officer. Allegedly, when the FBI raided his apartment, they found "army, navy, and marine corps uniforms, a short-wave broadcasting transmitter, and more than 200 letters written to de Meyer by American sailors and soldiers." Holding Frohlich incommunicado, the agency promised to "have more information about him later." But there was never any more. Perhaps it was a case of mistaken or stolen identity. Whatever the case, after Adolph de Meyer's death, the so-called "Austrian Count ... disappeared with all of the superb photos" that had remained in the elder Baron's possession.

By that time—1946—Perkins had shuttled from one odd job to another even while continuing to toil over the watercolors commissioned by Albert Lewin. He helped around a Culver City funeral parlor, "doing the stained glass windows, which were fake and depicted 'Happiness.'" While waiting to hear about his Guggenheim application, Perkins also worked, or intended to work, as a gravedigger, sending Whitney Morgan "plans and descriptions of Los Angeles & Hollywood's most elegant cemeteries, and a wonderful letter describing them, and getting down into a half excavated grave with a beautiful heavily hung young Italian grave digger, etc.," as Whitney somewhat tartly reported, suspecting, perhaps, that, as with so many Perkins anecdotes, there was a certain degree of license, artistic or otherwise. (And, given the date of Whitney's letter—1946—there is the question of just when Perkins *really* swore off sex.)

Perkins also held a job at the Western Stove Company, which was the very first factory established in brand-new Culver City, in 1922. By the time he joined the workforce, the manufactory had grown from "two small buildings and twenty employees" to a sizeable complex "with seven hundred and twenty employees on eleven acres." At some point, Perkins was in charge of the paint tanks in one of the factory buildings. He conjured up his workplace environment in one of the Lewin Commission watercolors, *"Japan" Lacquer Dipping Vat.* For Perkins, it is a comparatively pedestrian rendering indeed, packed with structural and technical details: fire extinguishers, admonitory signs, drums of Sherwin-Williams paint, hoses and hooks, trolleys and dollies, and a clear sight line into the vat, where a piece of dripping sheet metal has just been lifted out of its black lacquer bath. In the background, we can see completed stoves traveling along an assembly line. It is about as sober-sided as Perkins ever got, but there are a couple of "Kilroy was here" giveaways. Around the water cooler, unseen workers have tossed their empty paper drinking cones on the floor even though there is a trash bin right there. And someone has left the tap open on a drum of lacquer solvent. Overflowing the bucket beneath, the liquid is spreading messily across the floor. Then there is Perkins' fast-and-loose orthography: the sign on the apparatus reads "DANGER/ Restricted Area/ Laquer Vat."

What went on at Western Stove was more interesting. If it hadn't been for Charles Francis—a young Nebraska-born war veteran—this phase of Perkins' life would be a blank. But Charles so vividly remembered Perkins that he dedicated a whole chapter to him in a memoir. He had worked at Western Stove only a few weeks, he wrote, when the factory's "public address speaker announced a summons to the Personnel Director's office for me and my co-worker, Perkins." Charles was in a panic about the possibility of being fired; Perkins was nonchalant. The Personnel Manager told the two that a number of women had complained that the two were "having a homosexual affair that they found offensive." On the spot, Perkins came up with a rebuttal: the grapevine had it that the women, many of

them "lonely divorcées," were disappointed that Charles, a bachelor, had not asked any of them out. Mollified, the manager allowed the pair to return to their work stations. This incident illustrated what Charles described as Perkins' "sangfroid" in the face of the "universal homophobic attitude of the times."

In fact, the two were friends but not lovers. Perkins regaled young Charles with salty anecdotes about his long-ago sexual past, when his father Frank, discovering Perkins' sexual orientation, took him to a doctor and on the latter's recommendation, set him up with a prostitute in order "to align his carnal desires correctly." The therapy failed, and, according to Perkins, the doctor recommended marriage—"to which Perkins responded by marrying the prostitute who had supplied his first sexual experience." When Charles expressed bewilderment that his new friend, so obviously gay, claimed to have been married to a woman, Perkins assured him that it was so: "She was a wonderful woman—a medical phenomen[on]; her breasts sagged down to her knees." Charles noted that Perkins had a booming voice that he never moderated to suit his surroundings, even when he took the young man and his teenage sister on a bus trip to Long Beach and treated them, and everyone else on the bus, to "loud, hilarious obscenities." Perkins also entertained the Culver Hotel maids by pretending to have phone conversations in his room about scandalous events, which he related in "very explicit language" while the maids gathered outside his door to listen in.

Perkins took Charles under his wing and introduced him to some of his "unusual friends," including a prim gray-haired department-store saleswoman who in the 1920s had entertained at "film colony orgies" by performing her "speciality," oral sex, on some willing recipient. And then there was Margaret, the "fabulously wealthy widow," who owned a tract of land near Twentynine Palms and was planning to create a self-sustaining Utopian community to shelter all her friends from an impending and disastrous economic collapse predicted by some local mystic. She urged Charles and Perkins to join her there. Perkins bellowed back: "'Hell no, Margaret! If there's going to be a depression, I don't want to cower out in the desert—and miss it." Perkins may have been bellowing because he was becoming hard of hearing; his explanation, though, was that his mother had been deaf and everyone had to shout at the top of their lungs to get anything through to her.

Charles never accepted an invitation to dine with Perkins at the Culver Hotel because his would-be host cooked things like "tasty recipes for carrot and beet tops and various other produce throw-aways." But Perkins did take him to the house of "another gay artist friend," a vegetarian who prepared a multicourse dinner, the highlight of which was the dessert: "a fresh fruit tapioca, garnished with a lovely, frozen blossom on top. He had dipped the flower in honey-sweetened water and quickly froze it. 'You can eat the flowers,' he beamed." After dinner, the host showed Charles and Perkins a large, leather-bound photo album. This gourmet

vegetarian—"retired and elderly [only fifty-five in fact] but still trim and vigorous, with a full mane of snow-white hair"—was Hubert Stowitts.

Stowitts too hailed from Nebraska but after early youth never returned; an athlete, he managed to gain admission to the University of California, Berkeley, where he was captain of the track team and was planning to become a businessman until he went to a ballet performance in San Francisco and, inspired, began to take lessons. The celebrated Russian ballerina Anna Pavlova saw Stowitts dance at the Greek Theater on the Berkeley campus and invited him to join her company. For several years, he danced around the world with Pavlova and her troupe. He also designed costumes and scenic backdrops and painted portraits of the troupe's principals, including Serge Lifar (the Baroness, too, did a portrait of him).

Swept up in the enthusiasm for all things exotic in the teens and twenties, Stowitts—like Ruth St. Denis, Ted Shawn, Paul Swan and many others— embraced the Orient and ancient Greece. In a Baron de Meyer photograph we see him strutting elegantly, wearing a piratical headscarf, a fringed sarong, and a bejeweled dagger while brandishing an enormous but obviously fake scimitar over his head. Undoubtedly that was one of the photographs Stowitts had in his big leather album, along with many others from his dancing years, most showing him posed in chiseled profile, prancing decoratively like a dancer on a Greek vase and nude, or nearly so, the better to display his sinewy physique, "trained down to racehorse shape" as he described it. After Stowitts struck off on his own, he exhibited his nearly nude moves at the Music Box Revue in Manhattan in 1923 and subsequently at the Folies Bergère in Paris.

You can still see Stowitts dancing in a couple of films, too: *The Magician* (1926), and *The Painted Veil* (1934). In *The Magician*, a sinister necromancer needs the heart blood of a virgin in order to create life; he finds his victim in the person of Margaret, a young woman who has sculpted a huge statue of a faun (which looks for all the world as if it could be one of Rose O'Neill's "Sweet Monsters"). Later, the evil magician (based on the notorious real-life occultist Aleister Crowley) hypnotizes Margaret. In her trance, she dreams of an orgy in hell, where the faun—played by Stowitts—has come to life and now, grinning and tootling on his Pan pipes, presides over a Bacchanalian scene of shadowy figures capering madly around a steaming cauldron. Glistening body all but nude, Stowitts sports little more than a pair of thick spiraling horns and a perky little tail reminiscent of Nijinsky's in *Afternoon of a Faun*. He moves with supple grace as he bounds to Margaret's side, seizes her in a lascivious embrace, and plants an ardent kiss on her neck. Fortunately (perhaps), she comes out of her trance just as the faun has begun to ravish her.

In *The Painted Veil*, which starred Greta Garbo, Stowitts plays the Chinese sun god Yi, who rescues the moon princess from a ferocious dragon. Wearing a costume of golden rays, face painted in a fearsome black and white mask, he

moves with a stylized swagger to vanquish the dragon with his superior firepower. Stowitts' swaggering dance belied the onerous effects of his rubber and steel outfit, which weighed 165 pounds. It was so heavy, indeed, that he claimed it cut off his circulation below the waist, requiring aid to restore the flow of blood after each take. None of that strain shows, of course. It almost goes without saying that the whole scene—which Stowitts had a hand in designing—looks more like an Orientalizing spectacle out of Diaghilev's Ballets Russes (with more than a touch of Busby Berkeley) than anything aspiring to authenticity.

That same conceptual and stylistic mashup informed Stowitts' painting, for which he ultimately drifted away from dance. Self-taught and honed by experience designing dance costumes and sets, Stowitts spent three years living and traveling in Bali, Java and India to study cultural traditions there and also (just possibly) to enjoy the gay subculture that flourished in Indonesia and attracted like-minded Europeans and Americans who dreamed of creating a vibrant tropical paradise with art, music, dance, and beautiful native boys. He worked hard in Paradise, though, producing some seventy-five life-size portraits of Indonesian dancers and 155 paintings in the set *Vanishing India*, which was exhibited to loud acclaim in Europe and the U.S. in the 1930s.

Stowitts was a high-volume painter. His next project was to paint fifty-five nude portraits of male athletes preparing for the 1936 Summer Olympics in Berlin. He had hoped to gain the endorsement of the American Olympic Committee, but the work "so shocked the Americans that he was forced to send it at his own expense to Berlin," where, under the title *American Champions*, it was exhibited at a gallery on Tiergartenstrasse until the Nazi racial "philosopher" Alfred Rosenberg ordered it shut down because the collection included representations of black and Jewish athletes. One of these was the African-American decathlete Woodrow Strode, whose portrait was chosen for the exhibition poster. Like all fifty-five paintings, this one shows Strode (who later played a gladiator in combat with Kirk Douglas in *Spartacus*) as a magnificently fit and perfectly proportioned hero. The series as a whole is a visual ode to male beauty, strength, and erotic power: life-size against a blank blue background, the figures—leaping, diving, dashing—move in defiance of gravity. There is a photograph of Stowitts wearing a turtleneck and tweed trousers, standing (with a happy little grin) between two of his paintings, both depicting runners poised in mid-stride, their feet clear of the ground as if they were winged Mercuries. They quite literally embody the artist's desires.

Meanwhile, Hitler's filmmaker Leni Riefenstahl happened to see Stowitt's *American Champions* before it shut down and sought him out; she wanted to incorporate the paintings into her four-hour movie *Olympia*, which romanticized and mythologized the invincible strength and classical beauty of the athletic Aryan/Nazi body. Although for obvious reasons that didn't come to pass, she and Stowitts became friends, and the artist became an acolyte, decorating her new

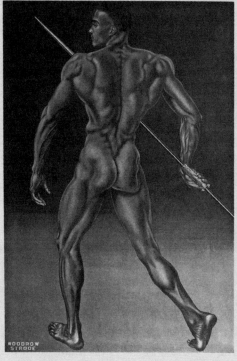

*Olympic decathlete Woodrow "Woody" Strode in poster advertising Hubert Stowitt's
1936* American Champions *exhibition in Berlin*

villa in Dahlem and "nagging her about her figure, forcing her to diet on salad greens" while she edited the film. Hoping to have *Olympia* distributed in the U.S., Riefenstahl traveled to Hollywood, with predictable results: once the word was out that Hitler's movie-maker was in the neighborhood, the trade papers *Daily Variety* and the *Hollywood Reporter* published glaring full-page advertisements paid for by the Hollywood Anti-Nazi League. They let it be known that there was an alien among them, trumpeting: "There Is No Room In Hollywood for NAZI

AGENTS!!" Stowitts' efforts to broker constructive connections had failed. While in Hollywood, Riefenstahl had planned to stay at the Garden of Allah—the site, ironically, of Jewish-born Alla Nazimova's orgiastic parties in the 1920s—but when the news leaked, the filmmaker had to seek more secluded quarters at the Beverly Hills Hotel.

By then, Stowitts had begun to enter his slow decline into obscurity. He produced a set of mystical paintings based on the sacred geometry of the circle, *The Atomic Age Suite*, or *Mandalas of the Hidden Wisdom*, and in his last, unfinished undertaking used future Superman Christopher Reeves as a model for *The Labors of Hercules*. Despite his almost fanatical obsession with diet, fitness, and health (he criticized Jean Cocteau for overindulging in drugs) Stowitts suffered a series of heart attacks and died at what we now tend to regard as the youngish age of sixty.

Charles Francis' account of his evening with Perkins and Hubert Stowitts evokes the insulated Hollywood gay subculture that allowed them to live in ways that were both out in the open and securely closeted. Breaching the boundaries of that world was risky and hurtful. Charles said that Perkins was "very kind" to him, and perhaps to express his appreciation of the older man's friendship, he invited him home to dinner with his whole family. Whether or not the dinner actually came about is unclear, but for wanting to bring home a homosexual, Charles incurred his father's wrath. Perkins, he recalled, stood up to such slights "with great dignity." Surely, though, they took a toll.

Charles Francis quit his job at Western Stove, moved away from Los Angeles, and lost track of Perkins. But years later, he wrote, "I was passing through the Los Angeles area again and drove out to the Culver City hotel . . . The desk clerk connected me via the house phone . . . I was pleased to hear his booming voice . . ." He invited Perkins out to have a cup of tea so that they could catch up on what had happened since they last saw each other. Perkins refused, telling Charles that he wasn't seeing people these days. Charles pressed him for an explanation. Perkins replied that he had come down with a very bad case of arthritis, for which he had been undergoing 'bee-sting' therapy. Pioneered by New York physician Bodog F. Beck, bee-venom treatment for arthritis involved a variety of delivery methods from topical application to ingestion and the use of actual bees to administer the venom naturally via their stingers. Perkins must have opted for the stingers: adamant, he told Charles "It has left me looking a mess. I refuse to let anyone see me in this condition." Charles had no choice but to drive off. Later, he wondered whether Perkins' colorful tales were nothing but fabrications. Had Perkins really been a mess, covered with swollen crimson welts? Or did he simply want Charles to go away? Whatever the reason, Perkins had gone to ground, socially speaking. His glamour days seemingly behind him, he lived by choice in a universe that had contracted down to two coordinates: the Culver Hotel, and the Ontra Cafeteria, where he worked, and worked, and worked, for close to forty years.

Trashy Cafeteria Queens

THERE IS A PHOTOGRAPH, A MUCH-FADED POLAROID, of three men—two young, one old, performing spoofy chorus-line kicks in a parking lot bordered by plain two-story houses and apartment buildings. Judging by the shadows they cast, it must be midday. Each one is in a crisp white uniform with a green stripe down the leg; the older man, in the middle, sports a white wedge-shaped side cap as well. Swiveling and raising their legs in synchrony, all three flash delirious grins. The young man on the left seems to be wearing a plumed headdress; it takes a couple of seconds to recognize that the plumes are actually the fronds of a palm tree at some distance behind him. On the back of the photograph is a typed label that identifies the dancers as "The Three Disgraces." The Disgrace in the middle is Perkins. What is he doing

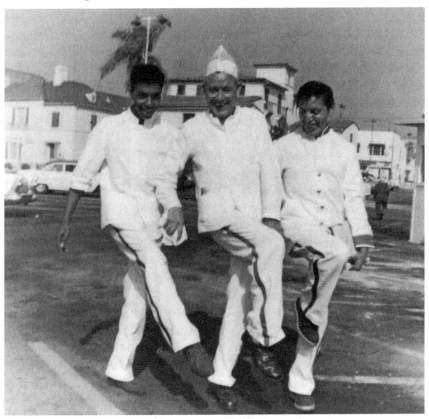

Perkins and his Ontra Cafeteria friends as The Three Disgraces, c. 1961

here—wherever here might be—and who are his merry companions? Why is he wearing a uniform?

This was the uniform Perkins wore for his job at the Ontra Cafeteria, where he went to work after leaving the Western Stove Company in 1947. He claimed that an employment agency had sent him there, and perhaps that was the case. The job would have been a good fit given his past experience in the food-service business. Whether or not he planned to be there for the long term is impossible to say, but once ensconced, Perkins really *did* stop painting; this was his "period of artistic amnesia," as he described it. His world, too, seemed to shrink down to a couple of points: his Culver Hotel room, and the cafeteria, always in a frenetic bustle.

The Ontra was so called because food there was placed ON the TRAY. (There is still some disagreement about pronunciation, some few maintaining that it should be On-Truh, but having heard Perkins say it on tape, I can state unequivocally that it sounds like the French imperative, "Entrez"—bidding someone to come in—or "entrée," the main course at dinner.) By the time Perkins arrived, there were four branches of the cafeteria: on Wilshire Boulevard, South Vermont Avenue, North Vine Street, and South Crenshaw Boulevard. With the exception of the branch on North Vine, which bore the earmarks of 1920s Spanish Colonial Revival, they occupied modernist buildings in sunbaked pastels with "Cafeteria" in casual cursive or no-nonsense sans-serif splayed across the façades. Inside each was a vast dining room with elegant touches: fancy patterned wall-to-wall carpets, white tablecloths, and bud vases; contemporary postcards show straight ranks of elegantly draped tables and solid wooden chairs receding into the distance. They look like tea parlors on steroids, which was pretty much the desired effect; as Perkins put it, each one—a "high-class dump"—had a "luxurious, refined tea room atmosphere coupled with Roxy Theater décor."

The actual food line was kept well insulated from the overscaled "tea room." A mid-century postcard captioned "For gracious dining . . . it's ONTRA cafeteria" graphically represents the array of abundant choices available to hungry (or gluttonous) customers. Neatly laid out on a bright turquoise tray are: a small salad with bits of green pepper, tomato wedges, and a slice of pickled beet; a little bowl of mashed potatoes, a bread plate with two dinner rolls, a mini-baguette, and a pat of butter; a dinner plate with a half chicken, possibly barbecued, a clump of green beans, and a tiny bowl containing a gooey yellow lump of indeterminate nature, perhaps a condiment or sauce of some sort; a generous slice of chocolate layer cake with fat swirls of pink icing on top; and a shiny mini coffee- or tea-pot ready to fill the pink cup that leans against it.

The garish hues of this ensemble may be the result of the Ontra's customary practices aiming to enhance the attractiveness of its offerings. As detailed by Perkins, "Red food coloring which is certified coal tar aniline dye according to the labels on the bottles, is used extensively in coloring beets, strawberries, fruit drinks,

etc., while yellow coloring is used to heighten the eye appeal of banana squash, chicken noodle soup, lemon pie filling, etc." On one occasion, a truckload of watermelons were found to have yellow flesh rather than the more alluring pink; consequently, a worker pumped them full of a "strong solution of red dye ... which made them look as pretty inside as are the red crab apples we use to garnish the veal cutlets, which is a hue not found anywhere in Nature." Perkins claimed that he and his cafeteria colleagues ate the watermelons "until we peed red." Another time, after consuming four peaches that had been sprayed with "carbolic acid, arsenic and lead," he became violently ill and had to have his stomach pumped. He also had attacks of food poisoning "from eating baked beans, baked hash, spaghetti, and macaroni."

Manifestly, the Ontra was not for those with sensitive stomachs. On occasion, indeed, it could be much more dire, as when an outbreak of salmonella infected eighty employees, all the managers, and several customers. "The entire equipment had to be thoroughly scrubbed, steamed with caustic chlorinated detergent and repainted," Perkins wrote. Worse, probably, "Each Friday all the ones able to locomote gathered at the store and were hauled in loads of ten to the Health Center for their stool tests." Perkins went on to describe—in bawdy detail—every humiliating step of the process whereby said stools were collected, along with the aggrieved reactions of the "crap brigade," including "Old Pancho," the Japanese fish cutter, who yelled "Do I have to kaka in that little bottle?"

Perkins could have written a book about the Ontra, and in fact he did in a loosely but fancifully autobiographical novel, *Trailing Oyster Feathers*. Never published, the manuscript is tattered, soiled, and water-stained. In the story, the Ontra has become the Bean Pot but is otherwise clearly recognizable, especially since Perkins duplicated or embroidered on many of the same stories he told in letters and various reminiscences. While as a novel it comes up short, *Oyster Feathers*, despite its wooden narrative, affords vivid glimpses into the environment and the daily routine that structured Perkins' life all those many years. Early on, he describes the cornucopian steam tables: "There are huge pans of stews, baked fish, fried fish, prime round of beef, creamed chicken, fish casseroles, chop suey, barbequed pork chops, baked hash, stuffed green peppers, turkey, prime ribs of beef, macaroni, spaghetti, vegetable soup, chicken soup, baked potatoes, French fried potatoes and eight other vegetables." There are innumerable salads, too—"a bewildering array of greenery"—and a "vast collection of gelatin concoctions," which are "as tough and tasteless as my big toe" and probably made from "worn out automobile tires."

Perkins' job (in the novel as in real life) was that of "hot supply man" responsible for replenishing every pan, pot, and reservoir on the steam table, a routine that demanded constant, frenetic circulation between the front and back ends of the food assembly line. "At the peak of the rush hours," Perkins wrote, "carving knives

flash, trays of dishes crash to the floor . . . Trucks, carts and dollies loaded with pastries, clean dishes, soiled dishes, milk cans, dripping coffee bags and cases of soft drinks cause bottle necks and traffic jams . . . Managers, assistant managers, floor ladies, counter ladies and maintenance men scurry, yell, and sometimes froth at the mouth while directing the hectic, complicated movement of flunkies like . . . orderlies in a mad house." There were plenty of hazards, too. "If we forget to walk on our toes and our heels strike a wet or greasy spot, down we go flat on our backs and the splashing of whatever we are carrying creates an additional hazard . . . Heat lamps hang from the ceiling for the purpose of giving additional heat to the prime round, standing prime rib, and other items that stand above the surface of the counter. These heat lamps are as hot as branding irons and we are ever bumping into them and getting another scar. The hot supply has to be mighty quick when removing a pan from the steam counters. The instantaneous escape of steam is about as vicious as a rattlesnake. One is nipped before he knows it." In the kitchen, slicing and chopping machines posed a danger to careless fingers, and the "twenty five thousand dollar washing machine that doesn't remove egg from the breakfast dishes" could readily mangle unwary hands.

We can actually see and hear Perkins, at work and in motion, in a tiny film made by Alan Warshaw (brother of Henry—friend of Alexander King, and an ardent Perkins booster) in 1969. It is Easter Sunday, and the queue of diners shuffling along with their trays includes many elderly ladies in Easter bonnets and cat-eye glasses; today we would probably label them as classic grannies. Perkins is at the steam table, where those lamps hang, radiating heat; he lifts out a depleted pan and hustles into the kitchen/work room, where there are huge mixing vats, industrial-strength ovens, walk-in freezers, and a constant background clatter and hum. People are rushing about. Perkins reloads the pan, sprinkles on some garnish, and takes it back out; this is what he does, for eight hours, day after day, month after month, year in and year out. He is nearing seventy years old now, and he wears thick rectangular black plastic eyeglasses that evoke nerdy 1960s scientists in starched white shirts with pocket protectors. He says that his feet hurt from walking on hard tile floors, but he likes the job because of its rhythm: he moves in a circle, over and over, from the kitchen to the steam tables to the pot-washing station and the garbage cans. With a loud, barking explosion of a laugh, he states "I'm very obscene, and everything that is said I have a comment about, and they get used to it . . . even the customers like it." He adds that he intimidates the customers because they think he's the chef even though he's only a flunky.

Perkins' obscenities aside, the Easter Sunday grannies and probably most of the other clientele would be shocked if they knew what else went on at the Ontra, at least as Perkins saw it. There was the handsome young Japanese cook who sculpted "cute little objects from carrots, turnips, potatoes, pumpkins," and made lamp shades out of turkey carcasses and created fancy designs or wrote

phrases with paprika sprinkled over the chicken à la King and turkey noodle casserole. One day, he wrote Perkins' name on the baked macaroni, then on the next, he inscribed it "I love you," and on the next, "Fuck you." Customers gobbled up the glop nonetheless: Perkins placed the trays with the words "facing the inside of the counter where the help could enjoy the effect unimpeded." Then there was Hazel, "the color of an old fashioned telephone" who wore a "pale pink chiffon evening gown to work" and had an "amazing ass cheek shimmy." Hazel's sexy hard-boiled, hard-luck sister Love wore black, skin-tight capri pants and (according to Perkins) could revolve *her* ass cheeks in different directions at the same time, clockwise and counterclockwise. Their mother Fleurine fed the dishwashing machine; Perkins mused on her name, commenting that "If her name designates flowers, then she must be a man-eating begonia." Literally and figuratively larger than life, Love—with her gargantuan appetite for food and sex—may be an invention or at least a prodigious exaggeration on Perkins' part. There are no extant photographs of Love, but there is one of Perkins standing with his arm around a staid and pleasantly smiling Hazel, who wears a neat white uniform rather than pink chiffon and seems in no way large or likely to participate in the drunken family fist fights that Perkins alleged to be frequent occurrences. Of course, appearances can be misleading.

Which leads us back to the "Three Disgraces" photograph of Perkins and his co-workers rehearsing their chorus-line moves in the cafeteria parking lot. Below that title on the back of the photograph, Perkins identified them (and himself) as "Charleen, Perquin, Francine, Trashy cafeteria queens." Almost a rhyming couplet, it points to the queer subculture that flourished at the Ontra. "At work," Perkins wrote to Bill Alexander, "My boss and half the help is queer. All of the camping, dishing, hair pulling, jealousy, groping, and drag balls would kill you." Even so, he went on, "There's not a decent piece of meat in the joint. Not even on the counter!" He signed the letter "Charleen Glutz," the surname translating as "slut." Apparently anyone could be a Charleen, or a Francine, though there was probably only one "Perquin." Whether Perkins had any idea that it was a name derived from the Italian *Porcino*, or fungus, is an open question. (There is also Perquín, a little town in El Salvador; translated, it means "path of hot coal.")

Queer culture at the Ontra was an open secret at a time of active and unrelenting police suppression. Various bosses at the cafeteria attempted to exert control over the queers and queens with little success. On one occasion, management posted a notice stating that "the boys and girls were to eat at separate tables, No more fraternizing! There was the question as to where the 3rd sex was going to sit—with the he-men or the she-women. No table was big enough to accommodate all of them so several tables were placed end to end and that dining outfit had such gay and hilarious eating sessions . . . that the Management was obliged to revert to the original abnormal state of affairs,"

Perkins crowed. Then there were the Moon Fairies, inspired by a headline about a captured spy: "Lovely Moon Fairy arrested in war zone." Perkins reported that "All of the queens have a field day camping and screaming that they are lovely Moon Fairies." During Easter break that year, school kids swarmed into the Ontra "like May Fly pests," forcing Perkins to a point of exhaustion "toting out grub for the picnickers." The "big boss" admonished him to pick up speed filling the counters. "I say that I might be able to do it if I were a Fairy with a magic wand. He says that all that is missing is the wand. Ha."

Probably because the Ontra was ostensibly an upstanding, respectable establishment catering to bespectacled grannies and schoolchildren, it evaded the systematic harassment and entrapment visited upon Los Angeles' gay bars and bathhouses. William H. Parker, the police chief who ran the department from 1950 to the time of his death in 1966, ordered officers to "go after" homosexuals, which they did with zeal, staking out gay haunts and going undercover to lure and then (often brutally) arrest unsuspecting victims. At one point in the early 1960s, rumor had it that Parker (known as "Wild Bill" to the gay community) had ordered a suspension of vice arrests. Perkins recounted the all-too-brief exhilaration that followed: "The fags at Ontra went haywire. Whores and fairies came out of the woodwork...Out of long retirement came old beaten-up browning queens, rimming queens, Koke sackers, sock tuckers, cork soakers, cracker sackers, and the real McCoys. There was a sell-out of Vaseline, KY, and rubbers ... We visualized special trains, planes, busses, and hitch-hikers all headed furiously for Los Angeles. No more arrests, no more entrapment, no more inhibited incidents in this wonderful land of lidless activity. The Ontra featured Dick-burgers, Ass-burgers and pussy-burgers! ... And then the whole thing was a false alarm and all of the fairies and whores crawled back into the proverbial woodwork like so many Draculas at sun-rise." Koke (or Coke) sacker, cork soaker, and cracker sackers were all coded terms for cock-sucking. A sock tucker supposedly stuffed a pair of rolled-up socks into his crotch in order to enhance his natural endowments. The "real McCoy" reference gives away Perkins' game; this was purportedly an Army or Navy joke in which four McCoys appear in succession for enlistment interviews with a recruiting officer; the first three identify themselves, respectively, as a cork sacker, cork soaker, and a coke sacker; the last—overtly effeminate— announces that he is the *real* McCoy. Letter recipient Bill Alexander would surely have grasped the gay in-joke; we're left to wonder, once again, how much, if any, of Perkins' anecdote was true.

While Perkins toiled doggedly at the cafeteria, there was plenty going on in the nascent gay rights movement in Los Angeles, years before the pivotal 1969 Stonewall Riot in New York. In May 1959, police entered the gay hangout Cooper's Do-Nuts in the city's then-seedy downtown, arbitrarily singled out three men, and ordered them into the squad car. But something snapped for

the gathering of queens and butch hustlers: instead of surrendering to Law and Order, the crowd began to pelt the cops with doughnuts, paper cups, utensils, and anything else they could weaponize, driving the policemen back to their car, where (not surprisingly) they called for backup. When that arrived, many of the rioters were arrested, although the three initially detained managed to slip away. There were other riots, protests, and gruesome acts of police brutality throughout the 1960s.

But Perkins remained on the margins, in the camouflage of his crisp white uniform. He made one revealing comment to Bill Alexander, who asked Perkins if he was familiar with the Mattachine Society. Founded in 1950 by Hollywood screenwriter and avowed Communist Harry Hay and several others, notably Rudy Gernreich (later famous for the topless swimsuit and unisex space-age fashion), the Mattachine—named for medieval jesters who performed in masks—was a semi-secret society and support group for gay men. Although it suffered conflict and revolving-door leadership, the society spread to other cities and became a significant lodestar for gay rights in the years leading up to Stonewall and the real genesis of the Pride movement. But desirous of projecting a conservative Brooks Brothers image, the society from the start discouraged men who were too "swishy" and flamboyant, including queens—that is, effeminate men—and drag queens. Hardly a milieu for a self-described cafeteria queen, the Mattachine was, in Perkins' view, "a noble and necessary movement, a drop in the bucket to combat the mighty ignorantee [sic]." But it was not for him: "Since dick-licking and browning is going to be a part of human experience as long as humans are fascinated by luscious anatomies, I think society in general might just as well make up its feeble mind to accept the validity of cocksucking! Señor Kinsey, take heed!"

One particular luscious anatomy Perkins craved was that of a fellow worker, Orestes, a Canadian of Ukrainian descent. "I am in love!" Perkins announced to Bill Alexander. "He told me that he'd do anything in the world for me except permit me to love him, do him or get my claws into his personal sovereignty . . . which is the shame of shames." Perkins photographed Orestes many times, though the only surviving image is a cameo-like profile of the young man, who has a high brow, a straight nose, a strong chin, and a full head of brush-cut hair. "He didn't know he had a profile before I took this picture," said Perkins. But ex-logger Orestes hated that look of "exquisite Greek God delicacy . . . like poison." As for the other photographs, taken over time, and for several hundred dollars, at the studio of Joel of Wilshire, there were ninety-one of them showing Orestes (Orest for short) in "various states of dishabille." Perkins went on, "The views are modest due to the use of an enormous Philodendron leaf anchored to his privates by a rubber band . . . I assure you that the Philodendron leaf became closer to Orest than I ever did." Because of that, Perkins lived a life of constant and perpetual frustration: "I guess I am walking in a magic trance on account of Orestes," he told Alexander

and Margie King. "We have psychological orgasms every time we converse which is every day and has the whole cafeteria in an uproar." Unfortunately for Perkins, Orest had a "split personality," and both sides despised queers. Perkins was well aware of the futility of his desire: "I tell you, it's a camp. A pathetic, futile camp, but what isn't when an old bitch and a very young and very handsome kid are in precarious confluence?"

Also unfortunate was the fact that aside from his "incomparable physical beauty" Orestes was "a deadly bore" with an all-consuming passion for mechanics (that is, applied math, machinery, and physics, not grease monkeys).

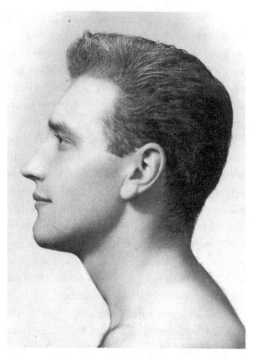

Orestes, Perkins' object of desire at the Ontra, c. 1962

His general demeanor resembled "that of a last year's dessicated [sic] cow flop," and he was given to sudden exclamations along the lines of "I wish I'd had a 303 rifle in Saskatchewan," or "bounced off a white rock a quarter of a mile away." Eventually, Orestes joined the United States Air Force, but he and Perkins corresponded, and, judging from the one letter that survives, Orestes was every bit as boring as his would-be lover claimed. Writing from the Mountain Home Air Force Base in Idaho, he filled two pages with technical talk: "I have a Citizen Band transceiver of 100 milliwatts of power. The range of the 'Walkie-Talkie' is a little over a mile. Transmissions are excellent with no obstruction & the power loss is only about -20 decibels." One can only imagine the tedium Perkins must have experienced with letter after letter continuing in the same vein. As he told Alexander King, all of Orest's letters were "filled with technical symbols . . . and are totally devoid of anything personal, affectionate, or even human . . . Given a batch of wires, a soldering iron and a bunch of tubes, he is in superlative ecstasy."

Orest did have a social life of sorts, since he mentioned a barracks-mate who was a kindred spirit enthralled by technology. Perhaps that spurred Perkins to break off the correspondence: "I was insanely jealous of him sharing his attention with anyone else," he wrote. "I was completely possessive . . . He had become

an obsession, an ever present fixation, a fitting into an old, flea-bitten pattern." Perkins went on, resolutely disparaging the boy he had so adored: "He is a bigoted anti-homo ignoramus . . . His teeth were bad and he had a vapid mind." And a hairy body. In the end, Perkins said, "My emotional reactions were inevitable. My infatuation was . . . a continuation of an attitude harbored all through my life. It goes too deeply for me to discuss or attempt to analyze." But elsewhere, he did analyze it: "I endured all of this exceedingly dry, vapid, moronic carrying on just because I am a victim of a distressing malady which impels me to lay posies at the feet of the gods. Beauty is so ephemeral and I will endure anything just to bask in its sometimes poisonous effluvium . . . even if it is only an animated physical appearance." Perkins could have been ventriloquizing or channeling Oscar Wilde, whose worship and pursuit of beauty, above all male beauty, ultimately brought about his downfall. Perkins' downfall was far more mundane, but, despite his many protestations to the contrary, his thirty-seven years of grueling work at the Ontra surely constituted some sort of purgatory. What he may have been atoning for—if indeed he was—is impossible to say with any confidence, but the turning point may have been the mysterious crisis that drove him from a promising career in the movie business and down into the world of menial labor.

Orest did have one positive effect on Perkins, though, which was to disabuse his frustrated would-be lover of the mystical beliefs that for some fifty years had been a driving obsession. How Perkins managed to fit this obsession in with Rose O'Neill, Mexico, the dance family, the Index of American Design, and *Dorian Gray*, not to mention his novelistic endeavors and life as a drag queen, is a wonder. It took root during Perkins' first Los Angeles career in the 1920s, when—in the company of Don Forbes and Fernando Felix—he began to attend lectures by Manly Palmer Hall, the charismatic spiritual teacher and preacher who attracted many thousands to his esoteric philosophy from the 1920s to the time of his mysterious demise in 1990. According to Felix, Manly Hall was the inspiration behind the watercolors "about gods and goddesses and Budah [sic] and things occult" that both he and Don had made at the time, though "Don was very ashamed of them afterwards." Perkins confirmed his prolonged immersion in mystical thinking, telling Bill Littlefield that he had been "A fanatical Theosophist for forty five years" before Orest jolted him out of it by introducing him to "elementary Physics. Energy equals matter—matter equals energy, a mathematical fact. It's hard to hang on to dogmatic rigmarole after studying Physics."

But what was the "dogmatic rigmarole" that absorbed Perkins for nearly half a century? The rigmarole, in fact, was nothing less—in Manly Hall's world view— than the wisdom of all the ages, from Ancient Egypt and Atlantis to alchemy, occultism, Freemasonry, spiritualism, Zoroastrianism, Hinduism, Buddhism, and Confucianism (this hardly exhausts the list). Hall, born the same year as Perkins, grew up in Ontario and migrated to Los Angeles a couple of years before Perkins

made his first trek west with The Most Beautiful Man in the World. Almost at once Hall—a largely self-taught polymath—began lecturing at the Church of the People, founded by a Transcendentalist (who ultimately reverted to Presbyterianism) and continued by a diminutive 33rd Degree Mason (who had to buy his suits in the children's section of department stores) until Hall filled in for him one Sunday so successfully that soon *he* became pastor. As Hall biographer Louis Sahagun tells it, the church's eccentric congregation included "populists, intellectual utopians, single-tax enthusiasts, vegetarians, and young drifters seeking direction in life." Perkins, Don Forbes, and Felix all fell into the last category.

How they gravitated into Hall's orbit is not known, but at that time (and ever since) Los Angeles offered a heady smorgasbord of alternative religions new and old, sects, and cults of all kinds. It would have been remarkable only if the trio *hadn't* sampled what was on offer. In the 1920s, the city's population more than doubled as opportunity-seekers, escapists, visionaries, and Hollywood hopefuls flocked there in vast numbers, guaranteeing ready-made congregations and cultists for the hodgepodge of denominations that sprang up and took root. So dramatic was the proliferation of faiths that by 1930 *Time* magazine had taken notice, writing of "Flowery, sun-drenched California, where Nature exhibits herself in mystical opulence, where plenty of people have plenty of money, where there are many invalids contemplating eternity," as "particularly propitious for this flourishing."

There was, for example, the men-only Holy City in the Santa Cruz mountains; its inhabitants wore long hair, sold barbecued pork and gasoline to travelers, "broadcast from their own radio station" and posted "signs reminding the countryside of the likelihood of Death." Then there was the Rosicrucian Fellowship in Oceanside that among other things practiced "spiritual healing through agents known as 'Elder Brothers' and 'Invisible Helpers.'" Then in Ojai there was the Theosophical colony of Krotona, practicing faith in reincarnation, karma, and other occult and mystical systems both Western and Eastern. Founded in Manhattan in 1875 by Russian émigré Helen Blavatsky, Theosophy ("Divine Wisdom") had any number of competing spinoffs, but the Krotona cult nurtured its own particular belief that children born on the Pacific Coast were "creatures of a new, sixth race, capable of seeing ethereal spirits, possessed of clairvoyance."

Given the cultural climate, Nathanael West's fictional sendup of Los Angeles cults in his 1939 novel *Day of the Locust* could pass quite plausibly for straight reportage rather than satire. The protagonist, Tod Hackett, is a young Yale-trained artist who migrates to Hollywood and finds employment as a scenic designer for a movie studio while he contemplates his *magnum opus*, a painting of *The Burning of Los Angeles*. Exploring the city for material, Tod visits different Hollywood churches, among them the "'Church of Christ, Physical,' where holiness was attained through the constant use of chest-weights and spring grips; the 'Church Invisible' where fortunes were told and the dead made to find lost objects; the 'Tabernacle of the

Third Coming,' where a woman in male clothing preached the 'Crusade Against Salt'; and the 'Temple Modern' under whose glass and chromium roof, 'Brain-breathing,' the Secret of the Aztecs, was taught."This passage was quoted in Carey McWilliams' seminal 1946 history of Southern California. Seemingly without a hint of irony, McWilliams appended his own real-life observations of various cult practices to those of Nathanael West: "In Los Angeles, I have attended the services of the Agaberg Occult Church, where the woman pastor who presided had violet hair (to match her name) and green-painted eyelids (to emphasize their mystical insight); of the Great White Brotherhood, whose yellow-robed followers celebrate the full moon of May with a special ritual . . . of the Self-Realization Fellowship of America, which proposes to construct a Golden Lotus Yoga Dream Hermitage near Encinitas at a cost of $400,000; and the lectures of Dr. Horton Held, who believes California is an unusually healthy place to live since 'so many flowers find it possible to grow in this vicinity. The flowers, cultivated or wild, give out certain chemicals which beneficially affect the human body.'"

Compared with all of the above, and many more, Manly Palmer Hall's Philosophical Research Society was—ostensibly at least—relatively sedate. It was certainly eclectic in its embrace of nearly every species of thought, from rationalism to the outright paranormal. Doubtless the main attraction was Hall himself, a "huge avocado of a man," as Sahagun writes, "six feet four inches tall and wide in the middle." He had "piercing blue-gray eyes and chiseled features worthy of a

Manly Palmer Hall looking into your eyes in William Mortensen's 1935 portrait photograph

Barrymore." Even photographs communicate Hall's magnetic presence: handsome when young and imposing when old, he has a hypnotic stare in some portraits and in others looks off into some visionary ether that only he can see. Possibly the most captivating image of Hall in his prime is the artfully doctored 1935 portrait by Hollywood glamour photographer William Mortensen. Here we see Hall full-face. His deep-set eyes look out from under furrowed brows; his nose is hawk-like; his thin lips a level line under a tidy little moustache that contrasts with his lush, unruly hair. Perhaps he has just run his hands through

his mane while hashing out some esoteric idea. One side of his face is in shadow; the other lit so that we can appreciate his noble brow, rugged cheekbones, and strong chin. He seems to be staring, or glaring, directly into our souls. (Mortensen's friendship with Hall in turn inspired the photographer's series of lurid images purportedly documenting the history of witchcraft through the ages; among other things, Mortensen's support was instrumental to the fledging career of Fay Wray, the screaming heroine/love object in the very first *King Kong* movie.)

No wonder Manly Palmer Hall attracted devoted supporters like Carolyn Lloyd and her daughter Estelle, who bankrolled the young sage's 1923 travel in Europe and Asia with their Ventura oilfield wealth. That trip in turn enabled him to research and collect vast amounts of material that resulted in *The Secret Teachings of All Ages: An Encyclopedic Outline of Masonic, Hermetic, Qabbalistic and Rosicrucian Symbolical Philosophy*, first published in 1928 and continuously in print ever since. Aside from the main schools of thought indicated in the title, Hall's tome also covered alchemy, the Tarot, astrology, Pythagorean mathematics, Atlantis, sorcery, the Apocalypse, and Native American symbolism. *Secret Teachings* cemented Hall's growing fame, which allowed him to launch a veritable industry of all things mystical and esoteric. By 1934, success and money enabled him to establish the Philosophical Research Society, which housed his vast library and served throughout Hall's long career as venue for lectures, instruction, and many, many publications; in all, the sage himself published one hundred and fifty books and gave thousands of lectures.

Hall commissioned architect Robert Stacy-Judd to design the Philosophical Research Society building in Mayan Revival style, which for both the architect and his client had mystical connotations. In the early 1920s, Stacy-Judd stumbled upon John Stephens' richly illustrated *Incidents of Travel in Central America, Chiapas, and Yucatan* (1843) and became a devotee of all things Mesoamerican. Fired up with excitement, he built the Aztec Hotel on Route 66 in Monrovia, California, a move that launched his career. As scholar Eric Davis writes, Stacy-Judd also "styled himself as an archaeological expert on the Maya," not only distributing pictures of himself in "pith helmets and Mesoamerican garb" but also patenting and marketing the "Hul-Che Atlatl Throwing Stick." Stacy-Judd believed that the Maya were direct descendants of settlers who had fled the destruction of the long-lost and legendary island of Atlantis, the ur-capital of ancient wisdom. Utterly convinced of this legacy, he also declared that Jesus Christ was "a master of esoteric lore whose last words were pure Mayan." It almost goes without saying that Stacy-Judd was the perfect fit for Manly Hall, who for his part published the builder's titles alongside his own.

Splendidly housed in ersatz Mayan magnificence, Hall for decades delivered his lectures from a massive and ornately carved throne. He believed that the destiny of United States after World War II was to "lead a still troubled mankind toward a

better way of life" culminating in world democracy and "Universal Brotherhood." He also believed that the pineal gland was the eye of God. He had two stormy marriages. His first wife, Fay B. de Ravenne, committed suicide; his second, Marie Bauer, nourished a fanatical obsession with finding and unearthing the so-called Bruton Vault, allegedly somewhere in the vicinity of Williamsburg, Virginia, where Elizabethan philosopher Francis Bacon's writings, including reams of unpublished plays by William Shakespeare, had (supposedly) been hidden. Hall had a chronic weight problem, going on a cottage-cheese and no-chocolate diet on one occasion so that surgical instruments could actually reach his troubled gallbladder, and subjecting himself to quack therapists such as William E. Gray, who claimed to emit cancer-curing jolts of energy with his hands. Carol Bell Knight, one of his personal secretaries, was a fan before she applied for the position, having seen "bright lights flashing" around Hall's head when he lectured. She would sneak cream puffs and chocolate eclairs into his office after she returned from lunch: the metaphysician in that context was all too physical. His death in 1990 is still an "open-ended Hollywood murder mystery," with well-grounded suspicion that Daniel Fritz, the sage's caretaker and executive officer, had killed Hall elsewhere and brought his gigantic ant-ridden body home, alleging that the philosopher had died in his own bed of natural causes. However Hall died, the *Secret Teachings* had a long and dubious afterlife: Robert Kennedy assassin Sirhan Sirhan had a copy, as did 9/11 terrorist mastermind Omar bin Laden.

After his return to California for *The Picture of Dorian Gray*, Perkins once again attended Hall's lectures at the Philosophical Research Society, sometimes with his young Western Stove Company friend Charles Francis. In what correspondence survives, Perkins had little to say about his study of what he called Idealistic Thinking—that is, until the moment when he decided it was all a sham. But from Francis' recollections we can at least glean a picture of Perkins in pursuit of the mystical and the magical. Francis recalled that Perkins was "very curious about paranormal topics. He invited me to accompany him on several events and related things he had observed. One such was a demonstration by an elderly Hindu woman who after dinner in a private home in Santa Monica placed two dining room chairs back to back, separated three to four feet apart, with a sewing needle threaded [between them]. She closed her eyes for a few moments and then the needle began to jerk and move of its own accord across the thread. Perk was very impressed by this but I could see no practical value in it."

Perkins also sought Hall's opinion and advice about topical issues such as the health of postwar American culture; Hall in his reply opined that fantasy fiction and cartoons were steadily becoming a "standard part of America's juvenile mental diet" and expressed the hope that young minds might be led to "a more generous acceptance of that concept of life which lies beyond the limitations imposed by materialism." Perkins must also have asked Hall where gay people

fit into the metaphysical and mystical order of things. Hall hedged: "The matter of homosexuality is still a little difficult to handle in a publication in our field, but I have given the matter considerable thought . . . in the course of time, we will include something bearing upon this subject in our Question & Answer Department in HORIZON [the in-house magazine]." Ironically, Hall himself may have inclined in that direction; rumor has it that both his marriages were sexless and that he had relations with other men.

Although Perkins left so few traces of his immersion in mystical matters, a surviving watercolor and a handful of doctored photographs suggest the impact of Hall and his eclectic spiritual practices. The original watercolor no longer exists, but luckily Perkins for unknown reasons had it reproduced, perhaps as a postcard. The caption well describes the image: "From the urn of material ashes/Shall rise youth's fair spirit/To no thing whence it came," it reads. And sure enough, at the bottom of the stiffly axial composition stands a gleaming silver urn draped with a garland. Directly above, an androgynous nude figure ascends toward the nebulous apparition of a god-like head, which hovers in an aureole of dim golden light that gradually shades off into lavender and green tones toward the edges. It is as heartfelt an image of transcendence as Perkins ever conjured up. The source of the carefully lettered caption remains obscure, but it may well have come from some pronouncement by Manly Hall, since his writings are scattered with references to ashes, urns, and transfiguration.

The photographs, which date from about 1943, are unlike anything else in Perkins' archive. In one, Perkins, in a work shirt, hair carefully slicked back, sits with a young boy on his lap. The boy, who might be five or six years old, wears a solemn expression and a striped T-shirt; his hair too is meticulously pomaded and groomed. The second photograph is Perkins in his Mary Pickford drag, grinning, with a long, wavy wig, artificial doves and flowers, and heavy makeup. The third is a composite, with the portrait photo of man and boy now accompanied by a vignette of Perkins in the same exuberant drag, though now with an expression as dour as the boy's. What's going on? Most obviously, here we see, for the first and only time, *both* sides of Perkins at once. There are further puzzles. On the back of the Mary Pickford-Perkins photograph is a typed label that reads "Unidentified ectoplasmic image fully materialized." Another copy of this photograph has a different and much lengthier label. "This exposure," it says, "made on Eastman Infra Red film with Infra Red flash bulb. Shot open flash in total darkness."

There is much more, in studiously technical language. Perkins' five o'clock shadow "shows clearly because of peculiarity of Infra Red film/also veins showing (partially retouched for smoothness.)" The "Ectoplasmic face," that is, the Mary Pickford version, "is not in sharp focus because allowance for change in focus with Infra Red rays made only with two visible [f]aces by extending bellows 1/32"

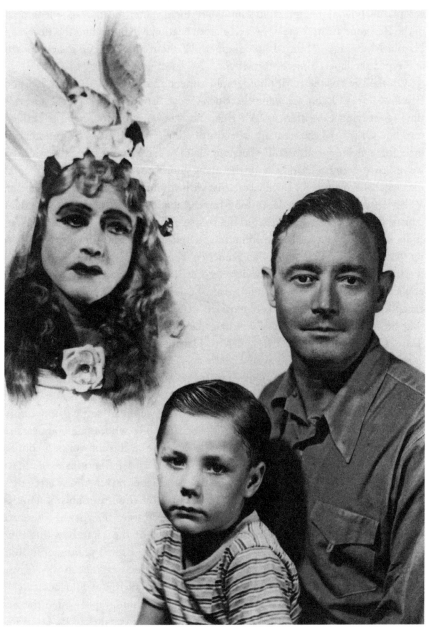

Composite photograph representing Perkins, little boy Joe, and Perkins in drag posing as an ectoplasmic image, c. 1943

over normal focus." The identical lighting on the two faces, the label continues, denotes "reflections of Infra Red waves rather than astral light." There is also "some ectoplasm showing behind child's shoulder." Finally, there is an acknowledgment of the Reverend Edith Mae Sprague, "materialization Medium," and the Reverend Harold M. Sprague, "Spirit Photographer." Without a doubt, Perkins composed and typed the labels himself. But why?

On the back of the spirit photograph, someone has written, "Perkins, Joe, and Perkins in drag." Later, someone else stuck a Post-It note on the reverse side, this time identifying the sitters as "Alter ego portrait w/ son." Joe, then, is Perkins' own boy. Or is he? Like so many aspects of Perkins' life, the history, or mystery, of little Joe is nebulous at best. Perkins did claim to have been married—twice. As we've learned, India Clark, she of the many abortions, was the first. The second marriage was to a certain Lucille, an artist with whom Perkins lived in Greenwich Village—so he said. There is nothing further about Lucille in any of the extant papers. But Perkins asserted that in the course of his first marriage, if such it was, India had first given birth to a stillborn son and then to a healthy girl who grew up to become the madam of a San Francisco whorehouse.

The problem is that in surviving records, including Perkins' 1931 passport application and the 1940 federal census, he is listed as "single," and, with the exception of his rambling octogenarian reminiscences, he never mentioned that he had a son—dead or alive—or a daughter. Perhaps it was merely what Tom Huckabee surmised: "Mr. and Mrs. Harnly were neither ideal parents nor compatible spouses; and following the divorce, Perkins had little contact with her or their children." This hardly squares with Perkins' weekly fried-chicken visits to India before he left New York, however.

When asked directly about "Joe," Perkins answered in the vaguest terms. His interlocutor posed the question, "Who is the 'Joe' whose name appears in several of the Index watercolors and also in some of the current works? I confess to being curious as to whether you are referring to Cornell." Perkins replied, "As I've previously mentioned I work by instinct and label my creations after they have been demonstrated. The 'Joe' is merely a tid bit from my subconscious. It might as well be Cornell." And indeed that may lead us to the answer. There are several other professionally lit studio photographs of the same boy, this time by himself. It is quite conceivable that in the supposed spirit photograph, "Joe" was manipulated into the scene just as the ectoplasmic drag queen was. Given the obscurity of little Joe's relationship to Perkins, all this would be scarcely worth mentioning, were it not for that composite photograph, which meshes with Perkins' Manly Hall-inspired enthusiasm for the occult and by extension the spiritualist practice of summoning the dead, ectoplasm being the gauzy substance extruded by a medium in order to materialize emanations from the great beyond. Yet at the same time, the photograph is obviously faked, in that

capacity foreshadowing Perkins' ultimate loss of faith in all things spiritual. In the end, he chose "Infra Red" over "astral" light.

Perkins' disillusionment seems to have been sudden and irrevocable. However, it was not only because of Orestes' tutorial on the elements of physics, though that may have been the ultimate death blow. Well before that, Ed Wemple had seeded Perkins' mind with new doubts: as Perkins wrote, "In one of his many superb letters from Charlottesville, Virginia, [Ed] said: 'It is wishful thinking and self hypnosis.' That made me mad. I had been so secure in my <u>understanding</u> of spiritual principles and superphysical conditions . . . that it all seemed real or actual to me." He began to wonder if individuals who advanced "Earth-shaking ideas" (like Manly Hall) "might have been nuts, off the beam and possessed with fantastic imaginations. Then a bunch of lesser crack pots possessed of lesser imaginations swarmed around the craziest crack pot like flies around a ripe plum or dead mule." From there, it was a foregone conclusion: "There is little or no evidence that any spiritual realm exists outside of man's imagination . . . Therefore all is bullshit."

Edwin Wemple was a friend from old New York days, but he had led a restless life, wandering the country during the Depression and working as a longshoreman and lumberjack before becoming a beatnik and jazz buff in New York and ultimately moving back to his hometown of Charlottesville. There is a photograph from the 1970s of Ed sitting on the front steps of his house. He has long hair and stares out with a quizzical and possibly toothless (it is hard to tell) grin; he wears an unraveling cardigan, shorts, and a pair of filthy socks so decayed that all of his grubby toes are poking out. According to the photographer, who lived in Ed's house for a time, "He had not had a bath in nine years and spent his time reading and sleeping. He went by taxi once a week to the Alderman library to replenish his book supply." It is hard to imagine just how squalid Ed's domestic arrangements must have been, but housekeeping was not his forte, after all. He had a prescription for Perkins after the scales fell from the latter's eyes: "I'm sorry you underwent an ordeal recently. Catharsis is useful but painful. For us orphans of the storm, it seems to be a periodical necessity. I believe you can accomplish the same end less painfully and clumsily by staying continuously high for a good, solid week about once a year. Procure about two dozen sticks of a good grade of marijuana, get on the first thing when you wake up, light up another couple of times while you're working, and once more early evening. Don't let yourself come down for even a half hour . . . You'll find yourself emptying out and cleansing the lower psychic depths . . . under conditions of joyful euphoria"—rather than "guilt, fear, and depression."

As far as we know, Perkins didn't follow Ed's recommendation, but he did proceed to divest himself of both idealistic thinking and his occult and metaphysical book collection, which he gave to the Philosophical Research Society

(duly acknowledged by Manly Hall in what was probably the last communication between the two). "Those books cost a pretty penny," Perkins grumbled. "I collected them over the past forty years." Disillusion or no, he asserted that his metaphysical study was "the most gratifying experience" in his life, and he wouldn't have traded it "for anything else in the world—THEN." Yet his disaffection was complete. He had "never experienced a glimpse of that which is supposed to exist above and beyond the sensory perceptions" and didn't know anyone who had. Even the most famous spiritual teachers and gurus, in the end, were mere flesh. "Buddha died of food poisoning. Blavatsky was an invalid for years, too fat and sick to get out of a wheelchair, smoking cigars, spitting phlegm all over the place and finally caving in at her digs in London. Mx Heindle, founder of the Rosicrucian Fellowship, was an invalid seven years and died just like any dog. Yogananda died at the banquet table here at the Biltmore during a testimonial dinner in his honor." Yogananda's followers believed that the guru had intentionally chosen that moment to leave his body, but Perkins no longer held out any hope for the "Fairy tale prospects for a personal gutless immortality."

It was not only the occult book collection that Perkins jettisoned. Periodically he divested himself of things—only to replace them with more and different things. His room at the Culver Hotel went through a number of metamorphoses as his tastes, and whims, found new objects of desire. Perkins dubbed this cramped chamber his "darling snuggery" and lavished attention on its decoration. Indeed, during that period of artistic amnesia he may have been closer to the snuggery than to any person; it was his refuge, his walk-in closet, his palace of dreams. Charles Francis saw it in one of its earlier incarnations. "His room in this bargain rate hotel was surprisingly well furnished with Louis XIV period pieces that I assumed he had acquired during his days as an art director for MGM," he recalled (Perkins here typically aggrandizing his role at the studio). "Over his elegant bed he had suspended on invisible wires, two stuffed, very life-like white doves. They were circling one another, wings unfurled, a few feet above his pillows. 'What's with the doves?' I inquired. 'Oh, those? I put them there because when I wake each day, I think at first I have died during the night and I'm now in heaven.' He smiled and batted his long eyelashes several times." Those doves were surely the same ones that Perkins posed with in his Mary Pickford drag.

Some years later, though, Perkins revamped the décor, moving from Louis XIV to a more classical aesthetic. He planned to install "indoor shutters in turquoise," a white Japanese rice-paper screen, ceiling-high bookshelves, and "high turquoise lamps with Italian-Spanish Renaissance bases in plaster." Later still, he transformed or at least augmented the décor once again just at the point when the survival of the hotel was in doubt. Writing to Bill Alexander, Perkins urged him to come and see his room before it had to be torn up: "The floor is turquoise enamel with a circular hand carved rug from Zandt's for which I paid

three hundred and seventeen bucks for eight feet." He hadn't yet acquired the indoor shutters, which he eventually managed, but he did have mirrors on the west wall, "all the way from asshole to belly button, five hundred bucks." He had a new sofa bed, too, in "white plastic covered textile," and on the walls were prints of fantasy Roman and Venetian architectural scenes. There was a "huge tropical plant," a new tiny gold clock, and a small, plain black-and-white TV. The latter replaced a Packard Bell television in a "French Provincial cherry wood cabinet with ormolu door pulls." As with most of his possessions, Perkins had purchased this pricey item on the installment plan. After he finally paid off the rug and other things, Perkins planned at last to buy the shutters and a chandelier, and then, "after sixteen years," the room would be finished.

Perkins' oasis suffered a minor catastrophe—or to him, major—when the landlady decided to close his windows in case of rain (during a scorching dry spell with no rain anywhere on the horizon). Unable to budge them, she sought the help of the house man, who knocked over Perkins' ten-foot shutters, which smashed into the five-gallon brandy snifter full of goldfish, shattering the glass into a hundred pieces and smashing his bird cage as well. "My hand carved rug was soaked and all the carving came out," he lamented. Finally, he got rid of nearly everything. He told a reporter that he had spent "$17,000 decorating the room with expensive furniture and mirror paneling that would reflect the moon. Then, in a turnabout, he had it all carted away." Now, all that remained was a "simulated leather couch bed and a bookcase," which held Perkins' library of oversized and lavishly illustrated volumes on subjects like the "Treasures of the Vatican . . . Great Houses of Europe, the illustrated History of Paris and the Parisians, Japanese Painting[,] The Treasures of Asia." There was one more object, too, "proudly displayed" on the bookcase: an "urn with his name and date of birth. It is for his ashes." The purge was not entirely voluntary: there had been another and worse catastrophe. Workers assigned to repaint and plaster Perkins' room dumped out all of his belongings and somehow destroyed most of his clippings and reference materials. At that point, Perkins got rid of everything except his coffee-table art books. "My new room is bare and I like it that way," he announced. "I'm through with junk."

But with or without junk, Perkins filled his humble sanctuary with music and schooled himself in music appreciation. Vaughan Williams was an early favorite; prompting Perkins to enthuse about the composer's *Symphony Antarctica*, which he deemed "wonderful strange, eery [sic] ghostly . . .[it] simply <u>sends</u> me." But eventually, Williams' "sheer polyphonic sounds," without "melody, beat, or some recognizable relation" to Perkins' "conditioned reflexes" grated on his nerves, unlike the "rip snortin', slash banging of Stravinsky" or even the "enemic [sic, probably "anemic"] ramblings" of Shostakovich, which were never trite. When Perkins' boss, an ardent Vaughan Williams fan, discovered that his hot-counter man had an

extensive collection of recordings, he exclaimed that he would almost give his soul for "'that batch of musical splendor.' He could save his soul, I told him, and give me his Grieg collection for my Williams collection . . . so we swapped and every body is deliriously happy." Perkins also sampled music by Wagner, Berlioz, Schumann, and Bach, among others. "When it comes to Beverly Hills Hotel boiled Salmon and this kind of music," he wrote, "I am an unmitigated hog."

Perkins also ventured out to the movies, gravitating toward productions that tickled his camp funny bone. He saw *The Loved One*, based on the 1948 Evelyn Waugh novel, five times, possibly holding the world record for repeat viewership of that morbidly not-for-everyone black comedy on the Los Angeles funeral industry. Perkins' favorite bit was "a camp, screamingly funny" sequence "showing a very fat woman in bed eating a roast suckling pig—to music!" The camp, presumably, arose from the spectacle of extreme (and revolting) gluttony juxtaposed with an incongruously sophisticated film-noirish jazz riff played on a wailing saxophone. *The Yellow Rolls-Royce* was another standout; Perkins declared his profound adoration of the film and extolled the interior English country-house sets as "a camp. They simply killed me. . . the endless screaming of the room's accessories were a balm to my weary soul. Some very wise and clever old QUEEN must have been the set dresser!" The décor is indeed over the top: the Marchioness of Frinton's boudoir, in particular, is an eclectic riot of style in which the scattering of relatively restrained Louis XVI pieces is awash in tides of ornament—gilded Rococo candelabra, fussy trinket boxes, richly patterned Sèvres vases encrusted with swirling gilt flourishes, and a lavishly cluttered dressing table with an imposing mirror framed in writhing golden scallops. Over the Marchioness' bed is a filmy chiffon curtain with gilt Cupid tie-backs; everywhere else—over walls and windows alike—hang thick draperies, their amplitude worthy of an opera-house stage. Even the feathery pink trim of the Marchioness' dressing gown is a camp, recalling as it does those extravagant boas so beloved by Mae West and her queenly followers. If Perkins' furnishings were sparse, his movie diet made up the deficit.

Although he had few if any visitors to his sanctuary, Perkins did have a companion: a canary, or, rather, many canaries in succession: when one died or made a break for it, he promptly replaced it with another. Pinky, whose cage was smashed when the shutters came crashing down, escaped unharmed. Another bird wasn't so lucky: it flew out an open window only to be run over by a car. Perkins missed it so sorely that he immediately ran out to buy a new one, a "fat fluffy canary named Big Boy." He renamed Big Boy, calling him "Jack Dem[p]sy" after the famous boxer. Appropriately pugnacious, Jack had six times as many feathers as other birds and pooped in excess of his own weight every day. When Jack died of cancer, Perkins replaced him with a flame-colored canary that sang its head off. Then there was the rare copperplate-orange roller that Perkins housed in a

"turquoise cage shaped like the temple of Heaven." Yet another canary died after being boarded at a pet store; Perkins quickly acquired another, pure yellow, that sang like mad. That bird died too and was succeeded by a bronze and black cream-bellied specimen that sang "its ass off all the time." Perkins honored his dead, or some of them: "When I lost my Jackie, the pet cemetery was not good enough for him so I wrapped him in green waxed florist's paper and tucked him in a bouquet of flowers and tossed him into a Forest Lawn grave that some Mexicans were filling up," he wrote. "So he rests in style and grandeur. No cost and perpetual care." And the company of movie stars for all eternity.

That was Perkins' life for some thirty-seven years. He became a beloved fixture in the cafeteria, his birthdays and landmark Ontra anniversaries—the twenty-fifth, the thirty-fifth—regularly celebrated with cakes, presents, and tributes published in the company's newsletter. Yet he also ventured out into the wide world, becoming an inveterate traveler during the 1970s, attending theatrical performances as well as movies, and exploring the universe of contemporary art, which with few exceptions was utterly alien to his own. And, in a small but significant way, he finally won fame.

Sort of Famous

I N THE 1970S, SUDDENLY THERE ARE MANY PHOTOS of Perkins, small-format color shots, some slightly overexposed. In most of them, Perkins, grinning from ear to ear, wears a white shirt, a black bow tie, and a gray or tan business suit. On hot days, he sheds the jacket but almost never the tie. We see him posing before an array of backgrounds: jet planes, palaces, a uniformed brass band, Salisbury Cathedral, a herd of long-necked alpacas, Rome's Trevi Fountain, Stonehenge, an Alpine lake, the Little Mermaid looking out to sea in Copenhagen, the ruins of Machu Picchu, the ruins of Pompeii, and the tomb of the Argentinian boxer Luis Firpo, the "Wild Bull of the Pampas," famously defeated in 1923 by the American heavyweight champion and Perkins' canary namesake Jack Dempsey, and, in the Perkins photo, cast larger than life in bronze and clad only in a dressing gown and his boxing booties. We see Perkins in Rome, posing playfully next to the marble backside of a heroically scaled nude figure on the monument to Johannes Goethe in the Villa Borghese gardens. Significantly, perhaps, the nude bottom belongs to the matricidal mythic hero Orestes, who has flung himself into the lap of his long-lost sister Iphigenia. Did Perkins know whose bottom it was? It's hard to believe he didn't. And we see him in Paris, laying

Perkins ready to roll in 1973

a wreath at the tomb of Sarah Bernhardt in the Père Lachaise Cemetery. He is almost always alone; who took these photographs is a mystery.

It has been forty years since he went abroad; in the 1970s, he will make seven trips, to various European ports of call (and famous cemeteries) and—on the seventh and last, in 1977—to South America. By the end of the decade, he has had some six gallery shows of new and old work and will have two more before he's through, the pinnacle of them all being an exhibition of his Index of American Design watercolors at the then-National Collection of Fine Arts in Washington, D.C. He has even appeared on Johnny Carson's *Tonight Show*. Yet through it all, he insists that he's only a humble food worker and that his art is mere doodling.

Redoubtable raconteur Alexander King was the catalyst for the Perkins renaissance, just as he had been in 1933, when he brokered Perkins' first show at the Julian Levy Gallery. The friendship had withered once Perkins found himself playing second fiddle to printmaker Fred Becker. Perkins met King again by chance in 1943. The Viennese raconteur was in Hollywood working on scripts (none of which seem to have made it into production); Perkins ran into him at the Assistance League Playhouse, where the celebrated female clown Lotte Goslar was in performance with Marjorie Bell (at that time married—very fleetingly—to King, though little else is known about the relationship, which ended in divorce in 1945; later, Marjorie became a celebrated dancer in films with her third husband, Gower Champion; she died at age 101 in 2020). "I sat next to old fat Charles Laughton," Perkins wrote. "Alex and I had a few cool words. He seemed self conscious and defensive. I don't know why. Then I never heard hide nor hair of him until . . . 'Alex in Wonderland.' That started it all over again with an important addition—Margie!!!" In 1943, Charles Laughton, born two years before Perkins, was hardly old, though he was certainly stout; in memory, Perkins probably conflated the earlier and later Laughton, who (earlier) had memorably played a sneering and sadistic Captain Bligh in the 1935 film of *Mutiny on the Bounty*. Margie—yet another Nebraska expat—was King's last, and lasting, wife; the two married in 1953.

Following that brief 1943 Hollywood encounter, Perkins and King fell out of touch once again for sixteen years. Suddenly famous in 1958 after his first appearance on the Jack Paar show, the voluble King in 1959 started his own television series, *Alex in Wonderland*, which limped through a total of thirteen episodes. After watching it, Perkins must have written Alex, and the friendship, plus Margie—a singer and actress—was born anew. King, possibly wanting to make up for those many years of neglect, urged Perkins to take up painting again and began scouting venues to host an exhibition. Perkins hesitated but finally, in 1965, began to work in earnest, producing nineteen drawings during his August vacation, telling King that he had been "humped over" his drawing board for fourteen hours every day, replicating a few of his earlier works and concocting

Margie King enjoying Alex King's storytelling, c. 1965

new subjects: "The un-dead Whore, The Three Graces ... Murder in Mausoleum, Heat Wave, Vanity, Reverie, The Eternal Flame."

Humped over the drawing board, Perkins was a world, and an age, away from the fiery Watts Riots, yet at the same time, hardly unaware of them, he responded with ambivalent empathy. The riots erupted on August 11, lasted for six days, caused massive damage to both people and property, and failed to end or even much ameliorate the gross discrimination, segregation, high unemployment, and oppressive policing that had sparked the uprising. Perkins followed the course of the riots via radio and television. Likening Watts to a nest befouled by those forced to live in it, he commented that the said nest had been provided by "the <u>superior</u> white trash, and the Frankenstein which took so long to manufacture finally turned on its creators and took a terrible revenge. It is ugly, mean, vicious ... a ghastly indictment of the white egotism that made it possible in the first place." He blamed the riots on down-and-outers, who had lived like "caged beasts with no opportunity for release from an inexorable pressure of deadly circumstance." Yet they had served "a profound purpose in calling to the world's attention the pitiful conditions which fomented such insane hatred and violence."

But through it all, he finished the nineteen drawings and dispatched them to New York. A couple of months later, Alex King died very suddenly, leaving plans for the Perkins exhibition in limbo. Perkins was devastated: "when the midnight phone call came from my boss," he said, "I dropped my brush and haven't touched it since."

In a long and heartfelt letter to the widowed Margie, he began by quoting the first stanza of Percy Bysshe Shelley's "Adonais: An Elegy on the Death of John Keats": "I weep for Adonais—he is dead!" and continued for several pages, exalting the "sheer magic" of King's personality and the facility of his mind, which could "weave spells out of anything." Eventually, by mid-January of the following year, Perkins resumed work on the paintings that Alex had prodded him into producing. Now, he thought, the planned New York show should be "boomed up somehow as a memorial exhibit for King." He told Margie that he had "never lost track for a single brush stroke the fact that my efforts are my memorial to the grandest and most important person I've ever known . . . Any financial remuneration in any amount would never compensate me for the love, sweat, tears and shit that has gone into the group. A true labor of love expects only the glory and satisfaction of accomplishment."

The New York show never happened, but through the efforts of Alex King's young friend Henry Warshaw, Perkins finally had an exhibition in 1969 at the Sun Gallery in San Francisco. Henry had inherited Alex and Margie's fifth-floor walkup studio apartment in Greenwich Village. Nominally a lawyer, Henry—a warmly genial and compulsively generous wheeler-dealer—embarked on numerous entrepreneurial ventures, or misadventures, that tended to fizzle over time. As Perkins told it, Henry "invested in a Hollywood poster company and lost his shirt . . . He went to Florida to attend a convention the members whom he intended to impress with his notion of . . . keeping [ships] from sinking with some kind of plastic foam . . . Then he went back to Washington trying to impress a Senator with the idea of buying all the copper in the Transatlantic cable and selling the copper for junk . . . He started a research lab and a two and a half year old baby blew it up." Which was not exactly true, but close enough: as Henry's brother Alan Warshaw tells it, "He was in the Golden Powder business for two years; it was a revolutionary replacement for black gunpowder. It was far safer—based upon Ascorbic Acid . . . Everything was fine until a worker blew the side of the factory off." Henry proved to have more staying power when it came to Perkins, however, and remained his loyal friend and booster to the end.

Perkins had been busy, finishing more than eighty paintings; the opening, which he attended despite a powerful fear of flying (which he somehow overcame or endured for those later seven trips abroad), was packed to overflowing and included a deafeningly loud band, a bathtub full of champagne bottles on ice, a huge punch bowl surrounded by glass cups, and, in the back room, Alan Warshaw's short film of Perkins at the Ontra and in his Culver Hotel room, running continuously. "Henry and I were weltering in a blaze of glory," Perkins crowed. At the after-party, there was a banquet with "piles of elegant food plus snails," and "wild dancing, jabbering, and embraces all around." Henry had even managed to reel in Thomas Albright, the *San Francisco Chronicle*'s chief art critic, to write up a review, which, while quite warmly enthusiastic, consisted of mostly of

prepackaged Perkins anecdotes, along with Albright's own impression of the artist himself: "a voluble, volatile mixture of dapper urbanity, bellowing earthiness and old-fashioned Bohemianism." The show was a success: fifteen paintings sold for a total of seven thousand dollars, of which Perkins received more than half.

Perkins' new work was an exuberantly eclectic mix of old and new ideas, which he continued to explore through the 1970s. During that time, he was a perpetual-motion artistic machine. He had broadened his technique and developed a decorative style combining flat, clear colors and crisp edges. He delighted in poking fun at religion; religion, he declared, was the province of "morons and old ladies" who needed something to do. He painted a deadpan send-up (literally, after a fashion) of Raphael's revered *Transfiguration* in the Vatican, hewing faithfully to the general theme and composition but equipping Christ and his celestial escorts with flaming booster rockets to propel them skyward. The Lord, he said could not have managed such a feat on his own or through any supernatural agency. There had to be a reason. Perhaps in a nod to Jesus' weightier status, Perkins gave him two rockets; each angel just has one. He also eliminated Raphael's hysterical foreground figures, replacing them with a row of closeup gesticulating hands, one of them sporting a diamond bracelet and a fancy ring. Then there is the spoof of the nativity: *Hallelujah, a Boiler Is Born*, in which Perkins took as his model the antiquated boiler in the Culver Hotel basement, a metal hulk bristling with pipes and dials but somehow supported on two human feet. The tiny newborn boiler, an exact replica of its mother, hovers in a radiant aureole that shoots out rays tracing the shape of a cross. All around are bodiless winged cherubim; they have the same features as Perkins' fantasy drag queens of the 1930s. The *Boiler* appeared in Alan Warshaw's film to the accompaniment of the "Hallelujah Chorus" from Handel's *Messiah*.

Possibly even more outré (to some, at any rate) is Perkins' depiction of all religions as, essentially, trash. At the bottom of the composition is a pensive ape, with a dreamy expression, a parrot, and a halo of sorts in the shape of the Earth's globe. At the top is a shiny silver garbage can with wings. It dumps out a crucifix, Papal crown, a menorah and sacred scrolls, a Buddha figure, the Islamic star and crescent, the original Ten Commandments tablets, a totem pole, the Soviet Union's hammer and sickle, and other bits of sacred rubbish. As the junk plummets toward the earth, angels hover about to make sure it all reaches its target.

Perkins also took up Victoriana again but in a literally more visceral manner, as in his rendering of a Victorian cottage being ground down to splinters by a pair of gigantic false teeth; this was a reference to the destruction of the fine Victorian houses on Los Angeles' Bunker Hill, in the name of urban renewal. Bunker Hill mansions, indeed, stand in the background of many of Perkins' later works, no matter the subject. He redid the corset house from his *Americana* days as well and essayed at least two versions of a Victorian house stuffed with guts: intestines, heart, liver, brains, unidentifiable offal. He did a send-up of Victorian sentimentality in

another painting, where we see the portrait of ringleted Victorian lady with a bouquet of roses, a votive candle, a diary, and, in an oval frame, the silhouette of an automobile inscribed "To Mom with Love." In front of the portrait are a bentwood rocking chair and a fancy William Morris recliner. Rose petals float down upon the ensemble from above. But an anomalous object interferes with the nostalgic mood: a piece of angular abstract steel sculpture that zigzags jaggedly across the foreground and incorporates car parts as well: a detached steering wheel and a tire. It is some sort of junky welded assemblage of the sort that Perkins both admired and derided. He may have been making fun of the New York abstract sculptor David Smith, "a former W.P.A. boondoggler," in Perkins' words. "He does twenty feet high monstrosities from welded 20 gauge steel," Perkins wrote, "the most hideous, awkward and hurtful-looking gadgets seeming the nightmares of a constipated idiot. The new crop of expressionists seem to want to shock and revolt the public. How empty and sterile they are."

Perkins fulminated along the same lines after viewing an exhibition of abstract painting at the then brand-new Los Angeles County Museum of Art, a gleaming cluster of modernist pavilions surrounded by reflecting pools (which were filled in once the ooze from the La Brea tar pits began to seep in and pollute them). The problem was apparent almost from the start. "The architecture," Perkins wrote, "is somewhat awkward in as much as the water stands in dark, dank pools . . . [it] is rancid and requires periodic treatment with disinfectant. It is nice to say that our new Museum stinks?" Initially, he thought that the contemporary art inside stank, too: "The new Museum is the center of the new 'Slop Art' movement in Los Angeles. It's a bowel movement indeed!" One canvas, he went on, "is forty feet wide and eighteen feet high. It is a dirty white canvas with absolutely nothing on it except a few dirty finger marks around the edge . . . Then there is a very large canvas having a multi-colored effect achieved by throwing gobs of thinned color on the canvas and the thin turpentine ran down to the bottom in puddles of shit." And yet the more he thought about Slop Art, the more it impressed him despite his reluctance to be impressed. "After studying all of the unspeakable objects, I was amazed to realize that I was getting the idea . . . The old fashioned approach to picture making was more or less literary while this new approach is meant to bewilder the sense and tax the credulity of the observer. I am astonished to have to admit that the god awful blobs and outrageously offensive trash set against the elegance of traditional backgrounds impressed me more than the things I like . . . It is intentionally meant to exasperate, repulse, shock, hypnotize, startle, puke and physic the observer. That's IT!" (Perkins did, however, immediately take to maverick San Franciscan Bruce Connor's *Couch*, a threadbare paint-splattered Victorian fainting couch on which lies a decomposing wax body, which Perkins interpreted as "the remnants of a nylon stocking murder.")

In his new paintings, Perkins made fun of and paid tribute to contemporary art a number of times, combining David Smith-like angular steel *Cubi*, for example, with

the scene of a guardian angel hovering behind a little golden-haired girl crossing a precarious wooden bridge over a seemingly bottomless abyss. The original, an early twentieth-century postcard design by the Austrian artist Hans Zatzka, was hugely popular (inspiring any number of spinoffs) and cloyingly sentimental, depicting as it did a lovely lady angel with long golden hair and swirling pastel robes, hands lovingly extended over two children, a big sister and her brother, as they traverse the bridge over very troubled and tumultuous waters far below. Perkins de-sentimentalized his version. Beneath the bridge, a red devil straddles the abyss and pokes a stick up between the wooden planks. In a minute the bridge will collapse, sending the innocent darling straight into the devil's clutches.

Then there were the flying butts (possibly punning on the flying-buttress construction of Gothic cathedrals): a flock of improbably and absurdly winged pink behinds—draped with bead fringes and crowned with tongues of flame—flapping over a scrubby green landscape where a monstrously jumbled spotted cow grazes, or tries to: its two horned heads—one on either end—are not heads at all but fat udders with staring eyes; in the middle of its body is a tail. In other paintings, Perkins inserted classical sculptural or painted nudes, stranding Titian's *Venus of Urbino* on a Los Angeles bus-stop bench, or grouping the musclebound Farnese Hercules, the *Dying Gladiator*, and several generic but very well-endowed marble males around a voluptuous female nude reclining on a golden chaise longue. Not a one of the statues gives her so much as a glance. In another painting, there are angels and putti scattering roses over a sign-bedecked gas station, in the foreground another bus-stop bench advertising the Forest Lawn cemetery and urging people to drink Coca-Cola. There are Bella Flower prostitutes in many of Perkins' compositions, too: we see them frolicking in a brothel while the Madam's away, being lifted up to heaven by straining angels, or languishing on Victorian divans.

Perkins also spoofed classical mythology, as in *Leda and the Swan* (now in Tom Huckabee's personal collection), the swan being one of Jupiter's many disguises assumed by the randy god whenever he set out to seduce some innocent nymph. Leda, nude save for a pair of elbow gloves, an enormous hat, and dainty slippers, brandishes a fan of black ostrich plumes, lounges on a fainting couch paying no heed to the golden swan in a golden crown who aims his sharp beak straight at her crotch. Perkins explained that, Leda being a virgin, the swan is pecking away at her hymen. Behind the swan is a towering potted plant with vivid pink flowers, some shaped like sausages and the rest like calla lilies—or vulvas. Perkins explained that this was a "pecker and pussy" plant and swore it was an actual shrub found in nature; however, an admittedly desultory internet search turned up nothing but X-rated videos. Then there is a newborn Venus, riding on her dove-drawn "chariot"—a modern toilet. Here, Perkins was no doubt punning on the so-called toilet of Venus, that is, her grooming rituals, as seen in many a Renaissance or Baroque painting.

There are many, many more, but for now, one last example, which features the flamboyant and hugely popular campy pianist Liberace on a billboard rising high over a sidewalk sale of "Moe's Cutrate Junk" store, and junk it is: there is a pot-bellied stove, a toilet, miscellaneous machine parts, and the framed picture of an exceedingly busty Gay Nineties beauty. In the middle, a man seen from the rear seems poised to urinate on the pavement as he gazes upward. Grinning out at us, Liberace wears a frilly shirt under a pink tuxedo jacket, lapels encrusted in rhinestones. With bejeweled fingers, he strokes his signature candelabrum. The text, in various fonts, advertises the entertainer as "The Inimitable Master Showman at the Crystal Room, Where Anything Can Happen." Above it all float winged Cupids pelting the billboard with roses.

Perkins considered the Liberace painting as too common, even vulgar, but that very vulgarity may have drawn him to the subject. When he purchased his fancy new French Provincial television, he found the "stinkin' quality of the programs" disappointing but now simply took them for granted—except for anything that featured Liberace and Criswell. Criswell, a.k.a. "The Amazing Criswell," was born Jeron Charles Criswell King in Princeton, Indiana and made his fortune as a psychic whose predictions were for the most part wildly off base, notably the destruction of Denver, Colorado, the assassination of the Cuban dictator Fidel Castro, and the very first "Interplanetary Convention" to be held in 1990 in the new Convention Center on the famed Las Vegas strip with "colony citizens of Mars, Venus, Neptune and the Moon in full representation." Married to a former speakeasy dancer who believed that her pet poodle was the reincarnation of her cousin Thomas, Criswell also owned a plush-lined coffin, in which he supposedly slept (perhaps in homage to Sarah Bernhardt, who likewise slept in one, at least for publicity), and, like Liberace, wore a sequined tuxedo. He was also fast friends with Mae West and predicted that she would become President of the United States.

One would imagine that Criswell would have been right up Perkins' alley, but Perkins detested him. "As for Liberace and Criswell!" he fumed, "I begin heaving even when I push my remote control button and see Liberace and Criswell flash past—the one with a china doll cocksucker fixed grin [Liberace] and the other with a yellow spit curl and a mouthful of saliva. God!!!!!!" He conceded that while from a "campish" point of view Criswell's "vapid information" might appeal to "washed out queens," that, plus his "jackhammer" emphasis on "very weak points" was enough "to give a fire plug the dribbling shits." Could Perkins have been nursing a grudge because Criswell so regularly appeared on the Jack Paar and Johnny Carson talk shows whereas (as we'll see shortly) he, Perkins, had had only one star turn, such as it was? He did provide Criswell with "material," he said, but didn't specify just what that material was, beyond hinting that he felt that he "must share it with the right kinds of people."

Prodigiously productive during those years, Perkins was on a roll that gathered increasing momentum. Two years after his triumph in the Sun Gallery, he had another exhibition, at Bill Alexander's gallery-*cum*-junk-and-antique store, The Mart, on Santa Monica Boulevard in West Hollywood. On a piece of Mart letterhead there is a piece of such shameless puffery that it could only have been written by Perkins; possibly it is a draft for a press release. It begins: "CAN THIS BE ONE PERSON?????? He is seventy and is still a counter-man at the Ontra Cafeteria . . . for the past 26 years!" Noting that the exhibition brings together seventy paintings (presumably those that went unsold in San Francisco, among others), the text goes on, enumerating assorted career highlights, including some outright fabrications: "He studied at the Sorbonne . . . Nebraska born." The puff piece emphasizes Perkins' macabre side, noting, "He has written an article on Necrophilia . . . He did research on cemeteries around the world; studied and practiced occultism." The "Necrophilia" article may have been Perkins' "My Kingdom for a Hearse," which, with Bill Alexander as intermediary, he submitted to *Playboy*. The magazine promptly rejected it, regretting, in a masterpiece of understatement, that the piece did not "suit any of our current editorial needs." This is hardly surprising, given that *Playboy* at that time steered clear of kink, let alone trafficking in sex with dead bodies.

The Mart exhibition sold not a single painting, but it somehow led to Perkins' guest appearance on the Johnny Carson *Tonight Show*. It is not at all clear how that came about. Bill Alexander later claimed that *he* had gotten Perkins on the show and grumbled of Perkins' "ingratitude." Another story has it that Carson had caught Perkins' interview on a local TV news feature (also brokered by Bill Alexander) about the Mart exhibition and invited him to be a guest on *Tonight*. However it happened, it was, or could have been, an apotheosis for Perkins. Many millions tuned in to NBC at 11:30 p.m. every week night to enjoy Carson's jokey monologue, assorted skits, musical intervals, and famous or notorious guests. Since its inception in 1962, the program had included luminaries and celebrities of every stripe: Nelson Rockefeller, Judy Garland, Barbra Streisand, John and Robert Kennedy, Gore Vidal, and the famous (and much-hated) atheist, Madalyn Murray O'Hair.

The episode in which Perkins appeared in all likelihood can no longer be seen: from 1962 to 1972, the network recorded over nearly all the original videos because tape at that time was prohibitively expensive. Reporter Matea Gold states that "All that is left from that era are some grainy black-and-white kinescope clips, taken by a film camera pointed at a television set." Otherwise, nothing remains but a handful of anecdotal accounts. There is an unattributed paragraph, which has the look of a news bulletin, titled "The Pride of Wilshire." It reports that when Perkins was on the November 17, 1971 episode, "The KNBC Studio audience howled when the cafeteria employee was introduced as 'an interesting man who had had

no tobacco, alcohol or sex since 1932.' Someone in the audience yelled, 'Is that old hash-slinger real or is this a put-on?'" It goes on to note that during his star turn, "Perkins described his cafeteria activities and explained the meaning of some of his paintings shown on the monitors." There is also one surviving fan letter, from a G.J. Monson in St. Paul, Minnesota: "Would you please advise me if Mr. Harnley [sic] was for real or if he was just a 'put on.' If he was 'for real' please also advise where his paintings might be purchased." Whether Mr. or Ms. Monson ever bought one is unknown.

But according to Alan Warshaw, "The memorable Perkins moment was actually Carson's reaction shot. Perkins (being deaf and loud) stepped on Carson's line—talked over Carson. Carson did an incredulous double take look on camera." This was a cardinal sin in the Carson playbook. His absolute rule was to "never lose control of the show." One wonders if, when Perkins drowned him out, Carson looked over at his producer, who during the broadcast would crouch off camera holding up a "'Go to commercial' card when a guest failed to deliver the goods." Perkins later was made well aware of his gaffe. "Carson said that he doesn't like to be up-staged and that I stole the show. Danny Thomas hugged me and said, 'I hope that when I'm your age I'll be as glib and full of energy. The star of [the popular show Rowan and Martin's] 'Laugh-in' shook hands and said 'You were marvelous. Would you like to have a Cameo spot on our show?'" Nothing came of that, since Perkins would have been obliged to pay two hundred and fifty dollars to the Federation of TV Artists—more than he would have received for being on the show. His television career was over.

Nonetheless, Perkins' *Tonight* performance inspired new fans. He commented, "Three months after the Carson show people come into the Ontra almost every day and comment on the incident. I wonder if everyone who appears on a TV show gets such attention? Strange." On one occasion, "Three mature, very handsome ladies came into the Ontra Cafeteria and stood looking at me. They said, 'Is it true that you haven't had sex since 1932?' I verified the statement by saying, 'If anyone has evidence to the contrary I'd be interested in seeing the second party to see if it might be my TYPE.' 'We'd be happy to relieve you of your dilemma,' said the ladies ... The Ontra Cafeterias got a lot of free advertising and a pick-up in business while the poor paintings have been ignored. Irony! The person of the artist as a cafeteria worker got the attention and adulation."

Perkins' turn on the *Tonight Show* also attracted another ardent admirer, Yvonne Kenward, who saw him as a kindred spirit and craved a deeper acquaintance. "My husband and I watched the program," she wrote, "and we both agreed that it is your delightful personality that is infused in your canvasses ... You are a truly unique individual and we rugged individuals should form a club or sumpin'. We are dying out and being replaced by a nation of unimaginative sheep." A "half-hearted artist" herself, Yvonne was keen to have Perkins paint a

precious and "fantastic" chair that she had salvaged from her previous house, "a lovely old replica of a Rhine castle," which the California Division of Highways had plowed under for a new freeway. Perkins never did make a painting of the chair, which was carved all over with "a religious scene . . . depicting monks and penitents," a "lovely pastoral scene of a field with a thatched cottage, men working . . . gathering crops, even dogs running about," plus forest scenes and faces everywhere, "some like gargoyles, some clownlike and some animal-like." She signed off with "Best regards from a new fan!"

Yvonne and her husband Bill, a liquor salesman, were serial castle dwellers, albeit the "castles" were all faux, having been built around Tujunga, California in the early twentieth century. Perhaps living in castles just felt natural to Yvonne, who claimed descent from King Henry II and Alfred the Great, among others, and asserted that she had inherited pieces of furniture from her family in Kilkenny Castle in Ireland, including a "French birdcage with a stuffed songbird that warbled when a handle was cranked, hand-carved royal thrones [like the one she wanted Perkins to immortalize] and a 300-year-old French pewter relief picture." The Kenwards had emigrated to the United States after World War II; they brought along Baron von Zeiglerhoff, a hefty German shepherd once owned by Hitler's notorious henchman Hermann Goering. According to Yvonne, Goering "disliked the dog and sent him to the Bergen-Belsen concentration camp," where an American officer rescued him, "still wearing ID tags and a gold swastika clasp." Another story, though, has it that Baron von Zeiglerhoff had been sent to Bergen-Belsen as a guard dog but failed at the job because of his "benign nature" and "wound up in a pound, where he was found by a young lieutenant." The Baron died in 1964, and Yvonne, then owner of an estate known as the Land of Enchantment, in Altadena, scattered his ashes in the hills.

The Kenwards were between castles and living in a modest North Hollywood bungalow when Yvonne wrote to Perkins in 1971, but the couple would go on to purchase another, which they romantically dubbed Weatherwolde. Purportedly (but not actually) that castle was built for a French count whose wife either jumped or was pushed from an upstairs window during a party. The count then "sold the property to a Dutch couple who disappeared without a trace soon after they moved in. The bank repossessed the house, and [according to Yvonne] the couple who bought it . . . complained that it was haunted by voices with 'thick Dutch accents.'" Perhaps Yvonne gravitated to castles because, as she wrote to Perkins, she had a "castle binge on" because of her unhappy childhood. Her parents had divorced at a time when "divorce was frowned upon." Her John-Barrymore-handsome father was seldom around, but on those rare occasions when he was, Yvonne "entered a fantasy land . . . He would call me his Little Princess and say that I belonged in a castle and for a few hours I soared . . ." Clearly, Yvonne craved a castle—whether on earth or (as seems to have been more often the case) in the air.

Bill Alexander—who had a car—took Perkins to visit Yvonne. She was thrilled. "It was a joyful occasion to finally meet you," she wrote, ". . . you were quiet and I know that when Perkins is quiet, wheels are turning! How I would like to see the scenes that are churning through your brain." It's probably just as well she couldn't, since—judging by her flirtatious tone—the Princess had no idea Perkins was a queen. For a time, the visits and correspondence (with both Bill and Perkins) continued. She dreamed of commissioning Bill to design a miniature castle for her (at the other extreme from Hangover House, presumably), and, in planning an excursion to The Mart, confided that "My husband Bill will come with me on Wednesday afternoon . . . You will wonder how I have kept from hatchet murdering him when you meet him, all is always at peace with Bill, he sees only the side of any situation that is sensible!" To Perkins, she recounted her many woes relating to real estate dealings and her own floundering art ambitions. When the Laguna Festival of Arts began to jury their annual summer exhibition in the mid-1960s, Yvonne and the other spurned artists mounted "noisy protests," with the "rejects" forming picket lines until a concerned businessman offered a vacant lot for a second show if she agreed to stop the picketing. Then there was the complicated debacle that ensued from Yvonne's sale of yet another house, a "charming gingerbread type with a huge sloping roof . . . in a canyon with a running stream which wound under a bridge under the front door." After a heavy rain, that picturesque stream flooded the lower floors of the house, and the new owners launched a hundred-thousand-dollar lawsuit against the hapless sellers for the "attempted murder" of their children. While the case dragged on through the courts, "hippies got into the house and left . . . a beautiful, expensive mess."

Perkins didn't paint Yvonne's majestic carved chair, but he did plan to create a picture of her "pink, oval couch with one of my Bella Flowers on it and the bird cage and old coal oil lamps and baroque bricbrac and geegaws." He may have finished it, but, like Yvonne Kenward, it has vanished. The correspondence breaks off in 1972. It may have continued, but if so, any remaining letters have been lost. Possibly, Yvonne offended Perkins when, in connection with her messy dealings in real estate, she remarked that a salesman for some interested buyers was "a very pushy Jew" who was determined to make her "give in." Perkins himself (as we shall soon see) was not entirely innocent of anti-Semitism, but not long before Yvonne befriended him, he had been in the process of a conversion to Judaism, possibly because he was on the rebound from the collapse of his long involvement with Manly Hall-style mysticism. "Some Jewish friends are trying to convert me," he wrote. "I convert very easily. I've been a Holy Roller, Catholic, Protestant, Theosophist, Rosicrucian, free thinker and non-thinker—So I might as well become a Jew. I've known some pretty swell ones!"

There is no evidence that Perkins' conversion ever came about, but for some time in the late 1960s he attended services at the glamorous Wilshire Boulevard Temple

led by Rabbi Edgar F. Magnin, a.k.a. "Rabbi to the Stars," whose congregation included a critical mass of Hollywood players: studio executives, actors, directors, designers. The 1929 temple itself was (and still is) a grandiose domed building, the interior less churchly than theatrical, evoking the ornate splendor of 1920s Los Angeles movie theaters. In a decided departure from the ancient Jewish prohibition of graven (or visual) images in places of worship, Rabbi Magnin wanted murals, too. The murals (paid for by the three Warner Brothers—Harry, Jack, and Albert) were the work of Hugo Ballin, a trained artist—and the original owner of Rose O'Neill's Castle Carabas—who had made a brief detour into directing silent movies before launching a successful career embellishing grand public buildings. Perkins could not have been unaware of the connection and no doubt relished it.

The Wilshire Boulevard Temple was a fitting venue for the charismatic Rabbi Magnin, who had a home, fittingly, in Beverly Hills and courted both Hollywood Jews and Hollywood gentiles. As author Neal Gabler puts it, Magnin as the "young rabbi in the community . . . solicited dinner invitations from the old moneyed gentile clans to prove that Jews didn't have horns." Perhaps his ruggedness helped: "He looked as if he had been hewn out of a sequoia," writes Gabler. "He was tall, heavy, and shapeless, and he carried himself with the kind of studied gravity that befitted an institution." And he had a golden voice. So powerful a draw was Rabbi Magnin that "Some in Hollywood joked that they would eventually have to reschedule the Friday-night fights rather than compete with him."

Rabbi Magnin was in his late seventies by the time Perkins embraced Judaism, or tried to, attending High Holy Day services at the Wilshire Boulevard Temple and describing the experience as "the most perfect and gratifying . . . I've ever had in a place of worship." Perkins described the rabbi as a "real charmer. He is theatrical but warm and able to speak to you in a human manner. He leans on the lectern, on the woodwork at the left of the ARK, sits down and crosses his legs just like one of the family." Perkins reported on one sermon in which the rabbi "likened the Jew to the Ugly Duckling [in the fairy tale by Hans Christian Andersen] that became a beautiful swan. He inferred that the Jew and God have a mystical union and run the universe as they have done for thousands of years and will do for additional thousands of years. One hour was spent reading the Psalms and prayers telling God what a swell guy he is and asking Him for various favors . . ." Something about all this, unfortunately, triggered a latent streak of anti-Semitism. In one breath, Perkins praised Rabbi Magnin's greatness as a civic leader and a powerful intellectual. Yet in the next breath, the sermon—or perhaps the rabbi's "defensive" response to a question afterwards—put Perkins in mind of "Shylock's whining." And in the next, he swore that his career had been "made possible by Jews and no others."

I can't make excuses for Perkins, and such comments make me almost not like him, or that part of him anyway, were it not for the fact that—as with so many

other dimensions of the past—reflexive anti-Semitism was at that time pervasive and even acceptable: it was "normal," just as it was "normal" in the South (and just about everywhere else in America, actually) to consider African-Americans inferior to white people. One would imagine, or hope, that Perkins' own outsider status might have modified his bipolar attitude toward Jews, but that seems to not to have been the case, or at least, not all the time. Somehow with Perkins (as with many I remember from my early days growing up in an Irish Catholic family), it took little effort and less thought to be simultaneously grateful to, and for, his Jewish friends and benefactors (supreme among them Alexander King) and yet still feel no compunction putting them down for whatever stereotyped traits marked them as Different. As Perkins ended that paragraph of praise and prejudice: "SO." In other words, that was how it was, and we can't time-travel back to erase it. For whatever reason, though, Perkins' flirtation with Judaism was brief; soon he would move on once again to his first and lasting love: death and all its trappings.

For many, many years, Perkins' routine has been dictated by the rhythms (and occasional raptures) of his Ontra job and Ontra family, his dabbling in, and disillusions with, various religions, and his friendships with fellow oddballs. But since moving to Los Angeles from New York in 1943, he had traveled no further than San Francisco. The Sun Gallery show, however, put money into his hands: for the first time, he was flush with cash. Perkins used the proceeds for the first of his seven trips abroad in 1970; he crossed the Atlantic again in 1971, 1973 (twice), 1974, 1975, and, finally setting out in a new direction, traveled to South America in 1977. Except for the Sun Gallery windfall, he financed his trips largely by putting aside some of his salary to save up for them. Perkins homed in on monuments and cemeteries wherever he roamed, critiquing them on occasion. He traveled to the Soviet Union expressly to see the disappointing remains of Vladimir Lenin in the Kremlin. Young soldiers with guns stood around the elaborate glass coffin, he remembered; Lenin, in a blue serge suit, was better-looking than in photographs taken when he was alive, albeit the body looked more like a wax effigy than organic remains. Elsewhere, Perkins made a memorandum of the Lenin embalming process: "tissue deeply cut in numerous places and steeped in a solution of glycerin, formalin, and potassium acetate, a hygroscopic or moisture absorbing salt, and paraffin wax." Queen Victoria's tomb at Frogmore, however, was an unexpected pleasure. Perkins had tried three times to see it, only to learn (rather slowly, it would seem) that it was open once a year, on Victoria's birthday. He had expected something campy, he said, but the mausoleum was purely classical, and Victoria's effigy represented a very young woman rather than the "old, fat mess that we know."

Occasionally Perkins made something of a mess himself. In Granada, Spain, he tried to find laurel branches for a wreath that an acquaintance had asked Perkins lay on the tomb of Columbus' patron, Queen Isabella. Failing to find

laurel branches at the local flower markets, he bought some mulberry branches instead and bent the twigs into the semblance of a wreath, not removing all the silkworms because it was getting late, and the Royal Chapel was soon to close for siesta. The iron-barred crypt being inaccessible, Perkins decided instead to "place the wreath against the bronze fence that surrounds Isabella's cenotaph, a large, very fancy alabaster monstrosity." Perkins recruited a boy to take his photograph while depositing the wreath, using Perkins' own Kodak Hawkeye camera. (This explains all those photographs of Perkins at all those different ports of call: in the pre-selfie era, he simply solicited other people to do him the favor.) Just as Perkins was posing and the boy readying the camera, the twine on the mulberry branches came loose, and "the twigs sprung open, scattering worms all over the floor. A big bunch of tourists with guide was entering the chapel. The attendants were scurrying around scooping up the worms . . . A good thing I don't understand Spanish!"

Perkins paying a call on Luis Angel Firpo at the famed boxer's resting place, La Recoleta Cemetery, Buenos Aires

In Buenos Aires during his final trip out of the country, Perkins had better luck. The Recoleta Cemetery, crammed with the famous and well-to-do in private mausoleums, was posh indeed: crusted with "outlandish sculptural ornamentation, the structures had glass doors, marble shelves, and elegantly formed hardware." Most of the "finer ones" had "regular porter or maid service, dusting, mopping, window washing and linen change." Then there was Firpo in his bathrobe, and the tomb of the dictator's wife Eva Peron, banked with carnations brought by weeping fans. But the crowning pleasure was the lying-in-state of "some handsome middle-aged man whose family sat on one side of the bier," which was covered in mounds of red and white carnations and surrounded by six tall candles. "The face of the deceased was exposed under glass," Perkins wrote. "He was made up slightly and had very heavy eyelashes and hair dressed perfectly. I looked at his dead face a long time. No one objected." Then the coffin was wheeled away; Perkins managed to take a

photograph, one of some eighty "good clear photos" documenting the Recoleta and the Cemeterio General de Santiago, Chile.

Ever the connoisseur of dead bodies, Perkins was highly critical of the conquistador Pizarro's mummy in the Cathedral of Lima. It was "so desiccated that it should be concealed back of a marble slab," he sniffed. "The poor old dried up mummy falling to pieces is in bad taste. It's like showing George Washington in his present state." Fortunately for good taste and the historical record, soon after Perkins left Lima for the next port of call, workers at the cathedral discovered several long-forgotten coffins in an old crypt; in one of them were Pizarro's real skull and bones. The anonymous mummy was hustled away and the conquistador's unsightly disarticulated skeleton and sword-gashed skull boxed up and properly enshrined in the same glass coffin that for so many centuries had sheltered the wrong body.

If it didn't actually disintegrate, Perkins' own body gave out in multiple ways during the trip, and he was forced to cut his schedule short. He had had enough of travel; his senses were worn out; he was jaded and bored; the thought of an airplane made him sick, and the trays of "uneatable grub" on planes turned his stomach. "In other words I've HAD IT. There are no more graveyards to investigate. I've got THAT out of my system at last," he wrote. Despite his ills, Perkins returned to the Ontra. By the following year, though, arthritis had made walking so painful that he tried to quit, only to find that his boss "would not let me go." Instead, "The Company made a job for me, peeling carrots, chopping cabbage, making cole slaw dressing, peeling onions, cleaning celery, cleaning melons, slicing radishes (yelling like hell at the garbage man), dicing turnips, chopping scallions and passing along dirty stories containing no references to raw vegetables." When his health took a turn for the worse early in 1984, Perkins seems to have taken sick leave with the intention of going back to work once he was able. His boss sent a reassuring letter: "Can't tell you just how much we miss you around here . . . and we're looking forward to your return . . . Don't worry about your position. It will always be open for you. So concentrate on getting well. We need you." Somehow, Perkins had become an Ontra institution. This time, though, after thirty-seven years, he was out for good.

Aside from his exhibitions—one of them in London, which brought fresh rounds of adulation and gratification—and his adventures abroad, Perkins' life thus still revolved around his Ontra "family," cultural excursions, and networks of old and new friends. Among his cultural excursions (so to speak) were visits to the home of his niece Boots, who maintained a "palatial mansion on Sugar Hill" in Los Angeles. Although Perkins had cut his family ties absolutely, he seems to have made an exception in the case of Boots, "a kept Lesbian who lives with her lover Gwen, a negress, president of the Sheet Metal Workers Union of So. Calif." Gwen in turn was the lover of Betty, "a ravishing Blonde ex-Reno show girl, who is built

like a whole row of brick relief stations with every brick in place." In their "bastard Georgian" house, the threesome slept together in a vast king-size bed, with a white telephone for Boots and Betty and a black one for Gwen. Perkins attended a garden party there with a dozen or so hard-drinking but "ladylike" lesbians.

Out of his element, Perkins was curious about just what gay women did with each other and got an earful after "Ming, the hostesses' half Spitz and half Pekingese dragged a yellow foam rubber Dildo out of the house and hid it under my garden seat. No one was embarrassed." Indeed, the girls promptly explained just how such a toy was to be used. Perkins averred that of course he'd read books, heard dirty stories, and talked about such things, but "when actually faced with them I felt decidedly Puritanical and inwardly outraged." Apparently he was treated to an actual demonstration rather than an abstract exposition. It was as bad as coming upon one's parents performing the act. "Well, seeing a big, yellow rubber dick and a pair of balls with a sort of harness attached," he wrote, "affected me disturbingly much as I felt the first time I saw a human body embalmed." And there was yet more to come. Perkins noticed that there were phones scattered throughout the house. Boots on the drive back to Culver City told him "everything. It is a Lesbian Call House," he wrote. "They supply all of Los Angeles with queer girls for other Lesbians. They charge a pretty penny and the police are not on to the racket . . . That is how the ladies can live in a hundred thousand buck layout."

Perkins also had a brush with fame, sex, obscenity, and the Beat Generation. In January 1968, he reported to Margie King that "A dirty show opened here the other night and the place was raided, the producer and actors were arrested. 'The Beard' was the offender. Jean Harlow and Billy the Kid were the characters. They simulated a sex act in a huge platter hand with a spot light from the theater ceiling." This was poet and novelist Michael McClure's play, which (like Mae West's long-ago play, *The Drag*) had stirred up such controversy (along with various raids and legal actions) in San Francisco that it became counterproductive if not impossible to perform it there. McClure, who fraternized with the likes of the great Beat poet Allen Ginsberg and the Doors' front man Jim Morrison, claimed that Jean Harlow and Billy the Kid had appeared at the foot of his bed one night and acted out the entire play, leaving it to him to transcribe. Instantly notorious, *The Beard* was set in eternity—symbolized by dark blue velvet hangings—where the sultry platinum-blonde movie star and the outlaw gunslinger, who died long before Harlow was born, spar verbally on the nature of life, desire, and death before finally performing, or rather simulating, the scandalous act that brought down the house and the wrath of the law. McClure claimed that *The Beard* was a theatrical exploration of his "Meat Politics" theory that—as Billy the Kid asserts—all humans are bags of meat, which can hardly be denied. McClure elaborated on the subject in his *Meat Science Essays* (1963). At any rate, Harlow and The Kid both sport wispy little beards fashioned from

strips of toilet paper, hence the title of the play. Whether the show was tantric, tedious, or obscene was up to the individual audience member, but the Los Angeles police, acting only on the "obscene" bits, regularly raided the production at curtain time.

Perkins adored *The Beard* and couldn't stay away. He saw it every two weeks over four months, and "one rainy night" saw it twice. The allure may have stemmed in part from Perkins' fleeting infatuation with the leading (and only) man, the actor Richard Bright, who would later appear as the thug Al Neri in all three of *The Godfather* movies, the high point undoubtedly being Neri's murder of the pusillanimous Fredo Corleone in a fishing boat on Lake Tahoe. Perkins managed to strike up an acquaintance with Bright but found the star cold and impersonal. He fared better with Bob Barrow, the play's producer, who went "stark raving nuts" about the artist's work and put twenty-two of his new paintings on exhibit, presumably at the theater; there is no record of this show except in Perkins' letters. In appreciation, Perkins gave Barrow a painting of *The Beard*, which as he described it depicted a "merman making improper love to a lady lying in a seashell while God above is angrily brandishing a big club and lightning is flashing out of his halo in all directions." Perkins made a copy, replacing the woman with a "white marble Venus torso," that is, without head, arms, or legs; the merman is busy applying his tongue to her crotch while Perkins' oft-seen Cupids flutter around with a coiling strip of red drapery. The real joke, though, is the angry God above, whose enormous beard streams out in one direction, balanced in the other by an equally enormous club that the deity hefts in preparation for smiting the sinners below.

This was a moment when nearly anything went as far as costume was concerned, at least for young people, who adopted romantic Victorian styles, dandified military outfits, and Buffalo Bill fringed jackets, among an infinitude of countercultural looks. Perkins may have been just that much older and set in his ways that the new permissible sartorial eclecticism was simply too far out. There is no evidence that he continued regularly to don drag in later years. He did, however, take extraordinary pains with his appearance on any festive occasion. In 1967 he attended a concert at the new (in 1964) Dorothy Chandler pavilion, "a place of sheer magic enchantment," as he enthused. There were peach-colored fountains shooting great jets of spray, crystal chandeliers and tapestries, and an Elsie de Wolfe room with Tony Duquette's models of famous opera settings. For such a special occasion, he wore his "new hundred dollar grey silk suit [a hand-me-down from his boss, whom it no longer fit], yellow shirt, blue tie, hundred and twenty five dollar shoes (handmade) and a <u>blue rinse</u>." In a sense, this guise too was a *dis*guise, just like drag per se: the gray suit, with its Shantung-like texture and pinstripes, was eminently suitable for "a conservative old man." And of course, thanks to Elsie de Wolfe, blue rinses were coded female.

The "conservative old man" was still colorful and weird enough to attract local human-interest reporters. In 1980, Norma Meyer, a columnist for *The Daily Breeze*, interviewed Perkins, who obligingly rolled out his much-rehearsed stories: his necrophilia, his humble room and humble job, his fleeting moments of fame on the Johnny Carson show, his art career. But Meyer cautioned readers not to "let that face of a gentle Midwestern farmer" fool them. "Harnly is a semi-reclusive eccentric with a booming laugh as stunning as the life he's led." Then came the kicker: "That youthful, mischievous face is not exactly his . . . Three months ago, for medical and not cosmetic reasons, Harnly had a facelift. 'Cost $6,312.80,' he announced. 'I had the same doctor who did Liberace's.'" Perkins may not have wanted to appear vain or superficial, but given that there seem to have been no significant *medical* reasons for the operation, that leaves vanity. When I first got wind of the facelift, I wrote it off as another Perkins tall tale. But then I found the bill from Santa Monica Hospital in exactly the amount quoted. He really did have one. And he wrote about it himself in a typescript that may have been a pitch to get a slot in the *Today Show* lineup. If so, it failed.

Perkins suggested that a sixty-five-year-old friend's successful facelift outcome put the idea in his head, even though previously "It had never occurred to me to tickle my ego in such a manner." The doctor at Santa Monica Hospital briefed Perkins on the procedure and asked if the patient wanted to think it over. Perkins replied: "NO . . . I'd like to get rid of this turkey gobbler wattle under my chin and the gopher-like cheeks." The wattles in particular were so obtrusive, he claimed, that when he shaved he had to hold them taut with clothespins. Perkins loved the results: "I had been a cemetery candidate morally and the cosmetic surgery raised my morale sky-high. Ladies who had been mere acquaintances became more personal. They seemed to like smooth cheeks. Now, I'm doing my hay-making while the sun is out." Doubtless there was little hay to make as far as ladies were concerned. But the operation was worth every penny; Perkins paid the hefty bill with his "vacation dough." "After seeing Mae West's under-chin area," he stated, "I feel confident that such an improvement is well worth giving up Europe," though of course he had already decided against undertaking any more trips abroad. In any case, and all unwittingly, he dialed the facial clock back in the nick of time: not long after, he fell in with the group of young people who would become his last family. They probably would have adopted him even with the old turkey neck, but looking even a little younger added to the contentment and security of those final years.

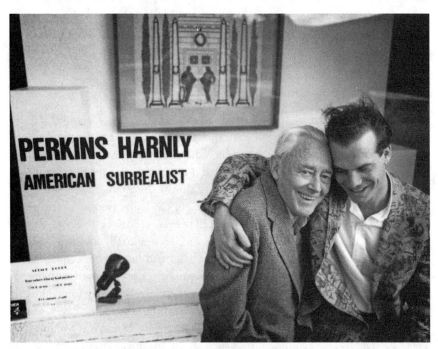

Bill Paxton hugging Perkins at his last-hurrah Attack Gallery exhibition

Such a Sly Old Man

I T IS THE EVENING OF JANUARY 18, 1985. AT THE Attack Gallery in Los Angeles, there is an opening for the exhibition *Perkins Harnly: American Surrealist*. It is Perkins' last show; he is eighty-four years old, and he has approximately one year and seven months to go before he finally discovers what lies on the other side of life. His young friend, artist and writer Tom Huckabee, is filming the occasion and querying attendees about which artwork is their favorite. One youthful fellow enthuses about a still life of sorts that centers on a wide-open six-petaled pink flower in a bed of lush green leaves. Symmetrically arranged on either side are two hands—with eyes embedded in the palms—ceremonially directing our attention to the hairy and obviously vaginal opening that has replaced the bloom's stamens and pistils. "He's such a sly old man," says the visitor, who proceeds to walk up close and jokingly aim his tongue at the blossom, which, fortunately, is under glass.

The gallery is jammed with young people, some vaguely punkish, all sporting bushy eighties hair; everyone is drinking, talking, and marveling at the outlandish fantasies on the walls. Perkins is there, wearing a neat tweed jacket and sweater vest; he has a strand of long white hair flopping over his brow and a somewhat bewildered but happy expression. The facelift has held up well: though clearly worn out, he looks considerably younger than his years. Friends enter and leave while Tom rolls the film. Suddenly there is Bill Alexander, now a dashing old gentleman with becomingly tousled hair and a voluminous ascot. He boasts that he and Perkins go back sixty years. Perkins studiously ignores him; they have had a falling-out over money. A few minutes later, Henry Warshaw, big, bearded, and bearish, comes over and gives Perkins a hearty hug; now Perkins is all smiles— smiles that only broaden when Bill Paxton, looking debonaire in a snazzy jacket, enfolds him in an affectionate embrace.

There is another video documenting Perkins' birthday party three months earlier. It is at the home of Tom and his wife, Barbara Cohen—both aspiring to Hollywood fame and fortune—who have taken Perkins in and nursed him after his recovery from a prostate operation. Several jolly young women are setting up tea and pastries in the dining room. Perkins is led to the place of honor—the middle of a squashy pink sofa in the living room—and various larger, younger friends arrive to sit and squeeze him in, or hold him up, on either side. The old man, in a plaid shirt and suspenders, looks small, frail, and considerably confused. His face lights up when handsome, genial Bill Paxton comes in and affectionately throws his arm around him. But then the equally handsome, genial Phil Granger

arrives, and Perkins' face lights up even more. Phil joins him on the pink sofa, and the two cuddle close while Perkins plays with a strand of the young man's hair, holds his hand, and looks into his eyes with what can only be described as adoration. Along with Rocky Schenck (now a famed Hollywood photographer and movie maker), these young people make up Perkins' last remaining family. Ill health has finally forced him to quit his job—though not before his previous birthday, when everyone at the Ontra hugged and kissed him.

Perkins owed this late-life happiness to Alla Nazimova's *Salomé*, which in an utterly fortuitous way completed the circle of his Hollywood years, early and late, very young and very old. I will let Tom Huckabee tell the tale. "[Perkins] first entered our lives in 1981 [1980 actually], after our friend Rocky met him on line at the Silent Movie Theater in Hollywood. They were both there to see the avant-garde rarity, *Salomé* . . . Rocky initiated the conversation, asking the little old man in the bow tie if he'd seen the film before. 'I should say so!' boasted Perkins, 'I was at the premiere in 1923! And I've wanted to see it again ever since!'" Fledgling actor Bill Paxton was there, too; the three ended up sitting together, and after the movie, the young men, on discovering that Perkins had only a bus pass, drove him back to the Culver Hotel. Thus began Perkins' late star turn among friends more than half a century younger. Among Perkins' flotsam and jetsam of papers, there is a Xeroxed image of Nazimova as Salomé, her body wound about with pearls, and topped off by an extravagant showgirl plumed headdress. On it, Rocky wrote in green marker, "'Our Divine Catalyst'/ Supreme Saint Nazimova/Long may she inspire!"

From that time on, Perkins served as the pet of this loosely woven group of Hollywood hopefuls just launching their careers. In the various videos that Tom and Bill Paxton made, we see him being the improbable life of the party. Women smile and coo over him; men hug him and collapse in fits of laughter when he spouts a dirty limerick or tells a raunchy story. Before meeting Perkins, no doubt the oldest people they had anything to do with were respectable grandparents; they had no idea that ancient fossils could have had such wild adventures and such kinky sexual escapades. Tom and friends made audiotapes, too, which are abundant founts of information (or, as so often with Perkins, misinformation); in them, Perkins tells and re-tells many of the stories that I've recounted throughout this narrative; he also tells some whoppers, as when he asserts that he was at one point in charge of Walt Disney Productions. He covers his whole life story many times and repeats many episodes, with variations, starting with his cross-eyed Nebraska uncles and the temperamental windmill on the family farm that required elaborate all-hands-on-deck measures to get it running. The young people egg him on.

Perkins falls madly in love with Bill Paxton, sending him letters by the ream, calling him "dear love" and declaring, "You'll never know how much you mean to P." As we've seen, they visit Buster Keaton's grave—more than once—and go on

various other excursions together. Perkins has a Polaroid camera, which he uses to take a few photographs of Bill in the nude, purportedly to serve as a model for a figure Perkins wants to put in one of his paintings. For he is making paintings again, prolifically, and giving them in gratitude to everyone in the gang. He tells Bill that it is all because of him: "You and your inspiration caused me to resume my painting after I'd given up." The paintings are mostly reworkings of Perkins' old themes; most of them have a fat queen/Bella Flower figure on a chaise longue amidst a welter of Victorian accessories, or they feature groups of frolicking whores; they are comical and bawdy and still technically refined, but in a certain sense they make one think of leftovers that have been reheated once too often.

There is a significant exception, though: Perkins made what he termed a "Beyond Poe" painting for Bill Paxton, who had somehow seen and admired Perkins' WPA-era nocturnal cityscape at the Metropolitan Museum of Art; the new work, Perkins said, was meant as a companion piece. The setting is a nocturnal graveyard; there are obelisks, sarcophagi, headstones, and a white-sheeted ghost. On the ground lies a skinny young man, nude, with an impressive erection; he is sucking a phallic coffin handle as if it were a Popsicle. In the foreground, an imposing urn on a pedestal leaks blood, which spills into a tall goblet below. The goblet overflows in turn, creating a gory puddle on the ground. Perkins explained that he had taken ideas from "Kraft Ebbing, Froid [sic] and the other guy who deals in Death and Sexualis. Bill is going to shit when he sees the new one." Perhaps Bill did, because he gave the painting away, claiming that it scared him. (To date, it has not surfaced.)

Phil Granger took Bill's place in Perkins' heart after Bill became increasingly involved with his British girlfriend Louise, who would later become his wife. "Phil has been my ever loving companion, having began [sic] where Bill left off . . . [we] get along like a clean kid and a worn out whore," he wrote. "It isn't hard for this old strumpet to fall in love all over again." Like all of Perkins' new young friends, Phil was kind, affectionate, and attentive, taking him to plays, parties, and movies and voluntarily tackling a refurbishment of the old man's Culver Hotel room, transforming it from a "hog wallow" to a "paradise," working his "marbles off making for a rich snuggery." As so often happened with Perkins' idols, though, Phil was fundamentally unattainable: "For the past 3 years I've concentrated all my attention upon these kids: Rocky and Phil disgustingly normal guys, all girl crazy, and wife and mistress crazy, leaving this poor old mess out in the cold."

But if his erotic life sustained itself only in fantasy, the poor old mess had one supremely rewarding (if modest) artistic triumph to savor. It was all because of Joseph Cornell. In 1979 Lynda Roscoe Hartigan, a curator at the Smithsonian's National Museum of American Art, was in her fourth year of intensive research on the artist. She had seen Perkins' name on the Levy Gallery's publicity for that long-ago exhibition when Perkins made his professional debut alongside

Cornell. After many dead ends, Hartigan finally stumbled upon Perkins' contact information. She wrote to him, asking if he remembered the year of the Levy show, and if he could tell her more about the exhibition, its size, scope, installation, and "the kind and extent of the Cornell objects" that were included. He did, and, at Hartigan's invitation, he also sent her a summary of his own career, complete with photographs of work, for the NCFA research files. Eventually Hartigan went over to the National Gallery of Art to examine Perkins' Index of American Design watercolors, which she praised in most extravagant terms, telling Perkins of the "resounding pleasure" they had given her and showering them with adjectives: "vibrant, dynamic, jewel-like, sumptuous, masterly, shrewd, captivating . . ." Flattered—not surprisingly—Perkins responded with elation, telling Hartigan that her "extravagant group of glittering adjectives will be incised on my incineral urn. If there's enough room." A sporadic but steady exchange of letters ensued, Perkins regaling (and apparently beguiling) Hartigan with anecdotes and salty opinions. Ultimately, Hartigan was inspired to organize an exhibition of selected Index paintings. The opening, coincidentally, fell on Perkins' birthday.

Hartigan exerted all her powers of persuasion to get Perkins to Washington for the event, but at first the ex-world-traveler refused, adamantly: "such a monstrous undertaking on my part is absolutely out of the question." He was too old and lame, he said. He had traumatic memories of flying; he had suffered a near-fatal attack of kidney trouble on a plane and now dreaded the mere mention of air travel. At that point, Bill Paxton intervened, using his "hypnotic" powers to change the old man's mind. It was a bit of a bait-and-switch: initially Bill had agreed to accompany Perkins (which was no doubt a huge inducement to make the journey) but bowed out when he was offered a role in a new movie. The "old bag of bones" had to transport himself across America.

If Perkins ever had an apotheosis, the opening party was surely it. Photographs show Perkins, wearing a suit and his signature bow tie, beaming next to the introductory wall text describing him as "perhaps the most imaginative and unique" artist to work for the Index; in another, Lynda Roscoe Hartigan cups his elbow with a friendly hand as he gazes down onto an array of ephemera including the brochure from the "I Remember That" exhibition at the Metropolitan Museum of Art; in another, he contemplates his rendering of the Baroness D'Erlanger's famously untidy bedroom. In yet another, he encounters—for the first time in forty years or more—the art historian Marchal Landgren, who once upon a time had taken Don Forbes to the tea dance where Don first met Rose O'Neill, and who had walked New York's deserted nighttime streets with him, crossing one of the bridges over the East River and sitting for hours at the end of a dock. Landgren's papers in the Archives of American Art include a photograph of him as a young man; he is dark and handsome (and tall, as we see in the 1981 photograph, looming over Perkins). Now, he looks ancient and autocratic, his once darkly swooping eyebrows faded

*Perkins and his very old pal Marchal Landgren
at the opening of Perkins' National Museum of
American Art exhibition, October 15, 1981*

and thin, his hair, once dark and abundant, now faded, sparse, and flat. Thanks to the facelift, Perkins looks younger, though he is actually six years older. It is hard to tell if Marchal is glad to see Perkins, even when—in yet another photograph—Perkins, as ever grinning madly, poses with one arm flung about his old acquaintance's shoulders, while Marchal, with a tight little half-smile, gazes down inscrutably, as if wondering how long this will go on.

The Washington Post reviewed Perkins' exhibition, finding the work "Funny, Fanciful and Fantastic," but much of the copy was about Perkins, who obligingly furnished details of his colorful past in an interview. Perhaps the most revealing quip was his characterization of the painting process: it was like "pulling a cork and letting the champagne fizz all over." There was a catalogue, too, featuring Hartigan's essay on Perkins, his art, and his life and times, the latter based on information he had supplied—selectively: he told Bill Paxton that it was "a fairly accurate sketch of my life a few pages missing, of course." While Perkins was in Washington, Hartigan also arranged to take an oral history with him for the Archives of American Art. The interview is long and detailed, but the same few— or more—pages are missing from that, too. Depending on the company he kept, Perkins knew how to edit himself. After the opening, Hartigan and her colleague Virginia Mecklenburg took Perkins to a café for refreshments. "Sitting at the tables we started talking dirty. Lynda told of a girl who put a cundrum [sic] on the Washington Monument. They egged me on to entertain them with my usual bawdy repartee. I was too modest and shy to shock them . . ." After returning to Culver City, Perkins telegraphed a dozen and a half yellow roses as an expression of gratitude to "the girls" who had made his modest triumph and his trip to the "magic classical city" possible.

The old bag of bones returned to Culver City and his vegetable-peeling shift at the Ontra. He kept up a scattered correspondence with Hartigan, writing

on New Year's Day, 1984, that his "lame rheumatic leg" was bearable and he was still going to work "as usual." Two months later, Henry Warshaw wrote to Hartigan, informing her that Perkins was ill; he had been found in his room by Bill Paxton and Rocky Schenck and taken to the home of Tom Huckabee and Barbara Cohen. "He wants to go back to his room and back to work," Henry told her. "I think his working days are over." A few weeks later, Perkins collapsed in the street. Henry wrote to Hartigan once more: "I saw his doctors this morning and he is having heart, kidney and prostate problems. Surgery is indicated for the prostate but they are not sure he can handle it." Perkins' working days were indeed over. Tom and Barbara, with extraordinary kindness, took him in and cared for him after the operation.

Tom cleaned out Perkins' storage locker at the Culver Hotel, and Henry busied himself trying, as always, to find a gallery for another Perkins exhibition. A couple of years earlier, he had badgered Bill Alexander on the phone in an effort to track down Perkins' many scattered paintings. Henry jotted down some notes of the conversation. To paraphrase: Bill had stored his Perkins things in the back of the old shop on Santa Monica Boulevard. Some of them got water-soaked and destroyed. Bill didn't know they were getting rained on. He never took money from Perkins. The ungratitude of Perkins. Would like to be helpful. Perkins' "ungratitude" had developed because he felt Bill was holding out on what he owed from whatever sales he had made on Perkins' behalf. That, it seems, may have been the reason Perkins snubbed his erstwhile long-term friend at his very last opening.

While Perkins recuperated, Tom and Bill Paxton recorded those audio and videotapes that are now such indispensable sources of information. But they also show Perkins in decline. Tom and Bill did two lengthy video interviews in which they dressed him up in a dinner jacket and positioned him before stagey drapes, red on one occasion, green on the next. During the red-curtain setup, also filmed, Tom says that this is the "I Love Perkins Show." They gently lower him onto the chair and ask if he wants lipstick—no—false eyelashes—no. What does he want? "Just dick!" he says emphatically. It is hard not to suppose that Perkins' answer is part of the act he put on for his young friends, that of a shockingly dirty old man. In the green-curtain interview, Perkins seems bewildered and exhausted. His hair is disheveled. He relates a far-fetched anecdote about how he once brought the malfunctioning windmill from the Nebraska family farm to New York; Tom exclaims, "You really weave a wild tale, buddy!" In both the audio and videotapes, Perkins is by turns long-winded but coherent—these are stories he's told scores of times, maybe hundreds—and at other times simply rambles nonsensically as if plucking memories, or fantasies, at random from a jumbled mental heap. He even professes a very belated affection for his hapless family, saying that he loved them all, long ago. In one tape, Tom has to go off on an errand but urges Perkins to keep talking, which he does, but after a few minutes he runs out of steam, tapers

off, and then sits silent, not knowing how to stop the recorder. Birds can be heard twittering outside. Perkins mutters that he doesn't think he can do this anymore.

Probably the most affecting of all the tapes is Tom's video recording of Perkins after the prostate operation. Tom and Barbara have made up a narrow bed in what is obviously a home office; there are file boxes on shelves, books, and Tom's drawings and paintings on the walls. Tom trains the camera through the open door at Perkins lying motionless under the covers, eyes closed, looking for all the world like a man who is already dead. Perkins wakes up; Tom zooms in, asks him how he feels. Perkins says he feels like a "million dollars" and chuckles weakly, perhaps with a dash of irony, since he clearly feels like nothing of the sort. They chat. Perkins misses Barbara, who has been so kind. Eventually he sits up to pull on his pajamas and get out of bed; he gets the catheter cord hopelessly entangled with the bottoms and has to start over. He chortles helplessly as he fumbles with cloth and tubing. "I don't want you to see my dick," he mutters. Fade to black.

Perkins repaid the kindness of his young friends with art, gratitude, and unconditional love. He showered them with his paintings and even drew up an official document transferring ownership of several works to Bill Paxton. He unstintingly adored and admired Tom, Bill, Phil, and Rocky. On one of the audiotapes, Perkins drops his mask momentarily and soliloquizes about the "kids" who have taken him in: "Without them I would have died," he muses. "I was dying when the kids picked me up . . . I didn't know I *was* so low." He couldn't work at the Ontra anymore, he couldn't walk, he had no stamina. The "kids" had given him a new lease on life, treating him with tenderness and care. Many of Perkins' letters from his last years are addressed, collectively, to "Dear Kids," as if his young saviors were indeed his own children, or grandchildren.

Finally, as Perkins steadily declined, the young people could no longer give him proper care. He spent the last short years of his life in nursing homes, dying on August 10, 1986. His body was cremated at a mortuary in Westwood but he was never interred anywhere, at least not in the conventional way. He had left a directive that his ashes should simply be thrown into the garbage, but, as Tom Huckabee writes, he and the other "kids" couldn't bring themselves to it. Instead, they placed the ashes in that "bronze urn, bearing his name, which he had purchased years before but had decided not to use." Tom thinks that Perkins' desire to go out with the trash was a "final act of vanity, since he wasn't able to afford the memorial he really wanted": a "small pond with a Roman column and his urn sitting on top," ideally to be located at "his beloved Forest Lawn Cemetery," where he had gone countless times to commune with dead movie stars. The "kids" held an informal wake, watching videos, telling stories, and distributing "paper bags of the ashes to anyone who wanted them—after tossing a token spoonful in the trash." Rocky Schenck recalls, "I was initially mortified at the wake, when they started doling out Perkins' ashes. But when people who barely knew him took out

scoops, I got in line. I've been living with my portion of Perkins Harnly for many years now."

But there was still plenty left in the urn, and, many years later, Tom set about creating—or at least approximating with the means at hand—Perkins' wished-for memorial in the grassy back yard of his home in Fort Worth, Texas. The urn, inscribed with Perkins' name and dates, is a dead ringer for the one in Perkins' "beyond Poe" painting. It sits in a birdbath, which rests in turn in a wide, shallow ceramic basin: he finally has his pond if not the classical column he had envisioned. It is not just the Perkins memorial, though. In 2017, at age sixty-one, Bill Paxton died of complications from surgery. Tom created a Paxton memorial bench for the garden, the seat a slab of concrete embedded with two film reels; the back yard—filled with an array of other sculptures—is now, officially, the Bill and J.L. Paxton Memorial Sculpture Garden and Contemplation Center. The urn and the bench stand only a few feet apart. At least here, Perkins and Bill are together, for the foreseeable future.

Perkins' urn in Tom Huckabee's sculpture garden, Fort Worth, Texas, 2020. Not far away is Tom's memorial to his dear friend and Perkins' idol, Bill Paxton

But we still need to end the story. Perkins was the subject and star of another movie, undertaken about 1976 by Ramon Caballero, a young film editor and aspiring director at MGM. His aim was to unfurl Perkins' life from the beginning. Ramon filmed him at the Ontra, at the Culver Hotel, and, of course, in cemeteries. Ramon says that on his visits to the Culver Hotel, Perkins would close his eyes and embark on an open-ended and potentially endless monologue, talking and talking and talking some more while his white curtains billowed in the breeze from the open windows. There was a script of some sort, but Perkins was stubbornly resistant to taking direction; ultimately, Ramon could only roll film to capture whatever his star was doing. For the cemetery scenes, Perkins made a full-size angel out of poster board and would dance around the headstones and monuments with it.

Ramon never shot the ending sequence, which would have been a plunge into pure Gothic fantasy, or comedy. It could happen as follows, he wrote: "Scene fades up to long hallway without end. Countless doors lined evenly on both sides disappear in perspective. At the end of the hall—well dressed man walks toward camera accompanied by the distant sound of funerary music. His narration might say: 'We're at the great *Futurium* in Monument Valley to witness the burial or interment of Harnly the Innocent.' The designated narrator would then appear and walk through a door opening to "a small room . . . appointed in 21 century motel. There on the twin bed lies the 'Harnly' with arms crossed, a dirty black suit and bow tie. As we move around the bed to gain a clearer view of the corpse . . . we can hear the faint but clear sound of supermarket music coming from Harnly's ear-phone radio headset." The Ontra help come in to "gawk at the cheerful dead, they begin to cry and weep." Their tears in turn short-circuit the headset and start a fire, which the narrator smothers with a pillow. Finally, there is a dissolve to "spectators on an observation deck looking through coin operated telescopes . . . we hear them say: 'Is it really a motel for the dead?'" It's hard to imagine a better sendoff.

Epilogue/Epitaph

BUT WE STILL NEED TO SEE PERKINS OUT IN STYLE— his style. Perkins imagined his own death and burial many times, possibly since the day his grandmother took him to his first cemetery. Yet in his own visual sendups on death and burial, he avoided any hint of the morbid or maudlin. Indeed, if anyone could make death jokes, Perkins was the man: he was the queen of graveyard comedy. It was Albert Lewin who gave Perkins the opportunity to realize his mordant funereal fantasies when he commissioned the artist to augment the original work he had done for the Index of American Design. Along with the various cocktail lounges, hotel lobbies, and iron foundries he produced for Lewin, Perkins explored the material culture of funeral parlors and monument manufactories in three sharply focused tableaux that take us on a paradoxically lighthearted tour of the entire industry.

Although there seems to be no specific sequence to the three scenes, the *Garage of a Funeral Parlor, 1917* is a logical starting point, since it ushers us into the back stage of the undertaker's art. Indeed, the *Garage* itemizes the tools of the trade with scrupulous care. There are candlesticks, flower baskets, a perforated cooling board, a candlestick telephone and city map, a hammer, a sawhorse set, a gleaming silver hearse, and a purple wreath with a black ribbon inscribed with the letters "IOOF," denoting the International Order of Odd Fellows. Several types of coffins are on view, including—with characteristic Perkins orthography—the "Baker Burgler Proof Grave Vault." Perhaps whoever purchases it will also want a "Coffin Linning" from the box stored overhead on a rack which also holds a stained-glass window waiting, presumably, for an opening. One of the coffins, fashioned of woven wicker, resembles a very large elongated basket. Invented in the mid-nineteenth century, wicker coffins of this sort were touted as a way for bodies to return quickly and organically to the earth rather than be hermetically and unproductively sealed in a vault. They were promoted in England by Sir Frances Haden, a surgeon and amateur etcher better known as the brother-in-law of the maverick American artist James McNeill Whistler, who once famously shoved Haden through a plate-glass window in a Parisian café during one of their frequent disputes. In the United States, though, wicker coffins were more often used for transport and temporary storage of bodies (and before body bags, they often served to remove corpses from crime scenes).

More than likely, that was the function of the wicker coffin in the undertaker's garage: on top of it, neatly laid out, are a man's necktie and suspenders, a ring, a pocket watch, a fedora, cufflinks, and a set of dentures—as if these items accompanied the shrouded body, which we see on a slab in a cramped antechamber with cabinets

holding all manner of syringes, pumps, suction devices, rubber gloves, and bottles of corpse makeup in several tints. Perhaps the wicker coffin has been shipped to this garage in the brass-handled crate nearby bearing the label "Joe Brown/Kansas City." In the foreground is a wreath with a purple ribbon bearing the name "Joe" in gold and surmounted by a pair of doves that look for all the world like fugitives from Perkins' Mary Pickford drag. It is as if Perkins is ushering the mysterious Joe out of the world—whether or not he ever ushered him in.

The *Funeral Parlor, 1895–1920* steps back a bit in time, but otherwise the scene could plausibly be a continuation of the narrative that began in the garage. Rendered in subdued tones of violet, green, gray, and blue, the room and its furnishings suggest the aftermath of a wake or a funeral service. There are two rows of wicker chairs facing out, slender columns hung with black ribbons, and a very large framed chromolithograph after the painter Johannes Oertel's famed and perennially popular *Rock of Ages*, representing a half-drowned woman desperately embracing a majestic stone cross that rises sturdily above the furious waves.

But the real story is all in the foreground, where an overturned chair, a bottle of smelling salts, an empty whiskey flask, a crumpled black-bordered handkerchief, a discarded palmetto fan and a purple-ribboned wreath labeled "HUSBAND" suggest the immediate aftermath of a widow's hysterical breakdown—hardly a laughable subject yet treated with Perkins' trademark black humor nonetheless. As if to deflate all this macabre levity, a homely cast-iron stove stands with a pair of rubbers drying out underneath it, and a black umbrella tilted against the adjacent window sill. The weather is indeed wet: outside is an ornate horse-drawn hearse waiting for its cargo in a driving rainstorm. But the coffin is still inside; we catch a glimpse of it behind a purple screen that also provides the backdrop for another wreath propped on an easel; the purple ribbon reads "Lodge No. 80" and bears a Masonic symbol. Around the wreath, Perkins' doves flutter and perch. Beyond the coffin is a partially open door, where we discover Perkins' tracks, almost literally: through the narrow aperture, we see the sole of a bare foot beneath an inverted bottle—no doubt formaldehyde—and a length of tubing. Someone has left the workroom door ajar. Here, glimpsed behind all the frippery, lies naked reality. But you can see it only if you peer very, very closely.

Next and last is the *Monument Display Room, 1888*. It is a spacious enclosure with large windows looking across the street outside a cemetery wall, above which we glimpse the tops of cypress trees and several monuments: urns, crosses, and an angel pointing the way to heaven. Inside the display room is a mirror image of that angel along with a much larger angel scattering stone roses. There is an assortment of headstones, crosses, urns, doves, and lambs, with generic inscriptions along the lines of "Precious," "Beloved," "At Rest," and "Darling." But there is one monument that stands out: on top is a large bronze anchor with a heavy chain and one fluke embedded in a rock. Dangling from one of the links is a pink tag declaring that

this piece has been "SOLD." The granite base bears the inscription "HARNLY," and it has only just now been completed: on the floor below and surrounded by chips of stone lies a chisel. Among the angels and lambs, it is strikingly anomalous. It looks as if it ought to be sitting atop Don Forbes' grave, not Perkins'. But Don was still alive, if on the skids, in 1947. Whatever the reason Perkins on this singular occasion chose the anchor over the urn, it lies buried.

But Perkins highlighted the urn in his ultimate fantasy, a full-bore Gothic nightmare set in a nocturnal cemetery, with bare trees—their branches like grasping claws—and an inky sky. In the foreground, an obelisk and a column bracket an urn placed on a pedestal in the exact center; this vessel is, in fact, the selfsame urn Perkins depicted in that mystical painting of the soul rising from its earthly shell. The inscription on the pedestal states "Born Oct. 1, 1901/Died Oct. 1, 1901." Although it is hard to make out, after each "Oct. 1" there is a faint smudge, as if another numeral had been rubbed out. That numeral was surely a four: the 14th, Perkins' own birthday. It is as if—born and died at the same moment—he had never lived at all, cancelled out before he even began. Then there are the skull-faced sheeted ghosts, a trio of them, gliding across the scene, the one in the center glowering out at us from empty sockets while dribbling gobbets of blood that trickle down the naked branches. Perkins told Bill Alexander what he was up to: "I am making a water color drawing for myself. It's the very first one I ever made for myself. The subject is my imaginary burial place! There are three ghosts flying

Perkins' grisly ghosts with ghostometers on their fannies, flying over his headstone at 60 miles per hour

through the air at sixty miles an hour according to the ghostometers attached to their fannies. Slow for traveling ghosts but necessary for the composition." Were they flying at top ghost speed, you would see them only as blurry streaks of light.

In the end, what to make of Perkins' life? His own family failing him, he found and lost many others in his quest for belonging somewhere, to someone. There was his first Los Angeles family—Don, José, and Fernando Felix, who collectively became his first New York family after their transcontinental odyssey. There was Rose O'Neill's louche Bohemian family, then the dance family, the Alexander King family, the Ontra family, and, at last, the family of young people who welcomed and cared for him, making him their honorary dirty old granddad. But he never found his heart's desire.

Ever busy, Perkins during his period of artistic amnesia produced the manuscript of another would-be novel, *Nature's Undesirables*, in which he set forth his own theories, or fantasies, of sexuality and gender. "The story," he told Alexander King, "contends that there is only <u>one</u> sex having dual aspects which fluctuate according to evolutionary processes in all kingdoms of Nature. All points of view expressed . . . are contrary to generally accepted ideas: Is normal, healthy heterosexuality a disease? Can it be cured? Is the female a potential father? Is a male a potential mother? Is normality a state of self hypnosis? Is the invert a necessary aspect in Universal Economy? Why does early enviorment [sic] affect one child in a large family and not all of the children where the enviorment is exactly the same? Do <u>expert, authoritative </u>psychologists know anything about it? Hell NO!!!"

Surely, that one child was Perkins himself, the one whose traumatic family experiences had indelibly stamped and shaped him and set him on his course through life. Like *Trailing Oyster Feathers*, *Nature's Undesirables* is a rambling verbal collage of colorful caricatures and fuzzy plot lines, interspersed with reflections on the big questions Perkins set forth in that letter to King. But tucked in here and there are passages that strike a confessional tone, that seem—at last—to disclose something real about Perkins' inner life. "So many inverts," reads one of these, "concentrate all of their psychic energy upon erotic appreciation, making that the primal concern of their lives. In my case, this ardent preoccupation has failed to attract the objects of my wishful thinking, my far-fetched fantasies. Besides, I block any possible contacts because I have a subconscious contempt for anyone who has the bad judgment to like me physically. So my sex life has consisted principally of window shopping." Then there is this: "I wonder if any man of my temperament has ever overcome his all consuming desire for the sensual love of men? Theoretically, an invert is not supposed to have any problems, if he accepts himself. I wonder which theory applies to the incidence of physical ugliness and sexual undesirability? . . . I guess it's a matter of forgetting the self, suffering it out. Senility and decrepitude

is said to dull the receptivities of normal heterosexuals, but the invert is stuck with his ever young and eager desires until the end of physical consciousness. The most hideous of human tragedies are incidents of elderly inverts tortured by uncontrolled, untransmuted sexual desires . . . I've always been driven frantic by every good looking boy I've seen. I'm free from stunning, crushing desire only in the presence of unappealing men."

Scattered through Perkins' papers are references to beauties, like the gorgeous Mexican husband stolen away by some young queen, or like Orestes, or indeed Bill Paxton, always beautiful, always unattainable, or just gone for good. Telling, too, is the hint in the above passages of an inability to receive or accept love because of some damage, or lack, that ruins any possibility of reciprocity. Whether this sense of lack or undesirability falls into the category of self-loathing is an open question, but it does appear to be the case that—for whatever complex reasons—Perkins never found an enduring or equitable love relationship. Yet however badly damaged by long-past traumas, Perkins over the course of his long, zigzag life managed to survive and find safe places to make the best of things. And in that spirit, we will let him have the last word— almost. "I am like a trap door spider patiently enduring endurance," he told Bill Alexander, ". . . I sit half asleep in the back seat from the arena of life's consequential activities. My pleasures and satisfactions are very small derived from very small things . . . Now, why should I want to feel important? I know myself. And what I know is of no importance. It's a mess in a multiplicity of messes. Why should I want life eternal? Why a continuance of this endurance, this struggle for WHAT? . . . I am just as well off and as happy now that I have given up the notion of becoming the spirit of a SUN by the process of myriads of lifetimes sucking cocks and being rammed up the asshole by big, juicy dicks. I've given up eternity and dicks both . . . To hell with eternity! If at the time of demise I am not six feet under or a little pile of shit it'll be just too bad, but for whom? I certainly won't give a shit. I have had a perfectly marvelous time while on earth. I haven't missed a lick according to my satisfaction. And you should have seen some of the things I've licked!!!"

If anything would make the perfect epitaph for Perkins, that last sentence surely fills the bill.

Archival Sources: Abbreviations

E. King Papers, NYPL: Eleanor King Papers, 1916-1991, Jerome Robbins Dance Division, New York Public Library for the Performing Arts.

Forbes Archive, MONA: Emory Abraham (Donald) Forbes Archives Collection, Museum of Nebraska Art, Kearney, Nebraska.

Harnly Artist File, NYPL: Perkins Harnly Artist File, The Miriam and Ira D. Wallach Division of Art, Prints and Photographs, New York Public Library.

Harnly Papers, AAA: Perkins Harnly Papers, 1946-1985, Archives of American Art, Smithsonian Institution.

Harnly Papers, HC: Perkins Harnly Papers, Tom Huckabee Collection.

King Papers, LC: Alexander King Papers, Series 1, General Correspondence, Box 1 and 2, Manuscript Division, Library of Congress, Washington, D.C.

Littlefield Papers, AAA: William Horace Littlefield Papers, 1920-1969, Archives of American Art, Smithsonian Institution.

LRH-PH Research, AAA: Lynda Roscoe Hartigan research material on Perkins Harnly, 1979-1984, Archives of American Art, Smithsonian Institution.

PH audio interview, Mar. 1984, HC: Audiotape interview with Perkins Harnly by Tom Huckabee, March 1984, Huckabee Collection.

PH oral history, 1981, AAA: Oral History Interview with Perkins Harnly, Oct. 15, 1981, Archives of American Art, Smithsonian Institution.

PH Video Compilation, 1984-5, HC: Tom Huckabee, Perkins Harnly Compilation, videotape recording, 1984-85, Huckabee Collection

PH video interview Apr. 1984, HC: Interview with Perkins Harnly by Tom Huckabee and Bill Paxton, videotape recording, April 21 and 22, 1984, Huckabee Collection.

Warshaw Letters, AAA: Henry Warshaw letters from Perkins Harnly, 1969-1982, Archives of American Art, Smithsonian Institution, Washington, D.C.

NAME ABBREVIATIONS:

BA: Bill (William) Alexander
BP: Bill Paxton
DF: Don Forbes
EK: Eleanor King
HW: Henry Warshaw
Kings: Alexander and Margie King
LRH: Lynda Roscoe Hartigan
MK: Margie King
SB: Sarah Burns
WHL: William Horace Littlefield
WNM: Whitney Norcross Morgan

INTRODUCTION

p. 15 "The Grandma Moses of Near-Porn": Anne Sharpley, "Painter from a Cattle Ranch in Nebraska," *Evening Standard* (London), May 3, 1973.

p. 17 "so-called old atrocities": "Victorian Satire for a Victorian Room," *The Art Digest*, v. 8 no. 7 (Jan. 1, 1934), 18.

p. 18 a fond memoir: Tom Huckabee, "Our Friend, Perkins Harnly," *Tease* (2004), 90–95.

"a garbage can only has two handles!" SB, telephone conversation with BP, Sept. 15, 2014.

"He's the cutest person!": PH Video Compilation, 1984–5, HC.

"into the crematory furnace": PH to Rocky Schenck, June 7, 1982, Perkins Harnly Papers, Rocky Schenck Collection.

"Perkins exaggerates": WHL to Marchal Landgren, Oct. 12, 1965, Forbes Archive, MONA.

"I would not worry about exact facts": PH to WHL, May 21, 1965, Forbes Archive, MONA.

CHAPTER 1

p. 22 "'When Bitchhood was In Flower'": PH to BA, Nov. 22, 1961, Harnly Papers, AAA.

p. 23 "Birthplace of Perkins Harnly": PH, undated typescript, PH Papers, HC.

"Giant brass safety pins": PH audio interview, Mar. 1984, HC.

"little bags of ASS*A*FED*ITY": PH to Kings, Mar. 1964, King Papers, LC.

"Messed-up bit of scraggly fire wood": PH to Kings, Dec. 26, 1961, King Papers, LC.

p. 24 "I hated the farm": handwritten note on untitled typescript, Harnly Papers, AAA.

"The cow must go": Greg Grandin, *Fordlandia: The Rise and Fall of Henry Ford's Jungle City* (New York: Picador, 2010), 40.

"traveling Evangelican loudmouth": PH to WHL, Apr. 15, 1965, Forbes Archive, MONA.

"trashy Tobacco Road types": Gerald Faris, "Artist, Satirist, Sensualist, Cafeteria Worker . . ." *Los Angeles Times*, Nov. 14, 1971.

"A little bit dopey": PH audio interview, Mar. 1984, HC.

"Everyone 'carried on' with animals": Ibid.

On the other hand, such behavior: Richard Von Krafft-Ebbing, *Psychopathia Sexualis*, rev. ed. (Brooklyn: Physicians and Surgeons Book Company, 1931), 561–71 records similar cases of bestiality.

"His siblings all 'kicked off'": PH audio interview, Mar. 1984, HC.

"guy named Fuller": PH to Kings, Mar. 1964, King Papers, LC.

p. 25 What is true: "Says He Imprisoned Her and She Made an Escape," *Lincoln Daily News*, Jan. 4, 1916; "Had To Escape From a Window," *Lincoln Daily Star*, Jan. 4, 1916.

A scarlet fever epidemic: "One Death in Every Four Cases," *Lincoln Daily Star*, May 2, 1916; "Harnly Gave Up Life for Child," *Lincoln Daily Star*, May 1, 1916.

p. 26 He later declared that he hated them: PH to Kings, Mar. 1964, King Papers, LC.

"So she was in bed for thirty years": Faris, "Artist, Satirist, Sensualist."

"Someone came behind me": PH to Kings, Mar. 1964, King Papers, LC.

p. 27 Before the scarlet fever: PH video interview. Apr. 1984, HC.

"'When the show would bomb'": "Slices of Life," *Washington Post*, Oct. 25, 1981.

p. 28 a small but eye-catching obituary: "Death Summons Sudden," *Lincoln State Journal*, Nov. 27, 1923.

p. 29 "a supreme example of the 'Monstrosity Decade'": "Victorian Satire for a Victorian Room," *Art Digest* v. 8 no. 7 (Jan. 1, 1934), 18.

one Queen Anne house to live in: PH to LRH, Dec. 8, 1980, LRH-PH Research, AAA.

"If architecture is frozen music": PH, untitled manuscript, Harnly Papers, HC.

"The first brick outhouse": Thomas Albright, "Fifty Percent Op/Fifty Percent Pop," *San Francisco Sunday Examiner & Chronicle*, June 8, 1969.

"Sears Roebuck catalogues": PH to LRH, Dec. 8, 1980, LRH-PH Research, AAA.

"vigorous nostalgia": "A Heritage Preserved: Interior America," *American Heritage*, v. 34 no. 1 (Dec. 1982), 95.

p. 31 "that part of the magazine was always the dirtiest": PH oral history, 1981, AAA.

Those ancient Sears underwear pages: examples taken from Sears, Roebuck mail-order catalogue #124, 1912.

"It's high time for under-drawers": PH to LRH, Aug. 20, 1981, LRH-PH Research, AAA.

p. 32 "a charming little cemetery": PH, "My Kingdom for a Hearse," 1971, Harnly Papers, AAA .

Mary had a reed organ: PH audio interview, Mar. 1984, HC.

"unusual" parties: "Visit, Explore and Enjoy Lincoln, Nebraska: thomasinnebraska.wordpress.com/people/ accessed Jan. 25, 2017.

Monuments in the Wyuka Cemetery: Ed Zimmer, *Wyuka Cemetery: A Driving and Walking Tour* (Lincoln, NE: Wyuka Historical Foundation, 2009), 62, 63, 65, 111.

p. 33 "not toward the corpse": Faris, "Artist, Satirist, Sensualist."

"There is an awesome, poisonous glamor": PH, "My Kingdom for a Hearse."

p. 34 "Once I cleaned out my closet": PH to Kings, May 31, 1962, King Papers, LC.

"He is fat and nice looking": Mary Harnly to PH, Jan. 1932, Harnly Papers, HC.

the lusty Mrs. Oltrogge: PH audio interview, Mar. 1984, HC.

"Grandma said, 'Willie!'": PH to Kings, Mar. 1964, King Papers, LC.

p. 35 randy fry cook: PH audio interview, Mar. 1984, HC.

"two fat sows": PH, untitled manuscript, Harnly Papers, AAA.

"Riding Academy": PH Video Compilation, 1984–5, HC.

"old charred bridges": PH to MK, Dec. 24, 1966, King Papers, LC.

"There was a sizable Gay Set": PH to WHL, Apr. 15, 1965, Forbes Archive, MONA.

p. 36 "Sarah was always fainting": PH, caption for "Sarah Bernhardt Receiving the Crown of Glory," in untitled manuscript, Harnly Papers, HC.

p. 37 So love-stricken: PH, "Bernhardt," Harnly Papers, HC.

"a dirty bawling out in French": PH to Eleanor King, Dec. 8, 1978, E. King Papers, NYPL.

"lugged the old girl upstairs": PH oral history, 1981, AAA; PH Video Compilation, 1984–5, HC.

Rotten teeth: Elizabeth Riddell, "Graveyard Fantasist Negotiates to Hit Our Cemeteries," The Australian, June 11, 1973.

"gorgeous box of chocolates": PH oral history, 1981, AAA.

p. 38 three Pullman coaches: PH audio interview, Mar. 1984, HC.

Willa Cather's younger sister, Elsie: PH to BA, Nov. 22, 1961, Harnly Papers, AAA.

p. 39 Better English Week: "Occasions," Links Yearbook (Lincoln, NE, 1920), 73–74.

"handle a spade and hoe and ax": "Beauty His Handicap," Washington Post, Apr. 25, 1915.

"the only job": "Paul Swan, Nebraska Born Artist, Pauses in Lincoln on Way to Home in Tecumseh," Nebraska Evening State Journal, July 30, 1938.

p. 40 "danced in a baby leopard costume": "A Suffragette Play," The Theatre Magazine, v. 17 (June 1913), 192.

p. 41 up on tiptoes: "How Man Will Look When Woman Votes," The Omaha Sunday Bee, May 18, 1913.

"Displaying the Exquisite Grace": "Why They Call Me the Most Beautiful Man in the World," The Chicago Examiner, Mar. 15, 1914.

"one long ecstasy": "A Greek God Reincarnated," Burlington Weekly Free Press (Burlington, VT), Oct. 9, 1913.

p. 42 "the womanly one": Walter F. Otto, Dionysus: Myth and Cult, tr. Robert B. Palmer (Bloomington: Indiana University Press, 1965), 175–76.

p. 43 "In New York I'm a freak": "Beauty His Handicap," Washington Post, Apr. 25, 1915.

"He picked up an acquaintanceship": "Nebraska Boy Called Most Beautiful Man," Lincoln Daily News, Mar. 28, 1914.

"a bit overwhelming": "Man Beauty of the World Once a Nebraska Plowboy," The Frederick Post (Maryland), May 25, 1914.

"a natural boy grin": Florence E. Yoder, "Dancing a Channel for All Thought, Says Paul Swan," The Washington Times, May 10, 1915.

p. 44 "dressed only in a string of pearls": "Paul Swan, As Faun, Chased by Lady Clad Only in Beads," Washington Times, June 8, 1921.

"struggling with many yards of pearls": PH to MK, Apr. 1, 1968, King Papers, LC.

In 1922, Swan was back: Janis and Richard Londraville, The Most Beautiful Man in the World: Paul Swan, from Wilde to Warhol (Lincoln, NE: University of Nebraska Press, 2006), 113. The Londravilles' book is the authoritative source on Swan's life and times.

"ran into him": PH video interview, Apr. 1984, HC.

"she painted badly": PH to WHL, Apr. 15, 1965, Forbes Archive, MONA.

"In the dead of night": Ibid.

CHAPTER 2

p. 47 "clumsy Negroes": Janis and Richard Londraville, *The Most Beautiful Man in the World: Paul Swan, from Wilde to Warhol*, 114.

"that old Fairy": PH to Kings, Aug. 14, 1964, King Papers, LC.

p. 48 "I worked as a soda squirt": PH to Kings, early March, 1964, King Papers, LC.

"The term 'MESS'": PH to WHL, Apr. 15, 1965, Forbes Archive, MONA.

"That great, sappy dream": PH to Kings, Aug. 14, 1964, King Papers, LC.

"gloomy, depressing day": PH to MK, Jan. 17, 1966, King Papers, LC.

He claimed that he had left Lincoln: PH Responses to Interview Questions, LRH-PH Research, AAA.

"'a wonderful man who gave a lot of glamour to Hollywood'": Harry Trimborn, "Nostalgia Unites Mourners at Novarro's Bier," *Los Angeles Times*, Nov. 4, 1968.

"worked at METRO": PH to MK, undated, King Papers, LC.

p. 49 "I had a silver service": PH to WHL, May 7, 1965, Forbes Archive, MONA.

"I was a dish scraper": PH, "Notes for Sandra Dorr," c. 1979, E. King Papers, NYPL.

p. 50 "'evenings of enchantment'": *José Limón, An Unfinished Memoir* (Middletown, CT: Wesleyan University Press, 2001), 13.

"He was a precocious boy": "Artist Donald Forbes and His Subject Both Lived in Lincoln," *The Nebraska State Journal*, Mar. 28, 1943.

"His Mother's maiden-name was Shickley": "Donald (Emory) Forbes," manuscript, Littlefield Papers, AAA.

p. 51 "squalid, dilapidated shack": PH to WHL, Feb. 1, 1965, Forbes Archive, MONA.

"Haines put his hand on the rail": Fernando Felix to PH, Mar. 24, 1965, Forbes Archive, MONA.

"Don went home": PH to WHL, Mar. 10, 1965, Forbes Archive, MONA.

Haines had actually been fired: on Haines see William J. Mann, *Wisecracker: The Life and Times of William Haines, Hollywood's First Openly Gay Star* (New York: Viking, 1998).

"haciendas and sugar refineries": *Limón, An Unfinished Memoir*, 13.

p. 52 "more curious ingredients": PH to BA, c. early 1960s, Harnly Papers, AAA.

"gathered watercress along the creek": PH to Kings, Aug. 6, 1964, LC.

"because you could only get to it by the bridge": Christopher Isherwood, *A Single Man* (1964; rpt. New York: Farrar, Strauss, and Giroux, 2013), 6-7.

p. 53 "I was once a member of the Vedanta Society": PH to Kings, July, 1964, LC.

"I have intellectual and emotional reactions": PH to Kings, Aug. 6, 1964, LC.

p. 54 "a mighty messy proposition": PH to Kings, undated, c. May 1962, LC.

"mere 'illusion'": PH to MK, Apr. 1, 1968, LC.

"soft gold, careless hair": Violent Sheridan, "They Say It Never Happens–But It Does: Marion Davies Becomes a Star–Overnight," *Motion Picture Magazine* (Aug. 1919), 51.

"resplendent Western makeup": Ruth Kingston "At the American Studios," *Motion Picture Magazine* (Sept. 1918), 59.

p. 55 In September 1921: on Fatty Arbuckle and Wallace Reid see Anne Helen Petersen, *Scandals of Classic Hollywood: Sex, Deviance, and Drama from the Golden Age of American Cinema* (New York: Penguin, 2014), Ch. 2 and 3, 14–38; on Reid, also see Mark Lynn Anderson, "Shooting Star," in Adrienne L. McLean and David A. Cook, eds., *Headline Hollywood: A Century of Film Scandal* (New Brunswick: Rutgers University Press, 2001), 83–106.

p. 56 "lives of wild debauchery": [Ed Roberts], *The Sins of Hollywood* (Los Angeles: Hollywood Publishing Co., 1922), 11–18, 73–75.

p. 57 "He was my heart-throb": PH to BP, undated, Louise Paxton Collection.

"green velvet and antique shadow box effect on an easel": PH to MK, Aug. 26, 1965, King Papers, LC.

"the most tremendous sex appeal": "What Makes Them Stars? 'Lure!' Says Fred Niblo," *Photoplay* (Nov. 1923), 116.

"all right pretty soon": "Siren Wooing Back Old Charm: Star Battles for Health," *Los Angeles Times*, Nov. 10, 1925.

La Marr died: Hadley Meares, "The Tragic Story of Barbara La Marr, the Woman Who Was 'Too Beautiful for Hollywood,'" *LA Weekly*, Feb. 10, 2017. See Sherri Snyder, *Barbara La Marr: The Girl Who Was Too Beautiful for Hollywood* (Lexington: University Press of Kentucky, 2017).

"swift, hot, violent life": Adela Rogers St. John, "Hail and Farewell: A Tribute to the Memory of Barbara La Marr by One Who Knew Her," *Photoplay* v. 29 no. 5 (Apr. 1926), 41.

"many hundreds rushed": "Women Riot at Star's Funeral," *Los Angeles Times*, Feb. 6, 1926.

p. 58 "screen-land's beautiful lady of sorrow": "Baby Rose Dwarfs Floral Bier," *Los Angeles Times*, Feb. 3, 1926.

"She was so very beautiful": PH to Kings, Aug. 26, 1965, King Papers, LC.

"snugly arranged in a cream chiffon velvet:" PH to Kings, Sept. 30, 1965, King Papers, LC.

p. 59 "When he died": Ph to Margie King, Oct. 22, 1969, King Papers, LC.

"a foreigner from the most foreign": Herbert Howe, "A Misunderstood Woman," *Photoplay* (Apr. 1922), 24.

"Nazimova!": Adela Rogers St. Johns, "Temperament? Certainly, Says Nazimova," *Photoplay* (October, 1926), 32.

"The Garden of Alla": Howe, "A Misunderstood Woman," 25.

p. 61 "Salomé is a theory": "Little Hints," *Screenland* (Sept. 1922), 41.

"this is bizarre stuff": "Salomé–Alla Nazimova Production," *Photoplay* (Aug. 1922), 61.

"The Orient had always been my first love": Pauline Koner, *Solitary Song* (Duke University Press, 1989), 24.

p. 62 "stunning, highly stylized backgrounds": PH to MK, Dec. 22, 1969, King Papers, LC.

"a filthy old tramp": PH to WHL, Mar. 18, 1965, Forbes Archive, MONA.

p. 63 "disreputable artist friends": *Limón, An Unfinished Memoir*, 14.

bitten by a rattlesnake: PH to EK, Feb. 18, 1974, quoted in *Eleanor King, Transformations: The Humphrey-Weidman Era: A Memoir* (Trenton, NJ: Dance Horizons, 1978), 299.

"truck drivers, salesmen": PH, "Notes for Sandra Dorr," c. 1974, E. King Papers, NYPL.

"very, very lightly tickle": PH to WHL, May 7, 1965, Forbes Archive, MONA.

CHAPTER 3

p. 65 "commercial artist": PH passport application, Harnly Papers, HC.

"silver brocade slippers": PH to HW, Jan. 15, 1978, Warshaw Letters, AAA.

"very first trek": PH to EK, Dec. 8, 1978, E. King Papers, NYPL.

p. 66 "fought like cats and dogs": PH to WHL, Mar. 10, 1965, Forbes Archive, MONA.

"fell madly in love with his virility": PH, "Notes for Sandra Dorr," E. King papers, NYPL.

"a fat detective": PH to WHL, Mar. 10, 1965, Forbes Archive, MONA.

The illustrations are credited: PH to WHL, Feb. 1, 1965, Forbes Archive, MONA.

"lowly maiden of the vineyard": Alexandre Kuprin, *Sulamith: A Romance of Antiquity* (New York: Nicholas L. Brown, 1928), 18–19, 77, 99.

p. 67 "erotic frankness": "Recent Books in Brief Review," *The Bookman* (Aug. 1923), 657.

"with a wail of pain and rapture": Kuprin, *Sulamith*, 110.

p. 68 "His Harper's covers": PH to HW, Dec. 10, 1973, Warshaw Letters, AAA.

"stole several thousand bucks worth": PH to MK, c. 1965, King Papers, LC.

His vocabulary alone: Gershon Legman, "The Language of Homosexuality: An American Glossary," in George W. Henry, *Sex Variants* (New York: Paul B. Hoeber, 1941.) Henry's work is discussed in John Loughery, *The Other Side of Silence: Men's Lives and Gay Identities: A Twentieth-Century History* (New York: Henry Holt & Co., 1996), 67–8.

p. 69 "in queer jargon": PH to Kings, Mar. 26, 1964, King Papers, LC.

"a plain old panzy": PH to BA, Feb. 8, 1962, Harnly Papers, AAA.

"my gorgeous Mexican husband": PH to BA, undated, Harnly Papers, AAA.

"almost all queers": PH to Kings, Easter Sunday, 1965, King Papers, LC.

"seventeen real-life fairies": John Loughery, *The Other Side of Silence: Men's Lives and Gay Identities: A Twentieth-Century History* (New York: Henry Holt & Co., 1996), 36.

"I've got the most gorgeous new drag": Mae West, *The Drag*, in *Three Plays*, ed. Lillian Schlissel, (New York: Routledge, 1997), 118.

p. 70 "muscular-shouldered, beautifully gowned creatures": "Hamilton Lodge Ball," *New York Amsterdam News*, Mar. 2, 1932. On the pansy craze see George Chauncey, *Gay New York: Gender, Urban Culture, and the Making of the Gay Male World, 1890–1940*, (1994, rev. ed. New York: Basic Books, 2019), Ch. 11, 301–329.

"There was always a lurking touch of male": C.J. Bulliet, *Venus Castina: Famous Female Impersonators Celestial and Human* (1928; rpt. New York: Bonanza Books, 1956), 11.

"His gowns were a burlesque": Ibid., 266.

p. 71 "notorious female impersonator": Robert Scully, *A Scarlet Pansy*, (1932), ed. Robert Corber (New York: Fordham University Press, 2016), 174, 145, 137.

"My grandest outfit": PH to BP, undated, 1980; Louise Paxton Collection.

"I got very drunk": PH to HW, Feb. 4, 1981, Harnly Papers, AAA.

"Don got plastered": PH to WHL, Mar. 10, 1965, Forbes Archive, MONA.

"I wanted to get buggered": PH to Bill Paxton, undated, 1980; Louise Paxton Collection.

p. 73 "They messed their drawers": PH to HW, Feb. 4, 1981, Warshaw Letters, AAA.

"Splendor," "Indomitable," "Fascination": Sad to say, Perkins' drag fashion drawings no longer exist. Perkins gave them, along with other works, to the New York Public Library in 1947. A couple of decades later, the library microfilmed them and deaccessioned the originals, which have not been seen since.

p. 74 "She's ridiculing and satirizing": PH, "Mae West the Incorruptible," typed manuscript, Harnly Papers, AAA.

"She invited him to tea": PH to WHL, Feb. 1, 1965, Forbes Archive, MONA.

p. 75 "I invented the name for little Cupid": Rose O'Neill, *The Story of Rose O'Neill: An Autobiography*, ed. Miriam Formanek-Brunell (Columbia: University of Missouri Press, 1997), 95.

"From Kewpie you'll not wish to part": Kewpie Doll Box, c. 1913, Collection of the Rose O'Neill Museum, Walnut Shade, Missouri.

p. 76 "child-bearing sheep": Rose O'Neill, "Woman's the Virtues," *New York Tribune*, Apr. 14, 1915.

"harness and hair-pins": O'Neill, *Autobiography*, 100.

p. 77 "I seemed to be entranced": Ibid., 120.

p. 78 "with magic, necromancy, and a touch of terror": Ibid., 128.

"The entire place": PH to WHL, Mar. 25, 1965, Forbes Archive, MONA.

"The house was always full": O'Neill, *Autobiography*, 128, 131.

"They have known the drifting fogs": Talbot Faulkner Hamlin, "Mystic Vision in Modern Drawings: The Art of Rose O'Neill," *Arts and Decoration* v. 16 no. 6 (Apr. 1922), 423.

"poetry of romantic allure": WHL, draft of Forbes biography, c. 1966, Littlefield Papers, AAA.

"the most morose person": PH to WHL, Feb. 12, Mar. 10, May 29, 1965, Forbes Archive, MONA.

p. 79 "Column of fun": Rose O'Neill to PH, June 30, 1932, Harnly Papers, HC.

"a series of monstrous figures": WHL, draft of Forbes biography, c. 1966, Littlefield Papers, AAA.

"Don Forbes was painting in oils": O'Neill, *Autobiography*, 131.

"My enormous studio": Ibid., 131.

p. 80 "Grecian-styled gowns of peach silk": "Missouri Women in History: Rose O'Neill," *Missouri Historical Review* v. 62 no. 4 (July 1968): front cover.

"Put a house in it!" Anne Sharpley, "Painter from a Cattle Ranch in Nebraska," *Evening Standard*, May 3, 1973.

"I was her guest because": Ibid.

"theoretical" lover: PH to WHL, Mar. 25, 1965, Forbes Archive, MONA.

One night, she invited herself: PH audio interview, Mar. 1984, HC.

"used to place a phonograph in the bushes": PH to WHL, Mar. 25, 1965, Forbes Archive, MONA.

p. 81 "special little doors": Alexander King, "Profiles: Kewpie Doll," *The New Yorker*, Nov. 24, 1934, 25.

"Not like anything else you would meet": O'Neill, *Autobiography*, 137.

"a savant scarcely capable of caring": Joshua Heston, "Rose O'Neill," stateoftheozarks.net/culture/craftsmanship/painting/roseoneill/road_to_bonniebrook.php, accessed Feb. 16, 2017.

"[H]e believed he was an engineer": PH, untitled biographical notes, c. 1960, Harnly Papers, AAA.

"he attacked the ship's captain": PH audio interview, 1984, HC.

"London crazy house": PH to WHL, Mar. 25, 1965, Forbes Archive, MONA.

p. 82 "tucked a box of kittens near the stove": Joshua Heston, "The Roads to Bonniebrook," State of the Ozarks Showcases, June 6, 2014, stateoftheozarks.net/showcase/2019/03/05/the-roads-to-bonniebrook/, accessed May 10, 2017.

"Although I had some idea of their social life": Jean Cantwell to PH, Mar. 10, 1972, Harnly Papers, AAA.

"She lived entirely in an illusion of sappy beauty": PH to WHL, Mar. 25, 1965, Forbes Archive, MONA.

"Once when Don went to town for trade": PH to WHL, Mar. 25, 1965, Forbes Archive, MONA.

"Darling Perk": Rose O'Neill to PH, June 30, 1932, Harnly Papers, HC.

p. 83 "It was Rose": PH to Mrs. Clay (Jean) Cantwell, Feb. 28, 1972; collection, Jean Cantwell.

CHAPTER 4

p. 85 "cemetery of Guadaloupe": PH to BA, c. 1956, Harnly Papers, AAA.

p. 87 Several were popular hits: Helen Delpar, *The Enormous Vogue of Things Mexican: Cultural Relations between the United States and Mexico, 1920–1935* (Tuscaloosa: University of Alabama Press, 1995), 55, 78.

"these same people": Leone B. Moats, *Thunder in Their Veins: A Memoir of Mexico* (New York: The Century Company, 1932), 272.

"All life and all death": Edith Mackie and Sheldon Dick, *Mexican Journey: An Intimate Guide to Mexico* (New York: Dodge Publishing Company, 1935), xii.

"The Mexican has a jocular camaraderie": Carleton Beals, *Mexican Maze* (New York: J.B. Lippincott, 1931), 240, 243.

p. 88 "There are skulls": Anita Brenner, *Idols behind Altars* (New York: Harcourt, Brace and Co., 1929), 20–26.

"On the Day of the Dead": Beals, *Mexican Maze*, 240.

p. 89 "It was always a great treat": PH audio interview, 1984, HC.

"A bride wearing a long white net veil": PH to WHL, Apr. 15, 1965, Forbes Archive, MONA.

"Palacio de Bellas Artes": PH audio interview, 1984, HC.

"cruel images of mythical deities": WHL, draft of Forbes biography, Littlefield Papers, AAA.

"A fat ass had a strong magnetic attraction": PH to WHL, May 14, 1965, Forbes Archive, MONA.

p. 90 "Leaving tomorrow night": William Spratling, telegram to Don Forbes, Mar. 26, 1929, Forbes Archive, MONA.

"Spratling had a house at Taxco": Moats, *Off to Mexico*, 95.

"Little red-tiled houses": Heath Bowman and Stirling Dickinson, *Mexican Odyssey* (Chicago: Willett, Clark, and Co., 1935), 87.

"cobblestoned lanes leading always up": Witter Bynner, *Selected Letters* (New York: Farrar, Straus, Giroux, 1981), 136–37.

"He mooched and mooched": PH to WHL, May 14, 1965, Forbes Archive, MONA.

"the attic of an ancient house": PH to WHL, Mar. 18, 1965, Forbes Archive, MONA.

p. 91 "at noon little boys would climb": PH audio interview, 1984, HC.

"the Spanish adaptation of the Baroque": Bowman, *Mexican Odyssey*, 88.

"a scene of spectacular drunkenness": Taylor D. Littleton, *The Color of Silver: William Spratling, His Life and Art* (Baton Rouge: Louisiana State University Press, 2000), 229.

Crane stayed at Spratling's: Paul Mariani, *The Broken Tower: The Life of Hart Crane* (New York: Norton, 2000), 395–97.

"Have you not heard": Hart Crane, "The Broken Tower," in *The Collected Poems of Hart Crane*, ed. Waldo Frank (New York: Liveright Publishing Corporation, 1946), 135.

After a brief stop in Havana: Mariani, *The Broken Tower*, 420–21; Mark Seinfelt, *Final Drafts: Suicides of World-Famous Authors* (Amherst, New York: Prometheus, 1999), 103–132.

p. 92 "didn't try particularly to emulate Hart Crane": PH to WHL, May 29, 1965, Forbes Archive, MONA.

he and Spratling knew each other: WHL to "Bill" [William Spratling], Oct. 21, 1965, Forbes Archive.

"make ripped flesh": Kelly Donahue-Wallace, *Art and Architecture of Viceregal Latin America, 1521–1821* (Albuquerque: University of New Mexico Press, 2008), 151.

"shock the senses and stir the soul": Xavier Bray et al., *The Sacred Made Real* (New Haven: Yale University Press, 2009), 15.

"nothing can be more lugubrious": Théophile Gautier, *Wanderings in Spain* (London: Ingram, Cooke, and Co., 1853), 41.

p. 93 "Encyclopedia of Mexican Santos' Wardrobes": PH, typed manuscript, Harnly papers, HC.

p. 94 "theatrical sawdust": Enrique Asunsolo, "Perkins Harnly," *Mexican Life*, Oct. 1933, 25.

"The white muslin eyelet embroidered flounced drawers": PH to MK, Dec. 14, 1965, King Papers, LC.

p. 95 "He is always the Mutilated One": "Holy Images by Mexican Indian Primitives," *The American Weekly*, Mar. 18, 1933.

Making veiled reference to the suffering Indian: Cindy Urrutia, "American Modern Photographers and Mexico: Interwar Aesthetics and Visual Culture South of the Border," Ph.D. Diss., University of California Irvine, 2015, 238-239.

p. 96 "a living Christ was nailed to the cross": Toor, *Mexican Folkways*, 112.

"whippings, flagellations and crucifixion": www.flickr.com/photos/artedelares/455972515 , accessed May 1, 2018.

"potential [homo] eroticism of religious ecstasy": Thomas Waugh, *Hard to Imagine: Gay Male Eroticism in Photography and Film from Their Beginnings to Stonewall* (New York: Columbia University Press, 1996), 96.

"afflicted deity for a profoundly afflicted people": Jennifer Scheper Hughes, *Biography of a Mexican Crucifix: Lived Religion and Local Faith from the Conquest to the Present* (New York: Oxford University Press, 2010), 7.

p. 97 "Mexico is drenched": PH to BA, undated, Harnly papers, AAA.

On Frances Toor: Michael K. Schuessler, "The Mystery of Frances Toor," *Nexos: Culture and Daily Life*, Feb. 4, 2017, cultura.nexos.com.mx/?p=12083, accessed May 14, 2018.

"crazy apartment building": Lesley Byrd Simpson, letter to William Spratling, c. 1964, cited in William Spratling, *File on Spratling: An Autobiography* (Boston: Little, Brown, 1967), 59.

p. 98 "Terribly snobbish": PH audio interview, 1984, HC.

"She was–oh, hell!–breath-taking": Addison Burbank, *Mexican Frieze* (New York: Coward-McCann, 1940), 25-28.

p. 99 "cocksucking, philosophy, Beatniks": PH to BA, Feb. 9, 1961, Harnly papers AAA.

"that tragic grotesqueness": Asunsolo, "Perkins Harnly," 23-25.

"San Simon looks like a good natured bum": PH, "Encyclopedia of Mexican Santos," Harnly Papers, HC.

p. 100 "went insane and died in Paris": PH to HW, Aug. 19, 1974, Warshaw Letters, AAA.

"Her bridal dress": Adam Hochschild, *King Leopold's Ghost: A Story of Greed, Terror, and Heroism in Colonial Africa* (New York: Houghton Mifflin, 1999), 136, 276.

On Alma Reed: Michael K. Schuessler, "Inter-American Memories: Frances Toor, Alma Reed and the Mexican Cultural Renaissance," *Les Cahiers de Framespa* v. 24 (2017), journals.openedition.org/framespa/4322 accessed May 10, 2018.

p. 101 "the bull-fighter of saints": Edwin Wemple, "Mexican Santos by Perkins Harnly," Dec. 9 to Dec. 29 (New York: Delphic Studios, 1935), n. pag.

"never took a bath": PH to WHL, June 4, 1965, Forbes Archive, MONA.

"an overwhelming love of the extremely perverse": PH to BA, undated, Harnly Papers, AAA.

"vain old queen": PH to BA, Oct. 27, 1961, Harnly Papers, AAA.

p. 102 "He is a rare personality": PH to BA, Sept. 5, 1961, Harnly Papers, AAA.

Buried with another woman: Schuessler, "The Mystery of Frances Toor."

CHAPTER 5

p. 103 Julien Levy: Ingrid Schaffner, "Portrait of an Art Dealer," introduction to Julien Levy, *Memoir of an Art Gallery* (1977; rpt. Boston: Museum of Fine Arts, 2003), ix–xxi.

"ex-illustrator": "Bestseller Revisited," *Time Magazine* v. 75 no. 11 (Mar. 14, 1960), 104.

p. 104 "the central decorative motif": "Victorian Satire for a Victorian Room," *Art Digest* v. 8 no. 7 (Jan. 1, 1934), 18.

p. 107 "brought down from the attic of the subconscious": Enrique Asunsolo, "Perkins Harnly," *Mexican Life*, Oct. 1933, 23–24.

"My very soul belonged to 1880–1910": PH, Responses to Interview Questions, LRH-PH Research, AAA.

"fearsome rubbish": Harold Donaldson Eberlein, "Furniture of the 'Dark Ages,'" *Country Life* v. 48 (Sept. 1925), 44.

"antimacassars, lambrequins, gilded rolling pins": Daniel Catton Rich, "Grandmother's Chairs: Some Relics of the Victorian Age Worth Saving," *House Beautiful*, v. 59 (Apr. 1926), 449.

p. 108 "certain bitter young painters": Elisabeth L. Cary, "A Machine Age Speaks," *New York Times*, Jan. 8, 1928.

"some long forgotten theatrical storehouse": clipping, undated, 1933, Harnly Artist File, NYPL.

"odd Americana": Howard Devree, "Galleries," *New York Times*, Dec. 17, 1933.

Joseph Cornell: See Lynda Roscoe Hartigan, *Joseph Cornell: An Exploration of Sources: Guide to the Exhibition* (Washington, D.C.: National Museum of American Art, 1982).

p. 109 "We hung around Levy's gallery together": PH oral history, 1981, AAA.

"Simply, Joseph was a 'good soul'": PH to LRH, Apr. 14, 1979, LRH-PH Research, AAA.

"I have always been very proud": PH to Julien Levy, Sept. 24, 1946, Julien Levy Gallery Records, 1857–1982, Philadelphia Museum of Art Archives.

p. 110 "And that was the only reference to balls": PH to MK, Christmas Day, 1965, King Papers, LC.

"So I got on Home Relief": PH Responses to Interview Questions, LRH-PH Research, AAA.

p. 111 "sincere childlike expressions": Holger Cahill, "Folk Art: Its Place in the American Tradition," *Parnassus* v. 4 no. 3 (Mar. 1932), 2–4.

"living stream of native cultural expression": Edward Alden Jewell, "Saving Our Usable Past," *New York Times*, Mar. 19, 1939.

"Respect for the object": Helen Kay, "The Index of American Design: A Portfolio," *Fortune* Magazine v. 15 no. 6 (June 1937), 103.

"camera-like precision": "Index of American Design: Review of Macy's Exhibition," *Art Digest* v. 12 no. 8 (July 1938), 34.

"the essential character and quality of objects": Holger Cahill, introduction to Erwin Ottomar Christensen, *The Index of American Design* (New York: Macmillan, 1950), xiv–xv.

Index of American Design: see Nancy Elizabeth Allyn, "Defining American Design: A History of the Index of American Design, 1935–1942; M.A. Thesis, University of Maryland, 1982; Virginia Tuttle Clayton et al., *Drawing on America's Past: Folk Art, Modernism, and the Index of American Design* (Washington, D.C.: National Gallery of Art, 2002).

p. 112 "it was a curiosity": PH Responses to Interview Questions, LRH-PH Research, AAA.

Lloyd Rollins: see Mary Street Alinder, *Group f.64: Edward Weston, Ansel Adams, Imogen Cunningham, and the Community of Artists Who Revolutionized American Photography* (New York: Bloomsbury, 2014), 126–134.

"an old queer": PH video interview Apr. 1984, HC.

"more and more crowded": WNM to WHL, Nov. 5, 1937 and Oct. 30, 1938, Littlefield Papers, AAA.

"life blood": PH to MK, May 21, 1966, King Papers, LC.

p. 113 "the mental states I endured": PH to LRH, May 7, 1981, LRH-PH Research, AAA.

"especially the ladies' underwear section": PH Responses to Interview Questions, LRH-PH Research, AAA.

"strong, innate sense of the ridiculous": Ibid.

p. 114 "I don't wish to spoil the atmosphere": PH to LRH, c. 1981, LRH-PH Research, AAA.

used a baited rat trap: Lot description information from Summer Estates Auction, June 27 and 28, 2009, Neal Auction company; www.nealauction.com/archive/0609/lot/paintings/american/, accessed June 8, 2018.

p. 116 "fat Queen posing": PH to "Dearest Kids," Aug. 5, 1982, Harnly Papers, HC.

p. 118 "gobby, clumsy, tumid, atrocious": H.D. Eberlein et al., *The Practical Book of Interior Decoration* (New York: Lippincott, 1919), 167–168.

"fine craftsmanship and original design": "'As We Were,' an Exhibition of Plates from the Index of American Design," Metropolitan Museum of Art, June 9–June 30, 1941, New York City WPA Art Project, n. pag.

"The drawings . . . are amusing": Benjamin Knotts, Foreword, "I Remember That: An Exhibition of Interiors of a Generation Ago," (MMA/IAD Publications, 1942) n. pag.

"manic overdecoration": Joel Smith, *Saul Steinberg: Illuminations* (New Haven: Yale University Press, 2006), 42.

p. 119 "shown as a record of the time, not as art": Ruby Ross Wood, "I Remember That . . . It Was Acidly ugly, but with an Engaging Charm," *Vogue* (Feb. 1, 1943), 66–67, 98, 101.

"American romantic trend": "The Origins of Today's Romantic Trend," *House and Garden* (Feb. 1940), 25.

"furnish her house in the Victorian manner": "Victoria Regina: The High Noon of English 19th Century Taste in the House of Helen Hayes," *House and Garden* (Aug. 1936): 20–25.

p. 120 Townhouse Parlor: "A Document of Decoration," *House and Garden* (May 1939), 32.

"Victorian gimcracks": "Life Goes Calling on Helen Hayes," *Life* Magazine (Nov. 13, 1939), 82.

"She had become very stout": PH oral history, 1981, AAA.

p. 121 "a John Henry Belter hand carved rosewood settee": PH to HW, Mar. 6, 1979, Warshaw Letters, AAA.

"camp sensibility of artifice": Erika Doss, "Grant Wood's Queer Parody: America Humor during the Great Depression," *Winterthur Portfolio* v. 52 no. 1 (Mar. 2018), 5, 21.

p. 122 "who are passionate": David Halperin, *How to Be Gay* (Cambridge, Mass: Belknap Press of Harvard University Press, 2014), 318.

"done in the Hollywood modern style": WNM to WHL, Dec. 8, 1935, Littlefield Papers, AAA.

"not a detailed history": WNM to WHL, Mar. 31, 1935, Littlefield Papers, AAA.

"ivory knob and ebony keyhole": WNM to WHL, June 28, 1939, Littlefield Papers, AAA.

"quite entertaining pieces": WNM to WHL, Mar. 31, 1935, Littlefield Papers, AAA.

p. 123 "They don't really belong to me": Liberace, quoted in Will Fellows, *A Passion to Preserve: Gay Men as Keepers of Culture* (Madison: University of Wisconsin Press, 2004), 133.

CHAPTER 6

p. 125 "I had a painting of Christ in jail": PH to MK, Jan. 7, 1966, King Papers, LC.

p. 126 "unpleasantly sadistic": Gilbert Seldes, "Savagery in Pictures," *Americana*, v. 1 no. 2 (Nov. 1932), inside front cover.

Narcotic Farm: See Nancy D. Campbell, J.P. Olsen, and Luke Walden, *The Narcotic Farm* (New York: Abrams, 2008).

"at war with the English language": *George Grosz: An Autobiography*, tr. Nora Hodges (Berkeley: University of California Press, 1998), 234.

"tore the mask": Rom Landau, "George Grosz," *The Arts* v. 12 no. 6 (Dec. 1927), 295.

"underworlds in the bodies": M.F., "George Grosz," *Artwork: An International Quarterly of Arts & Crafts* v. 3 no. 11 (November 1927), 204.

"neither my wings nor my fingernails": *George Grosz: An Autobiography,* 239.

Saturday Evening Post covers: Richard O. Boyer, "Artist Profiles, 1: Demon in the Suburbs," *The New Yorker* (Nov. 27, 1943), 33.

p. 127 "Blessed are they": E.E. Cummings, "And It Came to Pass," *Americana* v. 1 no. 1 (November 1932): 3–4.

"Apr. 6, 1930": Gilbert Seldes, "Short History of a Depression," *Americana* v. 1 no. 1 (November 1932): 10, 20.

p. 129 "only a queen might get the hang of": PH to MK, May 21, 1966, King Papers, LC. The other Memory Lane drawings parodied the songs "After the Ball is Over," "My Little Gray Home in the West," and "Only a Bird in a Gilded Cage."

"suave personality": PH to MK, Dec. 20, 1966, King Papers, LC.

p. 130 "he knew every bum in town": PH to MK, Sept. 25, 1966, King Papers, LC.

"They were copy-cats": PH to HW, Aug. 19, 1974, Warshaw Letters, AAA.

"a swindler, thief, and hopelessly addicted dope fiend": Mel Gussow, introduction, *Hirschfeld On Line* (New York: Applause Theatre & Cinema Books, 2000), 15.

"two cats peeing through a straw": PH to HW, Aug. 19, 1974, Warshaw Letters, AAA.

"novelists, poets, painters, gays, alcoholics": Fred Becker, "The WPA Federal Art Project, New York City: A Reminiscence," *The Massachusetts Review* v. 39 no. 1 (Spring, 1988), 74–92.

p. 131 "pansy interior decorators": Alexander King, *I Should Have Kissed Her More* (New York: Simon & Schuster, 1961), 187.

"listened with horror": Gussow, *Hirschfeld On Line*, 15.

"a sort of grownup Kewpie": Alexander King, *May This House Be Safe from Tigers* (New York: Simon and Schuster, 1960), 170–173.

p. 132 "created the matrix": Jamie James, *The Glamour of Strangeness: Artists and the Last Age of the Exotic* (New York: Farrar, Straus, and Giroux, 2016), 287. James' account of Seabrook's "experiments" comes from avant-garde filmmaker and adventurer Maya Deren, whose unpublished papers are housed in the Howard Gotlieb Archival Research Center at Boston University.

"Lizzie in chains": Marjorie Worthington, *The Strange World of Willie Seabrook* (New York: Harcourt, Brace and World, 1966), 139, 203, 216–227.

"hopelessly compromised": James, *The Glamour of Strangeness*, 288.

"blatant shock value": Alexander King, *Mine Enemy Grows Older* (New York: New American Library, 1958), 167.

p. 133 "what the human chop looked like as it slowly broiled": Ibid., 170–171.

"purchased several copies": PH to MK, Jan. 17, 1966, King Papers, LC.

"He was something of a necrophile": King, *Mine Enemy Grows Older*, 167.

"Richard Halliburton of the Occult": "Books: Mumble Jumble," *Time* Magazine (Sept. 9, 1940), 82–83.

p. 134 "The Farm": Gerry Max, *Horizon Chasers: The Lives and Adventures of Richard Halliburton and Paul Mooney* (Jefferson, NC: McFarland & Co., Inc., 2007), 46, 59, 61–62. Bill Alexander, one of Max's sources, makes frequent appearances throughout *Horizon Chasers*.

Bill Alexander in Los Angeles: Anthony Denzer, "The Halliburton House and its Architect, William Alexander," *Southern California Quarterly*, v. 91 no. 3 (Oct. 2009), 319–341.

p. 136 "asked to remove every stitch of his clothing": Jean Paul Slusser to WHL, June 12, 1954, Littlefield Papers, AAA.

"nicely shaped legs": Gerry Max, email to SB, Feb. 16, 2016.

p. 137 "I would love to come up to Boston": DF to WHL, Apr. 3, 1931, Forbes Archive, MONA.

p. 138 "ALL THE MONEY we have sent you": Annie Littlefield to WHL, June 10, 1928, Littlefield Papers, AAA.

Littlefield's portrait of Kirstein: email to SB from Arthur Hughes, Feb. 5, 2019.

William Horace Littlefield: I have compiled biographical information from James R. Bakker, curator, *William H. Littlefield 1902–1969: A Retrospective* (Provincetown: Cape Cod Museum of Art, 2006; and Arthur Hughes, "William Horace Littlefield," biographical notes, in email to SB, Feb. 4, 2019. 1935 photograph of Littlefield: www.worthpoint.com/worthopedia/william-littlefield-1935-modernist-438809920 accessed Feb. 6, 2019.

"Maybe I have failed": Annie Littlefield to WHL, Oct., 1933, Littlefield Papers, AAA.

p. 139 "ruled with a firmer hand": WHL to "Evert," June 23, 1956, Littlefield Papers, AAA

"As for his odious character": Lincoln Kirstein to WHL, May 10, 1944, Littlefield Papers, AAA.

"your disagreeable letter": James Thrall Soby to WHL, Sept. 12, 1955, Littlefield Papers, AAA.

"morose and sardonic manner": WHL, notes on Don Forbes, index card, Littlefield Papers, AAA.

"extremely self-conscious": WHL, draft of Forbes biography, c. 1966, Littlefield Papers, AAA.

"Forbes has a mysterious power" WHL, Sept. 28, 1965, letter appended to: Marchal Landgren to WHL, Sept. 25, 1965, Forbes Archive, MONA.

"Don is in the psychopathic ward at Bellevue," WNM to Louise Clairmont, Dec. 9, 1938, Forbes Archive, MONA.

p. 140 "I am horrified to hear": Monroe Wheeler, c. 1938, quoted in WHL, draft of Forbes biography, Forbes Archive, MONA.

"almost gangrenous colors": Harry Saltpeter, "About Donald Forbes," *Coronet* (Aug. 1937), 179.

"rat-faced German sailor": WHL, draft of Forbes biography, Forbes Archive, MONA.

p. 142 "'that anyone should be painting like that today'": WNM to WHL, Apr. 18, 1938, Littlefield Papers, AAA.

"inanition and inertia": WHL, draft of Forbes biography, Forbes Archive, MONA.

"like a dog sitting on its balls": PH to WHL, Apr. 15, 1965, Forbes Archive, MONA.

p. 143 "perfectly swell": DF to WHL, Mar. 5, 1934, Forbes Archive, MONA.

"tipsy old ladies": WNM to WHL, Jan. 12, 1940, Littlefield Papers, AAA.

"Don's room is very amusing": WNM to WHL, Dec. 20, 1934, Littlefield Papers, AAA.

p. 145 "like an Oxford Don": Letter from unknown to WHL, Apr. 30, 1947, Littlefield Papers, AAA.

"buzzards, vultures, hawks, and eagles": WNM to WHL, Sept. 25, 1934, Littlefield Papers, AAA.

"nude leopard-spotted boys": WNM to WHL, Oct. 30, 1938. Littlefield Papers, AAA.

"swing which is covered with rose vines": WNM to WHL, July 28, 1935, Littlefield Papers, AAA.

"many cheap effects": WNM to WHL, Feb. 2, 1940, Littlefield Papers, AAA.

p. 146 "no eunuchs were for sale": WNM to WHL, Oct. 2, 1934, Littlefield Papers, AAA.

"got along fine with Jesse": WNM to WHL, July 26, 1938, Littlefield Papers, AAA.

"free to let their hair down": George Chauncey, *Gay New York: Gender, Urban Culture, and the Making of the Gay Male World, 1890–1940* (1994, rev. ed. New York: Basic Books, 2019), 163.

"pretty elevator boys": WNM to WHL, Nov. 5, 1937, Littlefield Papers, AAA.

"He is not the bruiser type": Pat Codyre to WHL, May 26, 1930, Littlefield Papers, AAA.

"a mere pug": Pat Codyre to WHL, undated (c. 1930), Littlefield Papers, AAA.

"The narrative is very confusing": WNM to WHL, Oct. 4, 1937, Littlefield Papers, AAA.

p. 147 "We took a few theater interiors": WNM to WHL, Dec. 11, 1937, Littlefield Papers, AAA.

"piles of peach baskets": WNM to WHL, Jan. 13, 1938, Littlefield Papers, AAA.

"vacant lots full of abandoned machinery": WNM to WHL, Sept. 23, 1934, Littlefield Papers, AAA.

"an extension of childhood": WHL, draft of Forbes biography, Forbes Archive, MONA.

"somewhat chagrined to find him in bed": WHL to unknown, c. 1947, Forbes Archive, MONA.

"he enjoys persecution so much": WHL to unknown c. 1947, Forbes Archive, MONA.

"sudden change from sex, anarchy and pessimism": WNM to WHL, June 19, 1940, Littlefield Papers, AAA.

p. 148 "she looked for 'a personal statement'": Grace Glueck, "Marian Willard Johnson, 81, Dealer in Contemporary Art," *New York Times*, Nov. 7, 1985.

"a full-size copy of the chateau of Meudon": WNM to WHL, Oct. 14, 1928, Littlefield Papers, AAA.

Don's portrait of his mother: "Donald Forbes, a Nebraska Problem Child Who Made Good in New York," *Newsweek* (Feb. 9, 1942), 60.

"tragic artist": Howard Devree, "Donald Forbes Art on Exhibition Here," *New York Times*, May 30, 1952.

p. 149 "$200 awaiting him at the Lincoln orphanage": "Artist Donald Forbes and His Subject Both Lived in Lincoln," *Lincoln Journal*, Mar. 28, 1943.

"once more before I kicked off": DF to WNM, June 26, 1946, Forbes Archive, MONA.

"I am sorry I ever got the suit": DF to BA, Aug. 19, 1946, Forbes Archive, MONA.

"like a kept boy of the late 18th century": DF to WNM, Apr. 15, 1946, Forbes Archive, MONA.

p. 150 "victim ready for sacrifice": DF to BA, June 10, 1946, Forbes Archive, MONA.

"penchant for fat men": PH to WHL, Mar. 10, 1965, Forbes Archive, MONA.

"messy fat-assed queens": PH to WHL, Feb. 12, 1965, Forbes Archive, MONA.

"This country is like a big living permanent exhibition": DF to WHL, June 10, 1946, Forbes Archive, MONA.

"hundreds of barefooted people": DF to WNM, Feb. 13, 1946, Forbes Archive, MONA.

"I never met the one I want": DF to WHL, June 10, 1946, Forbes Archive, MONA.

"to get rid of some ghosts": DF to BA, Apr. 9, 1946, Forbes Archive, MONA.

"was then a dancing teacher at Arthur Murray's": WNM to WHL, Mar. 24, 1966, Forbes Archive, MONA.

p. 151 "so happy together down at Coxsackie": WNM to WHL, Sept. 2, 1947, Forbes Archive, MONA.

"Living very uncomfortably": WNM to WHL, Jan. 29, Feb. 6, Feb. 13, 1948, Littlefield Papers, AAA.

"keep-fit coop": WNM to WHL, Oct. 15, 1948, Littlefield Papers, AAA.

"persuaded them they should have an art teacher": WNM to WHL, Mar. 24, 1966, Forbes Archive, MONA.

"Crystal chandeliers, gilt sconces": Ruth Fischer, "A Russian Touch of Class at Marble Hall," *New York Times*, Nov. 13, 1977.

"formal gardens and tennis courts": "Albert Warner Buys $2,000,000 Rye Estate," *New York Times*, Mar. 10, 1929.

"He had 12 puppets 2 feet high": WNM to WHL, Dec. 19, 1948, Littlefield Papers, AAA.

"giving 4 women painting lessons": WNM to WHL, Sept. 15, 1950, Littlefield Papers, AAA.

p. 152 "I am so god Damn busy": DF to WHL, Jan. 25, 1951, Forbes Archive, MONA.

"a fixture in the hall": WNM to WHL, Jan. 12, 1951, Littlefield Papers, AAA.

"that horrid little chest of drawers": WNM to WHL, Mar. 24, 1966, Forbes Archive, MONA.

"in a drunken moment": WHL to PH, Feb. 23, 1965, Forbes Archive, MONA.

Klaus Mann: Frederic Spotts, *Cursed: The Tragic Life of Klaus Mann* (New Haven: Yale University Press, 2016), 252–253, 277.

"It seems as if the very facts melt away": WHL to WNM, c. 1965, Forbes Archive, MONA.

"When the book of life is closed": PH to WHL, May 29, 1965, Forbes Archive, MONA.

CHAPTER 7

p. 153 "squandered his fortune": PH, "Howard Lorenz Dies," obituary, White Crow Fine Paintings, whitecrow.squarespace.com/howard-taft-lorenz/ accessed August 2018.

"international diamond thief": WNM to WHL, June 2, 1935, Littlefield Papers, AAA.

"he became a malnourished hobo": PH, "Howard Lorenz Dies."

"told a strange man he was beautiful": PH to LRH, Oct. 16, 1979, LRH-PH Research, AAA.

"crammed with rubbish and filth," "cheap calendar colors": PH, "Howard Lorenz Dies."

"halfway between Ensor and Rube Goldberg": WNM to WHL, June 2, 1935, Littlefield Papers, AAA.

p. 154 "gigantic rope of braided hair": PH, "Howard Taft Lorenz Dies."

"a typical jungle scene": PH, "Howard Taft Lorenz Dies."

"tiresome bore": PH to LRH, Oct. 16, 1979, LRH-PH Research, AAA.

p. 155 "beheld tall black candles": Albert Parry, *Garrets and Pretenders: A History of Bohemianism in America* (1933; rev. ed. New York: Dover Publications, 1960), 321. On Clairmont and his milieu, see Parry, 316–324, and Ross Wetzsteon, *Republic of Dreams: Greenwich Village: The American Bohemia, 1910–1960* (New York: Simon & Schuster, 2003), 324–333.

"execrable": "A Prodigal Boom-Time Bohemian," *New York Times*, Aug. 20, 1933.

Robert Clairmont, "To Sylvia on Going through the P.R.R. Hudson Tubes," www.poetryatlas.com/poetry/poem/2589/to-sylvia-on-going-through-the-p.r.r.-hudson-tubes.html accessed Sept. 30, 2020.

"the greatest woman since Bach": PH to WHL, Mar. 26, 1965, Forbes Archive, MONA.

"Millionaire Playboy": Tom Boggs, *Millionaire Playboy: A Delirious and True Extravaganza of Inheriting a Fortune and Squandering It* (New York: The Vanguard Press, 1933).

"the most banal, trite, vapid mess of dull data imaginable": PH to WHL, Mar. 25, 1965, Forbes Archive, MONA.

"she would come home and marry him": Jeff Davis, "Around the Plaza," *San Antonio Light*, May 14, 1936.

p. 156 "broad cheek bones": WHL, draft of Forbes biography, Forbes Archive, MONA.

"She took him just as he was": Ibid.

"Then we sat on the esplanade": WNM to WHL, Aug. 26, 1936, Littlefield Papers, AAA.

"she reminds me of a man": WHL, draft of Forbes biography, Forbes Archive, MONA.

"Crimes Passionels": WNM to WHL, Sept. 20, 1934, Littlefield Papers, AAA.

"became very excited about a political argument": WNM to WHL, Oct. 11, 1934, Littlefield Papers, AAA.

p. 157 "Society Painter": Louise Clairmont to WHL, Feb. 9. 1964, Forbes Archive, MONA.

"such outlandish, outrageous, monstrous physical shape": PH to BA, c. 1963, Harnly Papers, AAA.

"a large petrified chunk of whale shit": Louise Clairmont to BA, June or July, 1963, Harnly Papers, AAA.

p. 158 "played nasty": PH to EK, July 21, 1975, E. King Papers, NYPL.

"brightly colored cheesecloth": PH to Sylvia Pelt Richards, Mar. 16, 1967, quoted in Richards, "A Biography of Charles Weidman with Emphasis upon His Professional Career and His Contributions to the Field of Dance," Ph.D. diss., Texas Women's University, 1971, 61.

"Fairalina Trusce": Ralph Bowers to Sylvia Pelt Richards, Mar. 8, 1967, quoted in Richards, "A Biography of Charles Weidman," 62–63.

"we would look through the contents of it and marvel": PH to Sylvia Pelt Richards, Mar. 16, 1967, quoted in Richards, "A Biography of Charles Weidman," 83–85.

"the Handsomest Man": "Union of the Splendidly Developed Dancers Ruth & Edwin Shawn," newspaper clipping, 1914, Eugenics Collection, American Philosophical Society.

"delirium of the senses": Ruth St. Denis, *Ruth St. Denis: An Unfinished Life* (New York: Harper & Brothers, 1939), 68.

p. 159 A drugstore poster: Ted Shawn, *Ruth St. Denis: Pioneer and Prophet: Being a History of Her Cycle of Oriental Dances*, v. 1 (San Francisco: John Howell, 1920), 3–4.

p. 160 "It was downright indecent": "Lady Managers Shocked," *The New York Herald*, August 5, 1893.

"Her mother was a Suffergette": PH to Kings, July, 1964, King Papers, LC.

p. 161 The split with Denishawn: Richards, "A Biography of Charles Weidman," 147–148.

"That old, fat-assed queen": PH to Kings, July, 1964, King Papers, LC.

"high-born sycophants": José Limón, "The Virile Dance," *Dance Magazine* (Dec. 1948), 20–21.

"I a lost soul in torment": *José Limón, An Unfinished Memoir* (Middletown, CT: Wesleyan University Press, 2001), 15.

"the two most handsome men": PH, "Notes for Sandra Dorr: José in Los Angeles and New York," E. King Papers, NYPL.

p. 162 "an ineffable creature": *Limón, An Unfinished Memoir*, 16.

"beautiful physique": Richards, "A Biography of Charles Weidman," 165.

"stock characters of the classic comedy": Winthrop Palmer, *Theatrical Dancing in America: The Development of the Ballet from 1900* (New York: B. Ackerman, 1945), 84.

"she moved like a gazelle": *Limón, An Unfinished Memoir*, 17.

p. 163 "the customary Ballet elegant-tea-cup positions": PH, "Notes for Sandra Dorr," E. King Papers, NYPL.

"I watched her spellbound": *Limón, An Unfinished Memoir*, 32, 60.

p. 164 "long white underwear": Richards, "A Biography of Charles Weidman," 218.

"It was all dreadfully intense": WNM to WHL, Oct. 14, 1938, Littlefield Papers, AAA.

"I hung around the dancers": PH to MK, Jan., 1968, King Papers, LC.

"Pussy Boy": Richards, "A Biography of Charles Weidman," 192.

"Today, I suppose, you would call it a commune": Charles H. Woodford, "My Dance Family," in June Dunbar, ed., *José Limón* (New York: Routledge, 2002), 45.

p. 165 "a very fat rich interior decorator": PH, "Notes for Sandra Dorr," E. King Papers, NYPL.

"with an antique house": PH to EK, Mar. 18, 1974, quoted in Eleanor King, *Transformations: The Humphrey-Weidman Era: A Memoir* (Trenton, NJ: Dance Horizons, 1978), 300.

"paneling of the Revolutionary Period": Richards, "A Biography of Charles Weidman," 191–193.

"I did him in the attic": PH to WHL, Mar. 25, 1965, Forbes Archive, MONA.

"until he grew big enough": PH to EK, July 21, 1975, E. King Papers, NYPL.

Peter Hamilton: Marcia B. Siegel, *Days on Earth: The Dances of Doris Humphrey* (Durham, NC: Duke University Press, 1993), 186, 187.

p. 166 "I must never again mention Charles Weidman's name": Woodford, "My Dance Family," 49.

Weidman and José: Selma Jeanne Cohen, *Doris Humphrey: An Artist First* (Middletown, CT, 1972), 162.

José's "pin feathers": PH, "Notes for Sandra Dorr," E. King Papers, NYPL.

"lovely funeral parlor seriousness": Ibid.

"Charles . . . sent a bouquet of roses": Woodford, "My Dance Family," 51.

"gorgeous piece of rough trade": PH to BA, undated, Harnly Papers, AAA.

p. 167 "empty Long John underwear": PH to Kings, Mar. 24, 1965, King Papers, LC.

"The war . . . had stunted everything": PH to LRH, June 19, 1981, LRH-PH Research, AAA.

"We did scale models of installations": PH to WHL, May 14, 1965, Forbes Archive, MONA.

p. 168 "with flying colors": PH Responses to Interview Questions, LRH-PH Research, AAA.

"car loads of early American furniture": PH to WHL, May 14, 1965, Forbes Archive, MONA.

"Well, you ought to know darling DON": PH to José Limón and Pauline Lawrence, Nov. 1, 1942, José Limón Papers, 1908–1972, Jerome Robbins Dance Division, The New York Public Library for the Performing Arts.

CHAPTER 8

p. 172 "The drawings in this book are amusing": Benjamin Knotts, "Foreword," *I Remember That: An Exhibition of Interiors of a Generation Ago* (New York: Metropolitan Museum of Art, 1942), 2.

Visitors were encouraged: PH oral history, 1981, AAA.

"he is simply steeped in it": Albert Lewin to Pandro Berman, Apr. 29, 1943, Albert Lewin Collection, University of Southern California Cinema Arts Library.

p. 173 On the Super Chief: PH oral history, 1981, AAA.

"the one man who could create": Albert Lewin to Pandro Berman, Apr. 29, 1943, Albert Lewin Collection.

"as though their subjects had been removed from newly opened graves": "Lavender and Old Bottles," *Time* Magazine (Nov. 24, 1941), 81.

"drowned corpses": "'Horror' Features Exhibit," *Herald Examiner*, Aug. 31, 1931.

"The story requires a portrait": Albert Lewin to Ivan Albright, Apr. 1, 1943, Lewin Collection.

p. 174 "chant[ed] the dead march": Adam Emory Albright, "Memories of Thomas Eakins," *Harper's Bazaar* v. 81 no. 2828 (Aug. 1947), 139.

"He is a little fellow": Albert Lewin to Pandro Berman, Apr. 29, 1943, Lewin Collection.

p. 175 Albrights' expenses: Invoices on MGM letterhead, Lewin Collection.

MGM studio: See Steven Bingen, *MGM: Hollywood's Greatest Backlot* (Santa Monica: Santa Monica Press, 2011).

"a small black and white drawing": PH Responses to Interview Questions, LRH-PH Research, AAA.

"1500, 2000 set-ups": Bernard Rosenberg and Harry Silverstein, *The Real Tinsel* (New York: Macmillan, 1970), 106.

p. 176 "For Dorian I ransacked": PH Responses to Interview Questions, LRH-PH Research, AAA.

"I was happy when you agreed": Albert Lewin to PH, Aug. 18, 1944, Harnly Papers, HC.

p. 177 "he would take off or leave on the gloves": Lindy Jean Narver, "Cedric Gibbons: Pioneer in Art Direction for Cinema," M.A. Thesis, University of Southern California, 1988), 4.

"I almost never saw Cedric Gibbons": Boris Levens, quoted in Mary Corliss and Carlos Clarens, "Designed for Film: The Hollywood Art Director," *Film Comment* v. 14 no. 3 (May/June 1978), 48–49.

"like a museum, a glorious collection": Bingen, *MGM: Hollywood's Greatest* Backlot, section 11.

p. 178 "merely a story of an exquisite character": Albert Lewin, cited in Rosenberg and Silverstein, *Real Tinsel*, 118–119. For a thorough analysis of the film, also see Susan Felleman, *Botticelli in Hollywood: The Films of Albert Lewin* (New York: Twayne Publishers, 1997), 41–61.

"pheasants en gelée": Angela Lansbury, Commentary, *The Picture of Dorian Gray*, DVD, Warner Home Video, 2008.

p. 179 "They come in to look at *The Door*": Oral History Interview with Ivan le Lorraine Albright, Feb. 5–6, 1972, Archives of American Art.

Scores of gossip columns: There are innumerable gossip-column anecdotes about the Albright twins in Hollywood. See Albert Lewin, "The Gremlins in Hollywood," *The Hollywood Reporter* v. 80 no. 32 (Oct. 23, 1944), Sec. 2, and Larry Lawrence, "Twin Artists from Illinois Give Hollywood Dose of Own Medicine," *Milwaukee Journal*, Mar. 27, 1944.

"pudgy, grey-haired, ruddy-faced, bright-eyed gnomes": Robin Coons, "Hollywood Sights and Sounds," newspaper clipping, undated, Scrapbook 1, Ivan Albright Collection, Ryerson and Burnham Art and Architecture Archives, The Art Institute of Chicago.

"Metro-Gnome": Lansbury, Commentary, *The Picture of Dorian Gray*.

"celebrated on quite a few bottles:" Ivan Albright to Helen McCabe, Jan. 2, 1943, Irene Helen McCabe Cantine letters from Ivan Albright and related clippings, Archives of American Art.

"I used to write a lot in Hollywood under the piano": Ivan Albright oral history, 1972, AAA.

p. 181 "in period of Oscar Wilde's book": Ivan Albright, Notebook, 1943–1948, Ivan Albright Collection, Series I, Ryerson and Burnham Art and Architecture Archives, The Art Institute of Chicago.

"rubber cobwebs": Ivan Albright to Helen McCabe, Jan. 2, 1943, McCabe Cantine Letters, AAA.

"[Skeets'] face was a contortion": Ivan Albright, corrections to draft of Michael Croydon, Ivan Albright, Michael Croydon Papers, Ivan Albright Collection, Series VI, Ryerson and Burnham Art and Architecture Archives, The Art Institute of Chicago.

"I packed it full of symbols": Rosenberg and Silverstein, *The Real Tinsel*, 118.

p. 182 "subtle poisonous theories": Oscar Wilde, *The Picture of Dorian Gray*, ed. Donald L. Lawler (New York: W.W. Norton, 1988), 217.

"fly right over the viewers' heads": Lansbury, Commentary, *Picture of Dorian Gray* DVD.

p. 183 "The picture of Dorian Gray": Ivan Albright to Earle Ludgin, Feb. 21, 1944, Earle and Mary Ludgin Papers, 1930–1983, Archives of American Art.

"Dorian with a green carnation": Ivan Albright, Notebook, 1943–1948, Ivan Albright Collection, Series I, Ryerson and Burnham Art and Architecture Archives, The Art Institute of Chicago.

"dreamy and imaginative": PH video interview, Apr. 1984, HC.

p. 184 "Wilde had to move behind a screen": Parker Tyler, "Dorian Gray: Last of the Movie Draculas," *View* (Fall 1946), 19–23.

"just like a dried-up crab apple": "Art: State Fair," *Time* Magazine (Aug. 18, 1947), 55.

p. 185 "old friend Donna Reed": PH to Dearest DEAR, undated, Harnly Papers, HC.

"designed sets at MGM": Gerald Faris, "Artist, Satirist, Sensualist, Cafeteria Worker . . .," *Los Angeles Times*, Nov. 14, 1971.

Production art: Steven Douglas Katz, *Film Directing Shot by Shot: Visualizing from Concept to Screen*, (Studio City, CA: Michael Wiese Productions, 1991), xi.

Cedric Gibbons assigned: George E. Turner, "Director Albert Lewin and cinematographer Harry Stradling Sr., ASC, spearhead classic 1945 screen version of Oscar Wilde's Famous Tale," *The American Cinematographer* vol. 78 no. 5 (May 1997), 87.

p. 186 "bad boiled lobster": Bosley Crowther, "The Screen in Review," *New York Times*, June 16, 1947.

"it was unlikely either would marry": "Ivan Albright gives his bride ghostly '$125,000' painting," *Milwaukee Journal*, Oct. 9, 1946.

"Malvin, the bachelor": "Brother Misses Brother," *Chicago Sun*, Oct. 7, 1946.

"Malvin, weeping uncontrollably": Michael Croydon, interview with Josephine and Ivan Albright, Aug. 28, 1975, Michael Croydon Papers, Ivan Albright Collection, Series VI, Ryerson and Burnham Art and Architecture Archives, The Art Institute of Chicago.

"I was humped over": Faris, "Artist, Satirist, Sensualist, Cafeteria Worker."

p. 187 "I was blackballed": Sarah Booth Conroy, "Slices of Life–Funny, Fanciful, and Fantastic," *Washington Post*, Oct. 25, 1981.

"physically and emotionally exhausted": Robert Myers, "Perkins Harnly: The Artist behind the Meat Counter," *Washington Post*, June 11, 1972.

"We should be pleased if Mr. Albert Lewin should offer": Erwin O. Christensen to PH, Mar. 5, Harnly Papers, AAA.

"Mail Order Period": PH, Description of Index and Lewin interiors, LRH-PH Research, AAA.

CHAPTER 9

p. 191 "Hell, they were terrible": Norma Meyer, "If Walls Have Ears, This Hotel Has Heard It All," clipping, c. 1981, Harnly Papers, HC.

"got smashed every night": Matt Weinstock, "'The Wizard of Oz,' the Last Munchkin, and the Little People Left Behind," *New Yorker*, July 11, 2018, www.newyorker.com/culture/culture-desk/the-wizard-of-oz-the-last-munchkin-and-the-little-people-left-behind accessed Jan. 10, 2019.

p. 192 "a locale for prostitution": Dianne Carter, "Culver Hotel Falls from Glory Days," *Los Angeles Times*, May 10, 1987. Also see Hadley Meares, "The Culver Hotel: Harry C. Culver's Flatiron of Fun," KCET, Los Angeles, Mar. 28, 2014, www.kcet.org/history-society/the-culver-hotel-harry-c-culvers-flatiron-of-fun accessed Nov. 2, 2018.

"The place had become a shambles": PH to Kings, c. 1962–64, King Papers, LC.

"a small apartment full of empty beer cans": Ibid.

p. 193 "fancily dressed ladies": Ibid.

"the YMCA is my new landlord": PH to MK, Dec. 5, 1967, King Papers, LC.

"worked every night until 1:00": PH oral history, 1981, AAA.

"One morning he was sitting on the kerb": PH to BP, Mar. 31, 1981, Louise Paxton Collection.

"At the time I never dreamed": Ibid.

"reinvented himself as a Whistler type": Emanuel Levy, *Vincente Minnelli: Hollywood's Dark Dreamer* (New York: St. Martin's Press, 2009), 21.

"snotty and ugly as sin": PH audio interview, Mar. 1984, HC.

The two quarreled: SB, conversation with Tom Huckabee, Oct. 10, 2014.

p. 195 swore off sex: LRH, notes on PH, c. 1980, LRH-PH Research, AAA.

"American primitives": PH to BA, undated, late 1950s, Harnly Papers, AAA.

"her pet monkeys": Thomas S. Hines, "Richard Neutra's Hollywood: A Modernist Ethos in the Land of Excess," *Architectural Digest*, Apr. 1, 1996; www.architecturaldigest.com/story/neutra-article-041996 accessed Aug. 27, 2019.

p. 196 "Did Tony tell you": PH to BP, Jan. 30, 1982, Louise Paxton Collection.

"*meuble*": Mary McNamara, "Legendary L.A. Designer Tony Duquette Dies at 85," *Los Angeles Times*, Sept. 11, 1999.

p. 198 "a decadent and delicious hellhole": Mitchell Owens, "On the Auction Block: A Trove of Fabulous Excess," *New York Times*, Mar. 8, 2001.

Dawnridge: see Hutton Wilkinson, *Tony Duquette's Dawnridge* (New York: Abrams, 2018).

"she has the industry of the bee": Myrna Oliver, "Elizabeth J. Duquette; Artist and Socialite," *Los Angeles Times*, Jan. 18, 1995.

"a tight chignon": Wendy Goodman, *Tony Duquette* (New York: Abrams, 2007), 69.

p. 199 Blue rinse: Jane S. Smith, *Elsie de Wolfe: A Life in the High Style* (New York: Atheneum Books, 1982), 202.

"withered, bright-eyed Grand Old Woman": "Art: Plenty of Time," *Time* Magazine (June 8, 1936), 44–45.

"A lively little figure": Janet Flanner, "Profile: Elsie de Wolfe, Lady Mendl, Handsprings across the Sea," *The New Yorker* (Jan. 15, 1938), 29.

p. 200 "When the urn was brought to Père Lachaise": Alfred Allan Lewis, *Ladies and Not-So-Gentle Women* (New York: Viking, 2000), 481.

p. 201 "the scarlet-haired Baroness": Hugo Vickers, *Cecil Beaton: A Biography* (New York: Little, Brown, 1985), 73.

"tattoos of quite exceptional obscenity": Beverley Nichols, quoted in Andrew Mead, "La Malcontenta 1924–1939: Tumult and Order," *Architects' Journal*, Nov. 26, 2012, www.architectsjournal.co.uk/la-malcontenta-1924-1939-tumult-and-order/8639256.article accessed Jan. 15, 2019.

p. 202 "she is exceedingly squat": Tony Wysard, "An 'Artist's' Queer View of Things," *Tatler*, Oct. 1, 1930.

"In her days of grandeur": *Cecil Beaton, Memoirs of the '40s* (New York: McGraw-Hill, 1972), 293–294.

"Baroness d'Erlanger's bedroom": Marie Jacqueline Lancaster, *Brian Howard: Portrait of a Failure* (San Francisco: Green Candy Press, 2007), 102.

p. 203 "La Baroness des Chats": Wystan Auden to Vera de Bosset, Nov. 20, 1947, quoted in Igor Stravinsky and Robert Craft, *Memories and Commentaries* (Berkeley: University of California Press, 1981), 159.

"Cafégeleh": SB, telephone conversation with Philip Mershon, Sept. 9, 2020.

"a great hostess for the gay set": PH to BP, Oct. 18, 1981, Louise Paxton Collection.

p. 204 "if you got her on a poor day": Hutton Wilkinson, *More Is More: Tony Duquette* (New York: Abrams, 2009), 189.

"I don't remember why": PH to Bill Paxton, Jan. 30, 1982, Louise Paxton Collection.

"his hair was dyed blue": Beth Saunders quoted in Sabrina Cooper, "Why Pioneering Photographer Adolf de Meyer is the 'Debussy of the Camera,'" DW, Apr. 12, 2017, www.dw.com/en/why-pioneering-photographer-adolf-de-meyer-is-the-debussy-of-the-camera/a-41595276 accessed Feb. 1, 2019.

p. 205 "no longer an arty social lion": PH to WHL, June 4, 1965, Forbes Archive.

"army colonel": PH video interview, Apr. 1984, HC.

"army, navy, and marine corps uniforms": "Spy is Nabbed on the West Coast," *The Daily Banner*, Greencastle, Indiana, Dec. 16, 1941.

"Austrian Count . . . disappeared:" PH to WHL, June 4, 1965, Forbes Archive, MONA.

p. 206 "doing the stained glass windows": PH Responses to Interview Questions, LRH-PH Research, AAA.

"plans and descriptions of Los Angeles": WNM to WHL, Feb. 15, 1946, Littlefield Papers, AAA.

"two small buildings and twenty employees": Culver City News Staff, "The Hayden Tract Is Rich in History," *Culver City News*, Apr. 10, 2011.

"public address speaker announced a summons": Charles Francis, *Encounters: A Memoir* (Bloomington, IN: iUniverse, 2014), 55.

p. 207 "to align his carnal desires": Ibid., 56.

"loud, hilarious obscenities": Charles Francis, email to SB, June 7, 2018.

"very explicit language": Francis, *Encounters*, 57.

"unusual friends": Ibid.

"Hell no, Margaret!": Francis, ibid., 59.

"tasty recipes for carrot and beet tops": Ibid., 58.

p. 208 "trained down to racehorse shape": "Gay Bears: The Hidden History of the Berkeley Campus," bancroft. berkeley.edu/collections/gaybears/stowitts/ accessed Apr. 20, 2019.

p. 209 His rubber and steel outfit: Dan Thomas, "Sculptured Costume," *Lima News* (Lima, Ohio), Nov. 13, 1934.

Beautiful native boys: On this aspect of Stowitts' career see Robert Aldrich, *Colonialism and Homosexuality* (New York: Routledge, 2002), 166–169.

"so shocked the Americans" Steven Bach, *Leni: The Life and Work of Leni Riefenstahl* (New York: Knopf, 2007), 173.

p. 210 "nagging her about her figure": Ibid., 174–175.

p. 211 Despite his almost fanatical obsession: Stowitts Family Website, stowitts.weebly.com/notable-names.html accessed Apr. 21, 2019.

"with great dignity": Charles Francis, email to SB, June 7, 2018.

"It has left me looking a mess:" Francis, *Encounters*, 59–60.

CHAPTER 10

p. 214 "period of artistic amnesia": "Artist Depicts Best, Worst of Bygone Age," *Los Angeles Times*, Nov. 14, 1971.

"high class dump": "Hash and Death," *Los Angeles Times*, May 2, 1973.

"luxurious, refined tea room atmosphere": PH to Kings, undated, c. 1965, King Papers, LC.

"red food coloring": Ibid.

p. 215 "hauled in loads of ten": PH to Kings, Mar. 24, 1965, King Papers, LC.

"There are huge pans of stews": PH, "Trailing Oyster Feathers," typed manuscript, Harnly Papers, HC.

"At the peak of the rush hours": Ibid.

p. 216 Tiny film: "Perkins Harnly: a film by Alan Warshaw," videotape recording, 1969, Huckabee Collection.

"cute little objects from carrots": PH to Kings, Easter Sunday, 1965, King Papers, LC.

p. 217 "The color of an old-fashioned telephone": PH to Kings, undated, c. 1965, King Papers, LC.

"My boss and half the help is queer": PH to BA, Mar. 11, 1961, Harnly Papers, AAA.

"where the 3rd sex was going to sit": PH to Kings, undated, c. 1965, King Papers, LC.

p. 218 "All of the queens have a field day": PH to Kings, Easter Sunday, 1965, King Papers, LC.

Systematic harassment: Lillian Faderman, *Gay L.A.: A History of Sexual Outlaws, Power Politics, and Lipstick Lesbians* (Berkeley: University of California Press, 2009), 78–84.

"the fags at the Ontra went haywire": PH to BA, undated, Harnly Papers, AAA.

"the real McCoy": The origins of this ubiquitously circulated and still current joke are probably impossible to trace. Paul Theroux repeats it in *Saint Jack* (New York: Houghton Mifflin, 1973), 30.

Cooper's Do-nuts raid: Faderman, *Gay L.A.*, 1–2.

p. 219 Mattachine Society: Ibid., 108–25.

"a noble and necessary movement": PH to BA, undated, Harnly Papers, AAA.

"I am in love!": PH to BA, July 3, 1962, Harnly Papers, AAA.

"He didn't know he had a profile": PH to Kings, Nov. 10, 1962, King Papers, LC.

p. 220 "We have psychological orgasms": PH to Kings, Mar. 1964, King Papers, LC.

"A pathetic, futile camp": PH to BA, Dec. 18, 1963, Harnly Papers, AAA.

"incomparable physical beauty": PH to Kings, Mar. 26, 1964, King Papers, LC.

"I have a Citizen Band transceiver": Orestes to PH, Mar. 13, 1964, King Papers, LC.

"filled with technical symbols": PH to Kings, Mar. 1964, King Papers, LC.

p. 221 "He is a bigoted anti-homo ignoramus": PH to Kings, Aug. 6, 1964 and early Mar. 1964, King Papers, LC.

"about gods and goddesses and Budah": Fernando Felix to PH, Mar. 24, 1965, Forbes Archive, MONA.

"A fanatical Theosophist": PH to WHL, June 4, 1965, Forbes Archive, MONA.

p. 222 "populists, intellectual utopians, single-tax enthusiasts": Louis Sahagun, *Master of the Mysteries: The Life of Manly Palmer Hall* (Port Townsend, WA: Process, 2008), 20–21. Sahagun's book is the major source on Manly Palmer Hall and the sole biography with a valid claim to objectivity.

Hodgepodge of denominations: Jules Tygiel, "Introduction," in Tom Sitton and William Deverall, eds., *Metropolis in the Making: Los Angeles in the 1920s* (Berkeley: University of California Press, 2001), 2.

"Flowery, sun-drenched California": "Religion: California Cults," *Time* Magazine (Mar. 31, 1930), 60.

"broadcast from their own radio station": Ibid., 61. For a thorough review of the subject see Michael E. Engh, S.J., "'Practically Every Religion Being Represented,'" in Sitton and Deverell, eds., *Metropolis in the Making*, Ch. 9, 201–219.

"'Church of Christ, Physical'": Nathanael West, *The Day of the Locust* (1939; rpt. New York: Ballantine Books, 1959), 92.

"the woman pastor who presided had violet hair": Carey McWilliams, *Southern California Country: An Island on the Land* (New York: Duell, Sloan and Pearce, 1946), 267–268.

"huge avocado of a man": Sahagun, *Master of the Mysteries*, 3.

William Mortensen: See Larry Lytle and Michael Moynihan, eds., *American Grotesque: The Life and Art of William Mortensen* (Port Townsend, WA: Feral House), 2014.

p. 224 "styled himself as an archaeological expert on the Maya": Erik Davis, *The Visionary State: A Journey through California's Spiritual Landscape* (San Francisco: Chronicle Books, 2006), 109.

"lead a still troubled mankind": Manly Palmer Hall, *The Secret Destiny of America* (Los Angeles: Philosophical Research Society, 1944), 1–4.

p. 225 Hall's domestic life: Sahagun, *Master of the Mysteries*, 161, 157, 195.

"open-ended Hollywood murder mystery": Ibid., 12.

"very curious about paranormal topics:" Charles Francis, email to SB, June 7, 2018.

"standard part of America's juvenile mental diet": Manly Palmer Hall to PH, Nov. 11, 1948, Harnly Papers, HC.

p. 226 marriages were sexless: Sahagun, *Master of the Mysteries*, 313–314.

p. 228 India Clark: PH audio interview, Mar. 1984, HC.

"Mr. and Mrs. Harnly": Tom Huckabee, "Our Friend Perkins Harnly," *Tease* (2004), 93. There is at least a shred of truth to Perkins' claims. Ed Wemple, in a letter to Alexander King, Jan. 10, 1961 (King Papers, LC), recalled a time when Perkins had taken him to dinner at his ex-wife's; unfortunately, or, rather, frustratingly, Wemple did not go into any useful detail.

"The 'Joe' is merely a tid bit from my subconscious.": PH Responses to Interview Questions, LRH-PH Research, AAA.

p. 229 "'It is wishful thinking and self hypnosis.'": PH to BA, Sept. 5, 1961, Harnly Papers, AAA.

"He had not had a bath in nine years": Jesse Andrews, caption to his photograph of Ed Wemple, Duke University Libraries Archive of Documentary Arts, repository.duke.edu/dc/jesseandrews/japph050010010 accessed Aug. 22, 2019.

"Procure about two dozen sticks of a good grade of marijuana": Ed Wemple to PH, Mar. 3, 1961, King Papers, LC.

p. 230 "Those books cost a pretty penny": PH to MK, 1966, King Papers, LC.

"Buddha died of food poisoning": PH to Kings, Aug. 14, 1964, King Papers, LC.

"Louis XIV period pieces": Francis, *Encounters*, 58.

Perkins' décor: PH to BA, Dec. 4, 1956, Sept. 5, 1961, and c. 1961, Harnly Papers, AAA.

p. 231 "my hand-carved rug was soaked": PH to MK, Sept. 28, 1967, King Papers, LC.

"$17,000 decorating the room": Norma Meyer, "Painting, Travel Reflect a Fascination with Death," *The Daily Breeze*, July 20, 1980.

"Treasures of the Vatican": PH to Kings, May 31, 1962, King Papers, LC.

"My new room is bare": PH to BA, Oct. 16, 1972, Harnly Papers, AAA.

"wonderful strange, eery, ghostly": PH to Kings, undated, 1962, King Papers, LC.

p. 232 "a very fat woman in bed eating a roast suckling pig": PH to MK, Nov. 11, 1966, King Papers, LC.

"Some very wise and clever old QUEEN": PH to Kings, Sunday, May, 1965, King Papers, LC.

Perkins' canaries: PH to MK, Sept. 2, 1965, Christmas Day, 1966/67, Aug. 17, 1967, Apr. 1978, King Papers, LC; PH to BA, undated, June 15, 1974, Feb. 1976, Harnly Papers, AAA.

CHAPTER 11

p. 236 Lotte Goslar: PH to BA, Sept. 13, 1971, Harnly Papers, AAA.

"I sat next to old fat Charles Laughton": PH to MK, Jan. 17, 1966, King Papers, LC.

p. 237 "The un-dead Whore": PH to Kings, undated, c. August 1965, King Papers, LC.

"the superior white trash": Ibid.

"when the midnight phone call came": PH to MK, Jan. 7, 1966, King Papers, LC.

p. 238 "boomed up somehow": PH to MK, Feb. 3, 1967, King Papers, LC.

"a two and a half year old baby blew it up": PH to BA, Aug. 14, 1971, Harnly Papers, AAA.

"He was in the Golden Powder business": Alan Warshaw, email to SB, Sept. 2, 2019.

"Henry and I were weltering in a blaze of glory": PH to MK, June 10, 1969, King Papers, LC.

p. 239 "a voluble, volatile mixture": Thomas Albright, "Fifty Percent Op/Fifty Percent Pop: Perkins Harnly's World of Victorian Satire," San Francisco Chronicle, June 8, 1969.

p. 240 "a former W.P.A. boondoggler": PH to MK, Jan. 17, 1966, LC. This was the memorial exhibition for David Smith, who had died in the previous May.

"our new Museum stinks": PH to Kings, May 6, 1965, King Papers, LC.

"the remnants of a nylon stocking murder": PH to BA, May 8, 1967, Harnly Papers, AAA. This was one of the objects in the museum's Assemblage and Beyond: American Sculpture of the Sixties, Apr. 28–June 25, 1967.

p. 241 "pecker and pussy" plant: "Perkins Harnly: a film by Alan Warshaw," videotape recording, 1969, Huckabee Collection.

p. 242 "stinkin' quality of the programs": PH to BA, undated, Harnly Papers, AAA.

"Interplanetary Convention": Jeron Criswell, Criswell Predicts from Now to the Year 2000! (Atlanta, GA: Droke House, 1968), 57.

Predicted that she would become President: criswellpredicts.com/jeron-charles-criswell.htm, accessed Sept. 24, 2019.

"As for Liberace and Criswell!": PH to BA, undated, Harnly Papers, AAA.

p. 243 "He has written an article on necrophilia": "CAN THIS BE ONE PERSON?????," typed sheets on Mart Gallery letterhead, Harnly Papers, AAA.

"suit any of our current editorial needs": Judi Sisson, editorial assistant, Playboy Magazine to BA, Oct. 11, 1971, Harnly Papers, AAA.

"ingratitude": HW, notes of conversation with BA, Apr. 28, 1982, Harnly Papers, HC.

"Another story has it": BA to HW, undated, 1971, Harnly Papers, AAA.

"grainy black-and-white kinescope clips": Matea Gold, "Here's Johnny, Digitized," Los Angeles Times, Aug. 11, 2010.

"The KNBC Studio audience howled": "The Pride of Wilshire," press release, LRH-PH Research, AAA.

p. 244 "Would you please advise me if Mr. Harnley was for real": G.J. Monson to The Tonight Show, Nov. 18, 1971, Harnly Papers, AAA.

"The memorable Perkins moment": Alan Warshaw, email to SB, June 6, 2019.

"never lose control of the show": Kenneth Tynan, "Fifteen Years of the Salto Mortale," The New Yorker (Feb. 20, 1978), 88. "Salto mortale" is the circus term for an aerial somersault performed on a tightrope.

"Carson said that he doesn't like to be up-staged": PH to MK, Jan. 31, 1972, King Papers, LC.

"Three months after the Carson show": PH to BA, Feb. 7, 1972, Harnly Papers, AAA.

"Three mature, very handsome ladies": PH to MK, Jan. 31, 1972, King Papers, LC.

"You are a truly unique individual": Yvonne Kenward to PH, undated, c. Nov. 1971, Harnly Papers, AAA.

p. 245 "French birdcage with a stuffed songbird": Cecilia Rasmussen, "Bulldozer Unveils Castle in the Woods, and Controversy," *Los Angeles Times*, Aug. 28, 2005.

"wound up in a pound": "Hermann Goering's Favorite Dog's Ashes Scattered," *Kokomo Tribune*, June 10, 1964.

"haunted by voices with 'thick Dutch accents.'": Rasmussen, "Bulldozer."

"castle binge": Yvonne Kenward to PH, undated, c. Nov. or Dec. 1971, Harnly Papers, AAA.

p. 246 "when Perkins is quiet, wheels are turning": Yvonne Kenward to PH, multiple undated letters, c. late 1971–early 1972, Harnly Papers, AAA.

Yvonne organized a noisy protest: Cindy Frazier, "40 Years of Sawdust," *Daily Pilot*, June 23, 2006.

"charming gingerbread type with a huge sloping roof": Yvonne Kenward to PH, undated, Harnly Papers, AAA.

"pink oval couch with one of my Bella Flowers": PH to BA, Feb. 7, 1972, Harnly Papers, AAA.

"Some Jewish friends": PH to MK, Sept. 28, 1967, King Papers, LC.

p. 247 "young rabbi in the community": Neal Gabler, *An Empire of Their Own: How the Jews Invented Hollywood* (New York: Anchor, 1989), 277, 266–267.

"he is theatrical but warm": PH to MK, Apr. 1, 1968, King Papers, LC.

p. 248 "blue serge suit": PH audio interview, Mar. 1984, HC.

"tissue deeply cut": PH memorandum on Vladimir Lenin's preservation, undated, Harnly Papers, HC.

"old, fat mess that we know": PH to HW, July 8, 1975, Warshaw Letters, AAA.

p. 249 "scattering worms all over the floor": PH to BA, June 9, 1970, Harnly Papers, AAA.

"The face of the deceased was exposed under glass": PH to HW, June 22, 1977, Warshaw Letters, AAA.

p. 250 "The poor old dried up mummy falling to pieces": Ibid.

"There are no more graveyards to investigate": Ibid.

"The Company made a job for me": PH to Lina Steele, July 31, 1979, LRH-PH Research, AAA.

"Can't tell you just how much we miss you": John Behrendt to PH, Mar. 9, 1984, Harnly Papers, HC.

"palatial mansion on Sugar Hill": PH to MK, undated, c. mid-1960s, King Papers, LC.

p. 251 "a yellow foam rubber Dildo": Ibid.

"a dirty show opened here": PH to MK, Jan. 1968, King Papers, LC.

"Meat Politics": Michael McClure, *The Beard* (San Francisco: Coyote, 1967), 12.

p. 252 "one rainy night": PH to MK, Apr. 1, 1968, King Papers, LC.

"merman making improper love": PH to Margie King, Apr. 29, 1968, King Papers, LC.

"a place of sheer magic enchantment": PH to MK, Aug. 17, 1967, King Papers, LC.

"new hundred dollar grey silk suit": PH to MK, Nov. 1, 1967, King Papers, LC.

p. 253 "that youthful, mischievous face is not exactly his": Norma Meyer, "Painting, Travel Reflect a Fascination with Death," *The Daily Breeze*, July 20, 1980.

He really did have one: Billing statement, Santa Monica Hospital Medical Center, Mar. 14, 1980, Harnly Papers, HC.

"the cosmetic surgery raised my morale skyhigh": PH, "Plastic Surgery," c. 1980, undated manuscript, Harnly Papers, AAA.

"vacation dough": PH to Lina Steele, July 31, 1979, LRH-PH Research, AAA.

CHAPTER 12

p. 255 *Perkins Harnly: American Surrealist* opening: PH Video Compilation, 1984–5, HC. The young fellow was musician Jerry Casale of DEVO, who bought the flower/vulva painting and owns it to this day.

Perkins' birthday party: PH Video Compilation, 1984–5, HC.

p. 256 everyone at the Ontra: PH to BP, Oct. 15, 1982, Louise Paxton Collection.

"[Perkins] first entered our lives in 1981": Tom Huckabee, "Our Friend, Perkins Harnly," *Tease* (2004), 92-93.

"'Our Divine Catalyst'": Nazimova as Salomé, Xerox reproduction, Harnly Papers, HC.

p. 257 "You and your inspiration": PH to BP, c. June 1980, Louise Paxton Collection.

"Kraft Ebbing, Froid and the other guy": PH to HW, Jan. 3, 1982, Warshaw Letters, AAA.

PH to Rocky Schenck, June 7, 1982, Harnly Papers, Rocky Schenck Collection.

"Phil has been my ever loving companion": PH to "Dearest Boy," undated, Harnly Papers, HC.

p. 258 "the kind and extent of the Cornell objects": LRH to PH, Mar. 23, 1979, LRH-PH Research, AAA.

"vibrant, dynamic, jewel-like": LRH to PH, Dec. 1, 1980, LRH-PH Research, AAA.

"extravagant group of glittering adjectives": PH to LRH, Dec. 8, 1980, LRH-PH Research, AAA.

"such a monstrous undertaking": PH to LRH, Aug. 28, Sept. 7, Sept. 28, Oct. 8, 1981, LRH-PH Research, AAA.

walked New York's deserted nighttime streets: Marchal Landgren to WHL, Sept. 25, 1965, Forbes Archive.

p. 259 "pulling a cork": Sarah Booth Conroy, "Slices of Life–Funny, Fanciful and Fantastic," *Washington Post*, Oct. 25, 1981.

Lynda Roscoe Hartigan, "The Vigorous Nostalgia of Perkins Harnly," in *Perkins Harnly: From the Index of American Design*, Lynda Roscoe Hartigan and Virginia Mecklenberg, curators, National Museum of American Art, Smithsonian Institution, Oct. 16, 1981-Feb. 15, 1982, 4-11.

"a few pages missing": PH to BP, postmarked Oct. 22, 1981, Louise Paxton Collection.

"magic classical city": Ibid.

p. 260 "his working days are over": HW to LRH, Mar. 1, 1984, LRH-PH Research, AAA.

"I saw his doctors": HW to LRH, Apr. 5, 1984, LRH-PH Research, AAA.

Bill had stored his Perkins things: HW, notes on conversation with BA, Apr. 21, 1982, Harnly Papers, HC.

he felt Bill was holding out: PH to HW, Feb. 1974, Warshaw Letters, AAA.

Two lengthy video interviews: PH video interview, Apr. 1984, HC.

p. 261 "a million dollars": Tom Huckabee, video recording of Perkins convalescing, Apr. 28, 1984, HC.

"Without them I would have died": PH audio interview, Mar. 1984, HC.

Perkins' wake: Tom Huckabee, "Our Friend, Perkins Harnly," *Tease* (2004), 90.

p. 262 His aim was to unfurl Perkins' life: SB, conversation with Ramon Caballero, Mar. 27, 2019. Ramon reports that there were only bits and pieces of unedited film rather than an almost-completed movie; it ended up stored in a vault in Hollywood.

p. 263 "'Is it really a motel for the dead?'": Ramon Caballero to PH, postmarked May 18, 1981, Louise Paxton Collection.

EPILOGUE

p. 267 "There are three ghosts": PH to BA, Nov. 9, 1960, Harnly Papers, AAA. Perkins sent the painting as a gift to Ed Wemple in Charlottesville. It has never surfaced.

p. 268 "there is only one sex": PH to Kings, undated, 1962, King Papers, LC.

"so many inverts": PH, *Nature's Undesirables*, typed manuscript, c. 1962, Harnly Papers, HC.

p. 269 "I am like a trap door spider": PH to BA, Sept. 5, 1961, Harnly Papers, AAA.

List of Illustrations

CHAPTER 1

p. 21 Rocky Schenck, *Perkins Harnly*, 1981. Courtesy of Rocky Schenck.

p. 22 *"When Bitchhood was in Flower,"* c. 1920. Huckabee Collection.

p. 26 *Perkins Harnly and Julia Josephine Moore Harnly*, c. 1902. Huckabee Collection.

p. 30 Perkins Harnly, *Ascension of the Outhouses*. Undated. Location unknown. Photograph, Huckabee Collection.

p. 38 Perkins Harnly, *Sarah Bernhardt*, 1970s. Tom Huckabee Personal Collection.

p. 40 *Paul Swan in His Trademark Leopard Skin*, reproduced in Paul Swan, "Why They Call Me the Most Beautiful Man in the World," *Chicago Examiner*, Mar. 15, 1914.

CHAPTER 2

p. 55 Anonymous, *The Sins of Hollywood*, Hollywood Publishing Company, May, 1922.

p. 58 *Barbara La Marr Lying in State*, 1926. Photograph courtesy of Allison Francis.

p. 60 *Nazimova in* Salomé, 1922. Lobby card. Author's collection.

CHAPTER 3

p. 64 Perkins Harnly, passport photograph, 1930. Huckabee Collection.

p. 72 *Perkins Harnly in Mary Pickford drag*, 1943. Huckabee Collection.

p. 76 Rose O'Neill, *The Spirit of '76: Votes for Women*, postcard, 1915. Public domain.

p. 77 Gertrude Kasebier, *Rose O'Neill, Illustrator and Originator of the "Kewpie" doll, posed in the photographer's New York City studio*. 1907. Library of Congress, Prints and Photographs Division.

p. 79 Perkins Harnly, *Wormy Boots*, 1933. Alan Warshaw Collection.

CHAPTER 4

p. 84 *Perkins Harnly with Fernando Felix, Mexico*, 1933. Huckabee Collection.

p. 86 *Perkins Harnly and "Lover,"* 1933. Huckabee Collection.

p. 94 *Perkins Harnly*, Exhibition Brochure, Frances Toor Gallery, Mexico City, 1933. Perkins Harnly Artist File, The Miriam and Ira D. Wallach Division of Art, Prints and photographs, New York Public Library.

CHAPTER 5

p. 105 Perkins Harnly, *Stylish Stout*, reproduced in *The Art Digest*, January 1, 1934, p. 18.

p. 106 Perkins Harnly, *The Gay Nineties*, 1933. From *Americana, Satire and Humor*, new series I no. 8 (June, 1933), 21. General Research Division, Astor, Lenox and Tilden Foundations, New York Public Library.

Color Perkins Harnly, *Boudoir*, 1902, 1935/1942. Index of American Design, Courtesy National Gallery of Art, Washington. Public domain. .

p. 117 Perkins Harnly, *Graveyard Scene with Coffin and "Harnly" Monument*. Undated. Tom Huckabee, personal collection.

p. 117 Perkins Harnly, *Peace on Earth*, c. 1935. Huckabee Collection.

Color Perkins Harnly, *Dentist's Operating Room*, 1935/1942. Index of American Design, Courtesy National Gallery of Art, Washington.

CHAPTER 6

p. 128 Perkins Harnly, *Silver Threads Among the Gold*, 1933. *Americana, Satire and Humor*, new series I no. 9 (July, 1933), 18. McCormick Library of Special Collections, Northwestern University.

p. 129 *Alexander King at the Beach*, c. 1925. Courtesy of Sarah Barab.

p. 135 *Bill Alexander at work on his first architectural assignment, Fort Schuyler, New York*, c. 1936. Courtesy of Gerry Max.

p. 137 *William Horace Littlefield with drawing for* Sailor Opening Shellfish, *Pampellone, St. Tropez, France*, Sept., 1928. Courtesy of Jim Bakker, Bakker Gallery, Provincetown, Massachusetts.

p. 142 Bruce Elliot, *Don Forbes at the Easel*, Sept., 1937. Emory Abraham (Don) Forbes Archives Collection, Museum of Nebraska Art, Kearney, Nebraska.

p. 144 William Horace Littlefield, *Whitney Norcross Morgan*, 1932. Private collection; image courtesy of Jim Bakker, Bakker Gallery, Provincetown, Massachusetts.

p. 149 *Don Forbes, Mexico, 1946*. Emory Abraham (Don) Forbes Archives Collection, Museum of Nebraska Art, Kearney, Nebraska.

CHAPTER 7

p. 159 H.T. Motoyoshi, *Egypta*, 1904. Ted Shawn, *Ruth St. Denis: Pioneer & Prophet, Being a History of Her Cycle of Oriental Dances*, vol. II: Plates (San Francisco: John Howell, 1920).

p. 163 Barbara Morgan, *José Limón, Mexican Suite ("Peon")*, 1944. Barbara and Willard Morgan photographs and papers, Library Special Collections, Charles E. Young Research Library, UCLA.

CHAPTER 8

p. 171 Perkins Harnly, Motion Picture Employee Identification Card, MGM, Dec. 13, 1943. Huckabee Collection.

p. 176 Perkins Harnly, *Basil Hallward's Studio*, continuity sketch for *The Picture of Dorian Gray*, 1944. Perkins Harnly Artist File, The Miriam and Ira D. Wallach Division of Art, Prints and Photographs, New York Public Library.

p. 180 Marie Hansen, *Ivan and Malvin Albright Work on First Dorian Gray Portrait Which in Final Canvas Will Look Like Model*, reproduced in *Life*, Mar. 27, 1944, p. 70. Getty Images.

Color Perkins Harnly, *Cocktail Lounge*, 1946, 1946. Index of American Design, Gift of Albert Lewin, Courtesy of National Gallery of Art, Washington.

CHAPTER 9

Color Perkins Harnly, *Bedroom, 1940*, 1946. Index of American Design, Gift of Albert Lewin, Courtesy of National Gallery of Art, Washington.

p. 197 *Tony Duquette Sitting in the Drawing Room of "After All," Elsie de Wolfe's House in Beverley Hills*, c. 1945. Photographer unknown. Courtesy of Hutton Wilkinson.

p. 198 *Elsie de Wolfe, Blu Blu, and Tony Duquette's "Meuble,"* 1944. Photographer unknown. Courtesy of Hutton Wilkinson.

p. 203 *The Baroness Catherine D'Erlanger wearing Her Diamond Tiara in the Garden of Her Hollywood Home*, c. 1945. Photographer unknown. From the Collection of Tony Duquette, courtesy of Hutton Wilkinson.

p. 210 Poster for Hubert Stowitt's *American Champions* exhibition, Berlin, reproducing his portrait of Olympic athlete Woodrow Strode, 1936. Courtesy of Blue Heron Gallery, Fallbrook, California

CHAPTER 10

p. 213 *The Three Disgraces*, c. 1961. Alexander King Papers, Library of Congress.

p. 220 Perkins Harnly, *Orestes in Profile*, c. 1962. Huckabee Collection.

p. 223 William Mortensen, *Manly Palmer Hall*, 1935. William Mortensen Archives, Center for Creative Photography, University of Arizona.

p. 227 Rev. Harold M. Sprague, Spirit Photographer, *Perkins, "Joe," and Perkins in Drag, a.k.a. "Ectoplasmic Image Fully Materialized,"* c. 1943. Huckabee Collection.

CHAPTER 11

p. 235 *Perkins Harnly on the Tarmac with Alexander Calder Jet*, 1973. Huckabee Collection.

p. 237 *Alexander and Margie King*, c. 1965. Courtesy of Sarah Barab.

Color Perkins Harnly, *Raphael's Transfiguration, Hollywood Style*, c. 1972. Collection of Alan Warshaw.

Color Perkins Harnly, *Flying Butts and Impossible Cow*, 1972. Collection of Alan Warshaw.

p. 249 *Perkins Harnly at the Luis Angel Firpo Vault, La Recoleta Cemetery, Buenos Aires, Argentina*, 1977. Huckabee Collection.

CHAPTER 12

p. 254 Rocky Schenck, *Bill Paxton and Perkins at the Attack Gallery Opening*, 1984. Courtesy of Rocky Schenck.

p. 259 *Perkins Harnly and Marchal Landgren*, National Museum of American Art, Washington, D.C. Oct. 15, 1981. Huckabee Collection.

p. 262 *Perkins Harnly's Urn in Tom Huckabee's Sculpture Garden, Fort Worth, Texas, 2020.* Courtesy of Tom Huckabee.

EPILOGUE

Color Perkins Harnly, *Garage of a Funeral Parlor, 1917*, 1946. Index of American Design, Gift of Albert Lewin, Courtesy of National Gallery of Art, Washington.

Color Perkins Harnly, *Funeral Parlor, 1895-1920*, 1946. Index of American Design, Gift of Albert Lewin, Courtesy of National Gallery of Art, Washington.

p. 267 Perkins Harnly, *Ghosts in a Graveyard*, c. 1960. Location unknown.

CODA

p. 315 Perkins and "lover," Mexico, 1933. Huckabee Collection.

p. 316 Letter from Manly Palmer Hall to Perkins, Dec. 17, 1964, thanking him for gift of Walt Whitman portrait. Huckabee Collection.

p. 317 Perkins's mystical vision, c. 1950s. Huckabee Collection.

p. 318 Perkins Harnly, *Hello, Cello*, c. 1934. Huckabee Collection.

p. 319 Perkins Harnly, *Heritage*, drag fashion plate, c. 1934. New York Public Library Artist File.

p. 320 Perkins' Imaginary Tomb, n.d. Huckabee Collection.

Index

A

abortion(s) .. 168, 228
abstinence .. 195
Abstraction 67, 127, 137, 139, 148
Addams Family .. 17
addict (-ion) 55, 103, 126, 130
aesthete 50, 52, 62, 96, 146, 172, 194, 204
African-American 65, 127, 164, 209, 248
Afternoon of a Faun 41–42, 208
Albright, Adam Emory .. 174
 -Ivan Le Lorraine173, 175, 178, 180, 182, 184–86
 -Malvin Marr 173, 175, 178, 180, 185–86
Albright, Thomas .. 238
alchemy .. 221, 224
alcohol 56–57, 80, 130, 132, 154, 168, 244
Alexander, Bill 90, 122, 134–37, 149, 151,
 157–58, 166, 195, 217, 219, 230,
 243, 246, 255, 260, 267, 269
Alex in Wonderland ... 236
Americana 108, 118, 128, 144
Americana magazine 125–29, 133, 239
American Ballet .. 138
American Champions 209–10
American Weekly .. 95, 100
Amman, Ralph .. 141
And Daddy was a Fireman 167
androgyny(-ous) 42, 48, 74, 77, 178, 226
angel 24, 29, 31–33, 116, 239, 241, 262, 266–67
antique 57, 108, 122–23, 131, 136,
 144, 165, 181–82, 196, 204
anti-Semitism 118, 134, 146, 246–48
Apollo .. 41, 43
Arbuckle, Fatty ... 55
architect 28, 97, 104, 134–36, 201, 224
architecture 16–17, 23, 28–29, 85, 89, 91–92, 104,
 107, 136, 159, 165, 176–78, 231, 240
aristocrat .. 195, 199, 204
Art Deco 67–68, 134, 175–76, 188
As Thousands Cheer 164-65

As We Were (Metropolitan Museum of Art show) 118
ashes (remains) 18, 200, 205, 226, 231, 245, 261
astrology .. 224
Asunsolo, Enrique 94, 99, 101, 107–8
As We Were .. 118
Asylum (William Seabrook) 132
athlete ... 42, 144, 208-9
Atlantis .. 221, 224
Attack Gallery .. 254, 255
auntie ... 35, 54, 161
Automat .. 146
avant-garde 95, 143, 155, 183, 256
Aztec ... 99, 150, 223

B

bachelor 182, 185–86, 207
Baggot, King .. 192
Baker, Josephine .. 65, 164
Baldwin Hill Village .. 186
ballerina .. 161, 167, 208
ballet 158, 161, 163, 167, 201, 208
Ballet Russes .. 209
Ballin, Hugo ... 78, 247
Bankhead, Tallulah .. 69
Baroque 91–92, 122, 146, 241, 246
Barrow, Bob .. 252
"basket" (slang) .. 69
Baudelaire, Charles 50–51, 55
Beard, the ... 251-52
Beardsley, Aubrey 59–62, 107
Becker, Fred 130, 153–54, 236
Bedroom, 1882 ... 115
Bedroom, 1940 ... 195, 200
Bell, Marjorie .. 236
Bella Flower 146–47, 194, 241, 246, 257
Belle of the Nineties .. 73
bell jar 108, 113–14, 120–21, 123, 204
Belter, John Henry 113–14, 121
Benjamin Franklin High School 109

Ben-Hur 47–48, 55, 175, 177

Berman, Pandro ... 172, 174

Bernhardt, Sarah 15, 36–38, 44, 54, 56, 59–60, 65,
116, 185, 188, 192, 236, 242

Beverly Hills.......................... 196–97, 211, 232, 247

bisexual ... 43, 130

bitchhood 21–22, 48, 62

Blairstown, NJ...................................... 164–65, 187

Blu Blu ... 196, 199–200

Blue Funeral Home .. 57

blue rinse.. 199, 252

Boggs, Tom ... 155

Bohemian 50, 59, 62, 74, 76-77, 81, 90,
142, 155, 164, 201, 239, 268

Bok, Edward ... 75

Bonar,John ... 185

Bonniebrook ... 75, 82

Boudoir.. 116, 121, 232

Bow, Clara .. 58

boxer(s)...................... 138, 141, 146, 232, 235, 249

Bright, Richard .. 252

Brooklyn Museum .. 109

Brooks, Romaine...................................... 201-02

browning (slang)............................... 69, 218, 219

Bryan, William Jennings 28–29

Bulliet, C. J. 70, 125

Burroughs, Edgar Rice.. 42

C

Caballero, Ramon... 13, 262

Café Gala.. 203

cafeteria(s)22, 48–49, 52, 55, 58, 62, 146, 211,
213–15, 217–20, 233, 243–44

Cahill, Holger ... 110–11

Camellia Room.. 157

camouflage.. 167

camp............................ 61, 113, 121, 184, 220, 232

canary 232–33, 235

cannibal(ism).. 132–33

Caprice.. 194

Carson, Johnny 236, 242–44, 253

Casino de Paris... 65

Castle Carabas............ 78–81, 131–32, 155, 164, 247

Cathedral of Lima... 250

Cather, Willa.. 38-39, 50

-Elsie ... 38–39

Cemeterio General de Santiago 250

cemetery (-ies) 16, 28, 31–34, 38, 57, 59, 65, 85,
102, 154, 161, 200, 205–6, 233, 236,
241, 243, 248–49, 253, 261–62, 265–67

Clairmont

-Robert... 154–55, 157

-Louise Bartley ... 155

Clark, India................................. 35, 49, 168, 228

cocaine... 56, 57, 153

coffin.................... 32, 88, 92, 93, 95, 101, 116, 178,
242, 248, 249, 250, 257, 265, 266

Cohen, Barbara 255, 260-61

Colonial Cafeteria..................................... 49, 52, 55

Conner, Bruce 240

Cooper's Do-Nuts 218

Cornell, Joseph 15–16, 98, 103–5, 108–9,
113, 228, 257–58

corset 17, 31, 71, 76–77, 80, 104, 106-7,
125, 128–29, 160, 194, 239

costume 40, 59–60, 73, 92, 98, 101, 150, 158–61,
164, 166, 178, 196, 201, 208–9, 252

Coxsackie 134, 136–37, 150–51, 161

Cozy Corner... 167

Crane, Hart..91-92

cremated..154, 205, 261

Criswell, Jeron 242

cross-dressing 19, 70, 201

cross-eyed 23–24, 154, 256

Crucible Steel of America 168

crucifixion .. 96–97

cruising ... 35, 66, 149

crypts ... 33, 90

cults ... 222–23

Culver, Harry C. .. 192

Culver City Hotel26–27, 185, 191–93, 207, 211,
214, 230, 238–39, 256–57, 260, 262

D

D'Erlanger, Baroness 196, 200–205, 208, 258

Dada (ism, ist)....................................... 103, 126, 129

Daily Breeze .. 253
Dali, Salvador .. 103, 109
Dance Family 164–67, 221, 268
Dance of the Underwear 167
Dawnridge .. 197–98
Day of the Dead ... 87–88
Day of the Locust ... 222
death 32–33, 55, 57, 87–88, 96, 101–2, 106, 133,
162, 173, 185, 222, 248, 251, 257, 265
Delphic Studios... 100–101
de Meyer, Baron Adolph 204–5, 208
DeMille, Cecil B.. 44, 47, 54
Denishawn Dance troupe................................. 160-62
Dentist's Operating Room 115
De Wolfe, Elsie 69, 196–200, 202–4, 252
Depression, the.................. 66, 70, 86, 109, 127, 229
Diana the Huntress .. 41
Door, the...178-79
Dope!...56, 130, 149
Dorothy Chandler pavilion 252
dowager (slang).. 69
Down Memory Lane .. 128
drag 15, 62, 69–74, 80, 90–93, 98, 104, 113,
118, 128–29, 146, 169, 188, 204, 217,
219, 221, 226, 228, 230, 239, 252, 266
Drag, the..69, 71, 129, 251
drag balls ... 69–71, 93
drag queen 15, 104, 128–29, 221, 228
drawers (underwear) 17, 31, 73, 94, 95, 99, 104, 128
Duncan, Isadora 42, 158, 163
Duquette, Tony............................. 196–200, 204, 252
Duquetteized .. 204
Durante, Jimmy .. 193–94

E

Eakins, Thomas.. 174
eccentric............................. 36, 74, 81, 109, 164, 195,
199, 202, 222, 253
ectoplasm ... 228
effeminacy .. 43, 68
elevator boy35–36, 44, 48–49, 59, 65, 193
El Station... 113–15, 118
Eltinge, Julian ... 70

Encyclopedia of Mexican Santos' Wardrobes 93
Ernst, Max .. 103, 186
Erté .. 68

F

facelift...200, 253, 255, 259
faggot .. 68
fairy, fairies45, 47–49, 54, 68, 82,
112, 158, 218, 230, 247
Farm, the... 134, 136
fashion photography.. 204
Felix, Fernando ... 49, 51–52, 62, 66, 68, 85–87, 89, 93,
97, 101–2, 104, 149, 221–22, 268
Federal Art Project (FAP).............. 110, 141, 148, 153
female impersonator 71, 74
Firpo, Luis Angel .. 235, 249
flit (slang)... 68
folk art..................................... 95, 97, 110–11, 118
Forbes, Don................. 18, 49–52, 62–63, 66, 68, 71,
74, 78–80, 89–91, 101, 130, 134,
136–40, 142–45, 147–49, 152–56 161,
167–68, 184, 196, 221–22, 258, 267
Ford, Charles Henri 145, 184
Forest Lawn Cemetery 57, 241, 261
Francis, Charles 206, 211, 230
Francis, Emily ... 74
freak show.. 43, 145
frilly 17, 26, 31, 114, 116, 167, 242
Frohlich, Ernest .. 205
funeral 18, 31–33, 48–49, 56–59,
166, 178, 206, 232, 265–66
Funeral Parlor, 1895-1920.................................. 266

G

Garage of a Funeral Parlor, 1917 265
Garden of Alla(h)..................................... 59, 62, 211
Gavit, Helen .. 43
gay 35, 52–53, 60, 68–69, 82, 96, 122–23,
144–46, 161, 182, 184–85, 203–4,
207, 209, 211, 217–19, 225, 251
Gay Nineties......... 73, 104, 106-7, 115–16, 125, 242
Gernreich, Rudy ... 219

Gibbons, Cedric............................ 172, 176–77, 185
glamour 47, 48, 54, 175, 192-93, 211
Golden Staircase .. 194
Gone with the Wind....................................... 119, 145
Goslar, Lotte .. 236
Graham, Martha ... 163–64
Granger, Phil... 255, 257
grave...... 38, 58, 65, 194, 205-6, 233, 256, 265, 267
gravedigger ... 206
graveyard(s) 16, 85, 88, 90, 185, 250
Greek 35–36, 40–42, 67, 77–78, 140, 158,
160, 182, 184, 202–3, 208, 219
Green carnation .. 183
Greenwich Village 69, 77, 101, 155, 157,
164, 184, 228, 238
Grocery Store .. 114
Grosz, George... 126–27, 129
Guggenheim Foundation............................... 91, 187

H

Haden, Sir Francis .. 265
Haines, William.. 51, 196
Hall, Manly Palmer......................42, 49, 55–56, 221,
223–24, 226, 228–30, 246
Hallelujah, a Boiler is Born 239
Halliburton, Richard......................... 53, 133–36, 158
Hamilton, Peter ... 165-67
Hamilton Lodge ... 70
Hangover House 122, 135–36, 195, 246
Harnly
-Benjamin (brother) ... 25
-Benjamin (grandfather)......................... 28–29, 35
-Frank.. 25, 33
-Julia ...23, 25–27, 35
-Lucile .. 25
-Mary28–29, 32–34, 39
Harper's Bazaar............................... 68, 174, 204-05
Hartigan, Lynda Roscoe............................... 257–60
hats............... 17, 57, 71, 73, 104, 115–16, 150, 188
Hayes, Helen... 119–20
Hearst, William Randolph 95, 100
high drag ... 69, 71, 73
Hirschfeld, Al.. 130–31

Hitchcock, Alfred 17, 151, 198
Hollywood Forever Cemetery 102
homophobic ... 207
homosexual(s) 123, 146, 218
Hoochie-Coochie.. 160
Hopper, Edward ... 108, 120
Huckabee, Tom..... 17, 96, 228, 241, 255-56, 260-62
Huichilobos... 99
Humphrey, Doris.......................... 125, 161–64
Humphrey-Weidman dance company ..100, 162-65, 167
Hunt, Hugh ... 185
Hunter, Bill.. 150–53

I

Index of American Design109-15, 118, 120–21,
125, 128, 162, 165, 167,
169, 171, 176, 187–88,
221, 228, 236, 258, 265
interior decorators 131, 196
inverts .. 268–69
I Remember That: An Exhibition of
Interiors of a Generation Ago 118–19, 171–72, 258
Isherwood, Christopher............................. 52–54, 62
Italianate.................................... 27, 35, 119–20, 192

J

Jacob's Pillow... 161
"Japan" Lacquer Dipping Vat................................ 206
Javitz, Romana... 110
Jewell, Edward Alden... 111
Jewish, Judaism 125, 146, 164, 209, 246–48
Johnstone, Elizabeth "Beegle"............................ 198
Julien Levy Gallery.................. 15, 17, 105, 236, 257
Jungle Ways ... 133

K

Kahlo, Frida .. 97–98, 102
Kahn, Eli Jacques ... 134
Keaton, Buster.. 193–94, 256
Kenward, Yvonne ...244, 246
Kewpies74–77, 82, 131–32, 188
Khayyam, Omar .. 50
Kiechel, Claire.. 47

King
 -Alexander26, 34, 44, 54, 61, 66, 100, 103,
 114, 125–27, 129–33, 161, 168,
 189, 192–93, 216–17, 220, 224,
 236–38, 242, 245, 248, 251, 268
 -Margie130, 220, 236-38, 251
Kirstein, Lincoln 138–39
KNBC............ 243
Knotts, Benjamin 118
Kreutzberg, Harold............ 162
Kuprin, Aleksandr............ 66–67

L

lace, lacy stockings........................22, 29, 31, 71, 73,
 92–93, 95, 113, 115–16,
 120, 128, 194, 204
Ladies Home Journal................................ 74–75, 133
La Marr, Barbara 57–58
Lady Mendl (see De Wolfe, Elsie)
Landgren, Marchal 258–59
Lansbury, Angela...................... 178–79, 185
Laughton, Charles............................ 236
Lawrence, Pauline "Pumba" 161, 164, 166, 168
Leda and the Swan 241
Legman, G............................ 68
leopard-skin............................ 41–42, 158
lesbian 69, 201, 204, 250–51
Leven, Boris............................ 177
Levy, Julien 15, 17, 89, 98, 103–5, 108–9,
 125, 146, 236, 257–58
Lewin, Albert ...172–74, 176–83, 186–87, 195, 206, 265
Levy, William Alexander (see Alexander, Bil)l
Lexington, Kentucky (Narcotic Farm) 126
Liberace, Wladziu 123, 242, 253
Limón, José49, 51, 62–63, 66, 86,
 140–41, 161–64, 167–69
Lincoln Hotel...................... 35–37, 44, 116
Littlefield, William Horace.......136–47, 152, 156, 221
loincloth............................ 61, 94–95, 158
Lorenz, Howard Taft........................ 153–54
Los Angeles County Museum of Art..................... 240
Loved One, the............................ 232
Lysistrata............................ 40

M

macabre 98, 155, 168, 243, 266
Mackie, Edith 87
Magician, the............................ 208
Magic Island, the............................ 132
Magnin, Rabbi Edgar F. 247
male shindigs 161
Mann, Klaus 152
Mansard............................ 110
Marble Hall ("milk farm")............................151-52
marijuana 130, 150, 229
Mart, the 136
"Mary Pickford drag" 72, 226, 230, 266
Mattachine Society............................ 219
Mayan Revival............................ 224
McClure, Michael 251
McKnight, Ian Duff............................167-68
Mecklenberg, Virginia............................ 259
Meet Me in St Louis............................ 194
Mendl, Sir Charles 69, 199
Metropolitan Museum of Art................ 15, 110, 118,
 169, 171, 257–58
Mexico 16, 49, 63, 68, 84–91, 93–103, 105, 107,
 125, 143, 149–50, 157, 164, 221
Mexico City 85–91, 94, 97–98, 100, 149–50
MGM........27, 48, 51, 68, 119, 169, 171–72, 175–81,
 183, 185–87, 191–94, 196–97, 230, 262
Minnelli, Vincente.....................194-95, 198
modern dance............................ 49, 162–63
modernism, modernist(s) ..91, 97, 103-04, 115, 122,
 126, 137, 142, 155, 157,
 195, 197, 204, 214, 240
Monstrosity Decade 17, 29, 107, 187
monument................ 31–33, 116, 235, 259, 265–66
Monument Display Room, 1888 266
Moon Fairies 218
Mooney, Paul134-36, 158
Morgan, Whitney Norcross.......... 112, 122, 139, 141,
 143-44, 147, 150, 153,
 156, 164, 167, 206
morphine............................ 55, 126
"Most Beautiful Man in the World" (see Paul Swan)
Motion Picture Magazine 54

Munchkins .. 191–93
My Kingdom for a Hearse 243
mythology ... 138, 140, 241

N

nance (slang) ... 68
Narcotics Farm ... 126, 133
National Collection of Fine Art 236
National Gallery of Art 111, 187, 258
National Museum of American Art 257
Nature's Undesirables (novel) 268
Nazimova, Alla 41, 59-62, 68-9, 77, 211, 256
Nebraska 15, 17, 19, 22–24, 26–29, 32,
 34–35, 39, 44–45, 47–50, 52,
 62, 68, 74, 92, 107, 121, 140,
 148, 158, 166, 168, 187–88,
 208, 236, 243, 256, 260
Nebraska State Reformatory 35
necrophile, necrophilia 33–34, 60, 62, 68,
 89, 133, 243, 253
nellie (slang) ... 35, 145
Neutra, Richard ... 195
New Orleans ... 66, 89, 90
New Yorker 104, 118, 127, 131, 199
New York Public Library 110, 185
Nijinsky, Vladimir 41-42, 201, 208
nostalgia 29, 109, 118, 123, 172, 187
Novarro, Ramon ... 47-48, 58
Noyes, Skeets .. 181
nude, nudism 56, 77, 94, 115, 127, 134, 136-37,
 141, 145, 156, 161, 174, 178,
 182, 188, 208-9, 226, 235, 241, 257

O

O'Gorman, Juan ..97
O'Neill
 -Callista ..76–77, 80–82
 -Clink (Clarence) ... 81–82
 -Meemie .. 79, 81
 -Rose74, 76–77, 82, 89, 107, 131, 134, 139,
 155, 164, 169, 208, 221, 247, 258, 268
oasis .. 193, 231
obscene, obscenities 207, 216, 252

occult (ism, ist) 133, 208, 221–23, 228–30, 243
Ogallala, Nebraska 15, 22-23
Omaha, Nebraska ... 36, 74
Ontra Cafeteria 211, 213–14, 243–44
opium ... 56
Orestes 219–20, 229, 235, 269
Orpheum Theater 35–36, 44, 159–60
Orozco, Jose Clemente 101
ostrich plumes 26, 73, 115, 241
outhouse .. 29

P

Painted Veil, the ... 208
pansy(ies) (slang) 68, 131
Pansies on Parade .. 68
paranormal ... 223, 225
Paris 34, 38, 44, 47, 77, 100, 103, 137, 155,
 161, 196, 199, 201-2, 205, 208, 235
Parker, William H. "Wild Bill" 218
Parr, Jack .. 131, 236, 242
Paul Swan is Dead and Gone 47
Paxton, Bill 194, 196, 204, 254-62, 269
Père Lachaise Cemetery 38, 65, 200, 236
Peron, Eva ... 249
perverse, perverted 24, 67, 33–34, 50, 52, 62,
 67, 101, 118, 129, 161
Photographer's Studio 114, 115
Picture of Dorian Gray, the 172, 176, 181, 183,
 186, 198, 225
Pizarro .. 250
playboy .. 153-56
Playboy magazine .. 243
pornographic (-ia) 67, 68, 116, 150
Pretty Penny .. 119–20
Pride movement ... 219, 243
privy(ies) .. 31
prop house 114, 176–78, 185, 187, 197, 202
prostitute, prostitution 192, 207
psychoanalysis ... 140, 148
Puck magazine .. 74

Q

queen 16, 18, 28-29, 32, 36, 38, 67, 69,
 107, 113, 119-121, 221, 228, 248

Queen Anne style.......................... 28–29, 32, 38, 121

Queen Isabella... 248

Queen Victoria 18, 113, 119–20

queer 19, 48, 53–54, 68–69, 82, 96, 102, 108,
112, 121–23, 135, 149, 217, 220, 251

queer space .. 135

R

Rambova, Natacha 59, 60, 62

Rand, Ayn.. 134

rat trap (as signature)........................ 114, 116, 128

Recoleta Cemetery ... 249

red necktie .. 144

Reed, Alma ... 100, 143

Reeves, Ruth .. 110

Regency style .. 177, 181

Reid, Wallace "Walter" 55-57

Riefenstahl, Leni ...209-11

reform-school, reformatory 24, 35

Regency ... 177, 181

Rimbaud, Arthur .. 79, 99

Rococo Revival ("Belter")................................. 113

Rollins, Lloyd.............................112, 121, 167-68

Rosicrucian Fellowship.........................222, 230

Rural Kitchen ... 114, 120

 Russell, Lillian 70, 71, 73, 120-21

S

Salomé.. 59–62, 69, 256

Sandpiper, the ... 198

Sandow, Eugen ... 42

Sanitary Hotel .. 25, 27–28

santos 93, 95, 97, 99–100, 103

Scarlet Pansy, a ... 71

scarlet fever.. 25, 27

Schenck, Rocky.................................21, 256, 260-61

Schoenberg, Arnold 50, 136

Scully, Robert .. 71

sculpture.......................... 32, 95, 122, 135, 240, 262

Seabrook, William...132-33

Sears Roebuck catalog29, 31–32, 104, 108,
113–14, 120–22, 177

sex24, 33–34, 48, 55, 57, 69, 102, 122, 130, 134,
147, 195, 206-7, 217, 243–44, 251, 268

Shawn, Ted158-61, 164, 208

Silent Movie Theater ... 256

Sins of Hollywood.. 55–56

Skelton, Red..192-93

Slaughterhouse Alley 130, 153-57

Slop Art ... 240

Smith, David ... 148, 240

Smithsonian.. 16, 201

snuggery.. 230, 257

Spratling, William ...89-92

St. Denis, Ruth...............................158-62, 208

Stacy-Judd, Robert ... 224

Steinberg, Saul .. 118

Stonewall Riot... 218-19

Stothart, Herbert .. 179

Stowitts, Hubert 208, 210–11

strike (labor)................................ 131, 186–87, 191

Stylish Stout.. 104–5

Suffrage, suffragette................................... 40, 76

suicide 70, 138–40, 152, 155, 182, 225

Sulamith: A Romance of Antiquity............. 66–67, 101

Sun Gallery ...238, 243, 248

Surrealism... 15, 103, 107

Swan, Paul39–45, 47–48, 54, 59, 68, 158, 208

Swanson, Gloria .. 44, 54

Sweet Monster drawings (Rose O'Neill).......... 77, 208

T

Tarzan... 42

Tashman, Lilyan ... 65

Taxco ...87, 89–92, 96

Ten Commandments, The 47, 239

Tchelitchew, Pavel139, 145-46

Theosophist ... 221, 246

Thomas, Danny ... 244

Thy Name is Woman.. 58

Tonight Show.. 236, 243–44

Toor, Frances85, 87, 94, 96-98, 102-03, 107

Townhouse Parlor, 1869 113, 120

Trailing Oyster Feathers215, 268

transvestite .. 70

 Tyler, Parker...183-84, 186

313

U

underwear 31, 101, 113, 128, 164, 167
urn 18, 31, 49, 57, 200, 226,
231, 257–58, 261–62, 267
Utilitary Columbarium ... 205

V

Valentino, Rudolph 58-59, 73, 102
vanitas .. 189
vaudeville ... 15, 27, 194
Vedanta Society of the West.................................... 53
Venus Castina .. 70, 125
Victorian...................... 15–17, 28, 31, 74, 79–81, 89,
97, 103-9, 112–14, 116–17, 119–23, 125, 128, 144,
146, 171–72, 178, 181, 187, 191, 194, 199, 239–41,
252, 257
Victoriana.....17, 107–8, 118–23, 128, 143, 173, 185,
194, 239
Victorians ... 33
View magazine...183-84
voodoo.. 132
Vogue magazine...................................118, 179, 204

W

Walsh, Johnny ..203-04
Warhol, Andy ... 16, 47, 143
Warshaw
-Alan ... 216, 238–39, 244
-Henry216, 238, 255, 260
Washington Post ... 259
watercolor 15, 29, 31, 38, 90, 103, 108–9,
111, 120–21, 167, 194–95, 226
Watts Riots ... 237
Wayne, John ..192-93
Weasner, Charles Hamilton (see Hamilton, Peter)
Weidman, Charles...........100, 125, 158, 160-67, 187
Wemple, Edwin...................................... 99, 101, 229
West, Mae15, 63, 69, 73–74, 195,
228, 232, 242, 251, 253
West, Nathanael..222-23
Western Stove Company 206, 214, 225
Westside Pharmacy... 66

Wheeler, Monroe 140-41, 147
wigs 60, 71, 92, 94, 129, 179, 185
Wilkinson, Hutton.. 198
Willard, Marian ... 148, 152
Willy boy (slang)... 43
Wilshire Boulevard Temple 246–47
Wood, Grant.. 121
Wood, Ruby Ross ... 118
Works Progress Administration(WPA) 110, 139
Wright, Cobina.. 204
Wyuka Cemetery... 32

Y

Yellow Rolls-Royce, the ... 232
YMCA ... 193
yoo-hoo.. 68
Young and the Evil, the.. 184
Young Men's Hebrew Association (YMHA) 109
Young's Million Dollar Pier............................. 71, 90

Z

zombies ... 88, 134, 184
Zupa, Nicholas ... 114

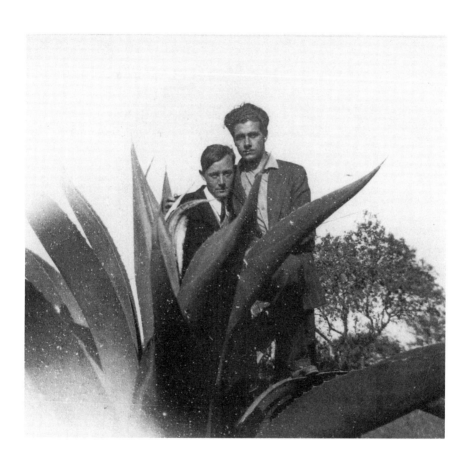

Perkins and "lover," Mexico, 1933. Huckabee Collection.

The Philosophical Research Society, Inc.

3910 Los Feliz Blvd. - Los Angeles 27, Calif. - NOrmandy 3-2167

MANLY P. HALL
PRESIDENT-FOUNDER

HENRY L. DRAKE
VICE-PRESIDENT

December 17, 1964

Perkins Harnly
9400 Culver Blvd.
Culver City, Calif. 90231

Dear Mr. Harnly:

 The autographed portrait of Walt
Whitman arrived safely. It is a very hand-
some picture, and we shall give it a dis-
tinguished place in the permanent collec-
tion of our Society. Personally, I have
always been very fond of Whitman's poems,
and the autographed portrait helps to
bridge the years and makes him seem a more
intimate part of our lives. Again, thank
you very much.

 With Season's Greetings, I am

 Most sincerely yours,

Letter from Manly Palmer Hall to Perkins, Dec. 17, 1964, thanking him for gift
of Walt Whitman portrait. Huckabee Collection.

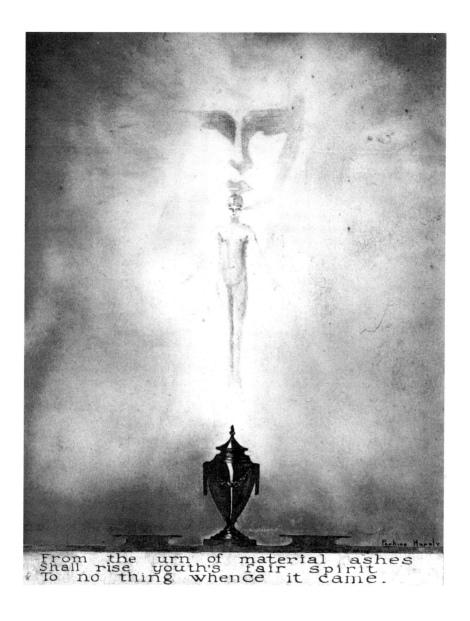

From the urn of material ashes
Shall rise youth's fair spirit
To no thing whence it came.

Perkins's mystical vision, c. 1950s. Huckabee Collection.

Perkins Harnly, *Hello, Cello*, c. 1934. Huckabee Collection.

Perkins Harnly, *Heritage*, drag fashion plate, c. 1934.
New York Public Library Artist File.

Perkins' Imaginary Tomb, n.d. Huckabee Collection.